G E N E A L O G Y

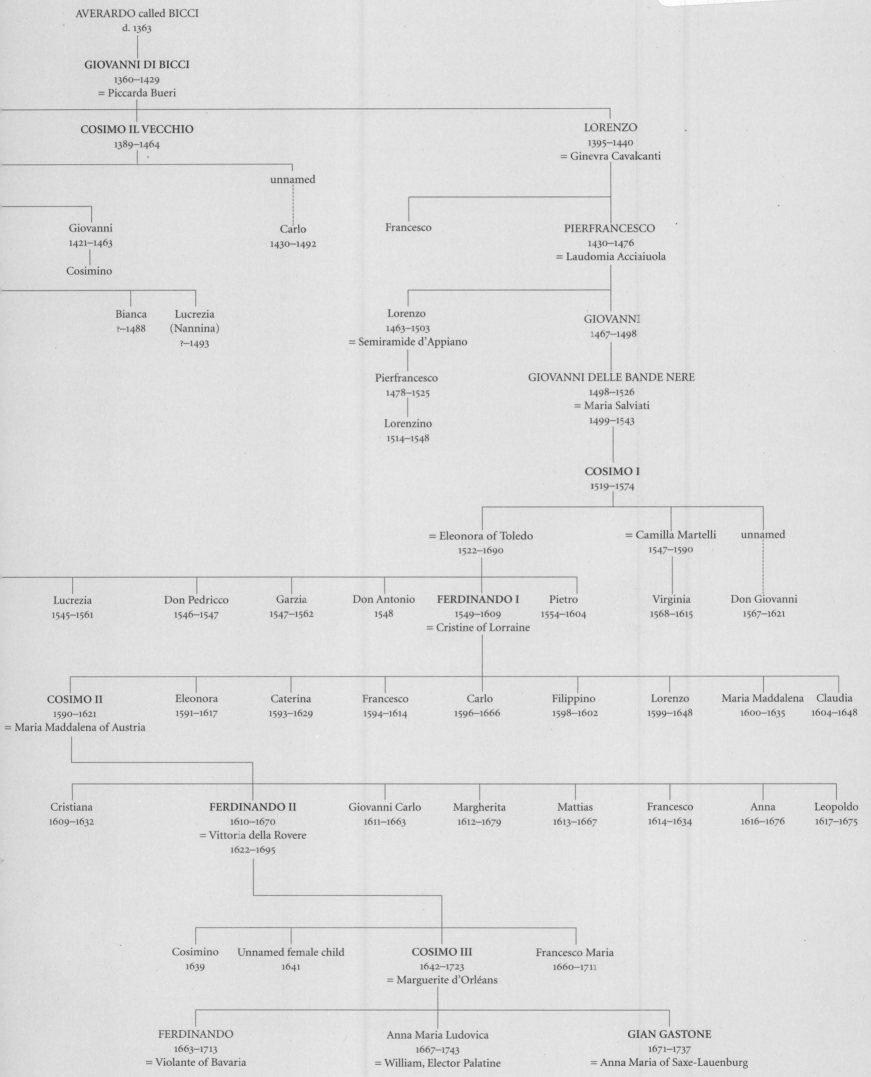

AVERARDO called BICCI
d. 1363

GIOVANNI DI BICCI
1360–1429
= Piccarda Bueri

COSIMO IL VECCHIO
1389–1464

LORENZO
1395–1440
= Ginevra Cavalcanti

unnamed

Giovanni
1421–1463

Carlo
1430–1492

Francesco

PIERFRANCESCO
1430–1476
= Laudomia Acciaiuola

Cosimino

Bianca
?–1488

Lucrezia
(Nannina)
?–1493

Lorenzo
1463–1503
= Semiramide d'Appiano

GIOVANNI
1467–1498

Pierfrancesco
1478–1525

GIOVANNI DELLE BANDE NERE
1498–1526
= Maria Salviati
1499–1543

Lorenzino
1514–1548

COSIMO I
1519–1574

= Eleonora of Toledo
1522–1690

= Camilla Martelli
1547–1590

unnamed

Lucrezia
1545–1561

Don Pedricco
1546–1547

Garzia
1547–1562

Don Antonio
1548

FERDINANDO I
1549–1609
= Cristine of Lorraine

Pietro
1554–1604

Virginia
1568–1615

Don Giovanni
1567–1621

COSIMO II
1590–1621
= Maria Maddalena of Austria

Eleonora
1591–1617

Caterina
1593–1629

Francesco
1594–1614

Carlo
1596–1666

Filippino
1598–1602

Lorenzo
1599–1648

Maria Maddalena
1600–1635

Claudia
1604–1648

Cristiana
1609–1632

FERDINANDO II
1610–1670
= Vittoria della Rovere
1622–1695

Giovanni Carlo
1611–1663

Margherita
1612–1679

Mattias
1613–1667

Francesco
1614–1634

Anna
1616–1676

Leopoldo
1617–1675

Cosimino
1639

Unnamed female child
1641

COSIMO III
1642–1723
= Marguerite d'Orléans

Francesco Maria
1660–1711

FERDINANDO
1663–1713
= Violante of Bavaria

Anna Maria Ludovica
1667–1743
= William, Elector Palatine

GIAN GASTONE
1671–1737
= Anna Maria of Saxe-Lauenburg

THE UFFIZI GALLERY
MUSEUM

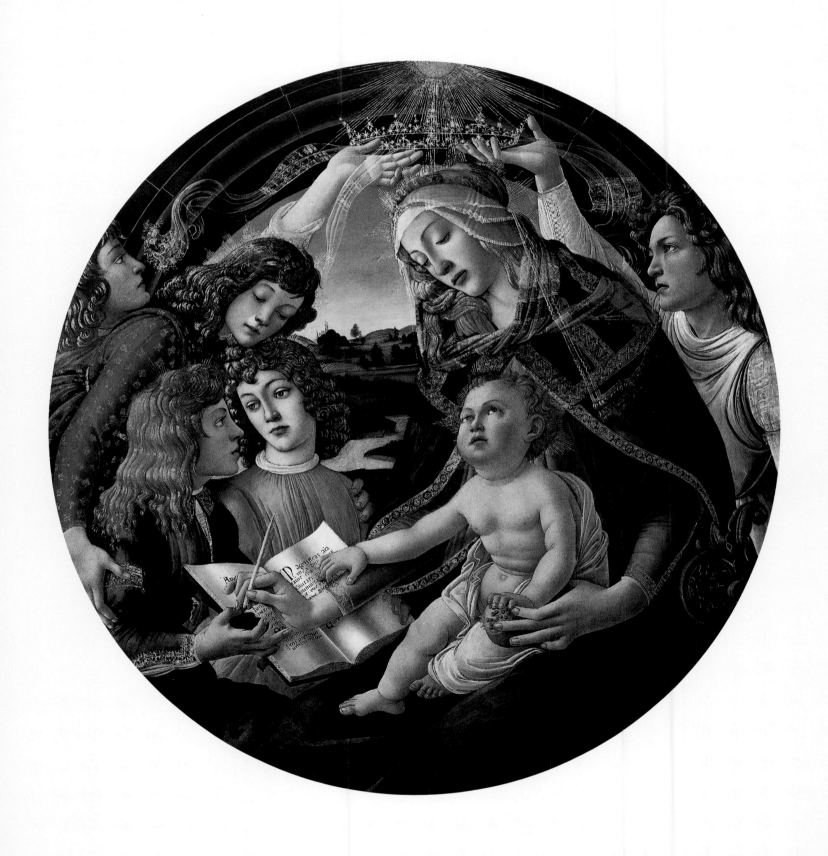

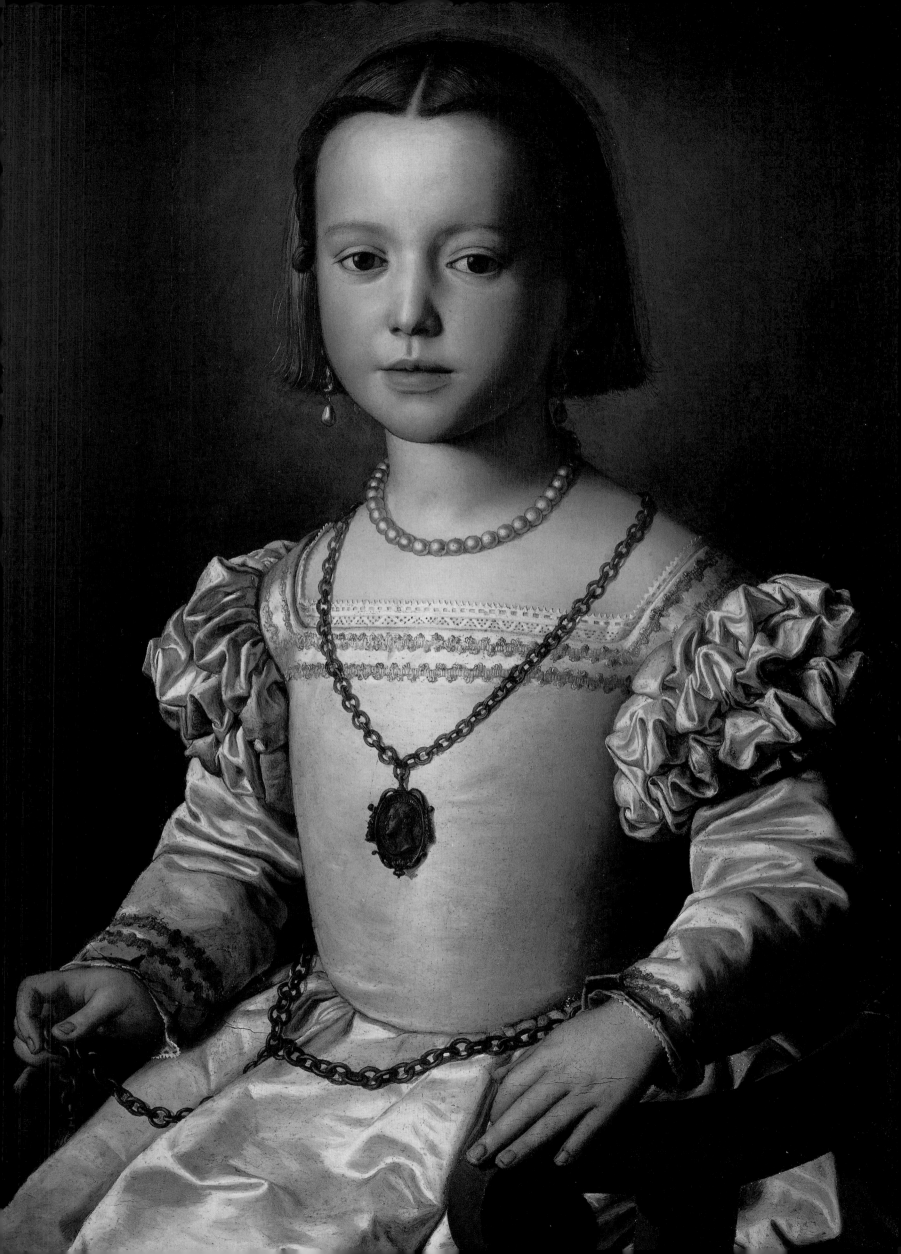

THE UFFIZI GALLERY MUSEUM

Alexandra Bonfante-Warren

HUGH LAUTER LEVIN ASSOCIATES, INC.

ISBN-10: 0-88363-518-6
ISBN-13: 978-0-88363-518-6

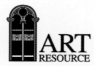 All photographs of artworks Courtesy of Art Resource, New York.

Project and Editorial Director: Ellin Yassky
Copy Editors: Jeanne-Marie P. Hudson and Deborah T. Zindell
Design by: Charles J. Ziga, Ziga Design

Distributed by Publishers Group West
Printed in China

P. 1

Sandro Botticelli (1445–1510). *Madonna of the Magnificat.* Ca. 1483.
Tempera on wood. Diameter: 46 ½ in. (118 cm).

The figures occupy a curious shallow dimension, between a kind of architectural oculus and the picture plane. The Virgin dips her pen in order to continue writing the *Magnificat,* the words of praise she speaks in Luke 1:46–55, after the angel's salutation. Mother and Child hold a pomegranate, whose red seeds foretell the Passion.

P. 4

Agnolo Bronzino (1503–72). *Portrait of Bia de' Medici.* 1542. Tempera on wood. 24 ¾ x 18 ⅞ in. (63 x 48 cm).

The year 1537 was an eventful one for Cosimo de' Medici. The assassination of the tyrannical Duke Alessandro made him heir to the title, and that same year, his daughter Bia was born to the unmarried teenager. Bronzino depicted, in his signature style, a self-assured child of the nobility. Little Bia died not long after sitting for this portrait.

ACKNOWLEDGMENTS

Thanks once again to Hugh Lauter Levin for the privilege of exploring some of the most remarkable creations of the human hand, mind, and soul. These works of art express the entire spectrum of human emotion, belief, and thought—from spiritual aspiration, political ambition, and aristocratic arrogance, to fear, love, lust, and longing of every kind. I thank my fellow-travelers, beginning with my editor, Ellin Yassky, whose passion for the works, enthusiasm for the book, and kindness toward me never seemed to flag. It was a pleasure to work again with Jeanne-Marie P. Hudson and to welcome the newest Hudson production. I am grateful to Jeanne-Marie and to Debby Zindell for their careful attention to detail. In Florence, ace detective Francesca Cecchi ran elusive facts to ground; grazie, Francesca! Thanks to Charles Ziga, of Ziga Design, who has once again made a project with many moving parts look effortlessly elegant. I'm grateful once more to Gerhard Gruitrooy, Director of Research at Art Resource, for his thoughtful and generous help. Also at Art Resource, Alicia Fessenden, Researcher, is a paragon of efficiency, professionalism, and good nature. In the offices of the Uffizi, Antonio Natali offered very timely help indeed. I thank my remarkable teachers, who will know, better than anyone, that all errors are mine. I am beyond fortunate in my friends and family, here and gone. This one's for you.

CONTENTS

Acknowledgments

OPPOSITE
Florentine School. *Ceiling Grotesques*. 16th century. Galleria degli Uffizi, Florence.

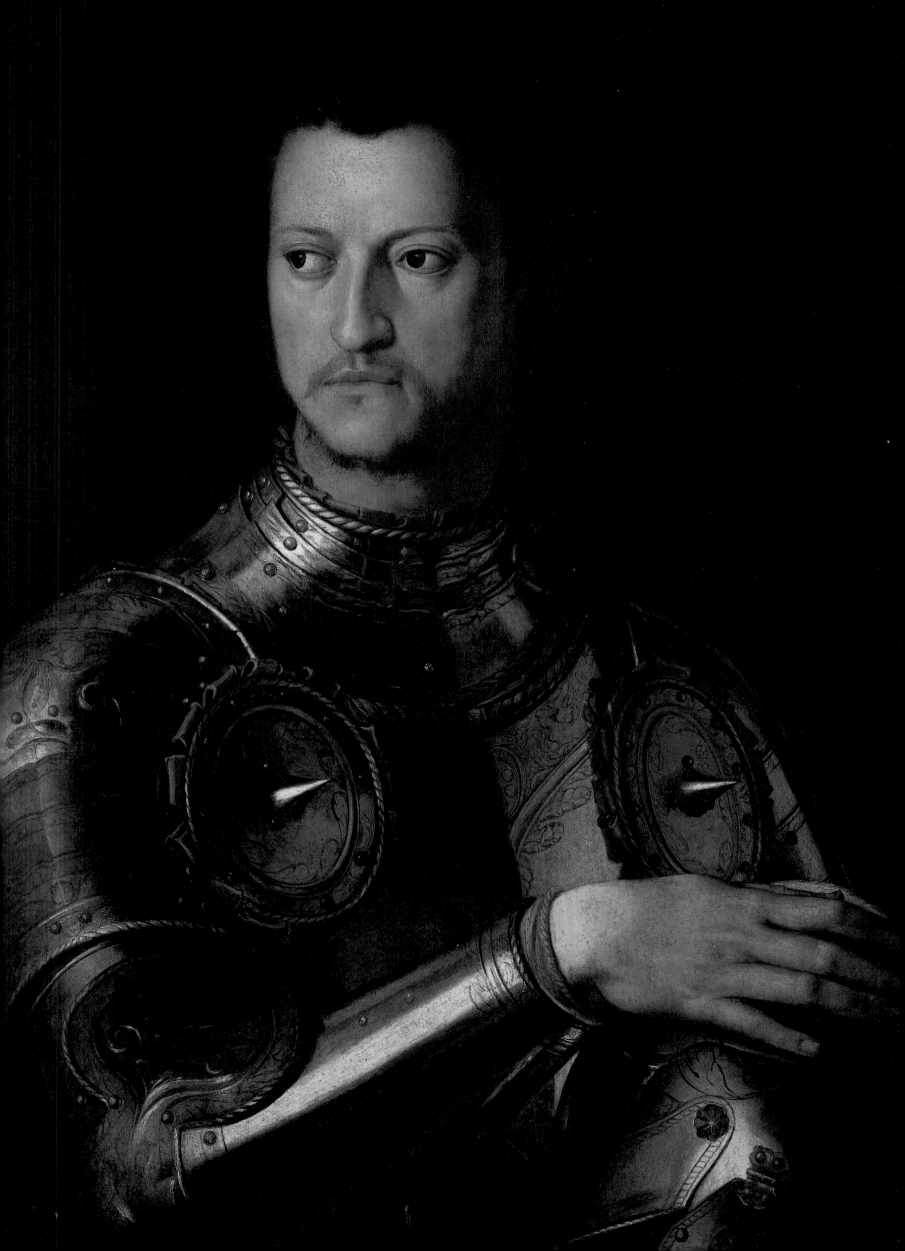

The Galleria degli Uffizi

The Uffizi is the world's oldest museum. Its aristocratic walls house two unparalleled collections: the Galleria displays masterpieces of painting dating from the thirteenth to the nineteenth century—the collection of artists' self-portraits extends into the twentieth and great works of sculpture from classical antiquity. The Gabinetto Disegni e Stampe holds nearly 120,000 drawings and prints, in a collection begun in the mid-sixteenth century and still growing today. In addition, the Uffizi comprises research and conservation institutes, serving scholars from all over the globe, and performing miracles of restoration on priceless objects, brilliant traces of history that are precious gifts to us in the present.

The Uffizi is intimately associated with the Renaissance, the period most strongly represented in its collections, and in the very fabric of its buildings. However, it has grown organically through the centuries, harmoniously absorbing changes in style and purpose, reflecting the times and tides of Florence's identities. Always—including the devastating 1993 bombing ascribed to the Sicilian Mafia—the galleries have demonstrated the multiple, powerful, and pleasurable fascination of art, and its continuous importance, to the individual and to civilization.

Like the Renaissance itself, the Uffizi would not be what it is—indeed, might not *be*—were it not for the Medici family. Cosimo de' Medici, who initiated the Uffizi project, with something very different in mind, was only eighteen years old when he unexpectedly inherited the title of duke of Tuscany in 1537, becoming Cosimo I de' Medici. In 1539, he married the splendid Eleanora of Toledo, daughter of the viceroy of Naples. Palazzo Medici, considered arrogantly magnificent when Cosimo the Elder had built it a century before, was far too modest for the family's new status, and especially for the duchess's retinue of servants and attendants. In 1540, Cosimo, Eleanora, and their court took over the Palazzo della Signoria, formerly the town hall, as their residence. They commissioned Giorgio Vasari, court artist and architectural superintendent, to renovate and decorate their new home.

Vasari was born in 1511 in the Tuscan town of Arezzo into a family of ceramists, *vasaii*. Unusually for a child of artisans, he studied Latin and possibly classical mythology and religion. He learned painting from a local artist who had worked in the Vatican and knew the frescoes of Raphael and Michelangelo there. Vasari also displayed a precocious talent for writing. In 1524, the tutor of the young Medici cousins Alessandro and Ippolito took Giorgio to Florence, where he continued his studies with them while pursuing his artistic training in the workshops of the most important Florentine painters of the day. (Michelangelo, too, had been taken into the Medici household, that of Lorenzo the Magnificent, a generation before, and became one of the family's artists, though he was sometimes distracted by papal commissions such as the ceiling of the Sistine Chapel.)

By the late 1520s, the still-teenage painter was already in great demand. He established a

OPPOSITE

Agnolo Bronzino (1503–72). *Cosimo I in Armor.* Ca. 1545. Oil on wood. 28 x 22 ½ in. (71 x 57 cm).

workshop, which soon expanded to handle commissions from all over northern Italy. He was a very practical person and a good businessman, who made no bones about his intention to be rich and famous. (We should recall that fame was a noble aim in Renaissance culture.) Vasari's atelier was traditionally structured, including the economical reuse of drawings and even of the large cartoons that served as patterns for paintings. Like his artistic forebears, his involvement in a given work might be limited to a sketch. It seems convenient that in his later theory of art he would prize the original conception of a work over its execution, but he was an ardent collector of drawings for their own sake. A sincere admirer of the work of others, he saw these works on paper as the most immediate and intimate traces of their makers' first thoughts and subsequent compositional processes. Vasari was also generous in the way that artists of his time often were: he gave other painters drawings for their projects, just as Rosso Fiorentino had done for him. Vasari's literary and linguistic upbringing influenced his own paintings, whose allegories were so recherché that he sometimes had to explain them in letters to his bemused patrons.

Vasari's architectural experience previous to his work on the handsome office complex of the Uffizi was limited, certainly compared to the output of his painting workshop. In 1532, he had entered the service of his former fellow student and lifelong friend Ippolito de' Medici, who had become a cardinal; when Ippolito died in 1535, Vasari went to work for Alessandro, the first Medici duke. Alessandro, when he could spare time from depravity, was concerned with military fortifications, and so Vasari studied architecture. Alessandro's defensive turn of mind, however, did not protect him from assassination at the hand of Lorenzaccio ("Bad Lorenzo") de' Medici, yet another cousin.

Concluding that tying one's wagon to the star of the Great was an uncertain business, Vasari worked successfully for a number of clients, without committing himself to any single patron. By the early 1560s, however, Cosimo I, who had inherited the title of duke from Alessandro, a distant connection, was commissioning so many projects from Vasari that Vasari could do little work for others—including the reigning Medici pope Pius IV, a patron of Michelangelo and Vasari's countryman and much admired friend.

With Siena and its territory finally brought into the Florentine political sphere, and with the Palazzo della Signoria regally, or at least ducally, spruced, Cosimo I began in 1546 to reimagine the city center around it; in particular, he envisioned bringing Florence's administrative and judicial offices, the *magistrature* or *uffizi*, under a single roof. In 1549, however, Eleanora purchased Palazzo Pitti, on the other side of the Arno River, and the long-neglected palace and its gardens required extensive renovation. It was not until 1560, therefore, that work on the Uffizi was underway. The final design, which may have been developed from a sketch by the duke, was by Vasari, who also supervised the construction.

The site presented a range of difficulties, beginning with its proximity to the river—the Uffizi is actually built out over the Arno, on sandy foundations. Vasari wrote that he had never built anything "more difficult and dangerous, because it had its foundations in the river, and almost in the air." The available space was narrow and irregularly shaped, and Vasari's solution was to build two wings of unequal length. The longer arm on the east incorporated part of the Church of San Pier Scheraggio, where the city council—including the councilor and poet Dante Alighieri—had met before the Palazzo della Signoria was erected, and where visitors enter today. The shorter arm on the west incorporated two existing structures. One was the old Zecca, where the city's internationally respected coin, the florin, had formerly been minted, and the other was the Loggia dei Lanzi. The two arms, which are perpendicular to the Arno, are connected by a brief gallery overlooking the river.

Despite the design's accommodation to the site, the area still had to be cleared of existing houses. A century before, the banker Luca Pitti had aroused great hostility when he used his connections to raze the humble homes that stood in the way of the future ducal residence that

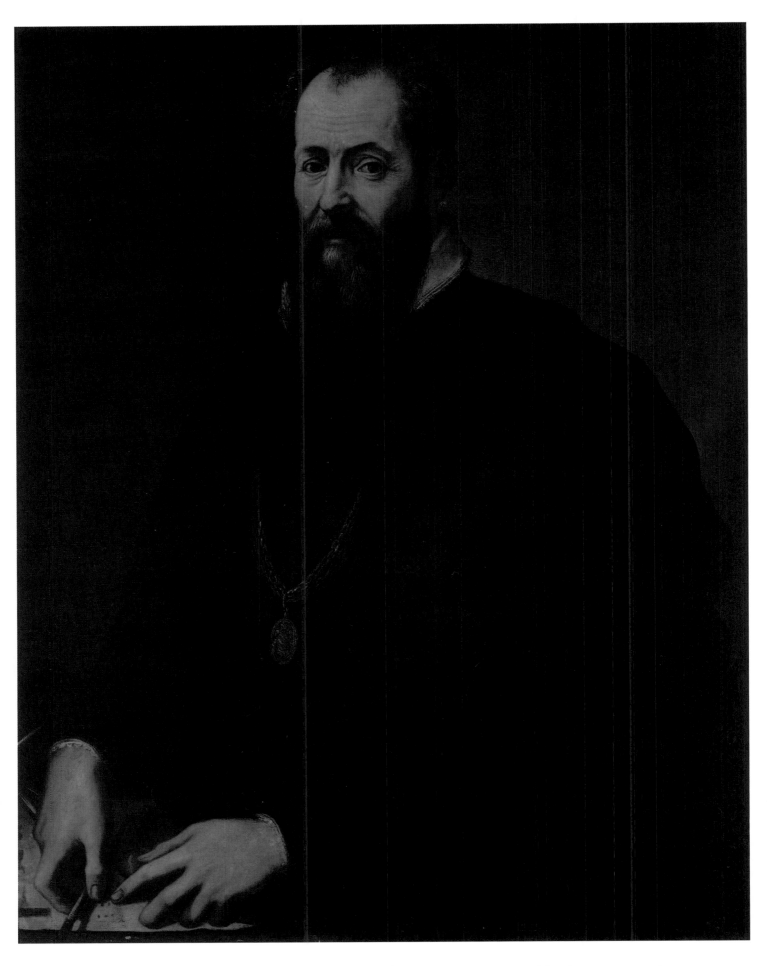

Giorgio Vasari (1511–74). *Self-Portrait.* Ca. 1550–1566/68. Oil on canvas. 39 ½ x 31 ½ in. (100.5 x 80 cm).

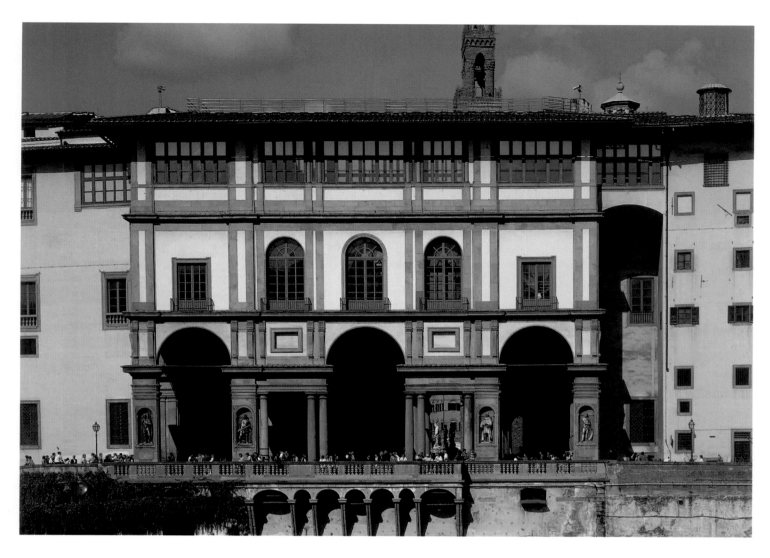

Giorgio Vasari (1511–74). *South Façade of the Uffizi Facing the Arno River.*

still bears his name. Now, Cosimo was forcing owners to sell and the magistratures to contribute to the financing of their new offices. A Medici of the old school, Cosimo was as well versed in psychology as he was in politics. And a bit of a gambler: he calculated to a fare-thee-well the degree of high-handedness that would achieve his immediate goal. And that goal was to root Medici power firmly in the public fabric, both physically, with his new building, and psycholgically, by showing who was, beyond a shadow of a doubt, boss.

It has been often observed that Cosimo wanted to keep an eye on Florence's points of power, formerly scattered throughout the city. This dispersal was emblematic of the independence and balance of power that had characterized the Republic. The price of the Republic's relative freedom, however, was a series of violent tumults, during which the Medici were routinely banished. By rationalizing the city's administration, Cosimo was also making a pledge of stability. Nevertheless, the Florentines were very sophisticated about the messages that architecture conveys, and the Uffizi's signal was loud and clear—the days of their cherished Republic were over, never to return.

Vasari's design for the Uffizi was something new. Much of Florence was built of *pietra dura* ("hard stone"), also called *macigno* ("big stone"), whose rough-hewn surfaces and warm shades of tan color the memories of so many of the city's visitors. It was a local stone—so local, in fact, that it was sometimes quarried directly from the building site. Those who could afford it used pale *pietra serena* as a decorative element. Vasari used this delicate stone on the Uffizi's exterior, accenting its delicate grayish blue-green with whitewash in a shade that one writer has described as the color of withered lemons. The contrasting hues constitute an impeccably elegant variant on the typical

Tuscan architectural practice of using lighter and darker marbles on façades. What the visitor does *not* see is Vasari's innovative use of iron to allow an airier sense of space, since the visible supports do not carry all the structure's weight alone.

Vasari's design was something old in other respects as well. The color scheme and the rhythmical series of arches paid tribute to another Medici commission, Michelozzo's Cloister of San Marco, built in 1437–43 for Cosimo the Elder. Vasari also looked to the Biblioteca Laurenziana, which Michelangelo had designed in 1523 and which was completed in 1559 by Bartolomeo Ammanati, who was also working for Cosimo at the Palazzo Pitti at the time. Vasari's references to ancient architecture as interpreted by Michelozzo and especially by Michelangelo were in keeping with his history and philosophy of Renaissance art.

In 1550, even as the plans for the Uffizi were taking shape, Vasari published the first edition of his no less monumental *Vite dei più eccellenti Architetti Pittori et Scultori italiani da Cimabue insino a' tempi nostri, descritta in lingua toscana da Giorgio Vasari Pittore aretino, con una sua utile et necessaria introduzione a le arti loro.* * The book is dedicated to Cosimo I, and the relationship between the duke and his court painter, architect, and decorator is the model that Vasari presented in the *Vite* as necessary for the arts to flourish.

The *Vite* is a compilation of biographies of—as the title states—"the best Italian architects, painters, and sculptors." The title recalls Plutarch's *Parallel Lives*, a series of comparative biographies of great statesmen originally published in the first century c.e., and translated in part in the fifteenth century at Medici expense under Cosimo the Elder, our duke's great-great-grand uncle and namesake.

Vasari's opus originally comprised 133 biographies, divided into three sections, corresponding to the three stages of the *rinascita*, or rebirth, of art, after the decadence of the barbarian, or Gothic, centuries that followed the Classical age. In the third stage, the Classical age was not only equaled, but surpassed—by Michelangelo, who, in the 1550 edition, was the only living artist. During his constant travels, Vasari revised his text, publishing the second and final edition in 1568, while the last pages of the first edition were still coming off the press. He corrected facts and added catalogues of artists' works, as well as some thirty biographies and a wealth of material on categories of artistic production and techniques.

Still today, the *Vite* provides valuable information about artists and their works and working methods—not to mention a great deal of sixteenth-century gossip. Even more significant, though, is the theoretical matrix in which these portraits are embedded. With his introduction to the overall work and his *proemii* to the three sections, Vasari became the first European art historian.

The space between the Uffizi's wings looks more like the courtyard of a private palazzo than a city square like the nearby Piazza della Signoria. The regular façade provided a separate entrance for each administrative entity. Each office occupied two and a half stories: the ground floor, a mezzanine, and a floor above; the gallery above the offices, to which those working in the offices had no access, was reserved for the ducal family—a family that would become grand dukes in 1569, thanks to Pope Pius V.

Each office was marked out vertically on the courtyard with Doric columns, which the ancient Roman architect Vitruvius associated with masculinity, and which Vasari reported Cosimo chose to represent Herculean stability, rather than an Apollonian reference to the arts. Between the columns and the building proper runs a portico, or covered walkway. Between the pairs of columns flanking each entrance are walls with niches in which Cosimo I intended to display statues of citizens famous for military, civic, and literary prowess, but except for sculptures of

* *The Lives of the best Italian Architects Painters and Sculptors from Cimabue to our times, described in the Tuscan language by the Painter from Arezzo Giorgio Vasari, with a useful and necessary introduction by him to their arts.*

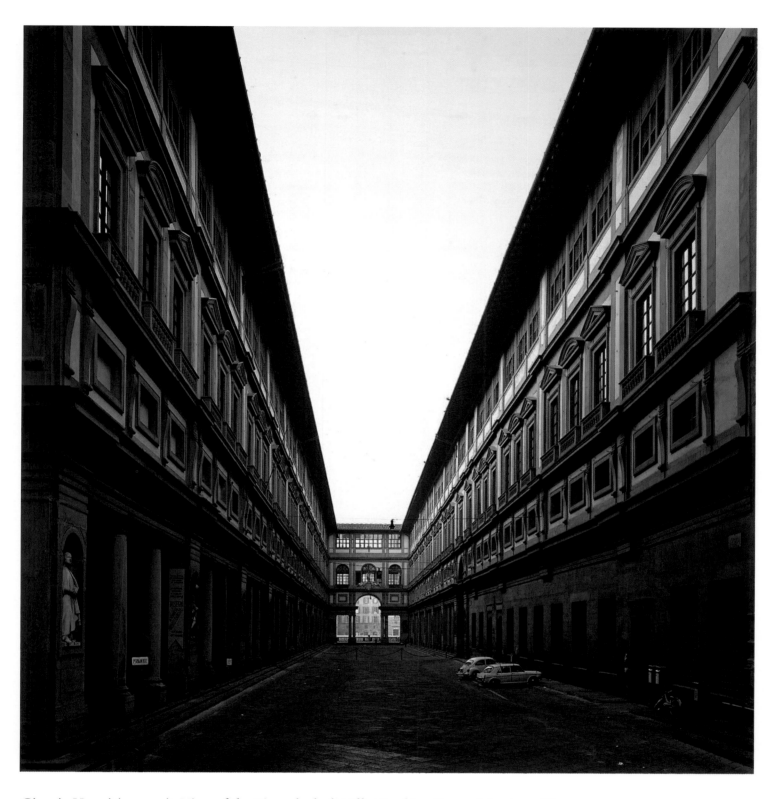

Giorgio Vasari (1511–74). *View of the Piazzale degli Uffizi Looking Toward the Arno River.*

Cosimo I and Francesco I, they remained empty until 1835.

Every floor is demarcated horizontally on the façade as well. The columns support a lintel, above which the mezzanine is marked by *cassoni,* that is, framed, box-like windows. On the top floor of the offices, a rhythmic alternation of triangular and arched pediments crowns the windows. The very different treatment of the floor housing the gallery supports a hypothesis that Francesco's architect, Bernardo Buontalenti, not Vasari, was involved in the design. On the short leg on the river side, Vasari adapted the arcade on the façade by leaving the arches open, allowing air, light, and what is today a highly photogenic view in both directions.

By 1564, the so-called Long Arm—the east wing—and the stretch along the river were completed. In 1565, the magistratures began moving into their new home. That same year, Cosimo and Eleanora's son Francesco I, heir to the duchy, married Joan of Austria, sister of Holy Roman

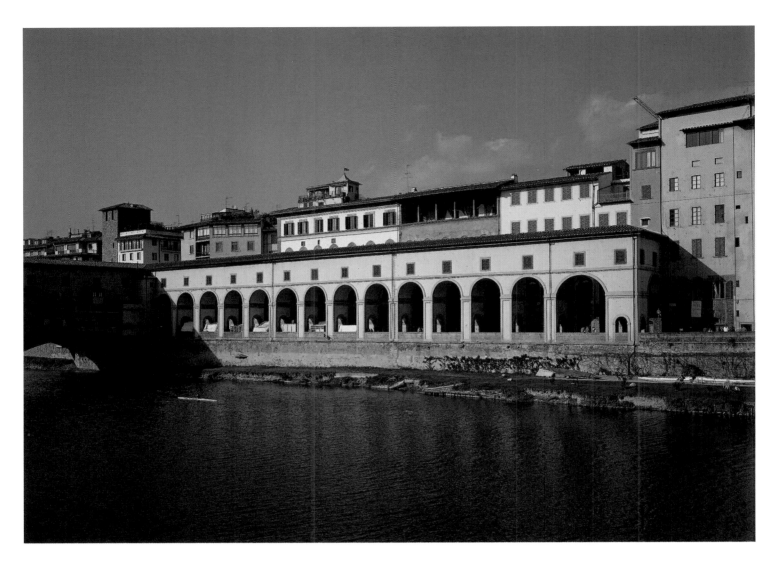

Giorgio Vasari (1511–74). *Exterior View of the Corridoio Vasariano.*

Emperor Maximilian II. Vasari designed the ephemeral architectures and decorations for their son's wedding, as he had for Cosimo and Eleanora's. Three years earlier, after Eleanora's death, the grieving Cosimo had increasingly transferred authority to Francesco, who had been officially named regent in 1564. The refurbishment of Palazzo Pitti and its gardens was well along; a residence worthy of the family, it included imposing reception rooms in which matters of state were discussed with foreign dignitaries.

Cosimo I was ruthless and resolute. As soon as he had become duke, he defeated the *fuorusciti*—the exiles who sent an army against him. The leaders who were taken were publicly beheaded, four each morning for four days. All the free bread and wine he dispensed could not reassure his subjects about this cold, incalculable man who now ruled them. He imprisoned his enemies at home and assassinated them abroad. Lorenzaccio, who had murdered his cousin Alessandro, died of a poisoned dagger wound in Venice. Cosimo's annexation of Siena—one of the geopolitical victories that the Uffizi marked—cost Siena more than half its population.

It became desirable in Cosimo's mind to link the places of power: the Uffizi; the Palazzo della Signoria—now the Old Palace, Palazzo Vecchio; and Palazzo Pitti. The advantage would be dual: the family would save travel time while dispensing with the need for an armed escort. Vasari's *corridoio* would be necessary as well as convenient. It was also an extraordinary achievement.

From Palazzo Vecchio, it crosses above Via Ninna to run adjacent to the top-floor gallery in the Uffizi. A flight of stairs brings the Corridoio Vasariano down at the Arno leg, where it courses above an arcade on the Ponte Vecchio to the Oltrarno quarter. There, the façade of the Church of Santa Felicita was removed and the Corridoio attached to the structure; visitors privileged enough to visit the Corridoio can look down into the church from it on their way to the corridor's

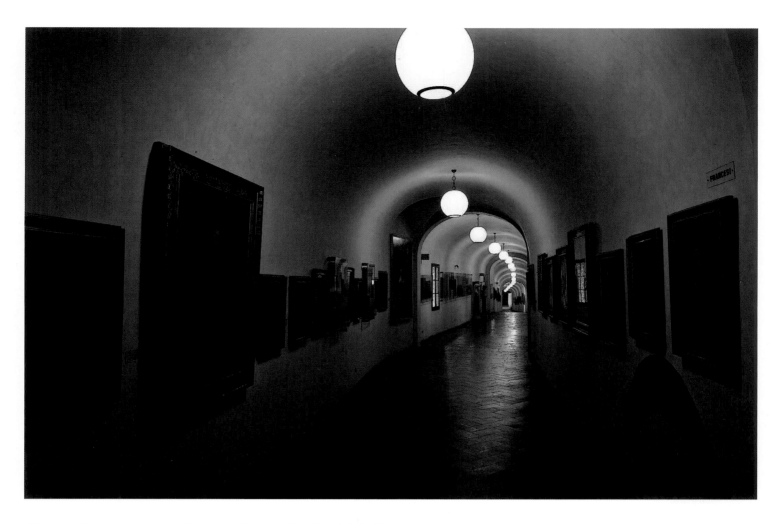

Giorgio Vasari (1511–74). *Interior View of the Corridoio Vasariano.*

terminus in Palazzo Pitti. So rapidly did construction proceed that five men died in the six months it took to build. The Corridoio was also a municipal gift to tradespeople: shops occupied the arches on the Lungarno—the riverbank—until the nineteenth century.

If he had not worked on much architecture before entering Cosimo's service, Vasari soon made up for lost time. During the 1560s, he undertook a number of important projects: in Pisa, among other assignments, he reconfigured the center of the city, removing all traces of the once-proud republic. In Pistoia, his great accomplishment was to dome the Church of the Madonna dell'Umiltà. Back in Florence, he remodeled two of the city's most important churches, Santa Maria Novella and Santa Croce. In 1567, Vasari found time to deliver a painting to Pius V, the successor of Pius IV—and all the while he was preparing the second edition of the *Vite*. We should not be too surprised if in 1574, the year both artist and patron died, the Uffizi was still unfinished.

Cosimo's sons Francesco and Ferdinando would devote themselves to the Uffizi, each in his own way, and each would leave his mark on the galleries for all time. Even though Francesco had been regent for a decade when his father died, his reign soon fell into disorder. Within three years, murder struck the family two times. First, Pietro, Cosimo and Eleanora's youngest son, strangled his wife—who was also named Eleanora and was also his cousin—in a jealous rage. We do not know whether Francesco actually approved. There was certainly no question of punishment: not only were the Medici above the law, but their position would have been irretrievably weakened had the culprit been called to account for his crime. Within a few months, Cosimo and Eleanora's last surviving daughter, Isabella, was murdered by henchmen of her husband, Paolo Orsini, who was in love with another woman.

All the siblings had grown up in a climate of sudden loss, danger, and violence. The several attempts on Cosimo's life had been brutally punished. Even had he cared to—and there is no evidence that he did—the saturnine Francesco I could do nothing about either assassination

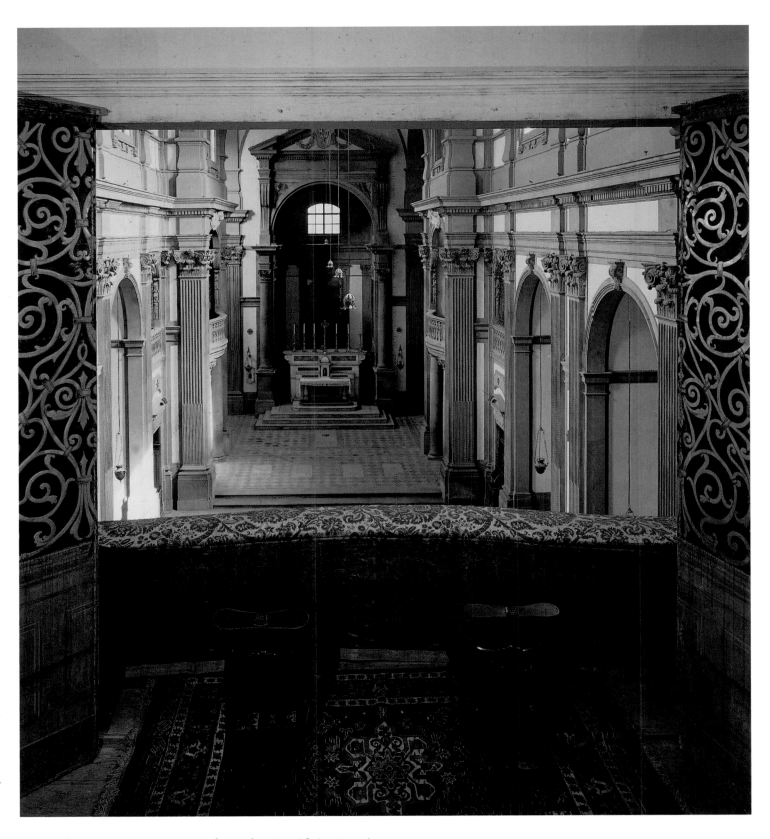

View of Santa Felicita As Seen from the Corridoio Vasariano.

without undermining the family's position. By definition, the Medici grand dukes, being the law, were above it. He himself, an extreme example of the melancholy and introverted Medici strain, had three ruling passions: the first was Bianca Capello, who became his lover three years after his marriage to Joan. When Joan died in 1578 from the consequences of a fall, Francesco marked her passing in appropriately stately and lavish style, then secretly married Bianca within months.

Francesco's second great passion was the Uffizi, and he picked up where his father had left off. Francesco's Vasari was Bernardo Buontalenti. Like Vasari, he was a polymath who had grown up in the Medici sphere, in fact in Cosimo and Eleanora's household. Bernardo was known as *buontalenti*—"good talents"—after a particularly impressive fireworks display he devised in 1550. At

Bernardo Buontalenti (1536–1608). *Drawing of the Main Entrance to the Medici Casino Palace.* Gabinetto dei Disegni e Stampe, Florence.

that time, Buontalenti and his principal collaborator, Alfonso Parigi, were seconded to the Pitti expansion and gardens, but now they devoted themselves to the Uffizi, which they completed in 1580.

Francesco I turned the loggia on the top floor of the Uffizi's Long Arm into an exhibition space. Beginning in 1579, he had the ceilings decorated with "grotesques," ornamentations borrowed from the antique. These witty vignettes were so called because they were discovered in the Domus Aurea—Nero's "Golden Home"—which resembled a series of caves, or *grotte*, when they were excavated in the late fifteenth century. These motifs were very popular, being intrinsically amusing and charming, as well as demonstrating a homeowner's conversance with the latest fashion in ancient decoration. Antonio Tempesta, a celebrated painter and printmaker, began the project. A team of painters led by Alessandro Allori continued Tempesta's project; Allori was also painting frescoes in Palazzo Pitti for Francesco at the same time. The ceiling decorations were completed in 1581; the following year, windows were on order from Venice. Glass was a princely substance; even a century later, the quantity of glass in Louis XIV's Hall of Mirrors in Versailles would still astonish visitors. (A broken mirror could cost a clumsy servant seven years' wages—hence, seven years' bad luck.)

By early 1583, the introverted Francesco could be seen debriefing secretaries in his two *gallerie*: one for sculpture and one for paintings, both distillations of the family's collections over some 150 years, since the time of Cosimo the Elder. Despite exiles, despite Savonarola's annihilating "bonfires of the vanities" and various depredations, the Medici collection was still one of the greatest in Europe, if not the world. The family had always favored modern art alongside the antique. This was especially true of Cosimo I and Eleanora of Toledo, patrons of cutting-edge mannerists such as Vasari and Agnolo Bronzino.

In 1584, Francesco built the celebrated Tribuna off the main corridor of the loggia in the Long Arm. Here, the plums of the Medici holdings, gathered over generations—emblems of the family's ultimate political survival, indeed, triumph—would be on display in an environment that reflected more than its builder's artistic taste. In the center of the octagonal space was a *studiolo* in the form of a small temple, which held medals, gems, and gold bas-reliefs by the sculptor Giambologna, who also made sculptures for the Pitti's Boboli Gardens. A second studiolo reigned in a niche in the back of the Tribuna, while an ebony console ran around the walls of the room, its 120 small drawers filled with tiny treasures. These included the ancient medals that Francesco systematically gathered; numerous letters survive from his agents, offering him these prized objects. Placed high in the Tribuna's walls to provide better lighting were windows of "Oriental crystal." As in today's museums, the selection of masterworks on display changed over time, and in 1649, the studiolo in the center of the room would be replaced with an octagonal table in inlaid pietra dura. Today, that table supports the emblematic *Medici Venus*.

The design of the Tribuna—the word means, in this context, "domed space"— is derived from the Tower of the Winds in the Roman Agora in Athens. In the original Greek structure, each wall is decorated with a representation of one of the eight wind gods (no goddesses). The Tower of the Winds is also known as "Andronikos's Clock," because it contains a water-driven timekeeping mechanism. More precisely, the Tribuna's design is from a description of the Tower of the Winds that appears in Book I of *De Architectura*, by the first-century architect and engineer Vitruvius— who, incidentally, disdained grotesques as silly ornamentation. Such architectural and painterly interpretations of the written word were characteristic Renaissance manifestations, evincing a deep acquaintance with Classical texts on the part of patrons, and, not seldom, of artists.

The wind theme carried over to the exterior of the structure: a weathervane stood atop the Tribuna's lantern, which was painted inside with a compass rose. Science informed the selection of objects in the room as well. The four elements fundamental to all matter—air, water, fire, and earth—were represented throughout, from the compass rose in the lantern (air), to the red velvet that covered the wall (fire), the nacreous shells adorning vault and walls (water), and the marble

mosaic of the floor (earth).

Originally proposed by the fifth-century B.C.E. Greek philosopher Empedocles, the four elements were the foundation of a scientific system that was undergoing radical revision. In the Christian sixteenth century, science was a completely integrated mechanism, a matter of divinely ordained hierarchies and analogies. The official cosmological model was an anthropocentric universe, created by God to serve human beings, who were just below the angels in the great hierarchy (except for women, who in the views of some were closer to animals, and except for the recently discovered inhabitants of the New World, whose status was under discussion). Human beings were microcosms, reflections in miniature of the macrocosm, the greater universe. Like the universe, human bodies were made up of four "humors," closely related to the elements. This belief and the medical practices it engendered persisted even after autopsies became routine. At the time that Francesco was creating the Tribuna, a few artists—Leonardo and Michelangelo among them—had found ways to attend or even perform dissections, in pursuit of an art that was as lifelike as possible.

To take an example from the plant world, mandrake root is forked, like human legs. It was therefore used to aid conception and as a remedy for impotence. Then as now, skeptics abounded: Niccolò Machiavelli wrote a play called *The Mandrake*, in which the medicinal plant is at the center of a riotous con game.

Ancient authorities ruled, and logical arguments were settled by whose scholar trumped whose. In the late fifteenth century, however, Leonardo da Vinci had championed direct observation over appeal to authority, and experiment over received ideas, although he never overtly challenged the religious establishment. The evolution of scientific discourse was taking place within the same rarified aristocratic circles that were commissioning paintings with increasingly erudite subjects.

The line between science and art could be fine or even nonexistent. The fact of art was itself a source of admiration, of *meraviglia,* for its capacity for imitating nature and fooling the senses. A gentleman or lady might have a *Kunstkammer*—an "art room"—displaying tiers of paintings up to the ceiling, and beside it, or integrated in it, a *Wunderkammer,* a "curiosity cabinet." The Medici had risen to eminence during the age of exploration; their *Wunderkammern,* enriched by their agents around the world, would be models of their kind for centuries. Like art collections, such rooms played an important social role, allowing connoisseurs to enjoy these objects in elite company. Cosimo I had collected such "wonders"; he had several carved ivory horns which may have been from the kingdom of the Kongo, and his celadon vases were the marvel of his time. His son Ferdinando would receive two suits of horse armor from the Persian shah Abbas and commission Caravaggio's *Medusa* as a kind of pendant to them.

Francesco was given to a practice on the cusp between chemistry and mysticism. Alchemy had emerged in the thirteenth century, when certain courts in western Europe were enjoying a degree of exchange among Christian, Muslims, and Jewish scholars. Out of the Arab tradition, which had absorbed knowledge from India and Asia, came the basis of modern-day chemistry. Its mystical roots may also lie in the closely guarded secrets surrounding transformative processes such as those of metallurgy. In turning ore into usable metal, for example, fire and air can turn solids liquid and enable them to form alloys—a third metal. With the multiplication of printing presses, alchemical theory and techniques became widespread, and contributed to art, for example, by producing greater quantities of pigments, such as rich red cinnabar, than had been possible before. Medicines could be distilled and preserved as never before. Gin and other distillates also owe their existence to alchemy.

In theory, only a pair of male and female "philosophers" dedicated to spiritual purification could make alchemy work. Only they could achieve the philosopher's stone, which could turn lead—a "base" metal—to gold, the most perfect of substances. The philosopher's stone would also allow the practitioners to achieve immortality. In practice, alchemy could inspire obsession and

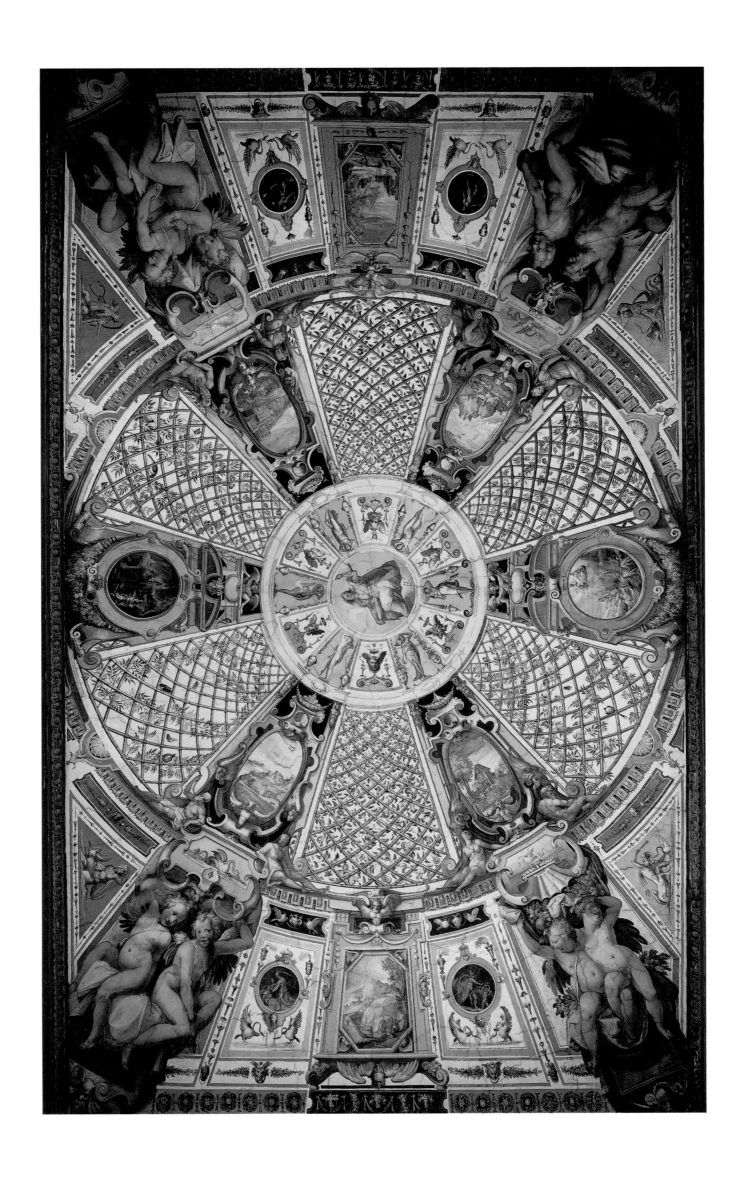

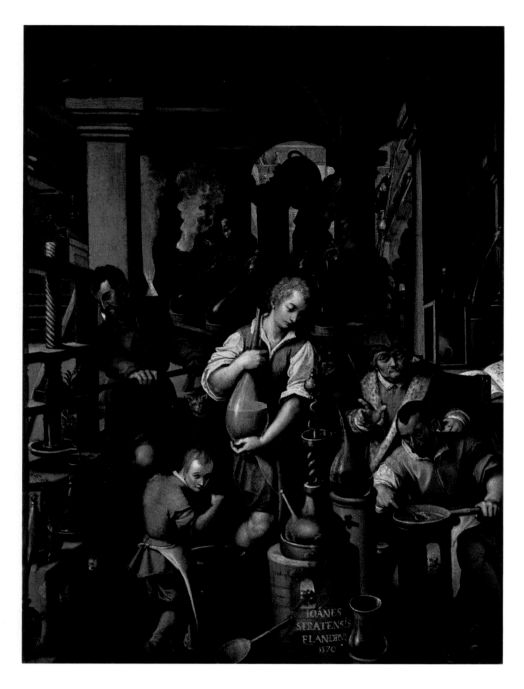

P. 21
Circle of Alessandro Allori
(1535–1607). *Ceiling Grotesques.*
16th century. Galleria degli Uffizi,
Florence.

LEFT
Giovanni Stradano (Jan van
der Straet, 1523–1605).
An Alchemist's Laboratory. 1570.
Oil on slate. 50 x 36 ⅝ in.
(127 x 93 cm). Studiolo of
Francesco I, Palazzo Vecchio,
Florence.

OPPOSITE
The Tribuna. Galleria degli Uffizi.
This polygonal room is where the
Medici displayed their most
prestigious artworks. The *Medici
Venus* can be seen in the back,
on the right.

financial ruin. The artist Parmigianino was reputed to have gone mad and died as a result of his unwholesome dedication to alchemy. But the word covered a broad range of activities, and some of the grand duke's private investigations had practical goals, for example, to discover commercial processes, such as seeking the secret of making porcelain or melting rock crystal, that could revive Florence's tepid economy. In his rooms in Palazzo Vecchio, Francesco engaged in more arcane experiments, while in the Uffizi he established more conventional workshops.

In 1583, Francesco had the terrace above the Loggia dei Lanzi, at the north end of the west arm of the Uffizi, designed as hanging gardens. On balmy evenings, cooled by breezes from the river and swathed in the scent of orange and lemon flowers, the court met to hear music, and perhaps engage in clever games like those described by Baldassare Castiglione in his bestselling *Book of the Courtier.* Francesco's practical side emerged in the garden: the blossoming orange, lemon, and peach trees also gave fruit; carnations kept the sometimes fatal Florentine mosquitoes at bay; and a small vegetable garden provided choice produce for the grand ducal table.

This combination of the princely and the practical was unusual for the time, and may have served as a model for Henri IV of France. Henry, the embattled scion of the small but crucial kingdom of Navarre, would marry Maria, Francesco and Joan's youngest daughter. Outside the ancient walls of the castle of the Louvre he planted utilitarian mulberry trees to encourage the nation's silk

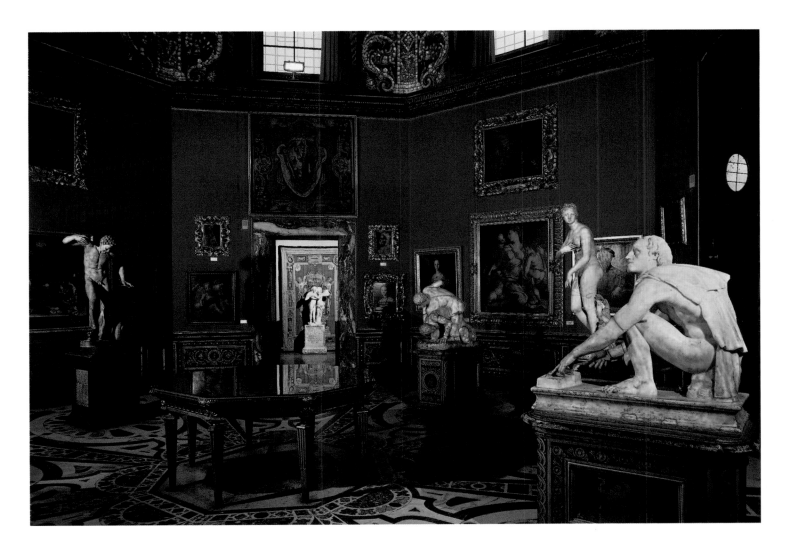

industry. It would be difficult to imagine two rulers less alike than Maria's father and her husband, yet the latter may have picked up an idea or two from the former—including that of a grand gallery connecting the Louvre and the Tuileries.

The years 1585 to 1587 were busy ones in the gallery of the Uffizi, with accounts showing payments to carpenters, as well as for "two fox tails for dusting the marble figures" in the Corridoio. Perhaps inspired by his father, but more likely by the times in which both he and his father lived, Francesco commissioned a series of portraits of men famous for feats of arms and literature.

In 1586, Buontalenti built a theater in the Uffizi, at the north end of the Long Arm; it was perhaps the first known private auditorium expressly built as such. Condemned on and off by the Church, or else restricted to the anything-went period of Carnival, theatrical and musical performances were especially important aristocratic pastimes, part of the elaborate festivities that accompanied weddings, births, military victories, and diplomatic visits. Traditionally performed in the courtyards of noble palazzi or in vast halls such as the Palazzo Vecchio's Salone dei Cinquecento, these performances were interspersed with musical interludes—Ferdinando produced Jacopo Peri's lost *Daphne*, generally considered the first opera, in the Teatro Mediceo.

Five years before, in the Venetian city of Vicenza, the architect Andrea Palladio, a member of the Accademia Olimpica—a group of men dedicated to reviving the antique—designed the famed Teatro Olimpico for the Accademia. Palladio's plan was essentially an indoor version of a Greek or Roman amphitheater, a semicircular seating area cut off by a stage with a proscenium opening inspired by the Roman triumphal arch. As a private, dedicated space within a palazzo, however, a theater represented an entirely new kind of architecture. Because it was private, its function was not visible on the outside, unlike, for example, the magistratures' separate entrances to the Uffizi.

For the Teatro Mediceo, Buontalenti abandoned the Classical model and altered the volumes of the only other kind of architecture devised for viewing and hearing—churches. Thus, the stage was at the end of a long U-shaped hall that was 178 feet 9 inches (55 meters) long, 65 feet (20

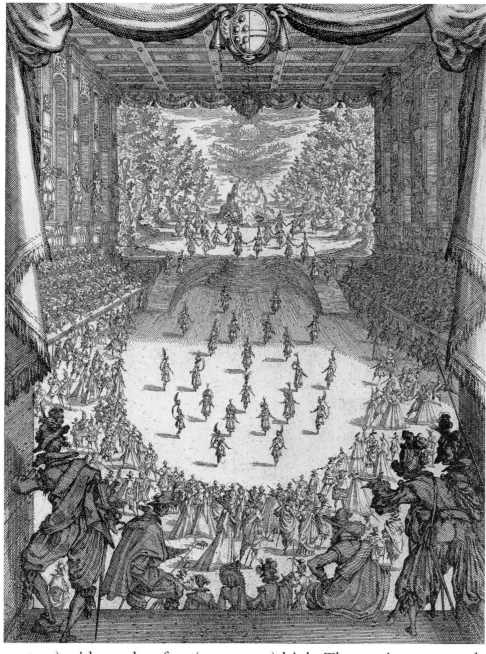

Jacques Callot (1592–1635).
The First Interlude of The Liberation of Tyrrhenus and Arnea Performed in The Medici Theater. Ca. 1617. Etching. Image: 10 ¾ x 7 ⅞ in. (27.3 x 20 cm). Plate: 11 ¼ x 8 ⅛ in. (28.6 x 20.6 cm). Gabinetto Disegni e Stampe, Florence.

This performance was designed by Giulio Parigi and performed during Carnival on February 6, 1617 (1616 in the Florentine style).

meters) wide, and 45 feet (14 meters) high. The seating was made up of banks of steps, like bleachers, with the family box in the middle. The theater occupied the second and third floors of the city end of the east wing, where the Gabinetto Disegni e Stampe is today. The impetus for the construction was given by the celebrations planned for the 1586 wedding of Francesco's half-sister, Virginia de' Medici, daughter of Cosimo and Camilla Martelli, who would become Cosimo's second wife.

The Teatro would only come into its own with the accession of Ferdinando I, Francesco's brother. Made a cardinal when he was fifteen, Ferdinando spent almost a quarter of a century in Rome, where he bought what became the Villa Medici and assembled a brilliant collection of antique statuary, including the *Medici Venus.* When Francesco died in 1587, however, it was not immediately clear who would be the next grand duke.

Francesco and Joan of Austria had had one son, Filippo, who died in 1582. After Filippo's death, Francesco legitimized Antonio, whom he believed—or chose to believe—was his son with Bianca. Stories abounded about the lengths to which the Venetian beauty had gone to assure her position by providing the grand duke with a male heir. According to one tale, she pretended to be pregnant, but made a secret agreement with three pregnant young women that she would covertly adopt the first boy born to them. That boy, the rumors claimed, was Antonio, whom Francesco had dearly loved. Whatever the facts of the case, Ferdinando found witnesses to swear that the late Francesco had not fathered Antonio, who would otherwise have inherited the title. Ferdinando,

who had never taken vows, resigned his cardinalate and took up his duties as heir.

Ferdinando was as outgoing and generous as Francesco had been dour and obsessive, and far more popular than his elder brother. Yet, some of Ferdinando's actions were to codify some of Francesco's initiatives. Ferdinando established workshops for goldsmiths, jewelers, miniaturists, sculptors, painters, porcelain makers, and even gardeners in the Uffizi's west wing. We may imagine them as resembling the decorous and industrious manufactories in Giovanni Stradano's scenes of ateliers, alchemical and otherwise, which decorate Francesco I's *studiolo* in Palazzo Vecchio. In the Uffizi, Ferdinando also founded the Opificio delle Pietre Dure to produce the hugely popular and costly objects of colored hardstone that the Greats gave one another as valued gifts. Ferdinando intended these commercial activities to revive Florence's sagging economy, which had suffered from Ferdinando's neglect. Though these initiatives did not achieve their end at the time, they reinvigorated the city's artisanal tradition, which is still alive and well today. The workshops were now united into a single administrative entity, as was the so-called Foundry, or Pharmacy, which produced "perfumes, wonder drugs, poisons, and antidotes to poisons." In the first draft of these laboratories, Francesco had experimented with insects, especially scorpions. His intense interest in the mysterious art of alchemy, his first wife's sudden death, and his and Bianca's unexpected passing within a day of each other had predictably ignited speculation about poisoning.

An epochal shift in Europe's intellectual history took place over the course of Francesco's and Ferdinando's reigns. Francesco's alchemical pursuits, for example, with its arcane language and lore, represented one current. Alchemy was just entering the mainstream (in the next century, Isaac Newton was at least a tourist in the practice), though most often as metaphor, where it expressed the Neo-Platonic stages of purification. Michelangelo, the great transformer of *disegno*, wrote: "I am enclosed like the pith / within its bark, here poor and alone, / like a spirit bound within an ampoule."

In the Uffizi, Ferdinando made a Hall of Maps. Occupying pride of place in the center of the room were a globe and a demonstrational—as opposed to observational, or practical—armillary sphere. These old-fashioned astronomical devices, composed of a series of rings that allowed the user to calculate the positions of the planets, were popular princely accessories.

In a gallery adjacent to the Tribuna on the north, Ferdinando's Hall of Mathematics displayed scientific instruments, while seven rooms between the Tribuna and the hall overlooking the Arno housed his collection of arms and armor. Here, frescoes by Ludovico Buti illustrate warrior arts like the invention of gunpowder—by Europeans, rather than by Chinese, in a revisionist image. This emphasis on the military was more an assertion of status than a family assemblage. Historically, the Medici were bankers and merchants, not fighters. In fact, when Caterina de' Medici married the French king Henri II, the widespread grumbling in her country of adoption focused on her origin among "tradespeople," as much as on her Italianness. The Italian cities were almost constantly at war, but battles were considered a matter for professionals, that is, mercenaries, not amateurs. The identification of nobility with warfare, however, went back centuries; families prided themselves on ancestors who had gone to the Crusades. Thus, Ferdinand's exhibition of armor at that time and place blurred a line between collecting and aristocratic identification.

The son might also have been paying tribute to his father's bellicose iconography—Bronzino's state portrait of Cosimo I shows him in full armor; the duke's portrait, painted in 1545, would have recalled one of the Medici dynasty's rare warriors. Cosimo's father, known as Giovanni delle Bande Nere, "of the Black Bands," was one of the most famous of the Renaissance mercenary captains—Machiavelli believed he was capable of unifying Italy. Giovanni received his nickname when he changed his *condottiere's* stripes from white to mourning black at the death of Leo X, the first Medici pope. Cosimo was seven when his ferocious and perpetually absent father died trying to keep the Germans out of Mantua. In the unsettled, nomadic years of exile that followed, the boy dreamed of being a soldier like his famous sire. He even dressed like a soldier, until his distant

cousin Pope Clement VII advised him to lay aside his armor and don his citizen's robe.

The last room at the river end, after the armorial displays, contained the collection of engraved gems that Ferdinando's consort, Christine of Lorraine, known as Madama, brought with her from France; the little room was called Madama's Room. Christine, who married Ferdinando in 1589, was Caterina de' Medici's favorite granddaughter; the wedding had in fact been postponed owing to the queen's death and Christine's mourning. Christine was not the only noble consort to make important contributions to the Uffizi Gallery, as well as to the more private princely collections in the Pitti: the much-defamed Bianca Cappello brought Botticelli's two small Stories of Judith.

Ferdinando continued to employ Bernardo Buontalenti, who designed the unprecedentedly splendid festivities celebrating the newest noble alliance. Besides the usual processions, dancing, and theatrical and musical entertainments, Ammanati's courtyard in Palazzo Pitti was flooded for a mock naval battle.

Francesco, too, had celebrated his official marriage to Bianca Cappello with appropriately over-the-top (and overly expensive, in the view of many Florentines) spectacles, but for his brother such social occasions were a way of life, and of politics, in which Ferdinando engaged on a continent-wide level. Once Henri IV was safely on the French throne, for example—thanks largely to Medici money—and his childless marriage to Caterina's daughter Marguerite annulled, Henri married Francesco's youngest daughter, Maria, by proxy. There were horse races, fireworks, and extravaganzas of every kind, as well as performances of the first operas, including *The Abduction of Cephalus*, with sets by Buontalenti. The composer was Giulio Caccini, whose daughter Francesca was also a composer. (As with painters, the daughters of musicians were sometimes trained in the family profession.) Caccini is notorious as the courtier who informed Pietro de' Medici that Pietro's neglected and abused wife, Elenora, was taking comfort in the arms of others—with tragic results.

Meanwhile, in 1591, Ferdinando opened his art collections to visitors on request. This did not mean that the average plebeian could take a refreshing break from selling fish on the Ponte Vecchio to see the grand duke's Raphaels. It did mean that the Uffizi, now opened to select viewers outside Ferdinando's circle of acquaintance, was public, was a museum.

The Uffizi, Pitti, and the Corridoio between them were an integral part of Ferdinando's prestige, the Corridoio being much admired for its combination of views over the city and river and the magnificent art it contained. An observer provided two records of life at Ferdinando's court: on November 26, 1602, "His Highness took the cardinals and lords to dine in the Gallery [in the Uffizi] and then through all those rooms and then they went there to see many fine things. . . ." On December 2, the ladies of the household joined the cardinals and lords in dining in the Gallery. They danced until 11:00 at night, when they returned by Vasari's Corridoio to Palazzo Pitti, where they enjoyed a play in the broad commedia dell'arte style.

And what would these merry bands of worldly prelates, these fashionable ladies and gentlemen, have discussed as their host led them through his brick-paved Uffizi gallery? Those halls brilliant with candlelight reflecting off windows and the varnished surfaces of paintings and bronzes, teasing shadows out of chaste marbles? The first inventory, of 1589, tells us what was on those walls. In Italian or French or Latin, these elite, educated viewers might have admired in Piero di Cosimo's *Perseus* the artist's elegant, mannered style and his skilled *sfumato*, the smoky treatment of outlines invented by Leonardo. The more studious collectors and patrons, knowing their Vasari, would have looked for naturalness and grace, or difficulties overcome. There might have been bantering disagreements, with the more classically inclined arguing for a more dignified rendering, while the more modern-minded appreciated playful *invenzione* and subtle or shocking deployment of color. The grand duke's guests would very likely have agreed that Piero's draftsmanship was exquisite, and exclaimed over this contour, or that line, while perhaps

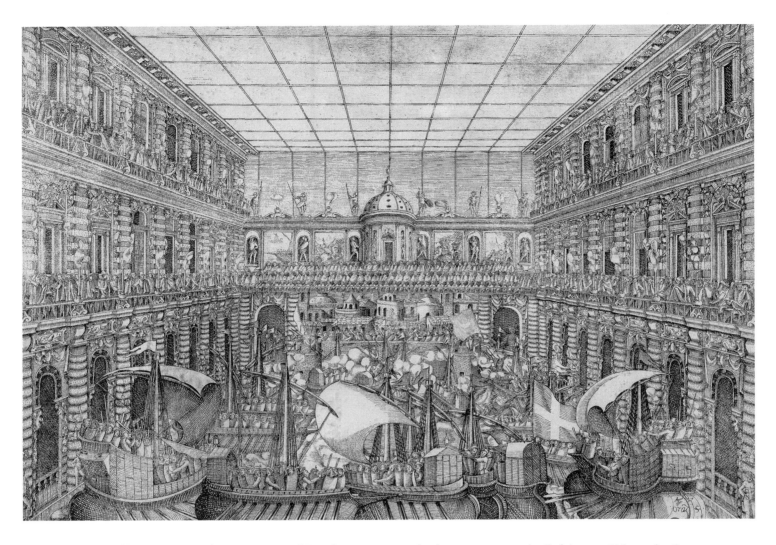

Orazio Scarabelli (active 1589). *La Naumachia.* Plate: 9 ⅝ x 14 in (24.4 x 35.6 cm). Gabinetto Disegni e Stampe, Galleria degli Uffizi, Florence.

Depicted in this etching we see a mock sea battle designed by Bernardo Buontalenti (ca. 1531–1608) and staged in the cortile of Palazzo Pitti (flooded for the occasion) as part of the festivities celebrating the 1589 marriage of Ferdinando I and Christine of Lorraine.

deploring the palette. Someone would have made a game of discerning the source for the image—Ovid or Apollodorus, Hesiod or Pindar? Or had the artist gathered from the poets like a bee from various flowers? These questions might have sparked a gallant competition, with the contestants quoting the ancient poets, and Ferdinando or Christine awarding a prize—such as an *objet de vertu* of pietra dura from the Opificio.

Raphael's portrait of Leo X, their host's great-granduncle, would have evoked praise for the artist's psychological insight into the pontiff's complex personality, for his decorum, and for his skilled representation of objects and textures. In private company, the visiting cardinals might have shared received anecdotes about the tough-minded pontiff who had restored the Medici to power in Florence, about his coarse, even cruel practical jokes and his pleasure in fine food and wines.

In the room of scientific instruments, among very close and trusted friends, the armillary sphere might have suggested thoughts on the Church's official position on Copernicus's sun-centered universe. A lively debate might have ensued, with some defending Ptolemy's Earth-centered system. (In 1591, Galileo was an uncontroversial professor at the University of Pisa studying gravity.) In the Tribuna, ancient medals would have evoked historical tales about the figures represented, and perhaps connections made with modern works in which the artists had rung ingenious changes on the antique models. The grand duchess's collection of engraved gems would have elicited fulsome words for the skill with which artisans etched the precious stones and, inevitably, someone would have quoted Pliny the Elder on jewels.

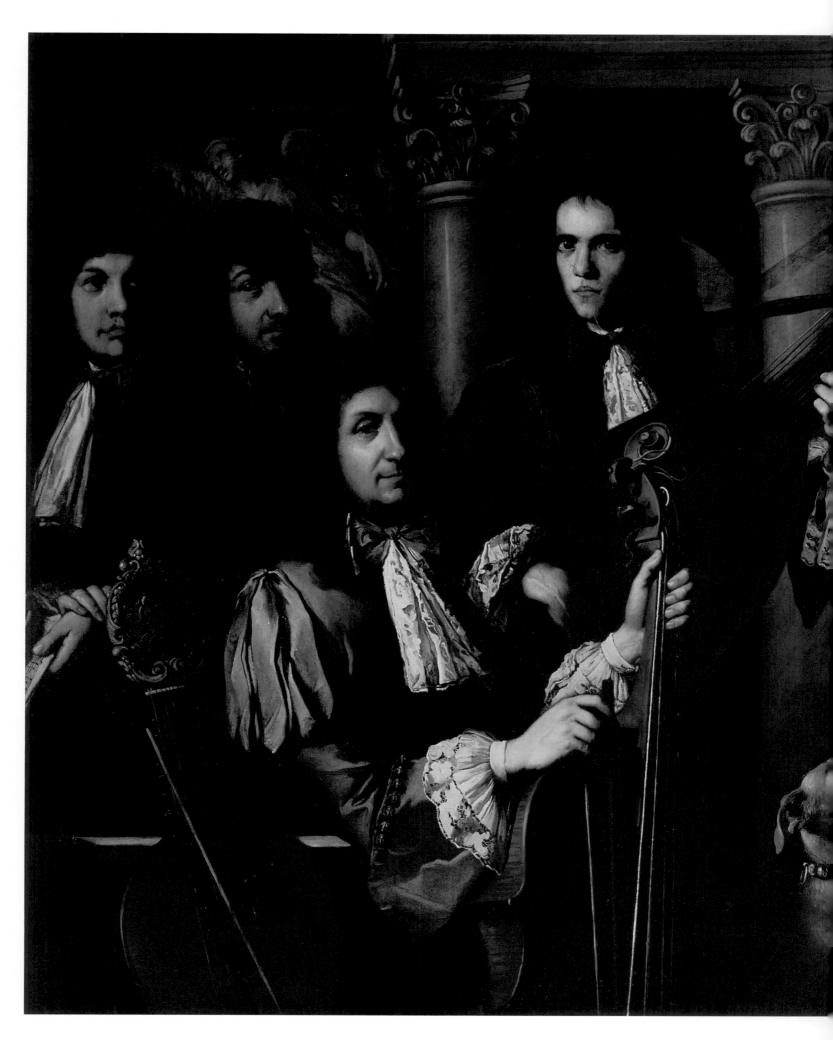

Anton Domenico Gabbiani (1652–1726). *Prince Ferdinando de' Medici and His Court Musicians.* Ca. 1684.
Oil on canvas. 54 ¾ x 87 in. (139 x 221 cm). Galleria Palatina, Palazzo Pitti, Florence.

The grand prince is the gentleman in blue brocade at the right.

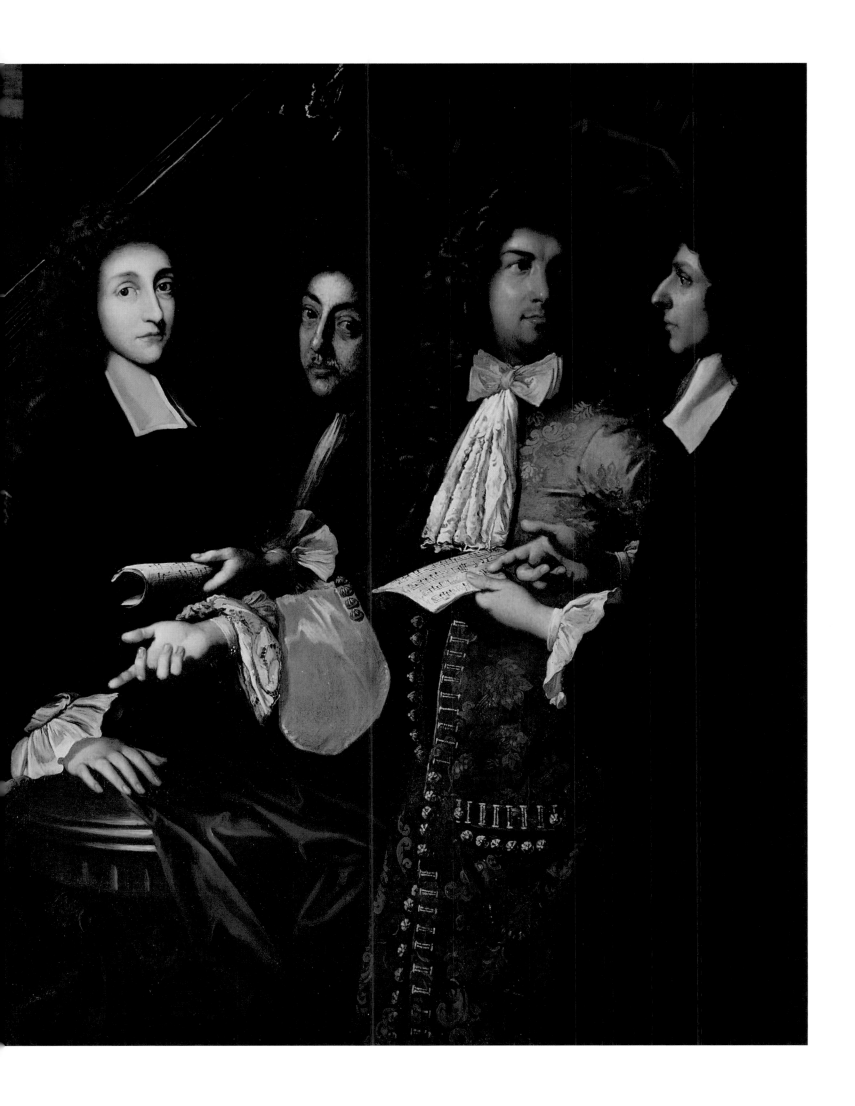

In confidence, the friends might have exchanged views on the Council of Trent and its few but clear directives on art. Was it wise to abandon the homely, apocryphal details that the lower classes loved, the manger scenes and episodes from the life of Mary? Could the less educated faithful comprehend the significance of the new emphasis on the Old Testament, as the Roman Catholic Church countered the Protestant claim to be closest to the roots of the Christian faith?

When Ferdinando I died in 1609, he was succeeded by his eldest son, Cosimo II. Cosimo was a sickly youth, often a virtual invalid, who did little in the Uffizi, but devoted attention to the grand ducal Palazzo Pitti. When he was nineteen, he married Maria Maddalena of Austria, an alliance that Ferdinando I had arranged and one that shifted the Medici allegiance from France to the bride's imperial family and the Spanish. By now, the Medici's hardworking origins were ancient history to the young grand duke, who adopted Spanish ways and abandoned the family's banking and trade businesses as unworthy of the family's high station. Toward the end of his life, perhaps to remedy the economic disaster that resulted from such a high-minded but delusional policy, Cosimo II would resume his father's development of Livorno. This port on Italy's Tyrrhenian Coast was thriving thanks to Ferdinando's policy of opening the city to those of every faith. He was competing with the draw of the New World, but persecuted people—especially Jews and Huguenots and other Protestants—flocked to Leghorn, drawn by the promise of work and prosperity. Today, the city still numbers more Jews than any other city in Italy.

Cosimo, who was often confined to his bedroom, was very domestic, and, thus, most of his artistic and architectural passions were directed to his home, Palazzo Pitti. He liked smaller paintings and realistic renderings, but he also brought important contemporary pieces into the Uffizi's Tribuna, such as Bronzino's portrait of his grandmother Eleanora of Toledo. Cosimo bought contemporary art, too, including Caravaggio's *Bacchus*, and works by Caravaggio's followers, such as Artemisia Gentileschi.

Cosimo II's reign was brief, but his son's, which began in 1628, lasted well into a new era. Ferdinando II was practical, civic-minded, and secular. In the family's palaces, he undertook vast fresco programs in Palazzo Pitti and purchased ancient statues, including *The Hermaphrodite*, for which Gian Lorenzo Bernini sculpted the couch upon which the dreaming boy-girl dreams. The grand duke's interests focused on small things—clocks, boxes, toys, and pietra dura work. However, his consort-cousin, Vittoria della Rovere; his soldier-brother, Matias; and his cardinal-brother, Leopoldo, brought such a wealth of masterworks to exhibit in the Uffizi that new rooms had to be cleared in the west wing, replacing the artisans' workshops and tripling the exhibition space. The grand duchess, proud descendant of the dukes of Urbino, brought what would become some of the gallery's best-known works, including Titian's *Venus of Urbino* and Piero della Francesca's portraits of Federico da Montefeltro and Bianca Sforza, the fifteenth-century duke and duchess of Urbino. Vittoria loved her paintings. They were her personal property, and she kept them in her private *guardaroba*; they joined the Medici holdings only after her death in 1694.

Matias, a soldier who fought in Germany in the dreadful Thirty Years War, was particularly fond of battle paintngs. He was also a collector who loved engravings, and practiced the art himself as an amateur. Among his favorite engravers were Stefano della Bella and Giulio Parigi. Parigi was the architect and landscapist who began the extension of the façade of Palazzo Pitti and created a planting of exotica in the Boboli Gardens. Parigi belonged to a dynasty of Medici retainers: he was the son of Alfonso Parigi, who with Bernardo Buontalenti finished the Uffizi in 1580; a grandson of Bartolomeo Ammanati, who designed the great courtyard of Palazzo Pitti under Cosimo I and Eleanora of Toledo; and the father of Alfonso II, who completed the extension of the Pitti on the side of the piazza.

One of the great Medici collectors, Leopoldo became a cardinal in later life and entered the priesthood later still. In assembling drawings, he followed Vasari's theory of the progress of art,

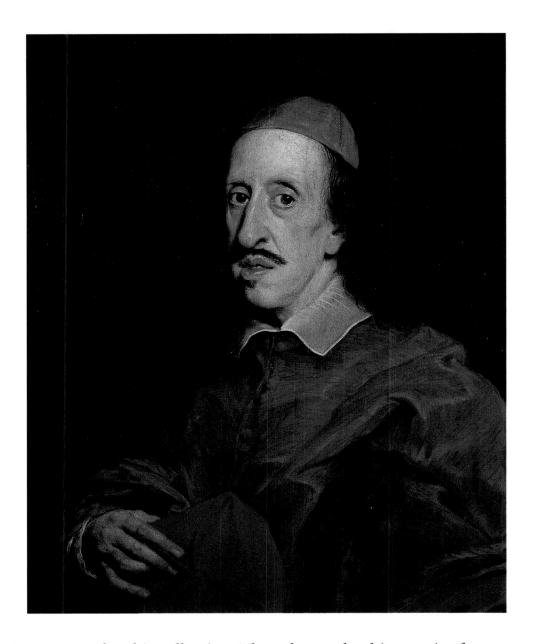

Baciccio (Giovanni Battista Gaulli), (1639–1709).
Cardinal Leopoldo de' Medici.
Ca. 1667. Oil on canvas.
28 ¾ x 23 ⅝ in. (73 x 60 cm).
Galleria degli Uffizi, Florence.

seeking examples by specific artists to complete his collection. Though we take this practice for granted today, Leopoldo was a precursor. It is estimated that over his lifetime he acquired, besides works in other mediums, 730 paintings, 11,247 drawings, nearly 7,000 medals, and some 800 pieces of Asian porcelain. Ferdinand left the renovation of the Uffizi's west wing to him. As for the quality of the works, about one-tenth of the paintings in the Uffizi and Pitti combined came from Leopoldo's collection. His drawings formed the nucleus of the Uffizi's Gabinetto Disegni e Stampe, one of the world's greatest assemblages of works on paper. Leopoldo, an amateur painter himself, was interested in literature and the sciences as well.

The reign of Ferdinando's heir, Cosimo III, was longer that that of any of his predecessors; unfortunately for his subjects he did not die until 1723. A religious fanatic, his inclination led him to buy elaborate and costly reliquaries, and to exercise a hysterical and arbitrary despotism, interfering violently in private, especially sexual, matters. Nevertheless, he prevailed on the Holy Roman Emperor to grant him the title of prince. His scientific and artistic interests inspired wonderful still lifes of flowers and fruit by Bartolomeo Bimbi, a taste his daughter Anna Maria Luisa shared. They also took a more morbidly Baroque turn in commissions to Bimbi to record two-headed animals and other freaks of nature, and to the wax sculptor Gaetano Zumbo for hyper-realistic anatomical works.

Like his uncle Leopoldo, and in the spirit of an age passionate for classification, Cosimo displayed a museological bent, identifying and filling gaps in the Florentine collections. He brought sculptures from Villa Medici in Rome, including the celebrated *Medici Venus*, which today adorns the Tribuna. Additionally, he continued the family tradition of collecting artists'

self-portraits, exhibited in the Uffizi, whose west wing he had decorated on the theme of the men and institutions that had made Florence great.

Cosimo's eldest son, Ferdinando, the last Medici of that name, was a collector of taste and vision. He favored the Venetian painters, whom Vasari credited with great talent for color, contrasting them with the Florentine artists, who the writer claimed were more skilled in *disegno*. Ferdinando had an eye for rich palettes, and sent his court artist, Anton Domenico Gabbiani, to Venice to learn from the masters. It was Ferdinando who acquired works from religious houses and churches, either by buying them or replacing them with copies. Andrea del Sarto's *Madonna of the Harpies* entered the Medici holdings this way, among other masterpieces. Ferdinando was also an enthusiastic patron of composers and musicians, the subjects of a series of paintings by Anton Domenico Gabbiani. Beginning in 1709, Ferdinando was afflicted with advanced syphilis, which would keep him in bedridden torment him until his death in 1713. At the Congress of Utrecht, Cosimo attempted to persuade the European powers to accept his daughter, Anna Maria Luisa, consort of one of the German elector palatines, as heir to the title, if her brother, Gian Gastone, predeceased her. At first, those convened appeared to agree, but in 1718 determined that the succession would pass to the House of Lorraine.

A patron and collector in her own right, the electress palatine sent Italian masterpieces to Düsseldorf and great Netherlandish works to Florence; her particular interest was jewelry. Although the House of Lorraine would inherit the Medici family titles, her ancestors' collections were hers to dispose of as she willed. Far too extensive to be housed in any one building, the family's holdings filled country villas in Tuscany and Rome, as well as the Medici's vast Palazzo Pitti and the ever-expanding Uffizi. Today, the Medici collections fill museums throughout Florence with ancient Egyptian, Etruscan, Roman, and Greek sculpture; small objects such as cameos, engraved gems, medals, and coins; majolicas and table settings of gold, silver, and porcelain; musical and scientific instruments; reliquaries and other religious furnishings of ivory and amber, gold and silver, as well as Pope Clement VII's miter, decorated with miniatures made of songbird feathers. There are intarsia tables, priceless cabinets, and tapestries designed by Europe's greatest names; unique pieces of arms and armor; enamelwork and fine goblets and vases. The Uffizi's collection of drawings is one of the world's greatest, providing intimate and invaluable insights into the artistic process.

Anna Maria Luisa willed this treasure to Francesco of Lorraine, but "on the express condition that all that which serves as State ornamentation, as public utility, and as an attraction to the curiosity of foreigners, shall not be transported and removed outside the capital nor outside the State of the Grand Duchy." It was the greatest gift in history. Anna Maria died in 1743, and from that time until the present, only two people would attempt to defy her testament—Napoleon Bonaparte and Adolf Hitler.

In 1737, the year of Gian Gastone de' Medici's death, under the regime of the new rulers, Francis Stephen, duke of Lorraine, and his Habsburg duchess, Maria Theresa, the commercial enterprises in the Uffizi's west wing began to be dismantled. By the early 1770s, the workshops were gone from the Uffizi. Documents mention the transfer of objects from the Magistrature—the original *uffizi*—to the galleries, which suggests that by this time the city's administrative offices had left the complex. The Uffizi acquired an archive and a library.

This was the century of the Enlightenment, of systems, and from its first years, aristocratic scholars had been publishing the collections in print and in prints. Francis Stephen had sponsored a catalogue of prints of the paintings gallery in Vienna, his capital. He became emperor in 1745, and in 1748 commissioned a series of prints of the Uffizi and its collections that were produced until 1765, the year of his death, under the direction of a Dominican, Vincenzo de Greyss. It was also the century of excavations, and archeological treasures made their way into the galleries.

The first guide to the Uffizi appeared in 1759, written by the Custode, or Keeper, of the Uffizi,

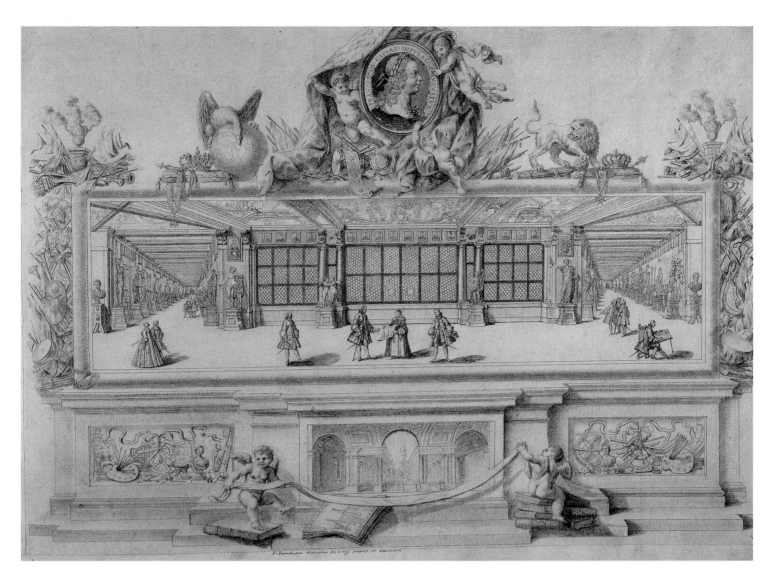

Benedetto Vincenzo De Greyss. *The Second Corridor. Frontispiece of the Inventory of the Uffizi Holdings Conducted from 1748 to 1765 under the Direction of De Greyss. The First Corridor Is on the Right, the Third, on the Left.* Graphite, pen and Indian ink, and traces of white lead on paper. 13 ¼ x 19 in. (33.6 x 48.3 cm). Gabinetto Disegni e Stampe, Galleria degli Uffizi, Florence.

Giuseppe Bianchi. The Bianchis were a dynasty of their own—Giuseppe was the fifth generation to be Keeper of the Uffizi. In 236 pages, Bianchi described the buildings and holdings; there were, for example, 12,000 medals and 3,000 engraved gems. One scholar criticized Bianchi for having skimped on details, "so that foreigners . . . would require his paid assistance." Be that as it may, the guidebook sold well.

Bianchi was also blamed for the fire that in August 1762 broke out in the west wing of the Gallery. (He also seems to have been sent away, accused of selling off objects from the Galleria.) Compared to what it would have been in the east wing, the loss was relatively contained, and it inspired a safety program that included sealing the Gallery's fireplaces, a short-lived initiative in a climate of cold and clammy winters.

Francis Stephen's successor, Pietro Leopoldo, took a passionate interest in the Uffizi. He opened it to the public in 1769, established the post of director, and undertook a radical reorganization of the collections, where things were "piled up," as the curator, Luigi Lanzi, put it, and where the quality was uneven, with too much in some mediums and not enough in others. The shade of Cardinal Leopoldo must have smiled with pleasure to see his systems become museological dogma. Lanzi wrote a new guide to the Uffizi in 1782 and—for all his ornate acknowledgments to His Royal Highness—seems to have actually downplayed His Royal Highness's hands-on approach, born perhaps of Pietro Leopoldo's wish to rival—or outdo—what

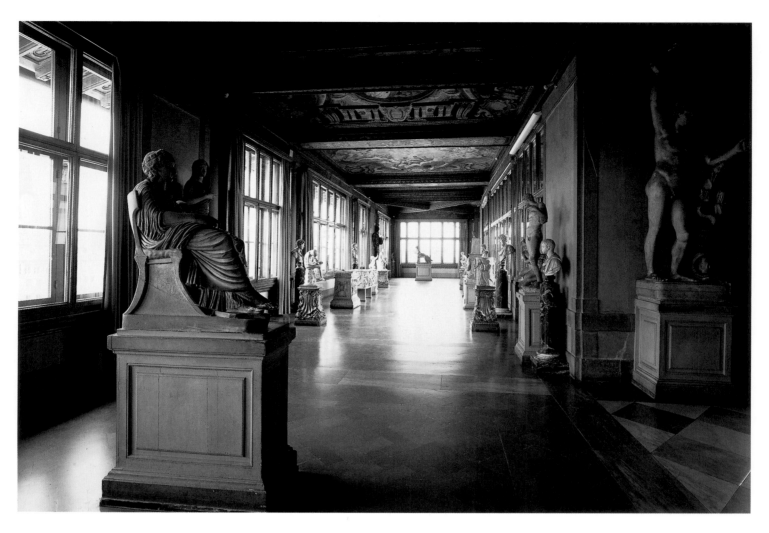

Interior View of the Third Corridor, Looking Toward the Second Corridor and the Arno River.

his brother was doing with the Habsburg collections in Vienna.

Where once sculpture and painting, arts unified through *disegno*, were together, now they were separated, as were the "decorative" arts from their "fine" counterparts. A capillary distribution of objects to other museums began, which would continue into the 1970s. In the 1770s, most of the armor was sold or dismembered and melted down for the precious metals. Other collections were purchased, and works from other Medici holdings were brought into the galleries, such as two paintings by Rubens. These *Stories of Henry IV* had originally been commissioned by Maria de' Medici for her Luxembourg Palace as part of an immense cycle celebrating herself and her royal consort. Rubens completed twenty-three huge Baroque mythologies starring Maria, but by the time he had turned his attention to the Henry IV cycle, his patron was fatally embroiled in a losing political struggle with her son and Cardinal Richelieu. In 1686, Cosimo III bought the two paintings, which entered the Uffizi in 1773.

Rubens's paintings adorned the walls of a room constructed in 1779–80 to house the Niobe sculpture group, which had arrived from Villa Medici in Rome only a few years earlier. And indeed, by the time Pietro Leopoldo returned to Vienna he had made substantial physical changes to the Uffizi. His Buontalenti was Zanobi del Rosso, who built the extension of Vasari's staircase, the Kaffeehaus and other constructions in the Boboli Gardens, and the elegant oval vestibule in the east wing that welcomes today's visitors.

Tommaso Puccini became director of the Uffizi in 1793, during the reign of Ferdinando III, the Habsburg-Lorraine heir who took the numeral to assert continuity with the Medici dynasty. Though Puccini engaged in what was by now a tradition of ongoing exchanges of art between Florence and Vienna, he also acquired works that appeared on the market as French aristocrats fled Paris during the Terror.

But Paris and 1793 were also the place and year in which the Muséum Central des Arts—significantly housed in the former royal palace—opened the Grande Galerie to the public. Directors and curators all over Europe and Russia were eyeing the museological choices made by their counterpart institutions, regardless of political regime. Thus, the skylights much discussed for the Louvre became a reality in the Uffizi, with the first ones installed in 1795–98. Also in 1795 the first didactic panels appeared in the galleries, against Puccini's wishes. The director believed that the works "should be appreciated only for their exquisiteness." With a verbal sigh, he went on, "Yet experience has taught us that the artist's name increases their merit in the eyes of the public."

We often take for granted certain museum practices, such as didactic panels, but we should not. There is, after all, nothing self-evident about the conventional information on them. In the Louvre, the former owners' names were given, in order to demonstrate that the property of the nobility was now in the hands of the people, but the people consequently mistook the personages portrayed in paintings and busts for those whose names they read in the labels. In the Uffizi, the old hierarchies still prevailed, with landscapes at the lower end of the worthiness scale of subjects. Puccini's acquisitions program was to bring the best works into the Uffizi. This may seem an obvious goal, but he was thereby electing to present a collection in breadth, rather than depth, "to increase the names rather than to multiply the works of Artists."

Puccini succeeded too well: in 1796, Napoleon Bonaparte admired the collection, especially the celebrated *Medici Venus*, whose hands British visitors were wont to kiss. The victorious general was already determined to gather Europe's masterworks in the Muséum Central des Arts. Three years later, when he conquered Tuscany, Napoleon demanded the contents of the Tribuna—including the *Venus*—as well as the Niobe sculpture group, *The Hermaphrodite*, and other antiquities. The desperate Puccini countered, not unsuccessfully, with economic considerations and legalisms: the Uffizi, even then a tourist magnet, was a major source of revenues for the city; the contents of the galleries belonged not to the grand duke but, by the terms of Anna Maria Luisa's far-sighted testamentary dispositions, to the nation of Florence.

After Napoleon defeated the Austrians at Marengo in 1800, however, Puccini simply packed up the Uffizi's most precious holdings and accompanied them in their sea voyage to Sicily. When Napoleon established the Kingdom of Etruria in 1803, the Uffizi's treasures returned home, all except for the *Venus*, whose faithful admirer now possessed her, albeit temporarily.

The heroic Puccini, who died in 1811, never saw the return of his beloved charges to the Uffizi in 1815. Their homecoming was greeted with massive popular celebrations, a special exhibition at the Accademia, and the ceremonial replacement of the *Medici Venus* on her rightful pedestal.

The balance of the century passed more peacefully. Between 1818 and 1825, Puccini's successor conducted an inventory that, when the dust settled, filled twelve volumes; the collection itself included books at that time. The Uffizi's identity continued to be refined. In the 1850s, its Egyptian antiquities and its modern art were sent off to other institutions. In 1860, the collection was diminished by misadventure, when a midnight burglary robbed the museum of 353 rings and cameos. Of these, 189 were recovered, but without their gems.

In 1859, Tuscany joined the Kingdom of the Two Sicilies. In 1866, it was decided to open the Corridoio to the public, so that "princes and private persons . . . might acquire a worthy notion of our past greatness, and hence a felicitous sign of and hope for" the new nation. King Victor Emanuel II lived in Palazzo Pitti during the years that Florence was the interim capital of the newly united Italy, The director at the time, Aurelio Gotti, sometimes came upon the affable monarch smoking a cigar in the Corridoio.

During the period when Florence was capital, the Senate met in the former Teatro Mediceo, and the royal postal service occupied the area that in the days of the Republic had once housed the Mint. Beginning in the mid-1850s, a series of laws reflecting the new secular state began withdrawing government support for all religious orders whose rule was not dedicated to either

teaching or aiding the poor. An 1866 law closing 2,382 religious houses brought a number of objects into the Uffizi. Though only a few of these were paintings, one of the paintings was Leonardo's *Annunciation*. In addition, donors from Italy and elsewhere followed the generous suit of the electress palatine and bequeathed entire collections.

Enrico Ridolfi, head of the royal galleries of Florence, published his professional memoirs in 1905. He was an energetic director, and most of his activities concerned the Uffizi. Space was (and is) a continuing problem. The Uffizi then held about 2,400 paintings, which were still hung in the old, crowded style, though less densely displayed than in earlier days. Ridolfi was able to take over the hall formerly occupied by the Senate, which had relocated to Rome when the Eternal City became the nation's capital. He divided the high space of the theater horizontally; the lower half, at the height of the second floor, today contains the Gabinetto Disegni e Stampe, while the architect, Luigi Del Moro, obtained seven rooms from the area level with the Galleria.

Research and conservation were priorities. Ridolfi brought fine antique frames out of storage, and had new ones made on the old designs. By studying inventories, Ridolfi discovered that the frame originally made for Michelangelo's *Holy Family*, known as the *Doni Tondo*, had migrated to a tondo by Lorenzo di Credi. Today it is back on the work it was designed for. An earthquake in 1895 had damaged the Niobe Room. In the course of repairs, Ridolfi and his team decided to rehang the room and remove the time-darkened Rubenses. These required extensive restoration, after which they took pride of place in a room named for them. He also established a conservation department for tapestries.

Ridolfi was brilliantly practical. He acquired buildings taken over by the city—Cosimo I would have recognized the technique—and created useful spaces, such as a courtyard that could accommodate carriages and allow works to be examined in a sheltered area. He imagined a cafeteria and improved visitor services with a more modern elevator that employed a hydraulic system. He installed more skylights, had paintings covered with protective glass, and updated the didactic panels with the most recent attributions. He replaced the early nineteenth-century furniture with period pieces or reproductions. He frugally mined storage areas with a scholar's eye, and at his suggestion a committee was formed to select contemporary self-portraits the equal of those already in the collection.

Not the least of Ridolfi's initiatives were his efforts to improve the conditions of the guards. The novelty of the Uffizi as a national public institution, and its piecemeal development as an institution at all, had created incongruous situations, and this was one. Ridolfi was scandalized at the guards' starvation wages and commented that most of the staff was "too wretchedly compensated, so that they and their families lead quite miserable and unhappy lives, while they are entrusted with the Nation's most precious and cherished treasures." The system he proposed, which derived part of its monies from a percentage of admission fees, later became a model used throughout the country.

In 1913, the *Mona Lisa* was displayed for a very few days in the Uffizi on her way back to Paris. She had been stolen from the Louvre and tracked down in Florence, where she was shown in the Leonardo room. The thief was Vincenzo Perruggia, a bad painter and self-styled patriot who claimed he wanted the masterpiece back in its homeland. He was sentenced to a year in jail.

In the mid-twentieth century, another would-be emperor coveted the Uffizi's precious horde. Napoleon had been well aware of the meaning of works of art as symbols of conquest; a procession in Paris in the style of the ancient Roman triumphs starred one of the world's most famous Classical sculptures, the *Laocoön*. Few missed the significance of its transfer to the Louvre, the shift of the center of gravitas of European civilization. Although the human response to art is often too complex to tease out its various parts, Napoleon seems to have loved certain works in the museum for reasons beyond their emblematic meaning—the *Medici Venus* being the most obvious example.

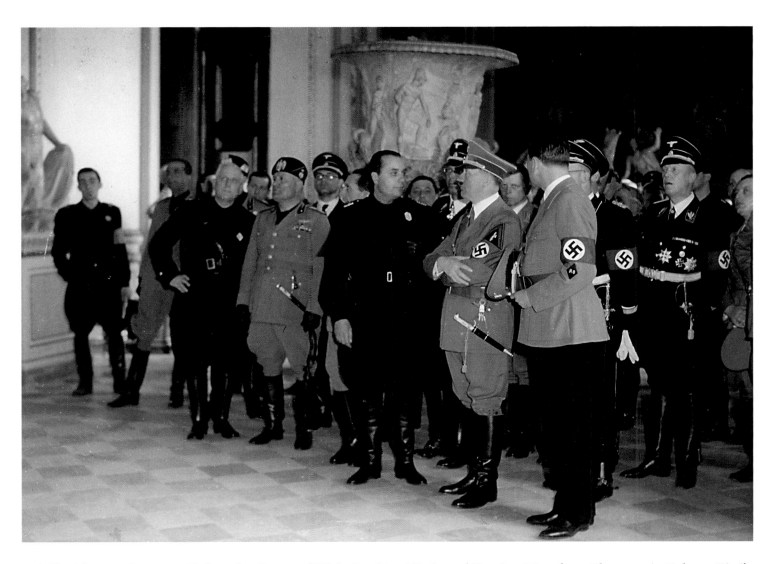

Adolf Hitler, Benito Mussolini, and a Group of High-Ranking Nazis and Fascists Meet for a Photo-op in Palazzo Pitti's Palatine Gallery, After a Stroll Down Vasari's Corridor, May 1938.

The image of Hitler and Mussolini strolling down the Corridoio to the Galleria in 1938 speaks volumes about the world-class importance of Florence's museums, though it seems that Hitler was taken aback by Mussolini's ignorance about—and lack of interest in—the works in the Uffizi and Pitti.

No sooner had Italy entered World War II than once again the gems of Florence's collections were packed up and dispersed to villas in the surrounding countryside, where still other dangers awaited them. Cesare Fasola's memoirs of the time recount the period in 1944 when bombs dropped within earshot of Cimabues and Giottos in storage in Montagnana, near Padua. The night watchman prayed to the saints in the painting to protect him (and the works), and later attributed their preservation (and his) to the saints' intercession. Indeed, who's to say?

Truckloads of precious pieces had made their way to two depots in northern Italy when on May 2, 1945, the Germans surrendered. The troves were surrendered to the allies. One of the American officers charged with escorting the works back to Florence was the art historian Frederick Hartt, best known for his generous and insightful textbooks. A scholar of Renaissance art, and so accustomed to exploring visual data, he worked as a photograph interpreter for the army during the war, and received a Bronze Star for his part in the repatriation of looted art.

The Uffizi and the Corridoio were severely damaged by bombing in the last desperate months of the war. Once again, repairs were expeditiously performed, and the opportunity taken to improve the lighting and to remodel, for example, removing the system of radiators. The director, Filippo Rossi, alongside whom Hartt had worked during the war, began to reorganize certain rooms in the gallery. This process would accelerate early in the next decade, when the museum replaced with a chronological sequence the former academic hang by schools of artists. The new

organizational principle allows visitors to appreciate the ranges of coexisting styles.

In addition, a new museological approach required a thinning of the numbers of works on display in the galleries—by 1952, the numbers were down to 480 from approximately 2,400 at the turn of the century. This permitted considerably more wall space to be available around each painting. This approach, however, also brought out the need for more gallery space, and in 1957 the Grandi Uffizi project was launched. The first phase consisted of moving the overburdened State Archives from the ground floor. Besides opening up more available space, the transfer also removed the significant fire hazard represented by centuries' worth of paper.

Water, not fire, threatened the Uffizi during the fateful flood of November 4, 1966, which wrought destruction throughout northern Italy. Damage was minimal to works in the Uffizi, thanks to the prompt intervention of the museum staff.

In 1950, the Uffizi had welcomed 105,000 visitors; that number rose to 626,000 in 1967 and 1,148,000 a decade later. By 1979, as many as 11,000 people had toured the galleries in a single day. Experience, common sense, and advances in conservation showed such numbers to be untenable, principally in terms of protecting the artworks. Inadvertent vandalism results from overcrowding, while the mere physical presence of human bodies produces emanations that cause chemical changes. (Only twenty-five people at a time are allowed into Padua's tiny Scrovegni Chapel, and only for fifteen minutes. In addition, visitors must spend twenty-five minutes in an "equalization chamber," which balances the microclimate that each of us, as an organism, creates.) These conditions, in turn, establish certain bureaucratic requirements, such as advance reservations.

The Uffizi permits nine-hundred people to enter every two hours, while heating and air conditioning systems initiated in the 1970s create a climate congenial to the artworks. The 1970s also witnessed a spectacular rehabilitation of the exterior, including roofing, stonework, and restorations of the nineteenth-century statues in the niches on the façade. The departments of Education and Research were instituted in the Uffizi, but with a mandate addressing all the public museums of Florence. The Education Department operates in two fronts, first, to work with schools and museums in the city and the surrounding area, and second, within the Uffizi, to introduce young people to their rich artistic legacy and to the broader history of art. The Research Department works in the areas of conservation and documentation, which includes eventually photographing every item in all the museums of Florence.

Most importantly, works continued to be acquired and shown. Lorenzo Lotto's remarkable *Susannah the Chaste* with its suggestive aerial viewpoint came from the Contini-Bonacossi collection in 1975; two paintings by Francisco Goya, including an unusual equestrian female portrait of one of Goya's most faithful patrons, also entered the museum in the 1970s.

As with all museums and other institutions worldwide, the Uffizi has always taken every precaution to ensure the safety of its precious works of art. Nevertheless, there are situations that cannot be anticipated. On May 27, 1993, in an attempt to discourage the systematic investigations of its activities in Italy, the Sicilian Mafia engaged in a campaign of car bombings. Minutes after 1:00 A.M., a bomb exploded in via dei Georgofili, behind the Uffizi. Five people were killed. In the Uffizi, the Corridoio was hardest hit: ten rooms were seriously damaged. Shattered glass destroyed Gherardo delle Notti's *Adoration of the Shepherds*, and Bartolomeo Manfredi's *Concert* and *Card Players* were shredded beyond repair.

Between canvases and panels, 173 works were saved. Curiously, advances in conservation technology allowed the Uffizi team to ascertain that certain works on wood were more damaged than they appeared. The explosion had created shock waves that had loosened the joins, thereby affecting the ground and the pigments laid onto the ground. The Opificio delle Pietre Dure volunteered to take on the restoration of the two canvases from Rubens's Henry IV cycle, which because of their great size—they measure approximately twenty-three feet high by twelve feet wide (nearly seven meters by four)—would have placed too great a strain on the resources of the

Installation of Paintings in the Botticelli Room. Galleria degli Uffizi, Florence.

Uffizi's conservation team.

Some fifty-six sculptures, including the *Dying Niobid*, were seriously affected, beyond the scratches and chipping they suffered from flying debris. In some cases, this was because the works were originally composed of several pieces, in others because they had already undergone restoration. Today, they are once again in place, delighting today's audiences as they surprised and inspired the artists of the Renaissance.

The Corridoio has only recently reopened and only to a select few visitors—essentially officials and select guests, for the most part professional colleagues. This return to the corridor's exclusive use only renders more striking the Uffizi's gradual development into one of the most public of the world's institutions. Its evolution proceeds within the long-term vision of the Grandi Uffizi, which foresees the museum's continuing expansion.

Down the torchlit halls where Francesco once ranged with his secretaries, where Ferdinando led friends and diplomatic allies to the sounds of laughter and music, where the king of an Italy unified at last enjoyed a smoke and a chat with a curator, where Hitler and Mussolini made their private pact, visitors from all over the globe in every language under the sun enjoy these treasures once reserved for the elite of a handful of nations. Across the courtyard from the west wing, where artisans once labored for Florence, Tuscany, and the grand duke, readers work in the Uffizi library, bathed in light from its great windowed wall. In the Gabinetto Disegni e Stampe, amid the ghosts of singers and their audiences, scholars study drawings to discern in the turn of a line the intimate secrets of the process of artmaking. Vasari would approve. Like other museums in the twenty-first century, the Uffizi is a living institution, one that both reflects and propels the times, constantly challenging itself to reexamine its audience and purpose, as it shares its true wealth—creations born of the highest human abilities, values, and, ultimately, love.

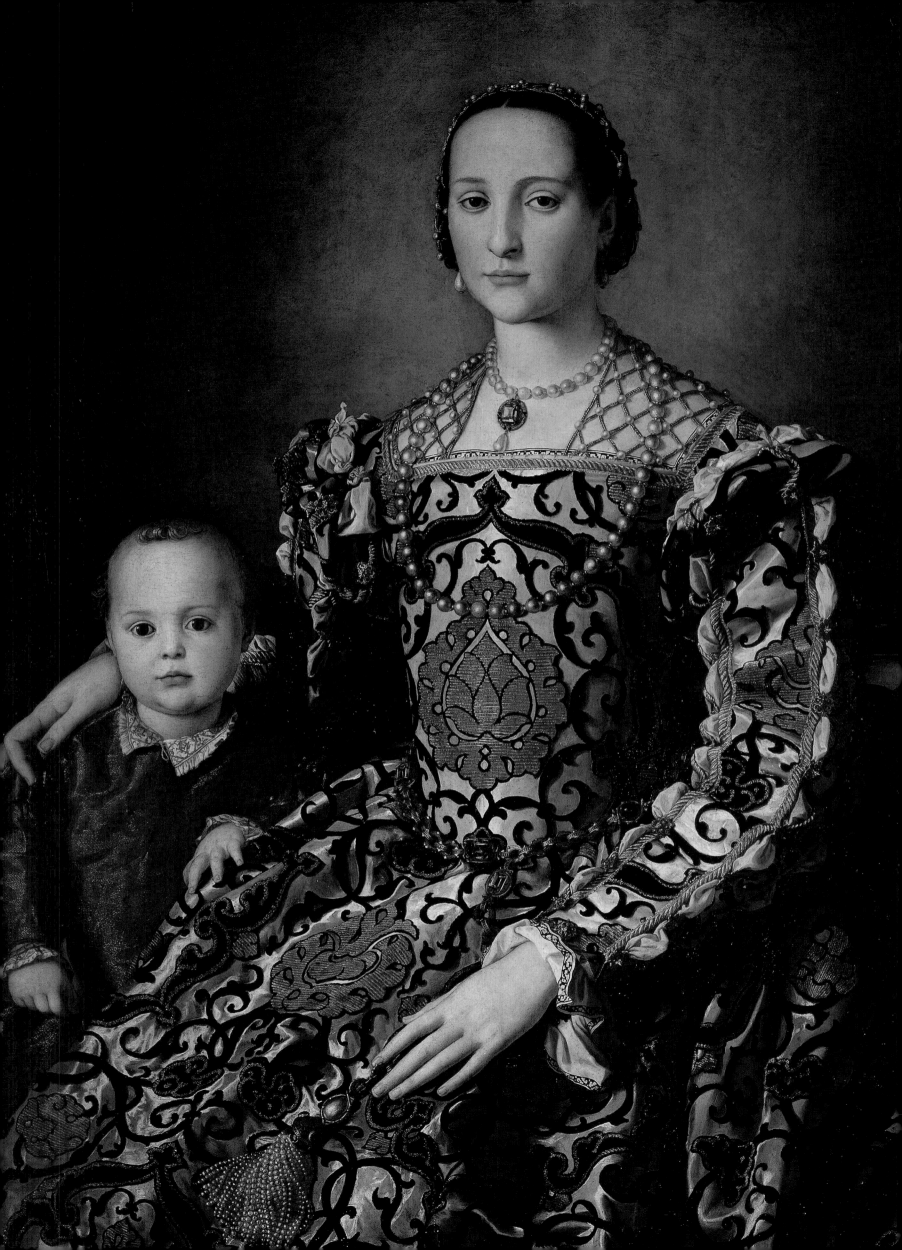

LA GALLERIA
Painting, Sculpture, Tapestry

The serene, intimate spaces of the Galleria degli Uffizi were created by Grand Duke Francesco I de' Medici to display the finest of the family's princely collections. The next grand duke, Ferdinando I, opened the opulent halls to an elite public beyond his personal and political acquaintance. The first king of a unified Italy, Victor Emanuel II, invited all citizens to enjoy the new nation's patrimony. This included paintings spanning some six hundred years, from the thirteenth to the eighteenth century, and select ancient sculpture, emblems of the humanist tradition that gave rise to the Renaissance. Today, these marvels of inspiration, imagination, and virtuosity—the artistic legacy of the greatest art patrons of all time—belong to the world.

OPPOSITE
Agnolo Bronzino (1503–72). *Eleanora of Toledo with her Son Giovanni.* Ca. 1545.
Oil on wood. 45 ¼ x 37 ⅞ in. (115 x 96 cm).

The date of this painting is based on the apparent age of little Giovanni, who was born in 1543. Eleanora's cool demeanor, emphasized by the blue aura around her well-coiffed head, is belied by her protective gesture on Giovanni's shoulder. Bronzino was one of the top artists in Italy at this time, and the duchess's dress cost more than the painting.

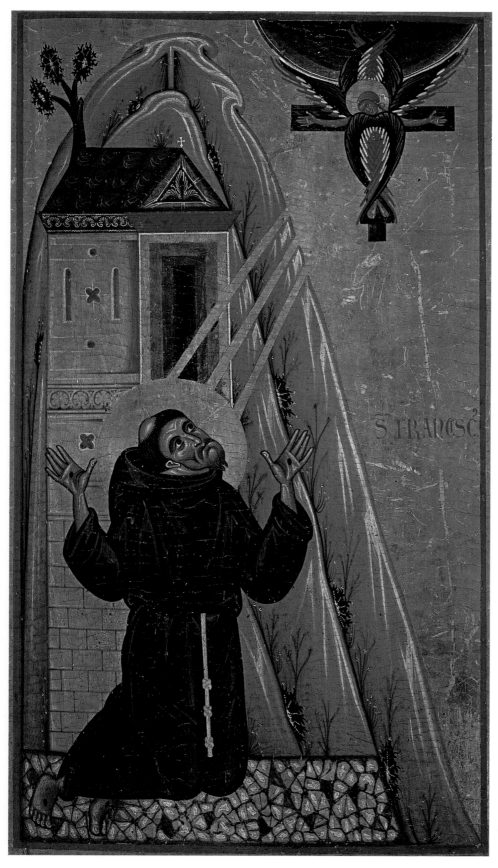

Cimabue (1240–1302). *Madonna of the Holy Trinity.* Ca. 1260. Madonna and infant Jesus, angels, four prophets below: Jeremiah, Abraham, David, and Isaiah. Wood. 151 ½ x 87 ¾ in. (385 x 223 cm).

The golden effulgence around the Virgin bespeaks her heavenly majesty—her *maestà*. The two prophets and two patriarchs hold texts referring to the Incarnation, the miracle of God becoming Man to redeem humankind from Original Sin. The almond-shaped eyes recall the iconic Byzantine style, but the graceful and varied postures are signs of the revolutionary new style.

P. 44

Duccio (ca. 1260–1318). *Madonna in Maestà* (Rucellai Madonna). Commissioned 1285. Tempera on wood. 169 x 114 in. (429.2 x 289.5 cm).

The regal throne suggests Mary as the Seat of Wisdom, the womb that bore the Child. Extensive cleaning restored the deep blue of the Virgin's mantle. The pigment, called "ultramarine," because it came from across the Mediterranean Sea (it is actually lapis lazuli), was the most expensive after gold. The red garments of mother and child foretell the Passion.

Master of the Bardi Saint Francis (active ca. 1240–70). *Stigmata of Saint Francis.* Ca. 1250. Tempera on wood. 31 ⅞ x 20 in. (81 x 51 cm).

Kneeling before his solitary cell at La Verna, Francis, identified by an inscription, mystically receives the stigmata, or wounds of Christ, from a winged Crucified Christ and the sphere above, which together stand for the three elements of the Trinity. This is one wing of a gold-bossed diptych that was made within a generation of Francis's canonization.

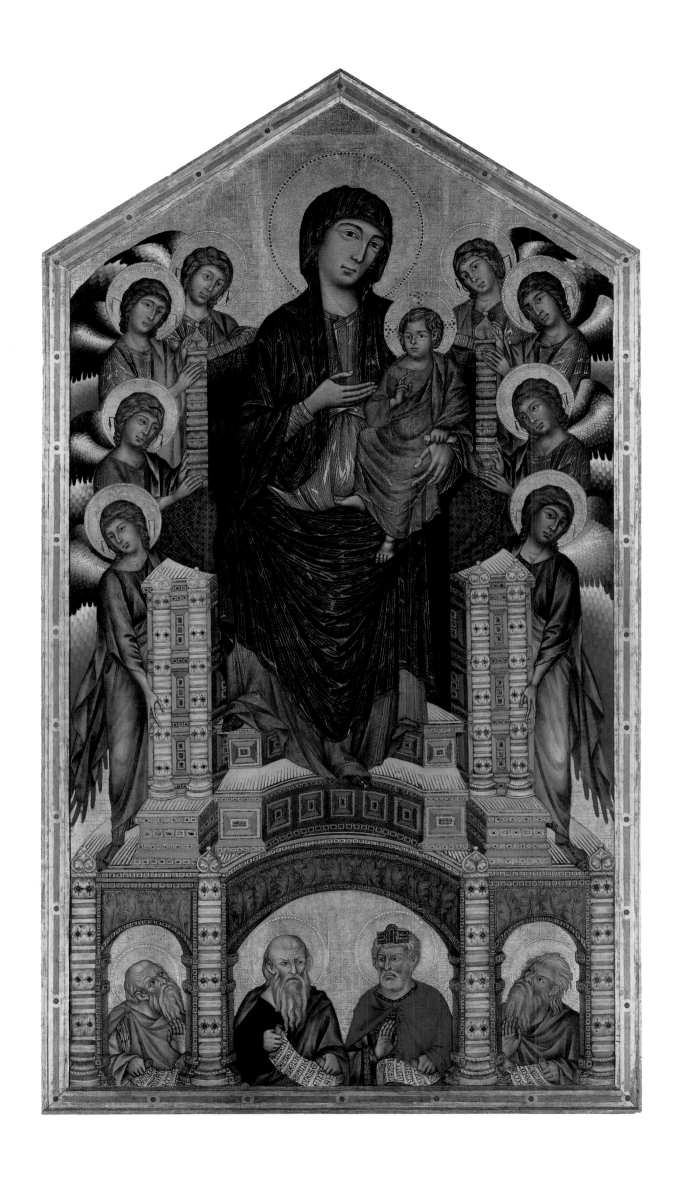

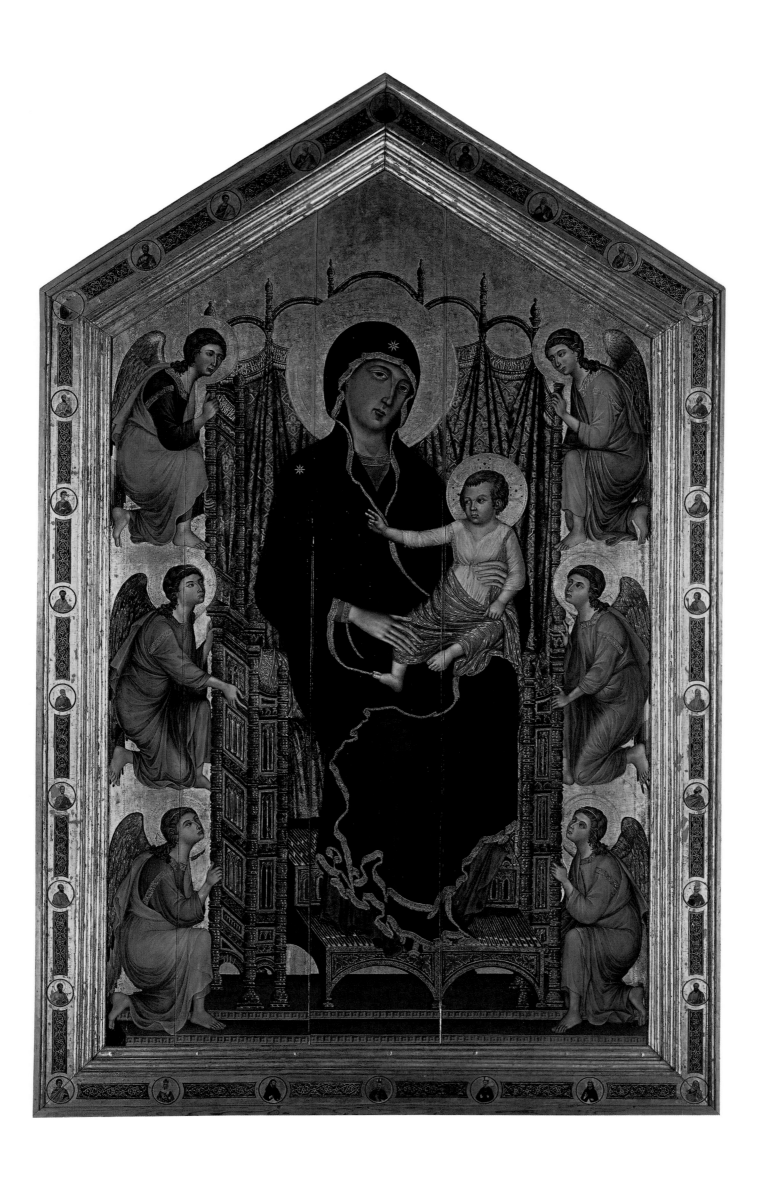

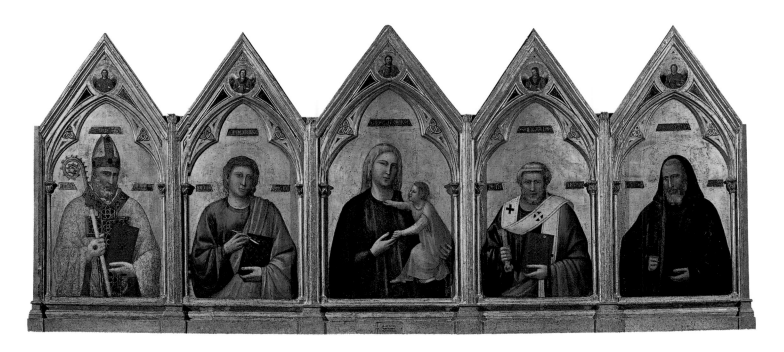

ABOVE

Giotto di Bondone (ca. 1267–1337).
Polyptych of the Badia. 1301/02.
Tempera on wood. 35 ¾ x 131 ½ in.
(91 x 334 cm).

Giotto brought an unprecedented
naturalness into art—consider the
Virgin's tender gesture of holding her
son's hand. Within a series of
architectural forms, she is flanked by
very important saints: Nicholas (of
Christmas fame); John the Evangelist;
Peter, with the keys of the Church; and
Benedict, founder of the order that
cared for the church for which Giotto
made this polyptych.

RIGHT

Giotto di Bondone (ca. 1267–1337).
Ognissanti Madonna. 1306–10.
Tempera on wood. 128 x 80 ⅜ in.
(325 x 204 cm).

The decoration of the Virgin's throne
resembles the colored marble work in
contemporary churches, while the
steps allow the viewer access to her,
emphasizing her role as intercessor.
The kneeling angels hold vases of lilies
and red flowers. The white is
associated with purity and the Virgin
Birth, the red with Christ's death on
the Cross.

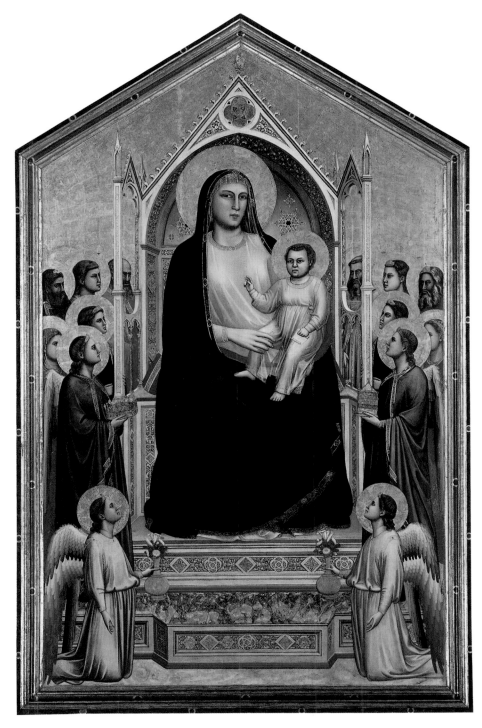

LEFT, TOP AND BOTTOM
Ambrogio Lorenzetti (1319–47/8?).
From *Stories of Saint Nicholas*.
Top: *Resurrection of the Boy.*
Bottom: *Saving Myra from Famine.*
Ca. 1327–30. Tempera on wood.
36 ¼ x 20 ½ in. (92 x 52.2 cm).

This pair of paintings and the other two shown here possibly made up a tabernacle door. In the top panel, the Saint brings a dead boy back to life. In the bottom panel, a terrible famine had struck Bishop Nicholas's province. Transiting ships were filled with grain, but when Nicholas asked them to give of their plenty, the sailors refused, fearful of arriving at their final port with less than the whole cargo. Nicholas promised this would not happen. Here, angels replenish the ships with grain, fulfilling the bishop's vow.

OPPOSITE, TOP AND BOTTOM
Ambrogio Lorenzetti (1319–47/8?).
From *Stories of Saint Nicholas*.
Top: *The Saint Provides a Dowry for Three Poor Girls.* Bottom: *He is Elected Bishop of Mira.* Ca. 1327–30. Tempera on wood. 38 ¼ x 20 ½ in. (97 x 52.2 cm).

In the top scene, Nicholas is throwing gold into the house of a man who was considering prostituting his daughters. In the bottom scene, he is elected his city's bishop. The future saint did the same twice more, dowering the girls so they could marry. By way of his Dutch name, this gift-giver turned into Santa Claus.

P. 48

Taddeo Gaddi (ca. 1300–66).
Madonna with Child and Angels.
1330–35. Tempera on wood.
35 ⅞ x 19 in. (91 x 48.5 cm).

The Queen of Heaven is
particularly regal, and her lavishly
robed son holds a swallow, symbol
of the Passion. At her feet, angels
waft incense and hold fragrant
flowers. Gaddi, a long-time
collaborator of Giotto, included
the patron with an inscription and
by painting the Segni coat of arms
on the rise of the Madonna's dais;
her foot points to it.

P. 49

Bernardo Daddi (active end of
the 13th century–1348). *Polyptych
of San Pancrazio: Predella with
Scene of Nativity.* Before 1338.
12 ¼ x 6 ¾ in. (31 x 17 cm).

A predella is a series of smaller
panels below an altarpiece. This
panel illustrates the Nativity and
the adoration of the shepherds.
Musical jubilation is everywhere:
the angels play fanfares on
trumpets and pluck sweet melodies
on stringed instruments, while a
joyous rustic tootles his humble
bagpipe. The ass and ox look on as
the Virgin tenderly swaddles the
Christ Child.

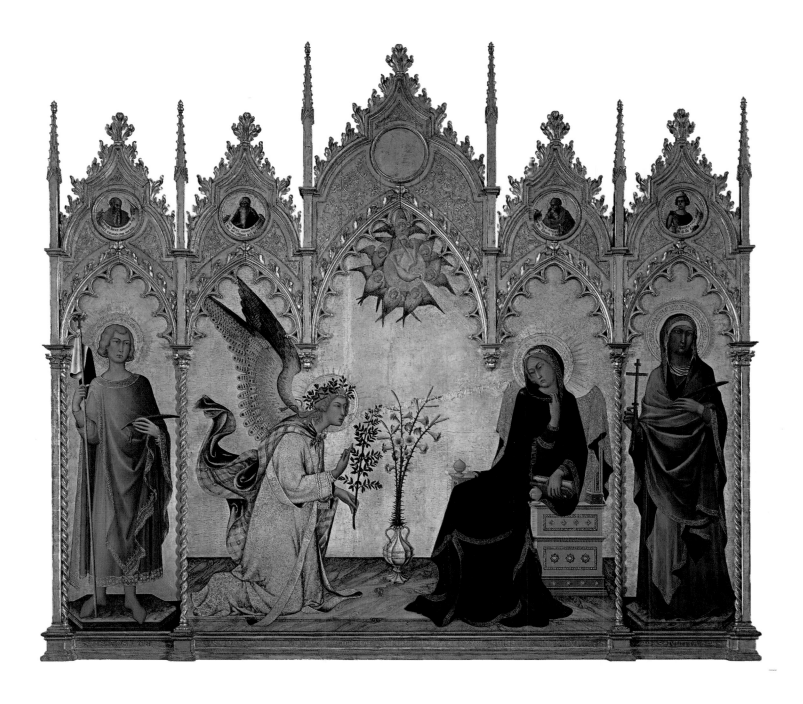

Nardo di Cione (active 1346–65). *The Crucifixion.* Ca. 1350. Tempera on wood. 57 x 28 in. (145 x 71 cm).

The faithful would have made the connection between Christ's sacrifice, represented in this painting, and the Eucharist in the hands of the celebrant at the altar below it, a connection emphasized by the angels gathering Christ's blood in bowls. His lightly veiled nudity is a sign of the Incarnation—of God made human.

Simone Martini (ca. 1284–ca. 1344). *The Annunciation with Saints Ansano and Massima.* 1333. Tempera on wood. 72 ½ x 82 ¾ in. (184 x 210 cm).

Gabriel's speech to Mary, AVE GRATIA PLENA DOMINUS TECUM (Hail, full of grace, the Lord is with thee), from the Gospel of Luke, is etched into the gold of the background. In this version, Mary may only be hearing the fateful greeting, as she does not look directly at the angelic messenger. The frame, added in the twentieth century, mistakenly places the side figures on the same level as the angel and Mary.

ABOVE AND OPPOSITE

Giovanni da Milano (ca. 1320–ca. 1369). *Polyptych of Ognissanti:* Lateral panels. Before 1365. Tempera on wood. 52 ⅜ x 16 in. (133 x 40.5 cm).

The original altarpiece numbered six such panels, three on either side of a central panel featuring the Virgin. The sixth panel is not in the Uffizi. The saints are Catherine and Lucy; Stephen and Lawrence; John the Baptist and Luke; Benedict and Peter; and James the Major and Pope Gregory. In the roundels above are the days of the Creation, in which the artist portrayed God the Father as resembling Christ.

P. 54

Orcagna (Andrea di Cione) (1315/20–68) and Jacopo di Cione (active ca. 1368–83). *Saint Matthew and Stories of His Life*. Ca. 1367–70. Tempera on wood. 114 ½ x 104 ⅜ in. (291 x 265 cm).

The Florentine Moneychangers' Guild commissioned Orcagna to make a work that would wrap around three sides of a church pilaster. When Orcagna died, his brother Jacopo di took over. Scholars attribute the layout of the scenes and the architectural design to Orcagna, and the painting to Jacopo di. In the central panel, the evangelist's book is open to the beginning of his gospel.

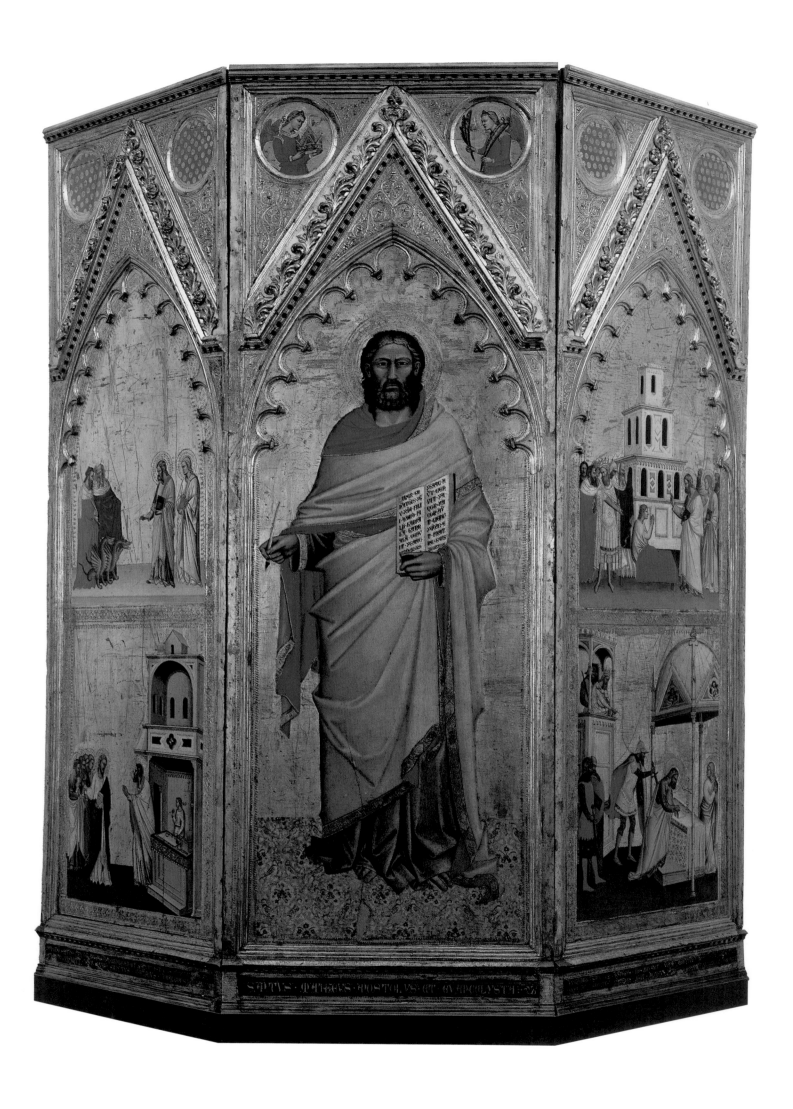

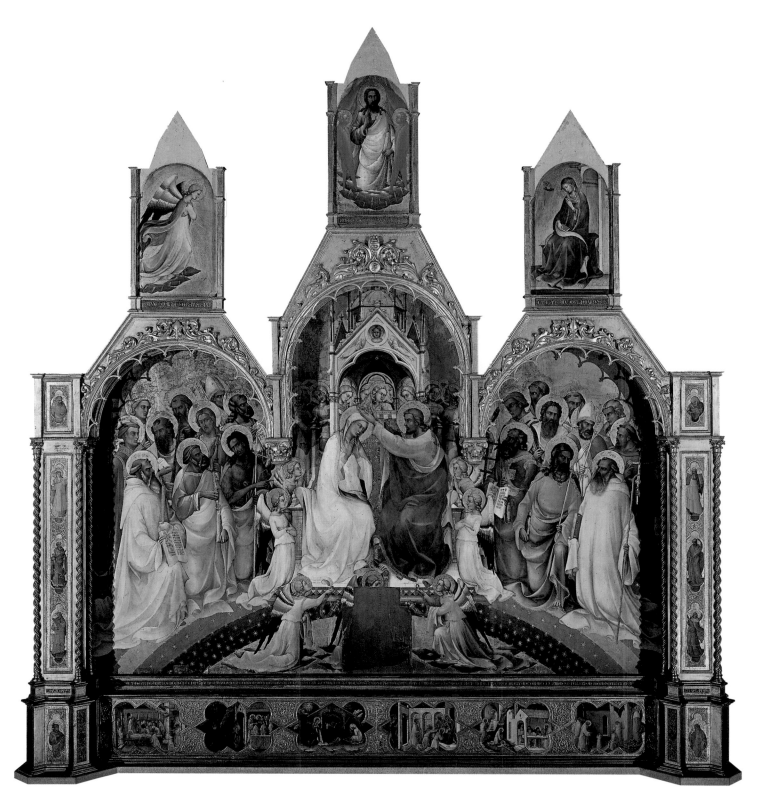

Lorenzo Monaco (ca. 1370–1425). *The Coronation of the Virgin*. 1414. Tempera on wood. 199 ¼ x 176 ¼ in. (506 x 447.5 cm).

A heavenly hubbub attends the coronation of the Virgin by her son; the celestial space is represented by clouds and starry swaths in shades of precious blue. Lorenzo the Monk was also a miniaturist, whose skill is especially apparent in the predella. Exposed by too-drastic cleanings, the greenish tinge of some faces is the underpaint that artists used beneath flesh tones.

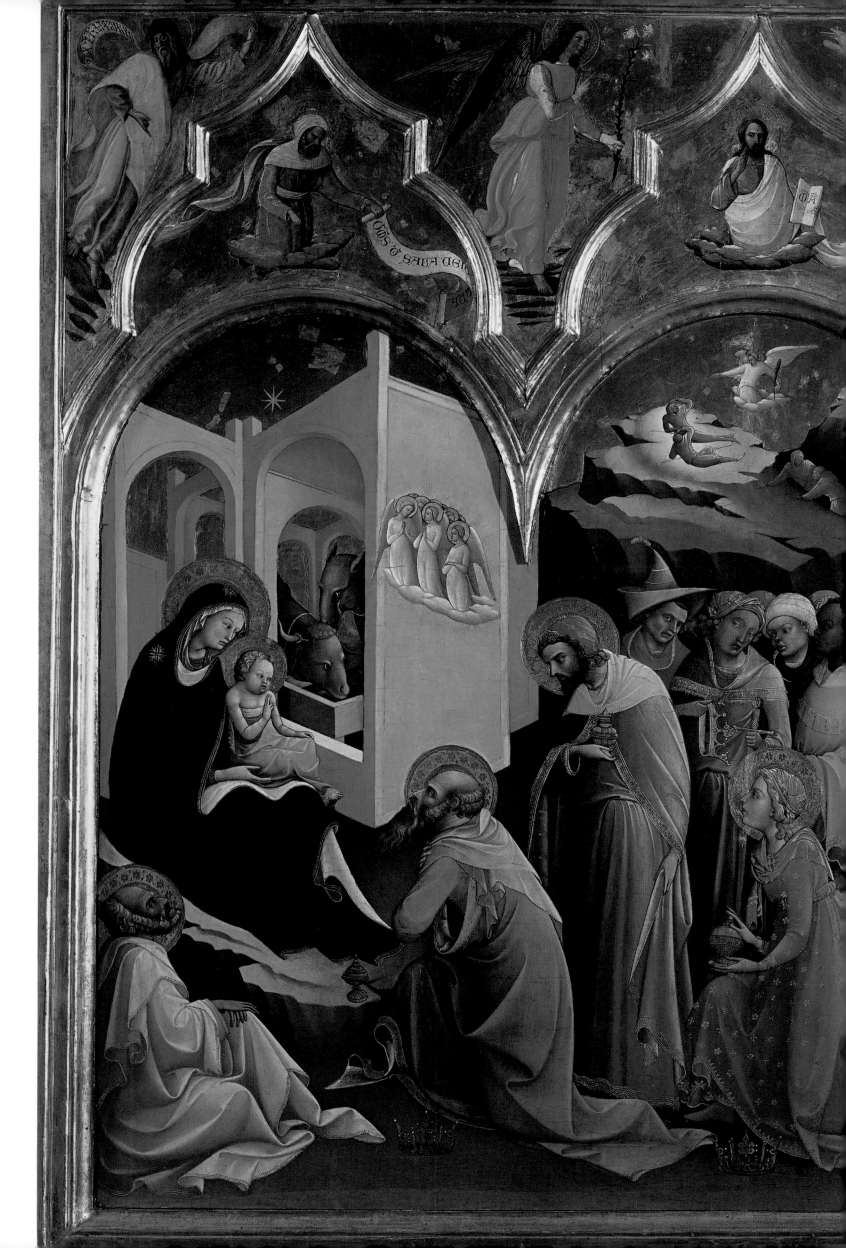

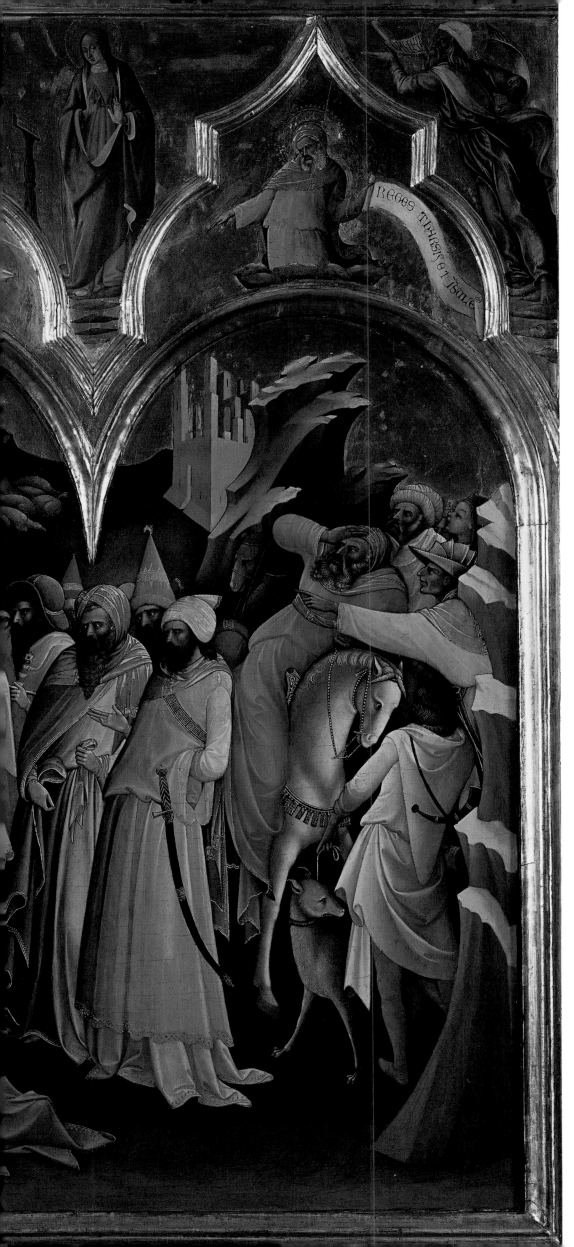

Lorenzo Monaco (ca. 1370–1425) and Cosimo Rosselli (1439–1507). *The Adoration of the Magi.* 1421/22. Tempera on wood. 45 ¼ x 67 in. (115 x 170 cm).

At the manger, the ass gazes at the Christ Child, while the ox looks away, conventional representations of the believers and the Jews, respectively. A curious detail: the third "king" looks like Mary Magdalen, holding her container of ointment. The bright and varied hues and fanciful settings are typical of the International Gothic style. Cosimo Rosselli painted the panel that was added above.

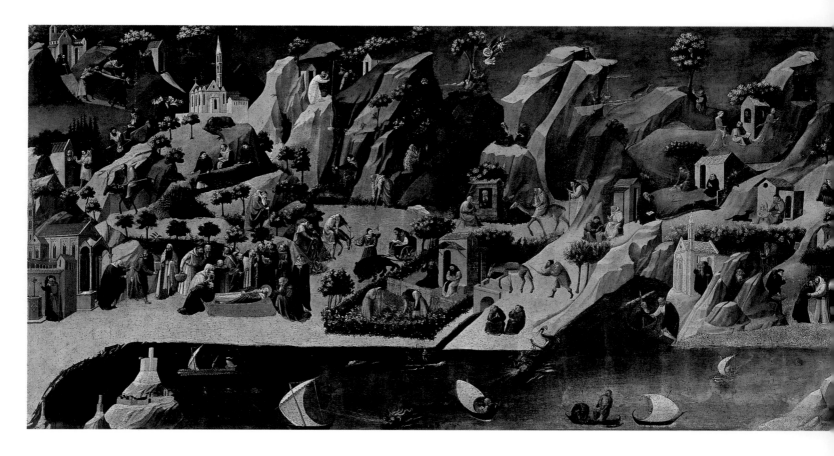

Gherardo Starnina (ca. 1354–before 1413). Or Fra Angelico? (ca. 1395–1455). *La Tebaide* (The Hermitage). Ca. 1420. Tempera on wood. 29 ½ x 81 ⅞ in. (75 x 208 cm).

Thebais, the Roman province of upper Egypt, was home to the first Christian monks, the desert fathers, who lived in these communities of single cells until the persecutions of the fourth century. The rhythmic treatment of the cliffs endows the scene with grandeur, while the individual vignettes reward close viewing. The attribution of this panting is still uncertain.

Niccolò di Bonaccorso (active 1372–88). *Presentation of the Virgin at the Temple.* Ca. 1379/80. Tempera on wood. 20 x 13 ⅜ in. (51 x 34 cm).

The Virgin has always been popular because of her suffering, which gives heart to her role as merciful intercessor with her divine son. This scene is from one of the apocryphal gospels recounting her life. The young Mary has elected to enter the temple. She has just gone up the steps by herself, where the rabbi receives her, and now she bids her parents farewell.

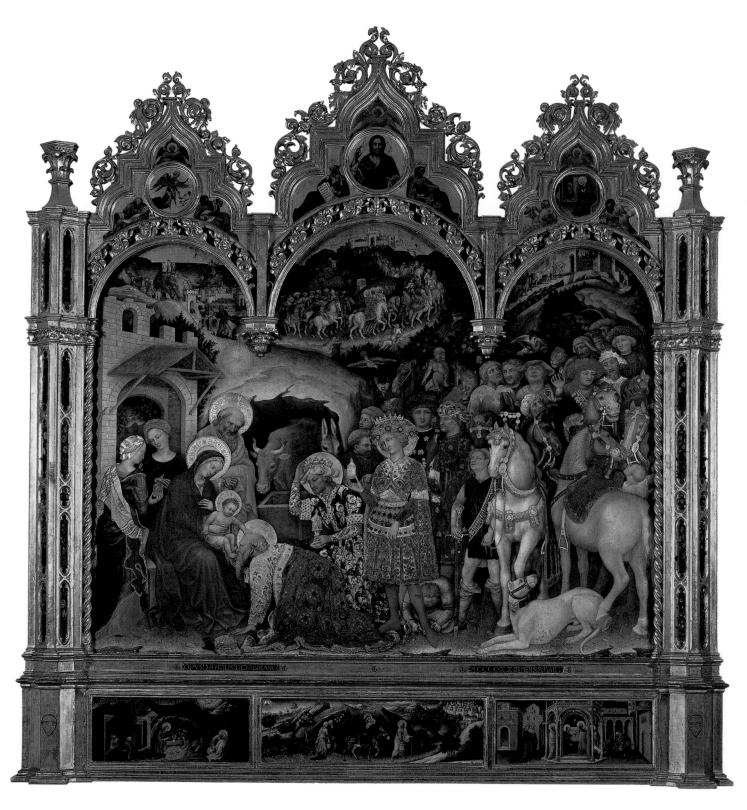

Gentile da Fabriano (ca. 1370–1427). *The Adoration of the Magi.* 1423. Tempera on wood. 118 ¾ x 111 ⅜ in. (301.6 x 283 cm).

In the winding throng, Gentile brought all of humanity to witness the moment upon which time and eternity pivot—the three kings represent the Three Ages of Man. This splendid and seamless combination of architecture, sculpture, and painting is probably all the artist's design, though his workshop would have played a part in such an undertaking.

Beato Angelico (1387–1455). *The Coronation of the Virgin.* Ca. 1425. Tempera on wood. 44 x 44 ⅞ in. (112 x 114 cm).

Saints invite us into the celestial crowd, as a joyous fanfare celebrates the Queen of Heaven. The angelic friar here bridged two styles: The undefined gold background is still medieval, while the recession of the Blessed into space and their animation already display a Renaissance temperament. The colors are especially intense and rich.

P. 62

Gentile da Fabriano (ca. 1370–1427). *Quaratesi Polyptych. Saints Mary Magdalen and Nicholas of Bari.* 1425. Tempera on wood. 77 ⅛ x 23 ⅞ in. (196 x 60.5 cm) (each panel).

In the leftmost lateral panel of the great altarpiece commissioned by the powerful Quaratesi family, Mary Magdalen holds her attribute, a jar of precious unguent. Beside her, Nicholas, bishop of Myra, holds three balls representing the dowries he gave three poor girls. His body was later taken to Bari, in southern Italy, and so he is also known as Nicholas of Bari.

P. 63

Gentile da Fabriano (ca. 1370–1427). *Quaratesi Polyptych. Saints John the Baptist and George.* 1425. Tempera on wood. 77 ⅛ x 23 ⅞ in. (196 x 60.5 cm) (each panel).

Like Mary Magdalen on the left, George, the dragon slayer, turns toward the absent central panel of the majestic altarpiece. John the Baptist holds a delicate cross, and his pointing gesture is more well mannered than the usual urgent signal of the fur-clad ascetic. The elegant flooring suggestive of sky is evidence of an early experiment in perspective.

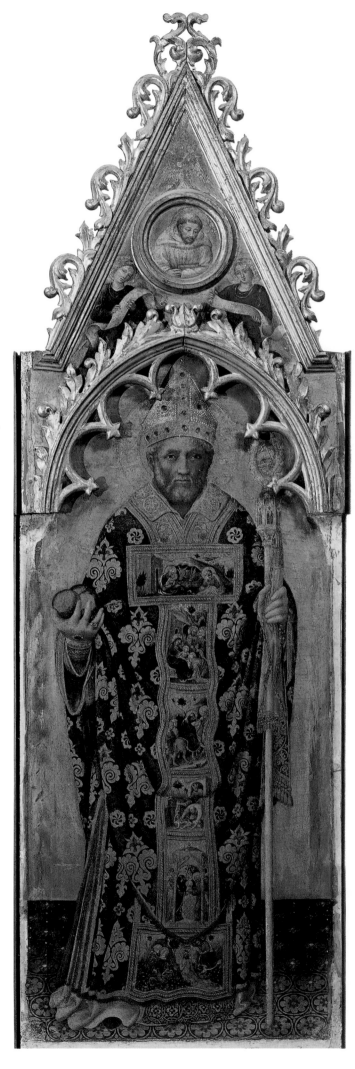

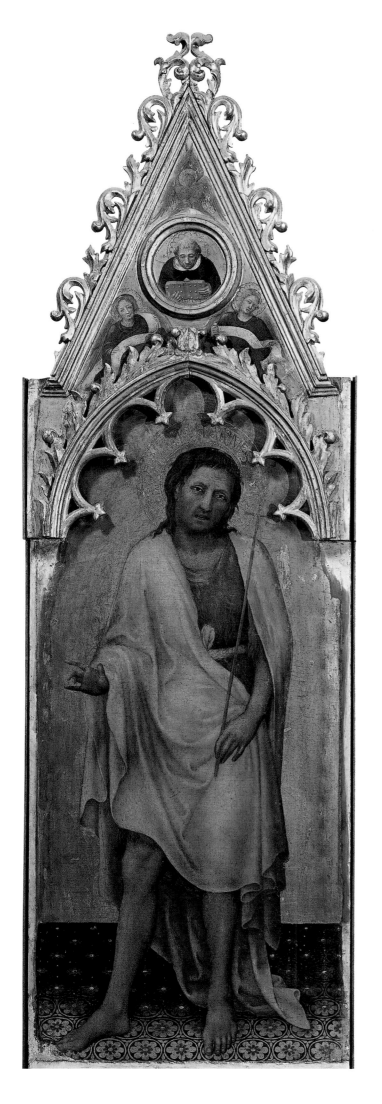
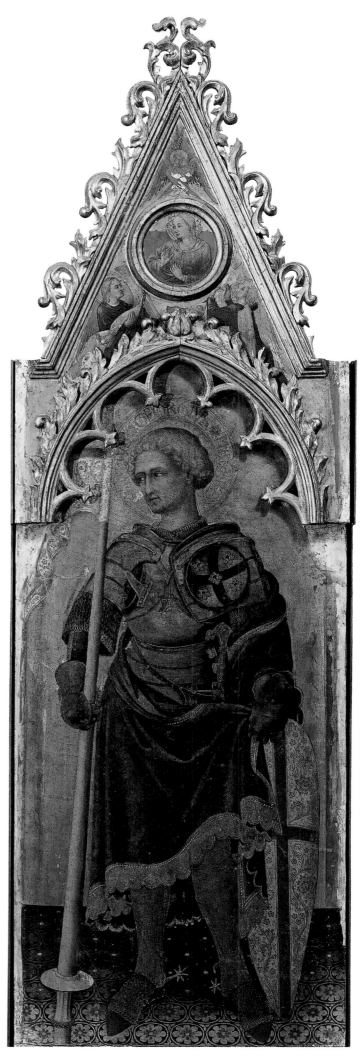

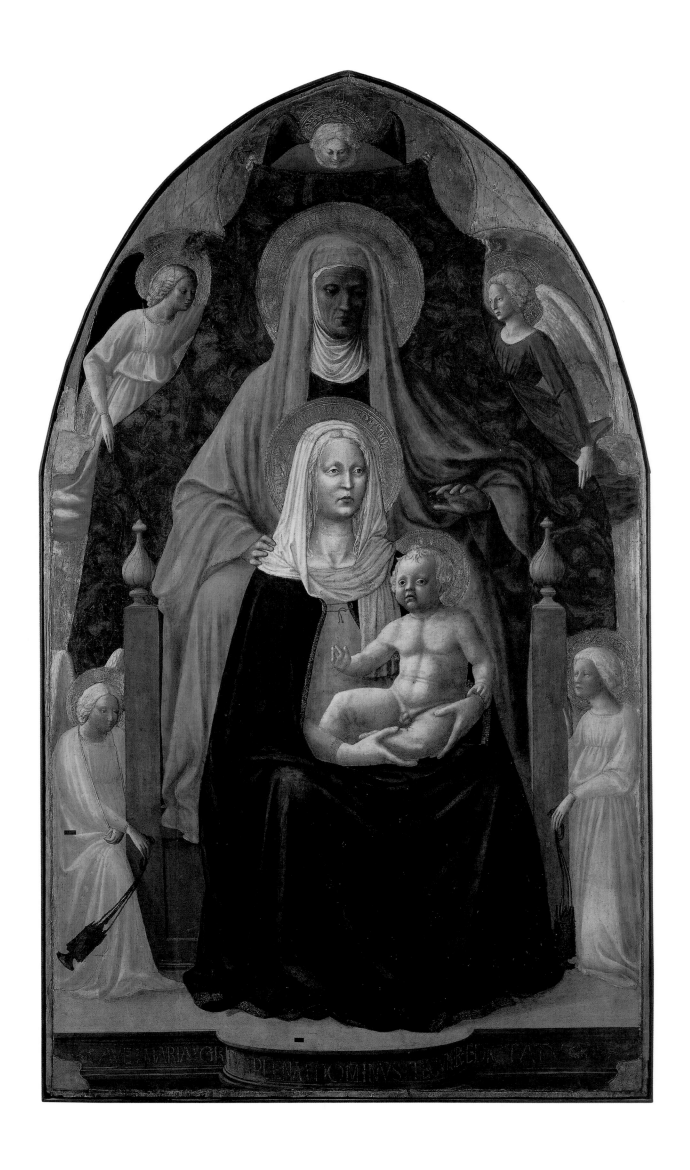

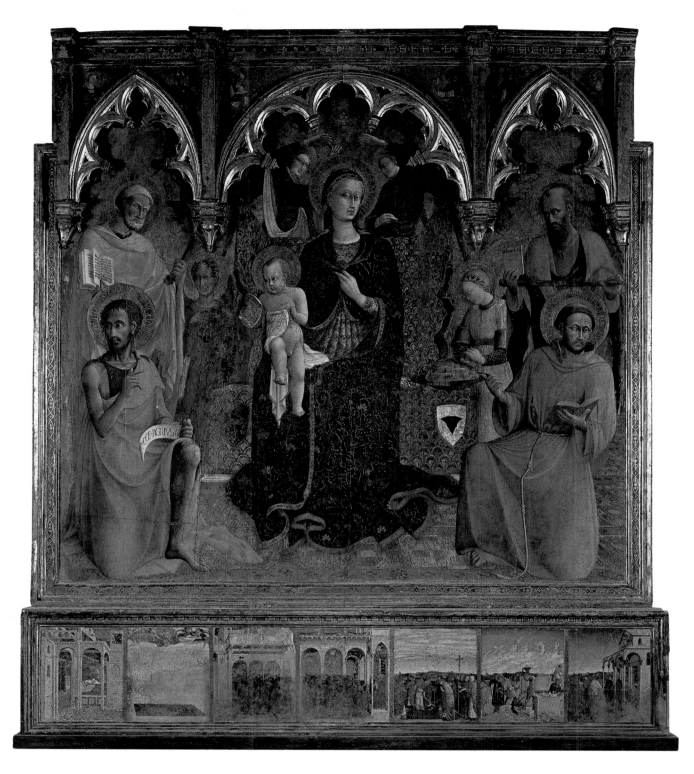

OPPOSITE

Masaccio (1401–28) and Masolino (1383–1440). *Madonna with Child and Saint Anne.* 1424/25. Tempera on wood. 68 ⅞ x 40 ½ in. (175 x 103 cm).

Saint Anne, the mother of Mary, does not appear in the canonical New Testament, but she was a significant figure in Florence: on her feast day in 1343, the people of the city expelled the tyrannical duke of Athens. The two artists worked together on several paintings. Masaccio's courtly style is an effective complement to Masolino's more somber realism. His Anne is a massive, protecting presence.

ABOVE

Stefano di Giovanni, called Sassetta (ca. 1392–1450). *Altarpiece of the Madonna of the Snows.* 1430–32. Tempera on wood. 94 ½ x 100 ¾ in. (240 x 256 cm).

This painting is lively with gestures, gazes, and patterns of designs. At the same time, the figures' slightly wooden quality is a memory of Byzantine icons. Texts are everywhere, signs of prophecy and doctrine. The coats of arms are those of the patron, Donna Lodovica. The object St. Francis indicates is the foundation of the Roman Basilica of S. Maria Maggiore.

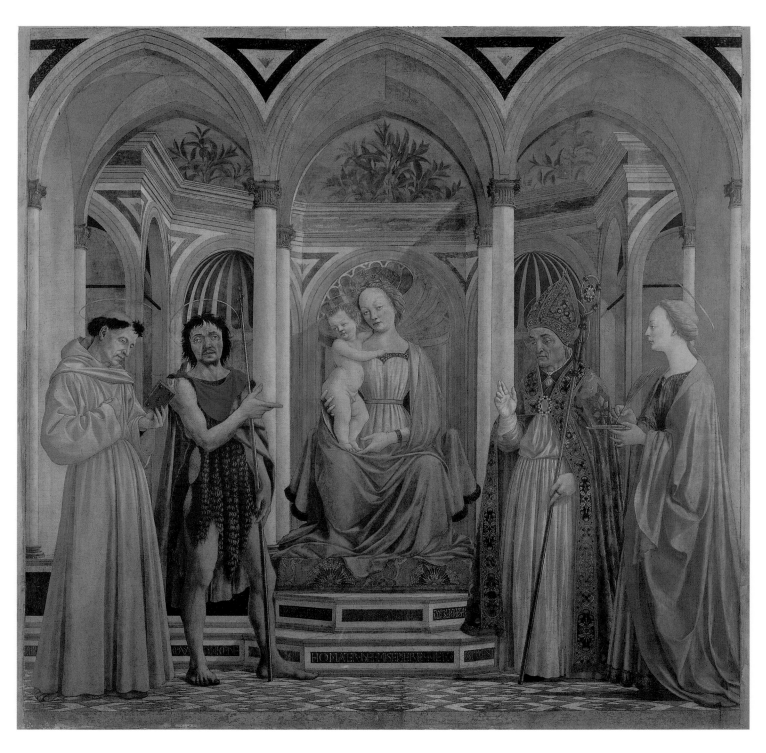

Domenico Veneziano (ca. 1410–61). *Saint Lucy Altarpiece*. 1439/40. Tempera on wood. 82 ⅝ x 84 ⅝ in. (210 x 215 cm).

Graceful lines, the variety of expressions and postures, the fruit trees with their suggestion of Eden all make this *Sacra Conversazione,* or Holy Conversation, a quintessential Early Renaissance work. Domenico was famous for his subtle and sophisticated hues. He added oil to the binder in which his pigments were suspended, and this is what gives the painting its luminosity.

Fra Filippo Lippi (ca. 1406–69). *The Coronation of the Virgin*. 1439–47. Tempera on wood. 78 ¾ x 113 in. (200 x 287 cm).

God the Father crowns Mary in a sacred space. The painter's lavish use of lapis lazuli for the many shades of blue, and the size of this altarpiece would have made it quite costly. Francesco Maringhi, the patron who footed the bill, is the kneeling, praying man on the right. Fra Filippo is the white-robed friar on the left who, chin in hand, contemplates the viewer.

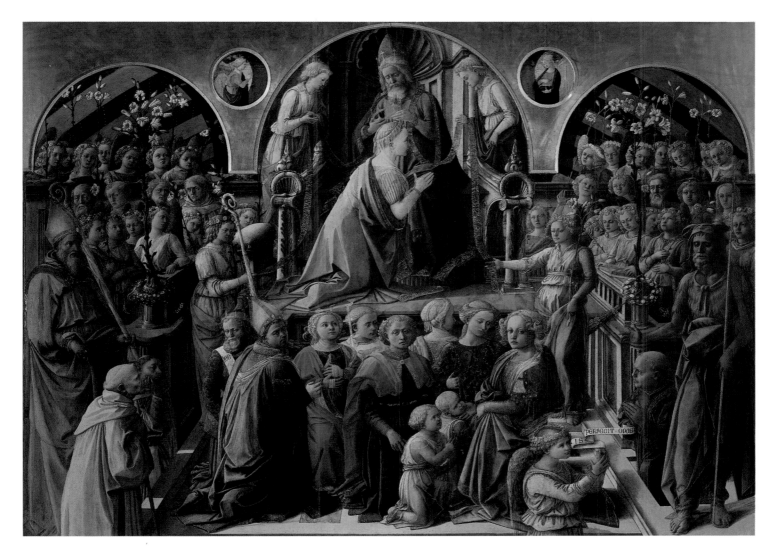

P. 68

Piero della Francesca (1416/17–92). *Portrait of Battista Sforza.* Ca. 1472–75. Tempera on wood. 18 ½ x 13 in. (47 x 33 cm).

Her serene gaze, pallid skin, fashionably plucked eyebrows and hairline, and gleaming jewels tell us that here is a highborn lady. The fertile landscape and low but enclosing white wall bespeak her maternity and chastity. In an age when the death of women—even noblewomen—went unannounced, great princes—and even Pope Sixtus IV—sent emissaries to Battista's funeral. The portraits of the duke and duchess of Urbino were once hinged together like a book.

P. 69

Piero della Francesca (1416/17–92). *Portrait of Federico da Montefeltro.* Ca. 1472–75. Tempera on wood. 18 ½ x 13 in. (47 x 33 cm).

Conventionally, with pendant portraits of wives and husbands, the husband often faces right, but Federico was blind in that eye, as the result of a jousting injury. Both sitters raise their heads against the open sky, which gives an impression of grandeur. The landscape behind Federico is an image of expansiveness, with roads and waterways leading into the wider world.

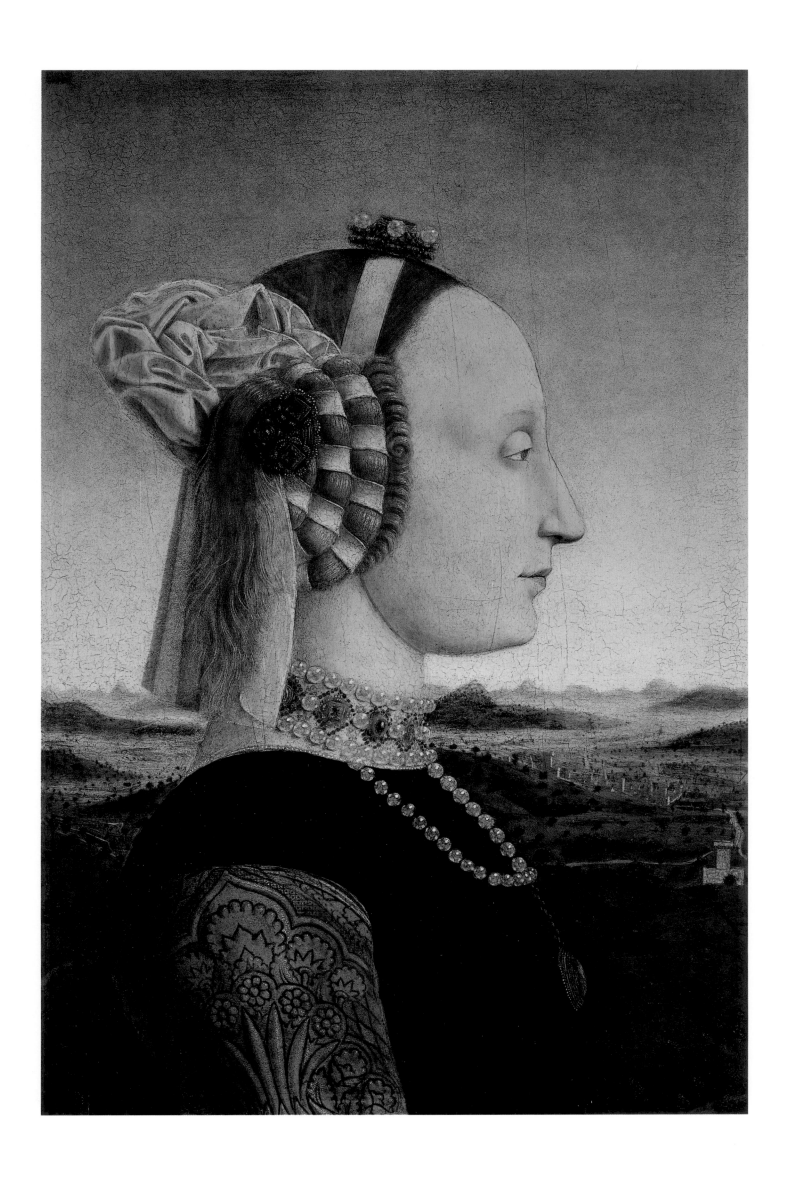

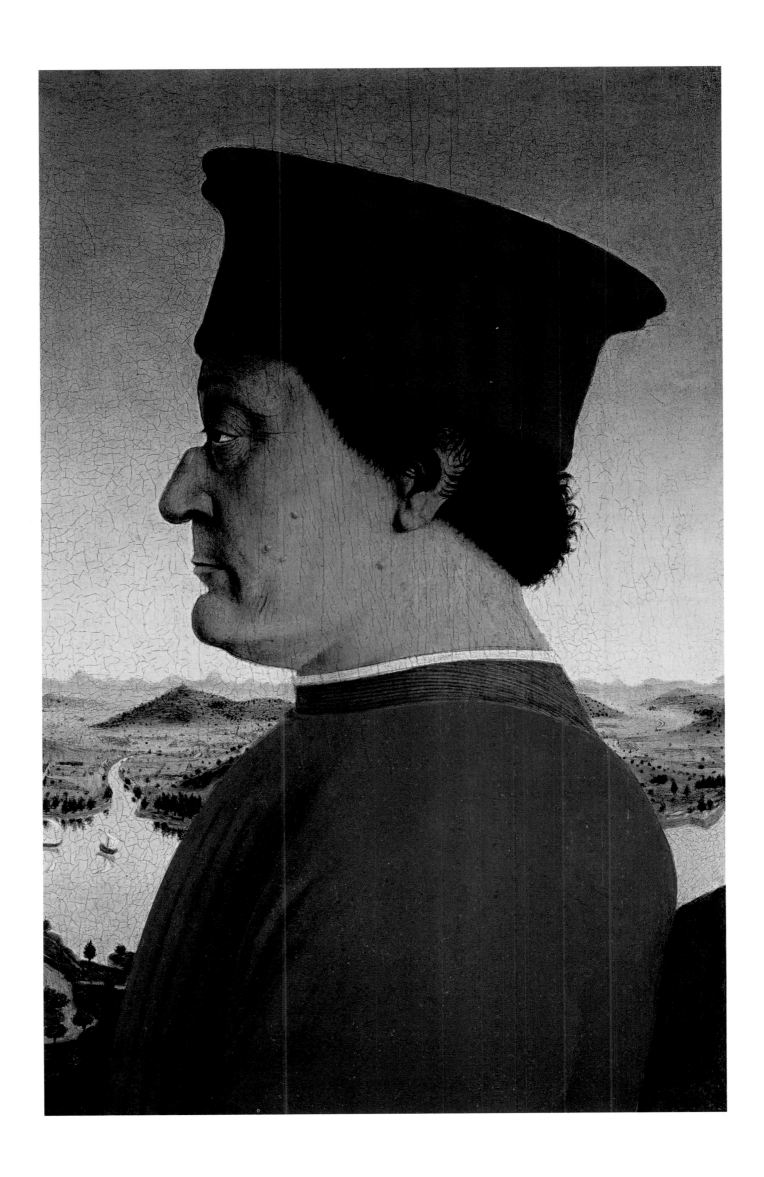

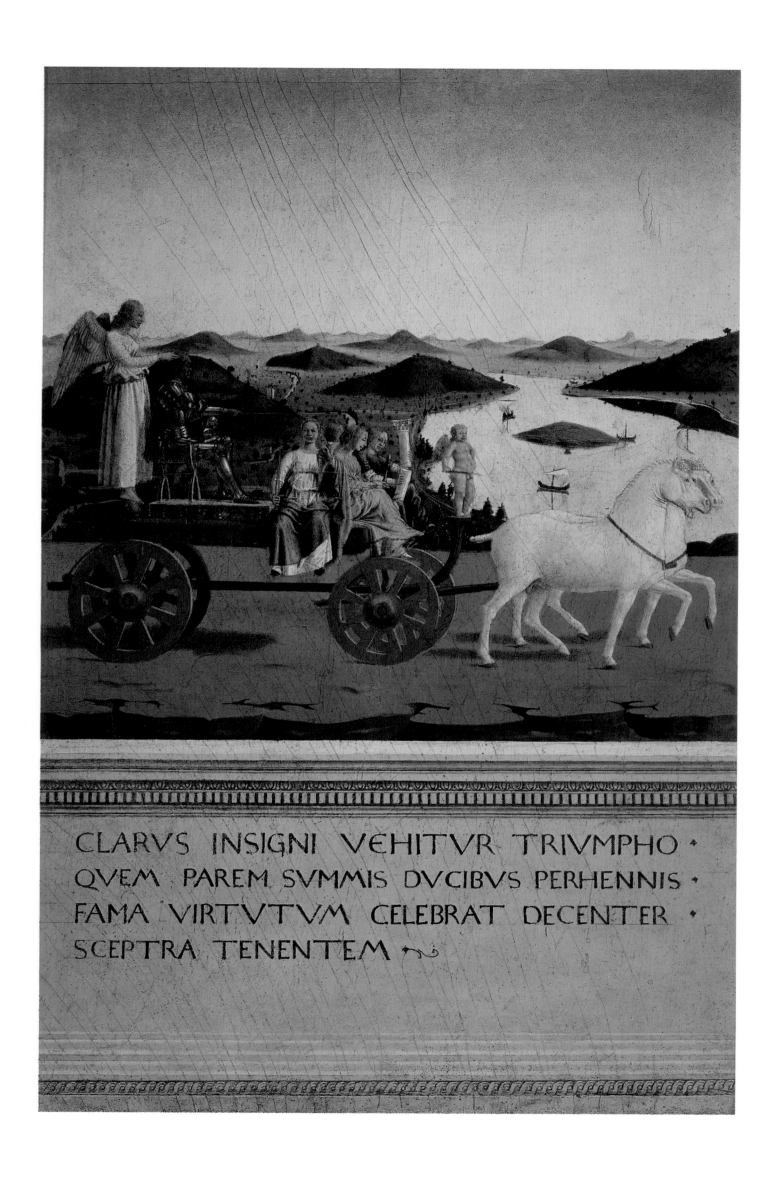

CLARVS INSIGNI VEHITVR TRIVMPHO ·
QVEM · PAREM SVMMIS DVCIBVS PERHENNIS ·
FAMA VIRTVTVM CELEBRAT DECENTER ·
SCEPTRA TENENTEM ᛊ

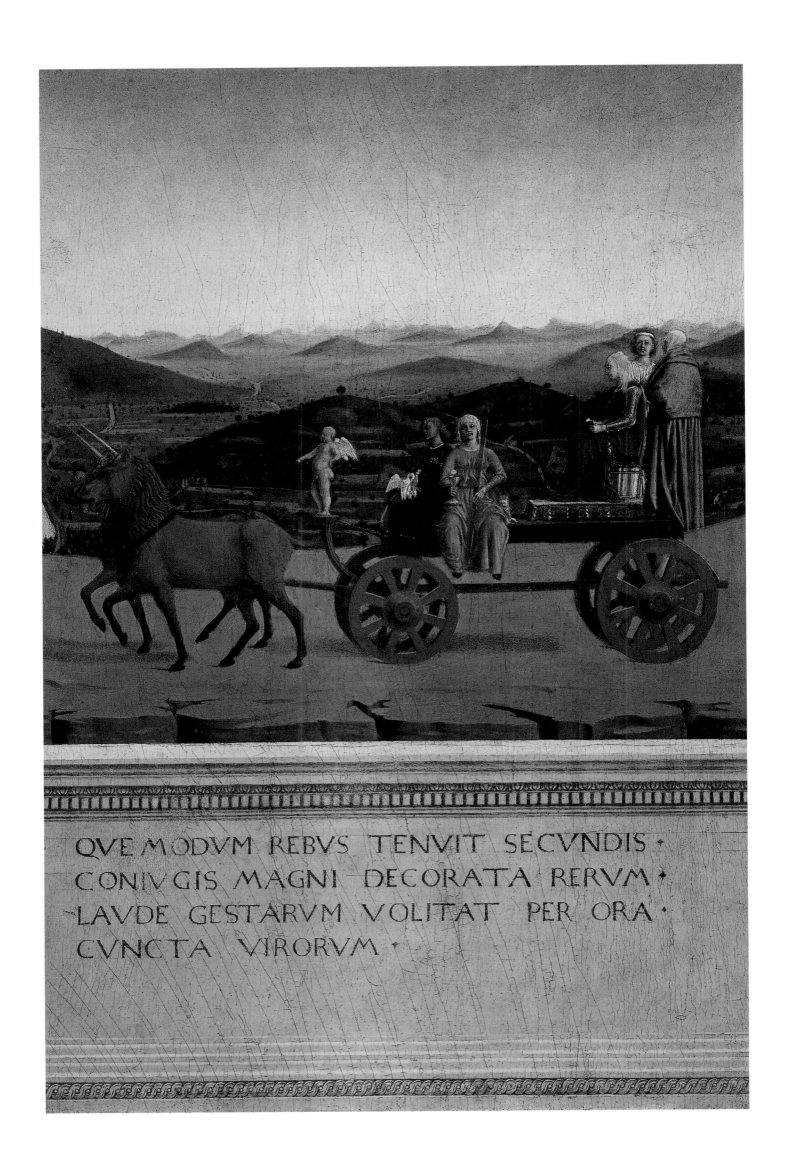

QVE MODVM REBVS TENVIT SECVNDIS ·
CONIVGIS MAGNI DECORATA RERVM ·
· LAVDE GESTARVM VOLITAT PER ORA ·
CVNCTA VIRORVM ·

P. 70

Piero della Francesca (1416/17–92). *Triumph of Federico da Montefeltro.* Ca. 1472–75. Tempera on wood. 18 ½ x 13 in. (47 x 33 cm).

The Renaissance adopted and adapted the classical Roman triumph. Federico da Montefeltro, duke of Urbino, was a legendary Italian *condottiere*, or mercenary. Like his consort's, the duke's chariot is driven by a Cupid. Before him are seated figures representing Justice, Prudence, Temperance, and Strength. Behind, Victory crowns him with a laurel wreath.

P. 71

Piero della Francesca (1416/17–92). *Triumph of Battista Sforza.* Ca. 1472–75. Tempera on wood. 18 ½ x 13 in. (47 x 33 cm).

Its small size implies that the book Battista Sforza reads in her unicorn-drawn chariot is a prayer book, but she was also an educated humanist. The inscription speaks of her in the past tense, so the composite work may have been made as a gesture of mourning. The two triumphs would have opened like a book with the portraits from pages 68 and 69 inside.

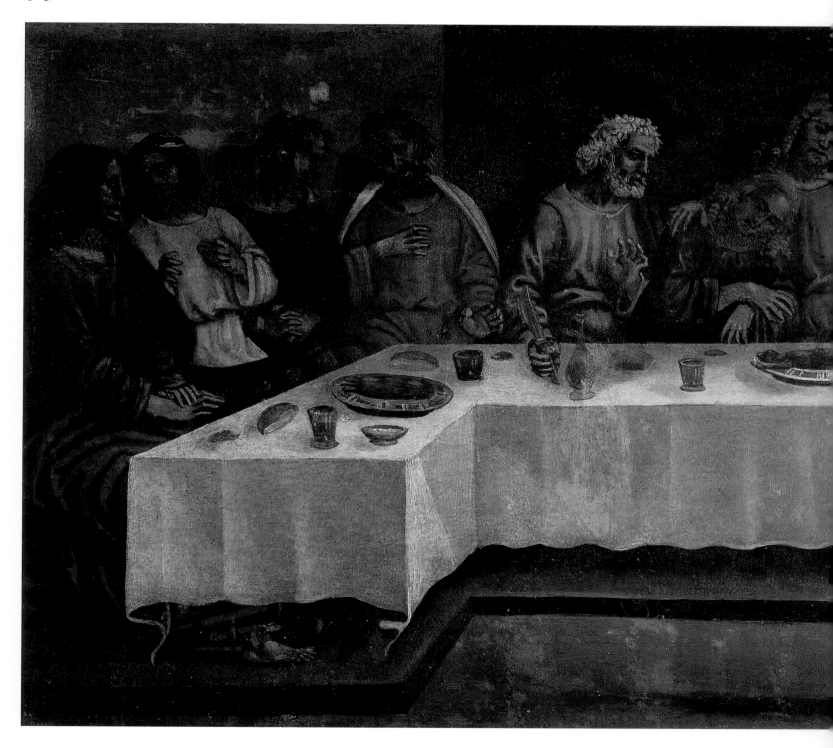

Luca Signorelli (ca. 1450–1523). *The Last Supper*. First panel of the predella of the altarpiece of the Trinity, Virgin and Child, Archangels, and Saints. 1500–1508. Oil on wood. Dimensions of entire predella: 12 ⅞ x 80 ½ in. (32.5 x 204.5 cm).

Artists have been most inspired by the dramatic effect of Christ's declaration that one of his trusted intimates would betray him. But it was also at the seder, the Passover meal celebrated by Jesus and his disciples, that Christ instituted the sacrament of the Eucharist, which would prove a point of fierce contention in the gathering schism.

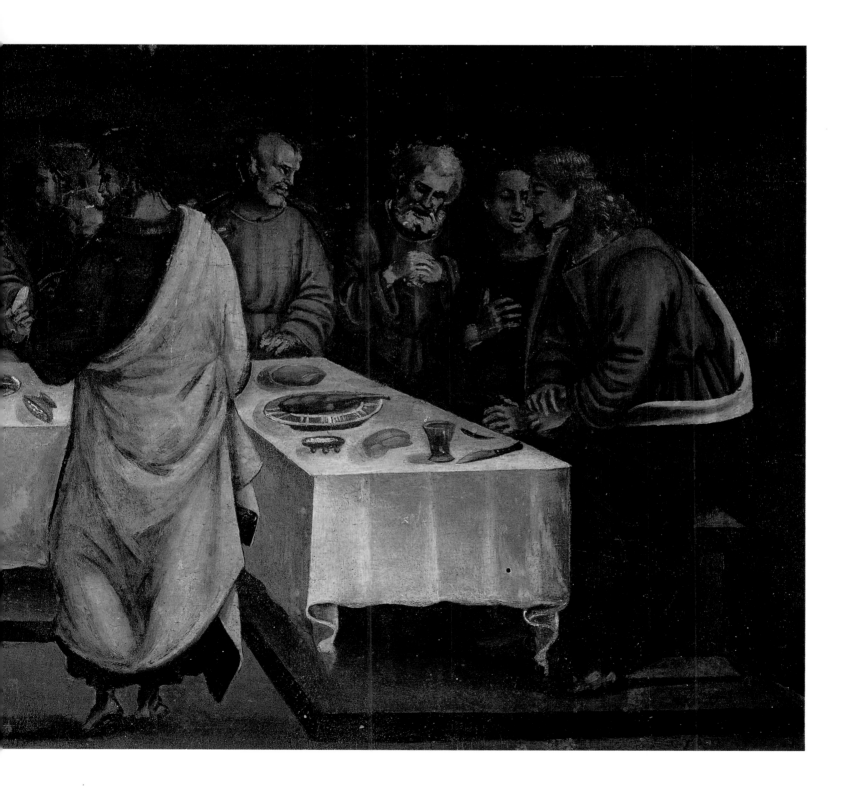

Luca Signorelli (ca. 1450–1523). *The Agony in the Garden*. Second panel of the predella of the altarpiece of *The Trinity, Virgin and Child, Archangels, and Saints*. 1500–1508. Oil on wood. Dimensions of entire predella: 12 ⅞ x 80 ½ in. (32.5 x 204.5 cm).

Here, after the Last Supper, Christ literally faces what lies ahead, ultimately accepting the "cup" proffered by an angel. When the predella was in place below its altarpiece, a single axis aligned the Trinity, the surrendering Christ in the predella, and the Host on the altar below, a visual statement of the Roman Catholic Credo.

BELOW

Luca Signorelli (ca. 1450–1523). *The Flagellation*. Third panel of the predella of the altarpiece of *The Trinity, Virgin and Child, Archangels, and Saints*. 1500–1508. Oil on wood. Dimensions of entire predella: 12 ⅞ x 80 ½ in. (32.5 x 204.5 cm).

Signorelli was famous for his handling of human anatomy. Here, the tormentors' naked contortions dreadfully emphasize the intensity of their exertions, and Christ's serenity and physical grace. Pilate, on the right, ordered the flagellation to appease the Pharisees, on the left. The cords and column are two symbols of the Passion.

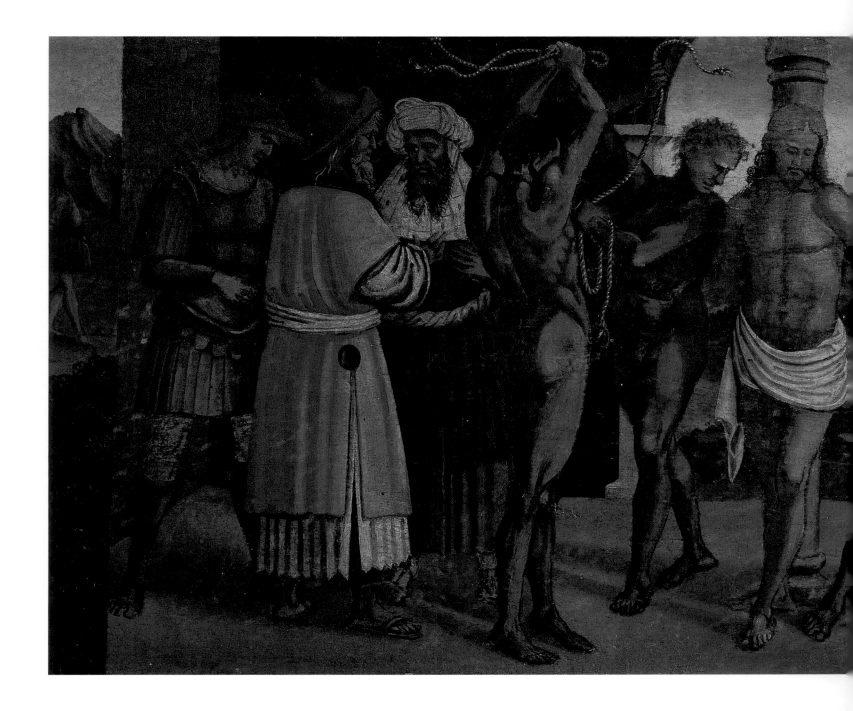

ABOVE

ABOVE

Benozzo Gozzoli (1420–97). *Predella with the Marriage of Saint Catherine, the Pietà, and Saints Anthony Abbot and Benedict.* Ca. 1459. Tempera on wood. 9 ⅞ x 88 in. (25 x 224 cm).

The saints in the side panels of this predella were all members of religious orders. In the first panel, the Christ Child places a ring on the finger of Saint Catherine, who was canonized in 1461; this is the Mystic Marriage she experienced in a vision. On the right are Anthony Abbot, the first Christian monk, and Benedict, the founder of European monasticism.

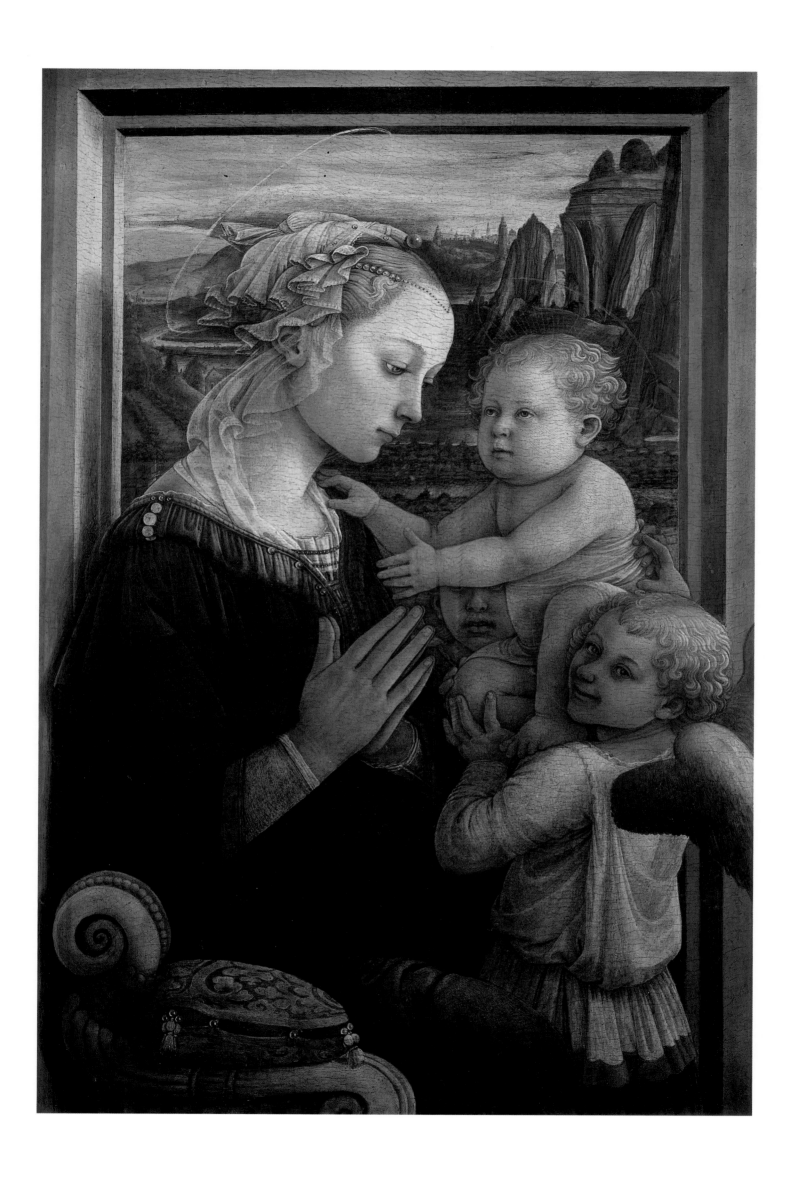

Fra Filippo Lippi (ca. 1406–69).
Madonna with Child and Angels.
Ca. 1465–67. Tempera on wood.
36 ⅝ x 24 ⅝ in. (93 x 62.5 cm).

Mary, dressed and coiffed like the
noblewoman the mother of Christ
would have to be—and like the
descendant of David she is—
contemplates the mystery of the
Incarnation. As her son reaches for
her, his gaze reaches toward
another realm. The angel who
holds him may be smiling with joy
at the future Redemption.

Hans Memling (1435–94).
Mater Dolorosa. 1480s. Oil on
wood. 21 ⅝ x 13 in. (55 x 33 cm).

The sorrowful mother's gaze seems
to travel back as far as the
Annunciation, but not yet forward
to the Resurrection. Her contained,
bottomless grief is both swaddled
and accentuated by her crisp white
linen. Scholars hypothesize that
this panel was half of a diptych,
the other half being a Man of
Sorrows— Christ crowned
with Thorns.

Andrea del Castagno (1417/19–57). *Queen Esther.* Ca. 1448. Fresco. 47 ¼ x 59 in. (120 x 159 cm).

Andrea was a sought-after fresco painter, who decorated the loggia of a villa outside Florence with a series of history portraits, *Illustrious Men and Women.* Esther was the biblical heroine whose courageous intervention on behalf of the Jews is celebrated by the feast of Purim. In 1851, the large frescoes were transferred to canvas and acquired by the nation of Italy.

Andrea del Castagno (1417/19–57). *Queen Tomyris.* Ca. 1448. Fresco. 96 ½ x 61 in. (245 x 155 cm).

This imaginary portrait is from the fresco cycle *Illustrious Men and Women.* The armor suggests that this is the warrior queen who, according to the Greek historian Herodotus, defeated Cyrus the Great. Scholars are still puzzling out the program, or governing theme, of Andrea's series. Esther and Tomyris appear in a Renaissance literary work, *On the Strength of Women.*

...RA VINDICAVIT SE DEFILIŌ ETPATRIAM LIBERAVIT SVAM

Paolo Uccello (1397–1475). *The Battle of San Romano*. 1456? Tempera on wood. 72 ⅞ x 86 ⅝ in. (185 x 220 cm).

This lively, noisy painting asks the viewer to participate by imagining the silver-painted armor in its original shining state. Even more than other Early Renaissance artists, Uccello was obsessed with perspective, here visible in various foreshortenings, although his poetic palette—blue horses, for example—belongs to an earlier age.

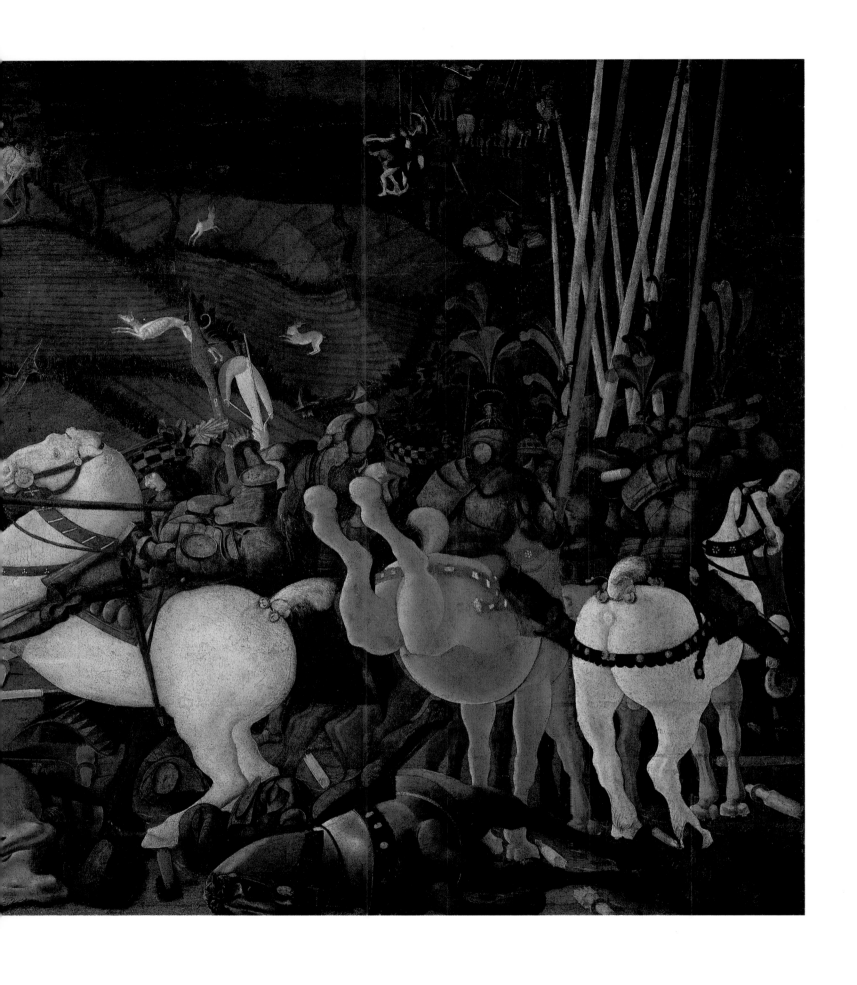

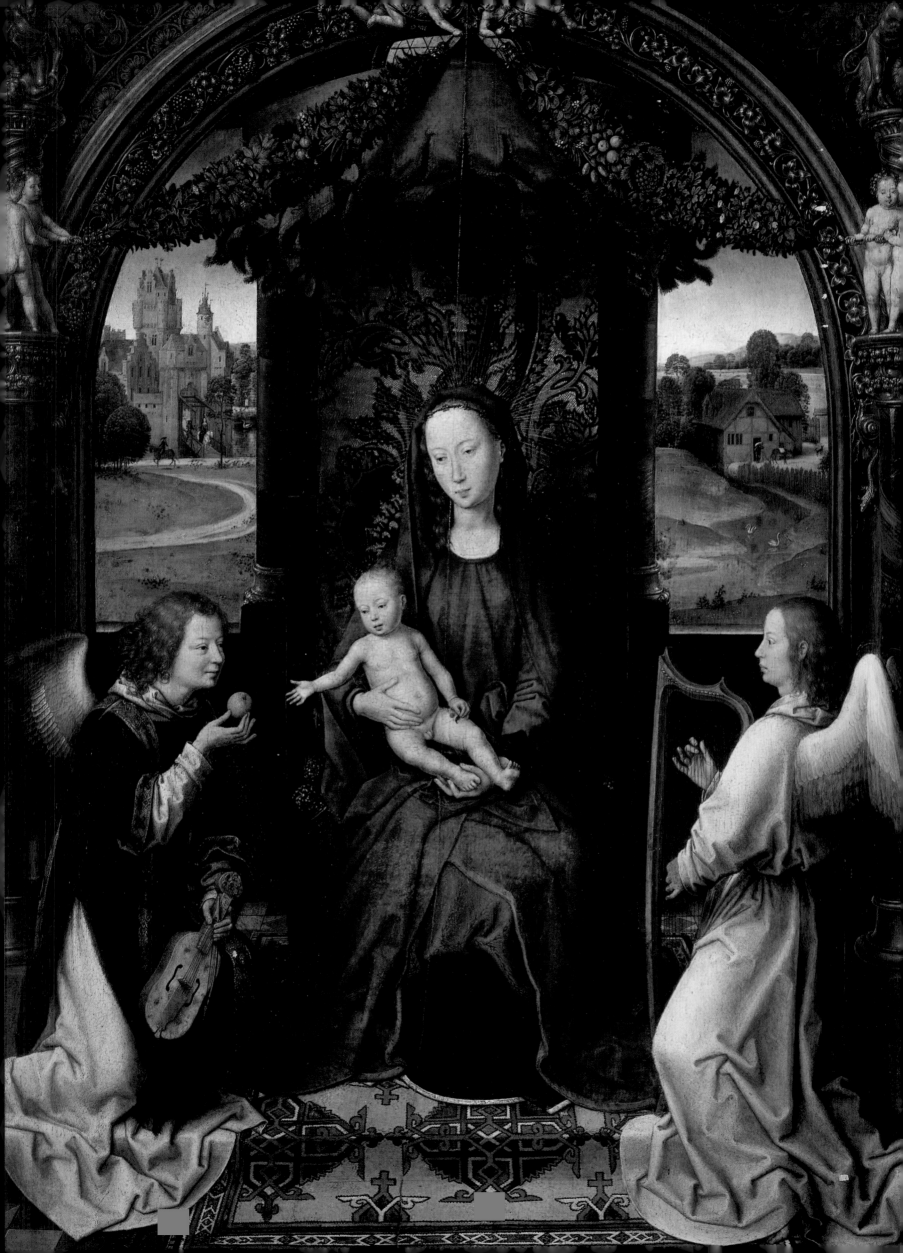

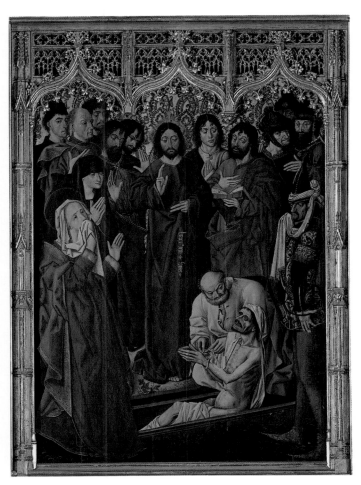
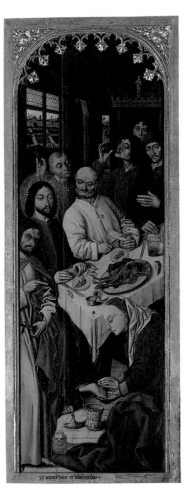

Hans Memling (1435–94). *Madonna with Child and Two Angels*. Ca. 1480. Oil on wood. 22 ½ x 16 ½ in. (57 x 42 cm).

A feeling of solemnity characterizes this intensely colored painting, but the music-making angels suggest celebration, too. The panel's small size suggests that it was made for private devotion, perhaps commissioned by one of the inhabitants of the northern European castle in the background. The angel on Mary's right, more richly garbed than the other, may be an archangel.

ABOVE

Nicolas Froment (ca. 1435–ca. 1483). *Resurrection of Lazarus*. 1461. Tempera on wood. 68 ⅞ x 78 ¾ in. (175 x 200 cm).

As the Medici commercial empire expanded into northern Europe, so did their art collections. Nicholas Froment was a key in the introduction of Flemish currents into French art. The resulting style was angular, awkward, and emotionally raw. In the central panel, alongside gestures of amazement, a woman covers her nose, speaking volumes about just how dead Lazarus was.

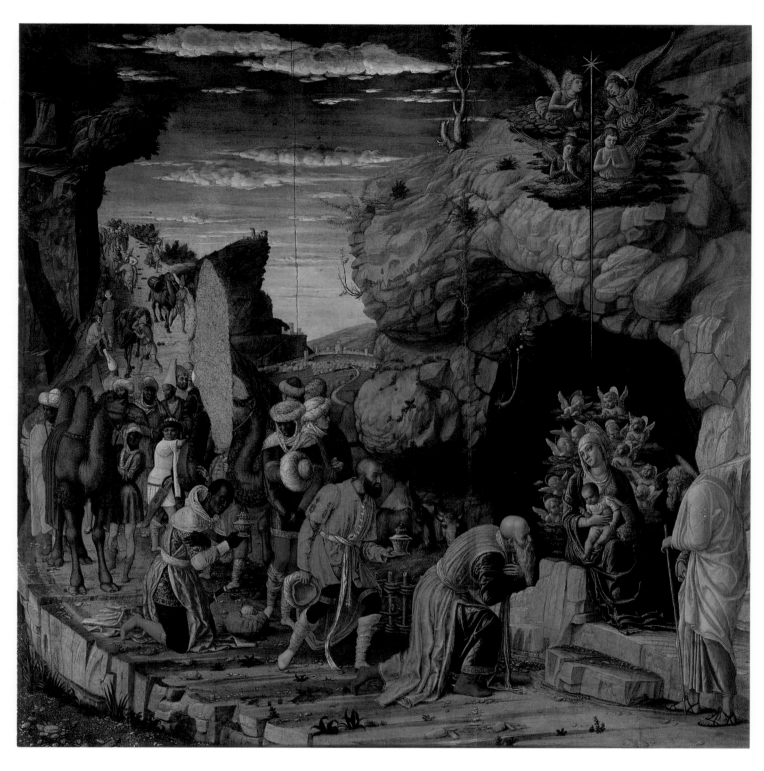

Andrea Mantegna (1431–1506). *The Adoration of the Magi* (central panel). Ca. 1464–66.
Tempera on wood. 33 ⅞ x 63 ½ in. (86 x 161.5 cm) (entire triptych).

From Africa and Asia—every known continent—the powerful come to make obeisance to the child. Even Joseph is outside the mystical space of the cave, which foreshadows the tomb into which the crucified Christ will be laid. The road, along with the exotic procession, leads out of the picture into the world of the viewer.

Roger van der Weyden (ca. 1399–1464). *The Deposition*. 1450. Oil on wood. 43 ⅝ x 37 ¾ in. (110 x 96 cm).

Beneath the three crosses, in the penumbra of the eclipse, Christ is laid on the Stone of Unction, which will also seal his tomb. His grieving mother stands at his right, while with her left hand Mary Magdalen reaches for her jar of precious unguent. Her right hand approaches Christ's feet. On Christ's left, is John and behind him are the elderly priest Nicodemus and the wealthy Joseph of Arimathea, who claimed Jesus' body.

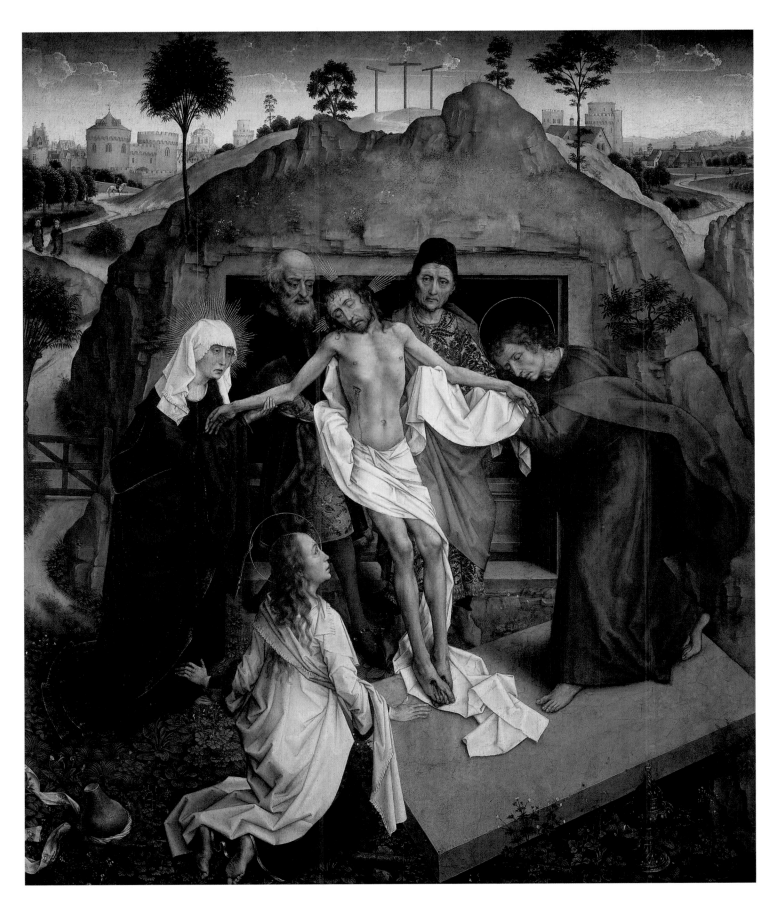

P. 88

Antonio Pollaiuolo (1431/32–98). *Hercules and the Hydra*. Ca. 1475. Tempera on wood.
6 ⅞ x 4 ¾ in. (17 x 12 cm).

As penance for slaughtering his family in a fit of madness, Hercules, the legendary founder of Florence, performed twelve daunting tasks. One was to kill the Hydra, a beast that sprouted two new heads for each one cut off. The small size of the panel would have allowed aficionados to pass it around and admire Pollaiuolo's depiction of the human body in movement.

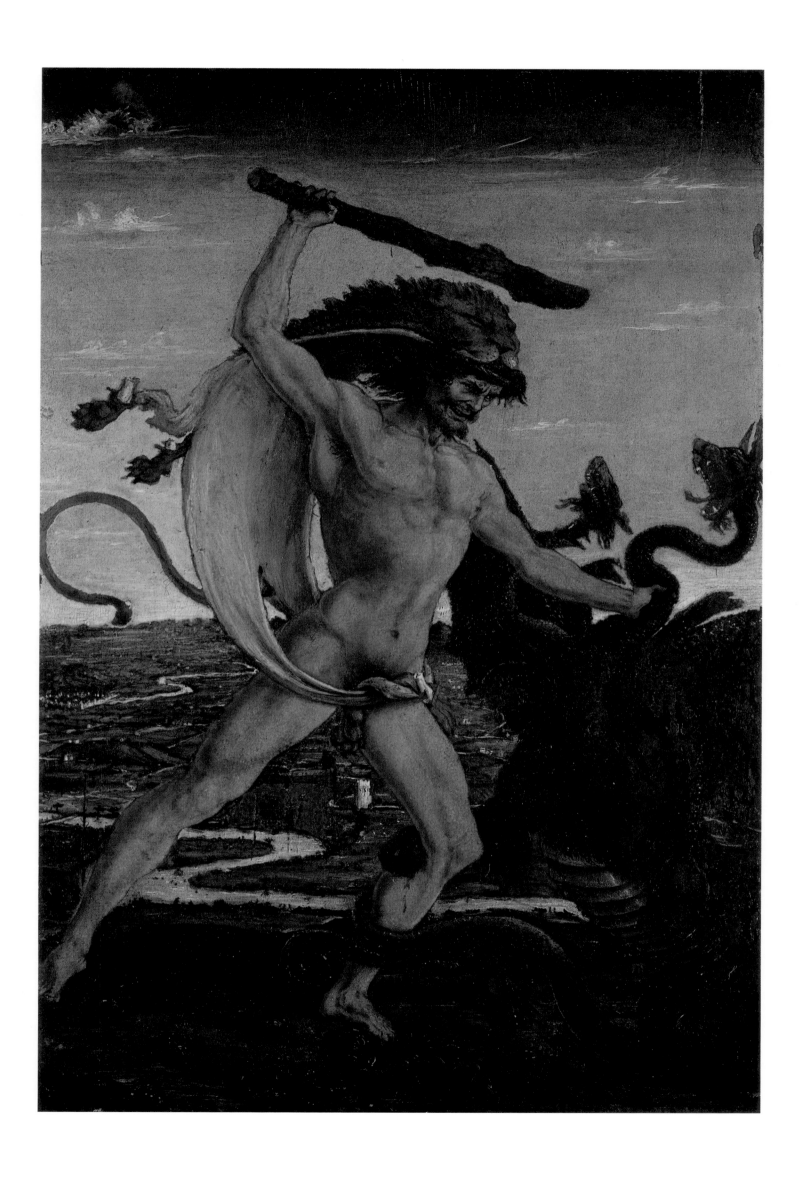

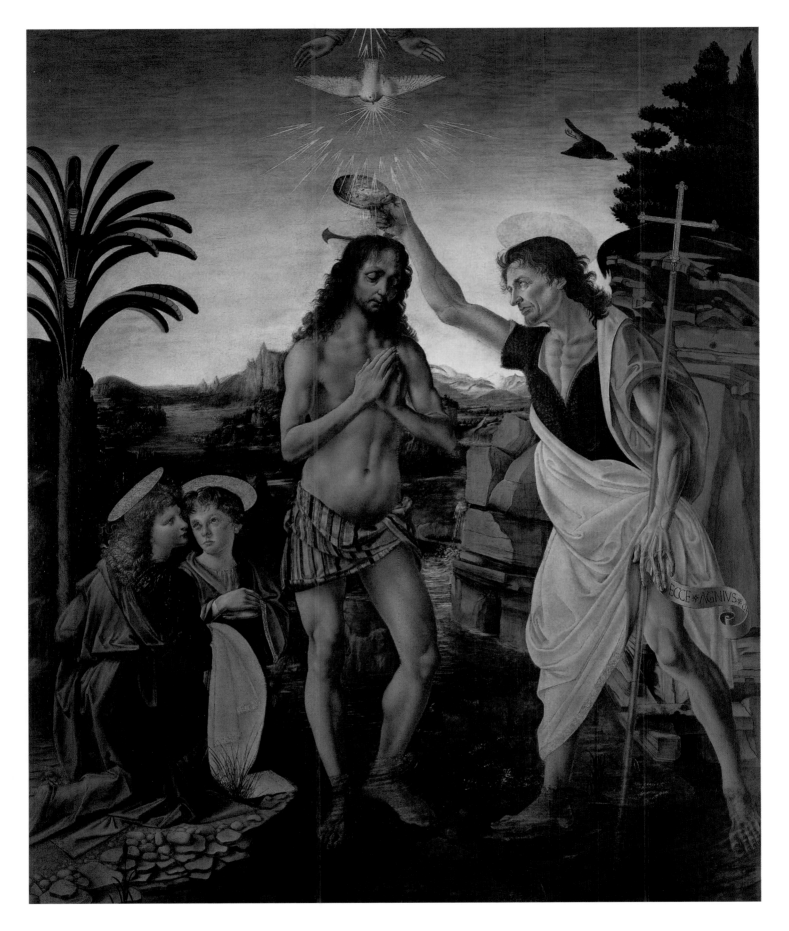

Andrea del Verrocchio (1435–88). *Baptism of Christ.* 1470–75. Tempera and oil on wood. 70 ⅞ x 59 ⅞ in. (180 x 152 cm).

One of the most fascinating aspects of this work is the variety of styles working within it. Leonardo's hand appears in the angel seen in profile. Unlike his fellows, who are each in a single plane, his body twists sinuously. The delicate contours and coloring of the angel's display the first hint of the *sfumato* that would revolutionize Italian art.

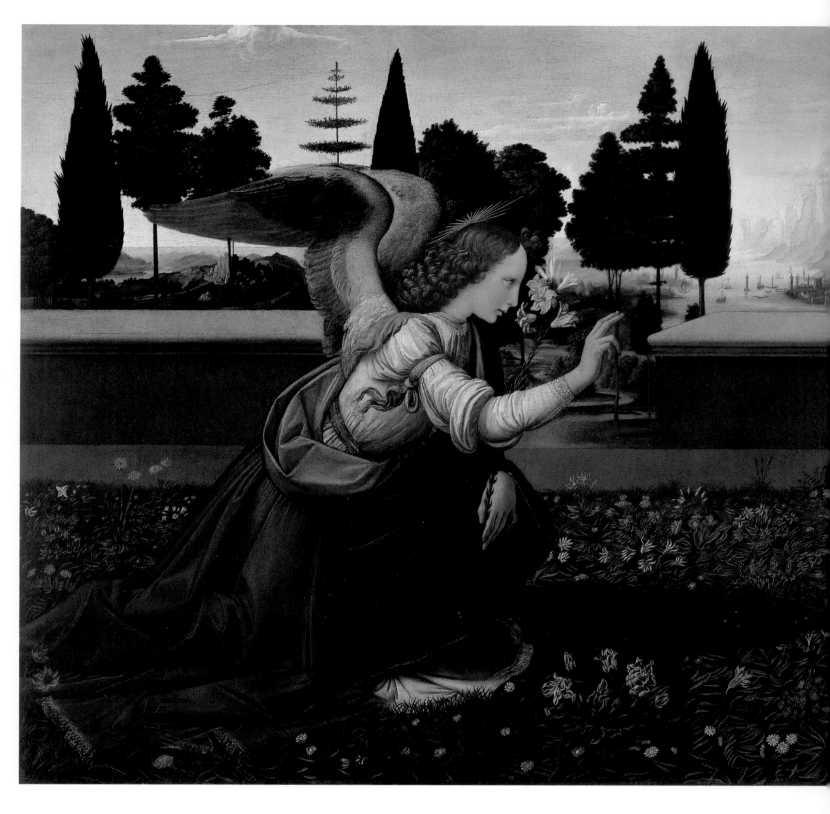

ABOVE

Leonardo da Vinci (1452–1519). *The Annunciation.* Ca. 1472. Oil on wood. 38 ⅝ x 85 ⅜ in. (98 x 217 cm).

Though there are scriptural references in this scene, Leonardo structured it so as to offer viewers an intuitive way into its layered message. For example, the angel is identified with nature, God's creation, and Mary with architecture, built by human hands. The angle of Mary's bookstand, which holds the Word of God, points to her lap, where the Word is being made God.

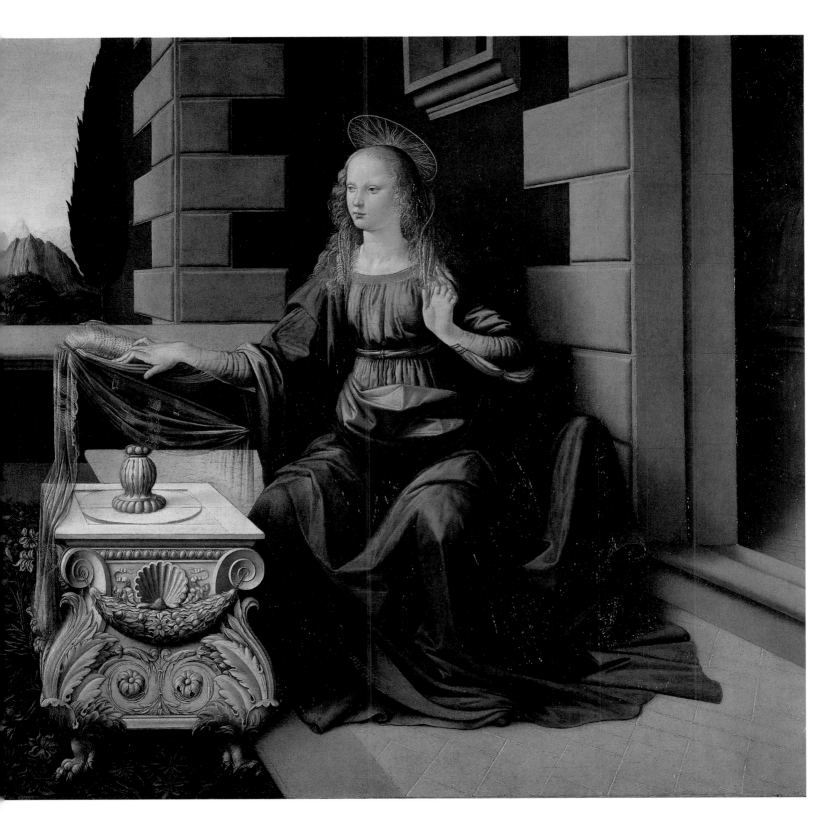

P. 92

Giovanni Bellini (ca. 1433–ca. 1516). *Sacred Allegory.* 1490–1500. Tempera on wood. 28 ¾ x 46 ⅞ in. (73 x 119 cm).

Giovanni Bellini constructed a visual enigma that continues to baffle. The enthroned Virgin and several of the saints gazing and praying at the child and the tree are identifiable. Two figures turn away from the sacred scene: on the left, a turbaned man—not an unusual sight in Bellini's native Venice—and in the middle distance, on the right, a centaur.

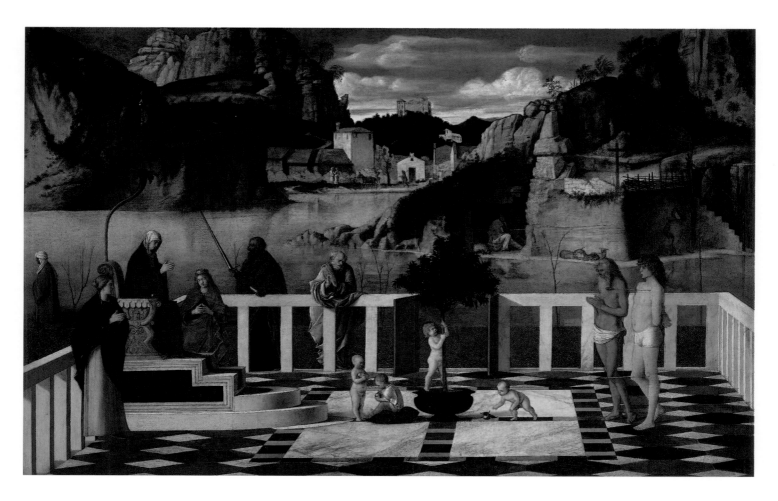

Cosmè Tura (1430–95). *Saint Dominic.* Ca. 1475. Tempera on wood. 20 x 12 ⅝ in. (51 x 32 cm).
The effortful, even anguished execution of the figure of the preacher-saint may express the nature of Dominic's spiritual journey to the surrender that informs his gaze and posture. Tura perhaps brought his skill as a miniaturist to the composition of this painting and to the figure's relationship to its framed space.

P. 94

Hugo van der Goes (ca. 1420–82). *The Portinari Altarpiece: Tommaso Portinari with His Two Sons in the Presence of Saints Anthony Abbot and Thomas* (left panel). Ca. 1475. Oil on wood. 99 ⅝ x 55 ½ in. (253 x 141 cm).

Thomas is identified by the lance he holds, referring to the wound in Christ's side into which the doubting saint placed his hand. He introduces the patron of the altarpiece, his namesake. Tommaso, an agent for the Medici office in Flanders, commissioned the painting from the gloomy Hugo van der Goes, who, after an unsuccessful suicide attempt, died of melancholy.

P. 95

Hugo van der Goes (ca. 1420–82). *The Portinari Altarpiece: Maria Portinari with Her Daughter in the Presence of Saints Margaret and Mary Magdalen* (right panel). Ca. 1475. Oil on wood. 99 ⅝ x 55 ½ in. (253 x 141 cm).

Their humility only relative, the women of the patron family are dressed in rich black, a difficult hue to achieve and maintain. Behind them, Margaret rests her foot on the dragon she defeated, while the penitent Mary Magdalen, the patroness's namesake, lifts her sumptuous brocade to reveal the more somber robe beneath. The women of the congregation were probably seated on the side of the church that would have allowed them an ample view of this panel.

Hugo van der Goes (ca. 1420–82). *The Portinari Altarpiece: The Adoration* (central panel). Ca. 1475. Oil on wood. 99 ⅝ x 119 ⅝ in. (253 x 304 cm).

When the altarpiece was in place, viewers would have followed the line connecting the Christ Child, the sheaf of wheat at the front of the painting, and the Eucharist— the bread of Communion—on the altar below. Northern European art, with its realistic rendering of faces and surfaces, would profoundly influence the more idealized style of Italian art.

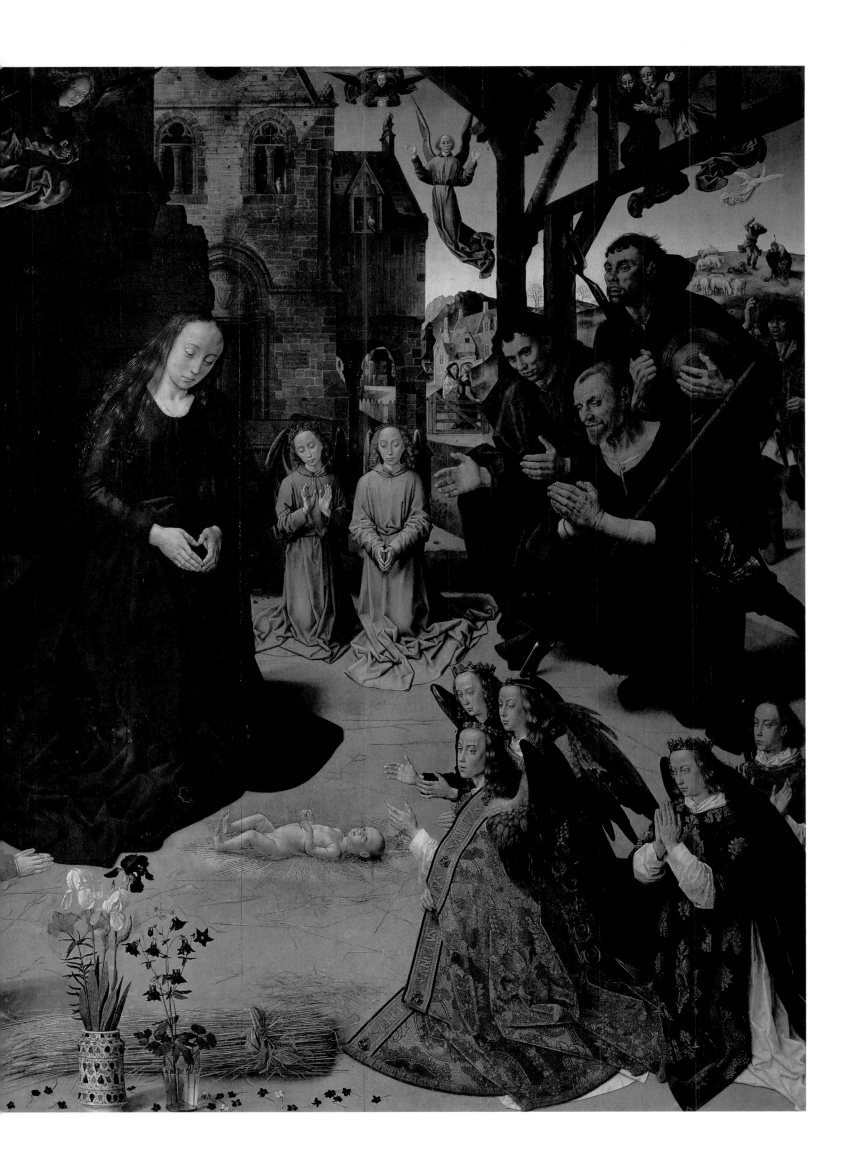

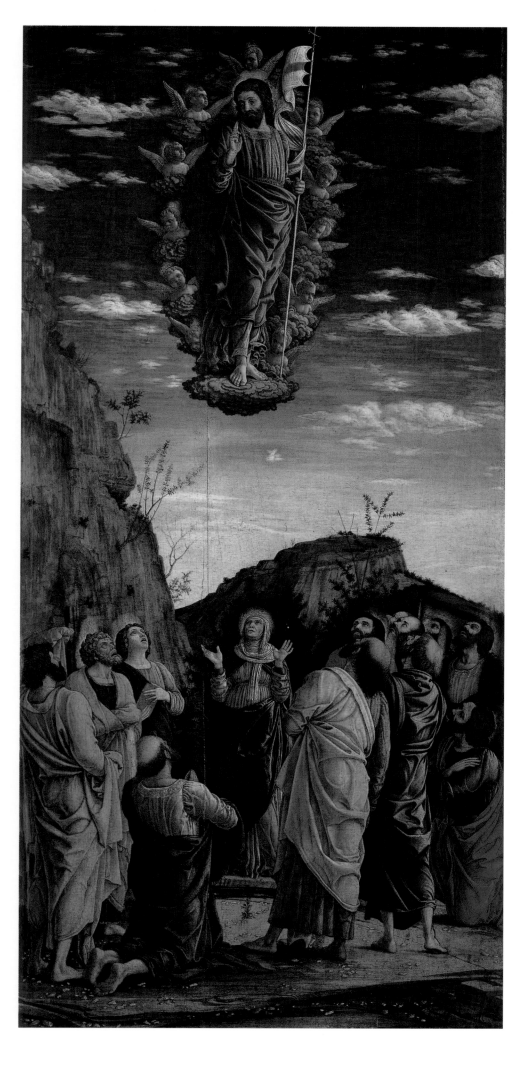

Andrea Mantegna (1431–1506). *Ascension of Christ.* Ca. 1463–70. Tempera on wood. 33 ⅞ x 63 ½ in. (86 x 161.5 cm) (overall dimension).

Mantegna captured a panoply of human emotion and faith on the faces of Mary and the disciples as Christ ascends into Heaven, bearing the standard of the Resurrection. Mantegna learned anatomy, exactness, and perspective from the sculptor Donatello. Here, he used them all in a work that turns perspective on its side—here, Christ is the vanishing point. This painting and Mantegna's *Circumcision* were not originaly composed as two panels of a triptych.

Andrea Mantegna (1431–1506). *Circumcision of Christ* (detail of right-hand side). Ca. 1463–70. Tempera on wood. 33 ⅞ x 63 ½ in. (86 x 161.5 cm) (overall dimension).

Mother and child console each other in a temple depicted as an ornate Renaissance palazzo. In the lunettes above are the Sacrifice of Isaac and Moses with a single Tablet of the Law. The Circumcision, the first shedding of Christ's blood, prefigured the Crucifixion, but was debated since Saint Augustine had declared that Christ the man was "perfect in all his parts."

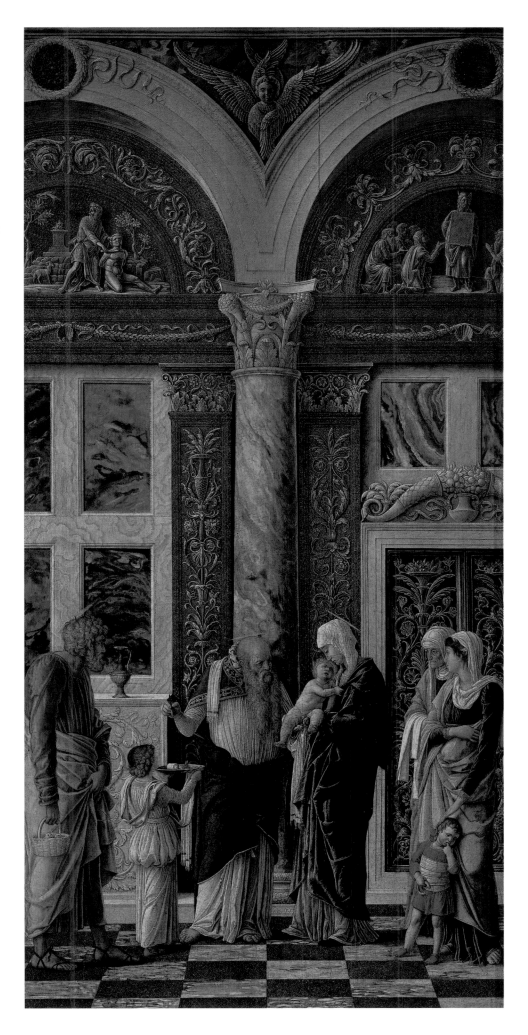

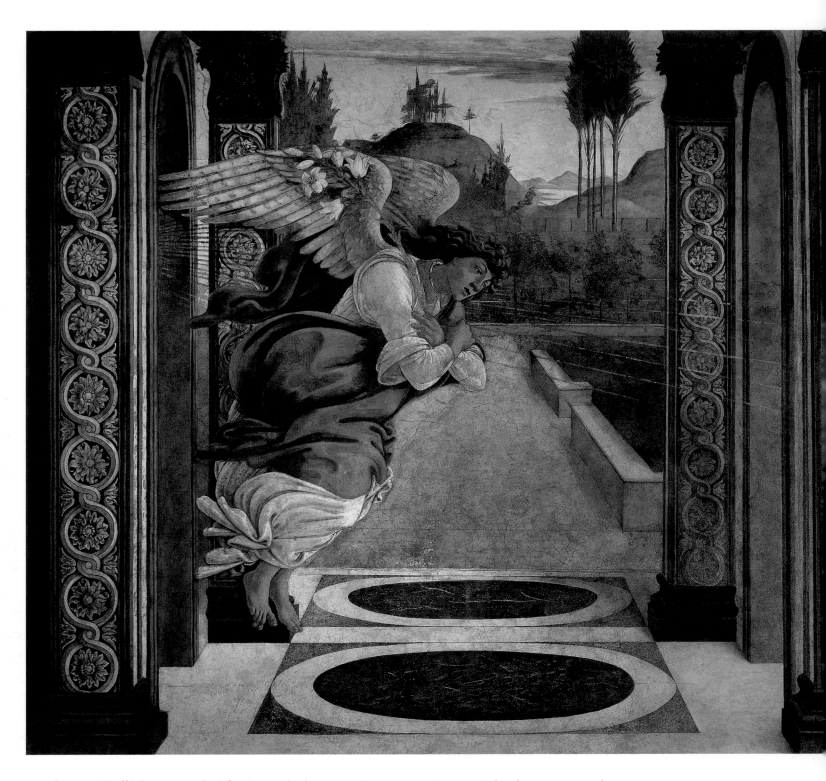

Sandro Botticelli (1445–1510). *The Annuciation.* 1481. Fresco. 95 ⅝ x 216 ½ in. (243 x 550 cm).

This intimate scene opens to cosmic time. The angel bows to the mother of the Redeemer and to the miracle of the Incarnation, and an informed Mary surrenders to the divine will. A dynamic perspective points to the culmination of the present event: the Crucifixion. Under Savonarola's influence, Botticelli would abandon grace notes like the hem of Gabriel's robe.

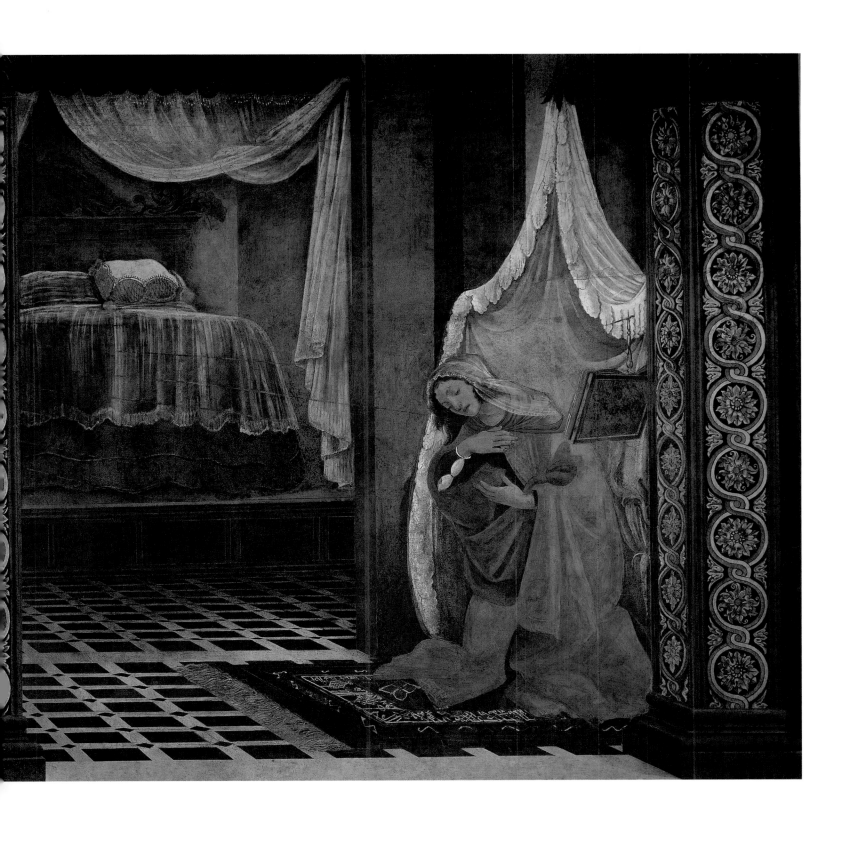

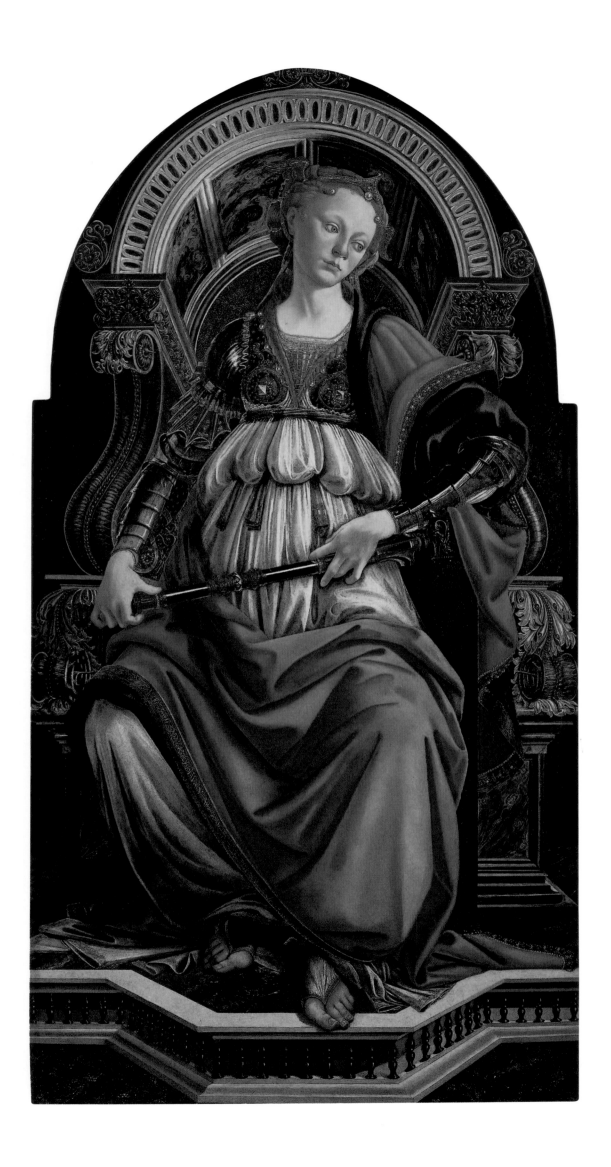

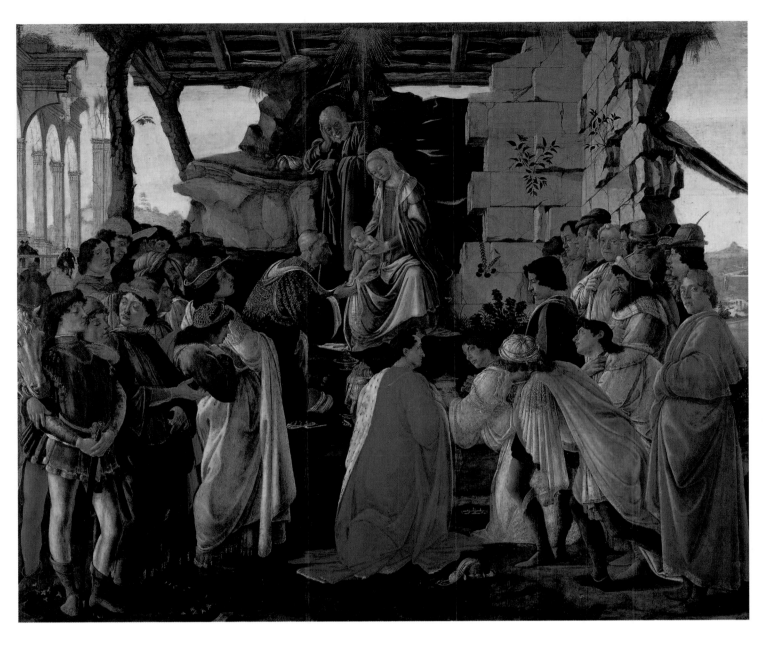

Sandro Botticelli (1445–1510). *Fortitude.* 1470. Tempera on wood. 65 ¾ x 34 ½ in. (167 x 87 cm).

This impressive painting was Botticelli's earliest secular work. The figure already displays the graceful pose and confident, yet sinuous draftsmanship that would be the painter's hallmarks. Botticelli did not work on the rest of the series of allegorical works, due to the protestations of the Pollaiolo brothers, who were originally commissioned to do the series.

Sandro Botticelli (1445–1510). *The Adoration of the Magi.* Ca. 1475. Tempera on wood. 43 ¾ x 52 ¾ in. (111 x 134 cm).

Amid the ruins of the old order, the Magi pay their respects to the newborn King. The elder magus is the late Cosimo the Elder, while the red-robed figure on the left is an idealized portrait of his grandson Lorenzo the Magnificent. The blond man on the right swathed in yellow and looking out at the viewer is Botticelli himself.

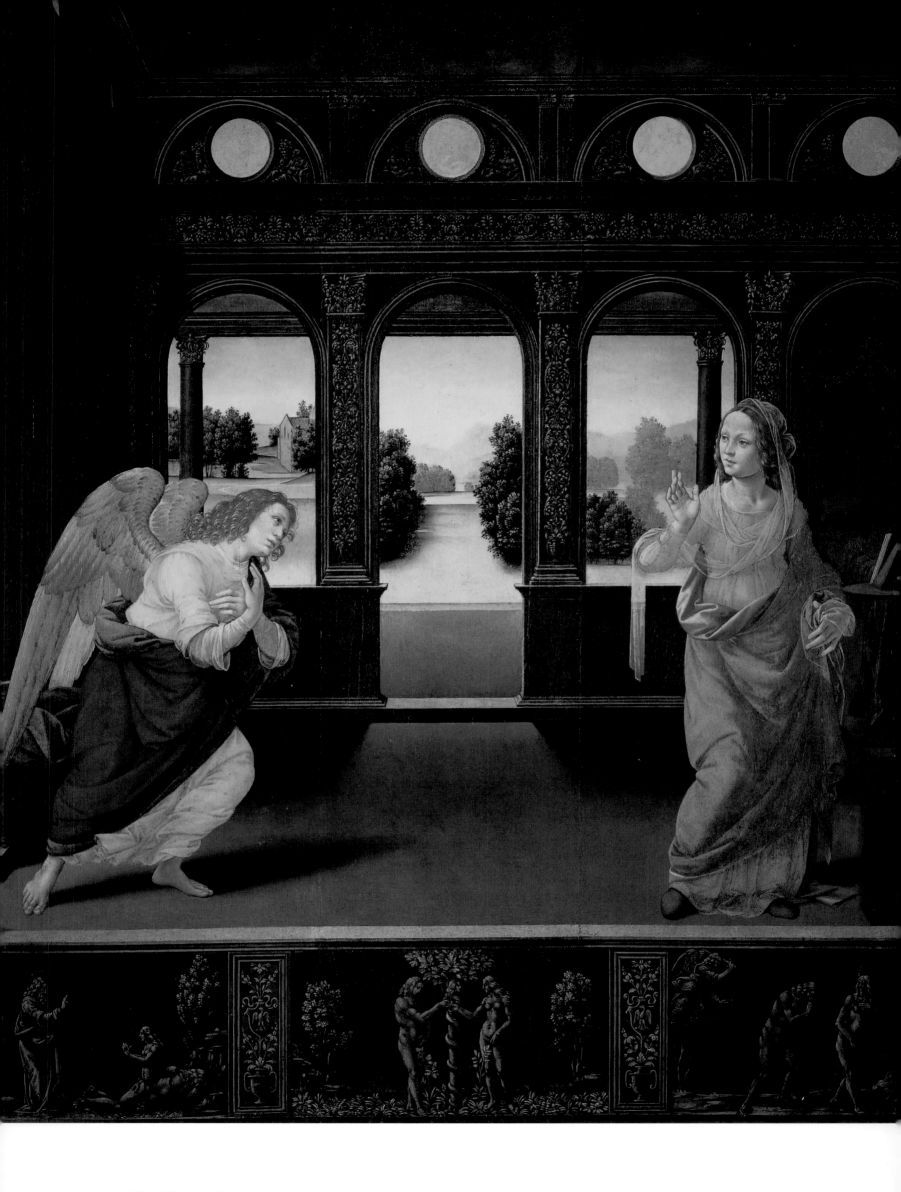

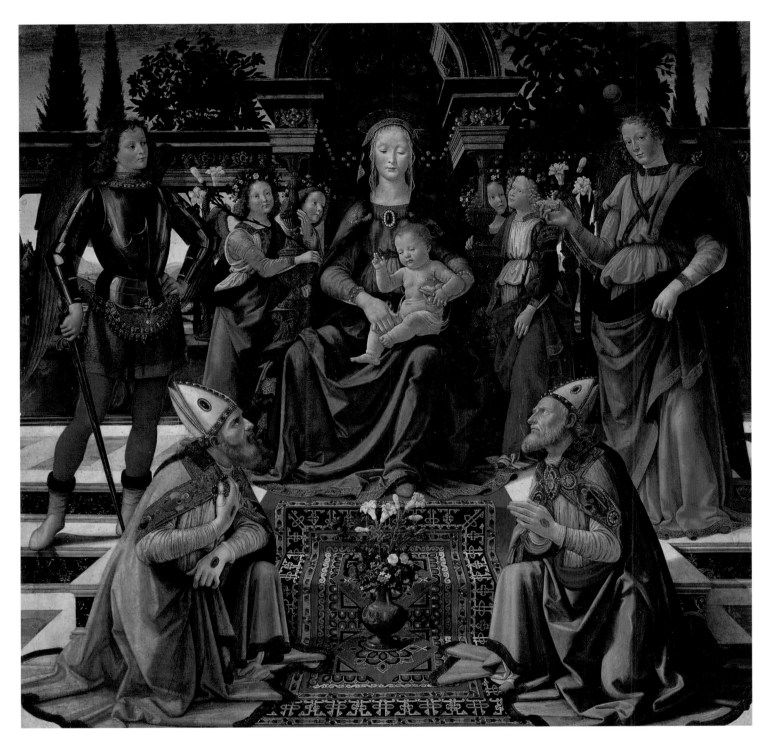

OPPOSITE

Lorenzo di Credi (1459–1537). *The Annunciation.* Early 1480s. Tempera on wood. 34 ⅝ x 28 in. (88 x 71 cm).

Her gesture seems to signify a sudden awareness of the angel's speech; Mary hears, but does not see Gabriel. Although the iconography of the Annunciation has been streamlined, Lorenzo painted openings everywhere. The Virgin is a young girl—even the pale blue of her dress is youthful. The fateful book that prophesies her future son's destiny is in the shadows.

ABOVE

Domenico Ghirlandaio (1449–94). *Madonna and Child with Angels and Saints.* Ca. 1484–86. Tempera on wood. 74 ⅞ x 78 ¾ in. (190 x 200 cm).

Mary and the Child are flanked by the archangels Michael and Gabriel. At her feet, by a resplendent Turkish carpet, kneel two bishop-saints. The Christ Child looks directly at the prelate on the left, who responds with a humble "Who, me?" gesture, so he is probably Justus, for whose church the altarpiece was made. On the right, then, is the famously long-lived Zenobius.

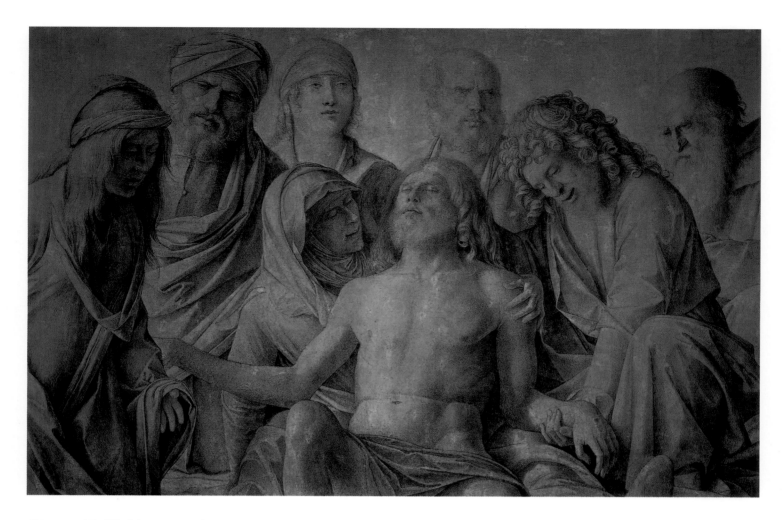

Giovanni Bellini (1430–1516). *Lamentation over the Dead Christ.* Ca. 1500. Drawing on wood. 29 ⅛ x 46 ½ in. (74 x 118 cm).

His friends surround the dead Christ. Mary holds her son on the lap that bore him, while John, the beloved disciple, contemplates the dreadful wound left by a nail. On the left, the disheveled and distraught Mary Magdalen stands helplessly by. The Bellini family was known for their draftsmanship—a precious legacy was a book of drawings handed down through the generations.

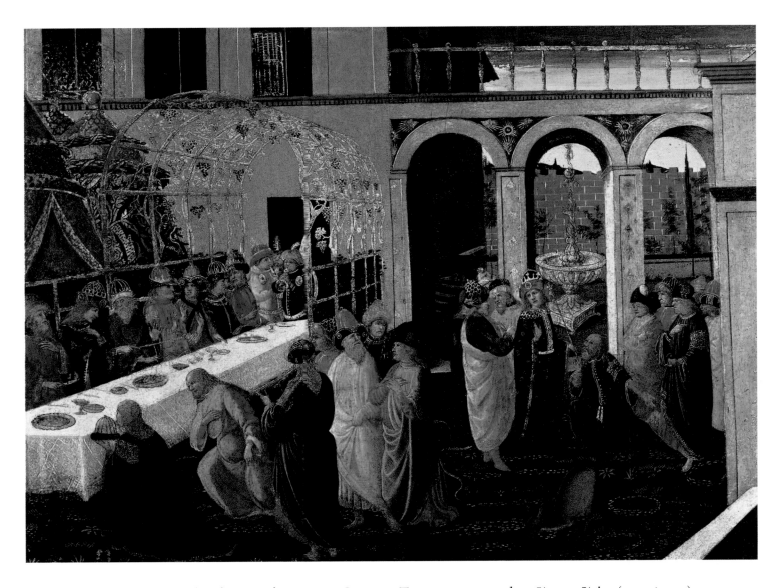

Jacopo del Sellaio (1442–93). *Ahasuerus's Banquet*. Ca. 1490. Tempera on wood. 17 ⅞ x 24 ⅞ in. (45 x 63 cm).

This is one of three panels of the Stories of Esther painted for a *cassone*, a chest often given as a wedding present. A cassone customarily featured tales of female heroines. The deep colors, fine details, and gilding all indicate that it was part of the furnishing of a wealthy home.

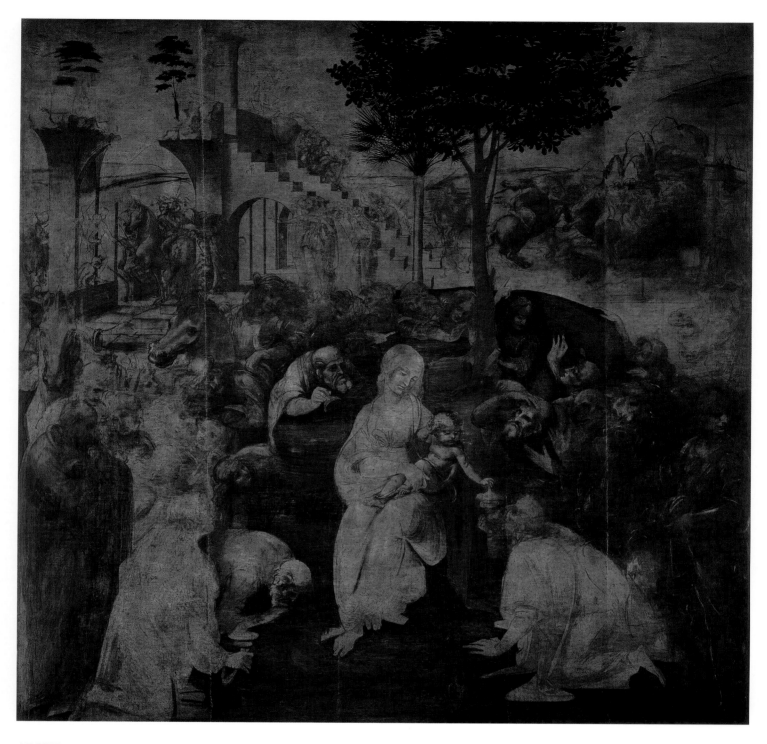

Leonardo da Vinci (1452–1519). *The Adoration of the Magi.* Unfinished. 1482. Tempera mixed with oil on wood. 95 ⅝ x 96 ⅞ in. (243 x 246 cm).

This unfinished painting reveals Leonardo's careful underdrawing. The Virgin and the Magi form an equilateral triangle, a geometric form of great stability, as the world nears them. The narrative is unclear, but recently scholars have noted that the ruined building in the background is being restored. The artist left the work and Florence to work for Lodovico Sforza, ruler of Milan.

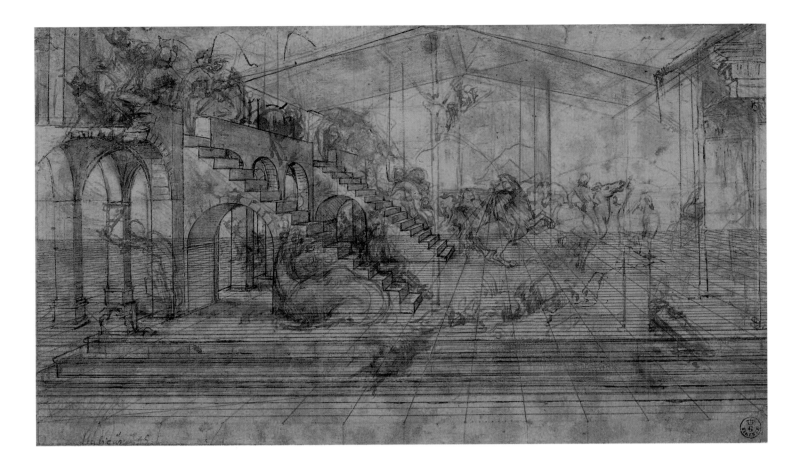

Leonardo da Vinci (1452–1519). *Architectural Study for the Background of the Adoration of the Magi.* Ca. 1480? Gabinetto dei Disegni edelle Stampe.

This drawing, in the Uffizi's Gabinetto Disegni e Stampe, demonstrates how carefully artists worked out the mathematics of single-point perspective. Leonardo received the commission for the painting in March 1480, and immediately began the preparatory drawings. This one is very close to the (unfinished) painting, so it is late in the process, though the central figures have not been sketched in.

Sandro Botticelli (1445–1510). *La Primavera (Springtime).* Ca. 1481. Tempera on wood. 79 ⅞ x 123 ⅝ in. (203 x 314 cm).

This panel once hung over a Medici bed, in order to assure that the children conceived beneath it would be beautiful. It also illustrates certain Neo-Platonic tenets, which pitted the spiritual—represented by the three dancing graces—versus the sensual—symbolized by Zephyr, the seductive breeze of spring. On the left, Mercury points to the higher realms to which human love can rise.

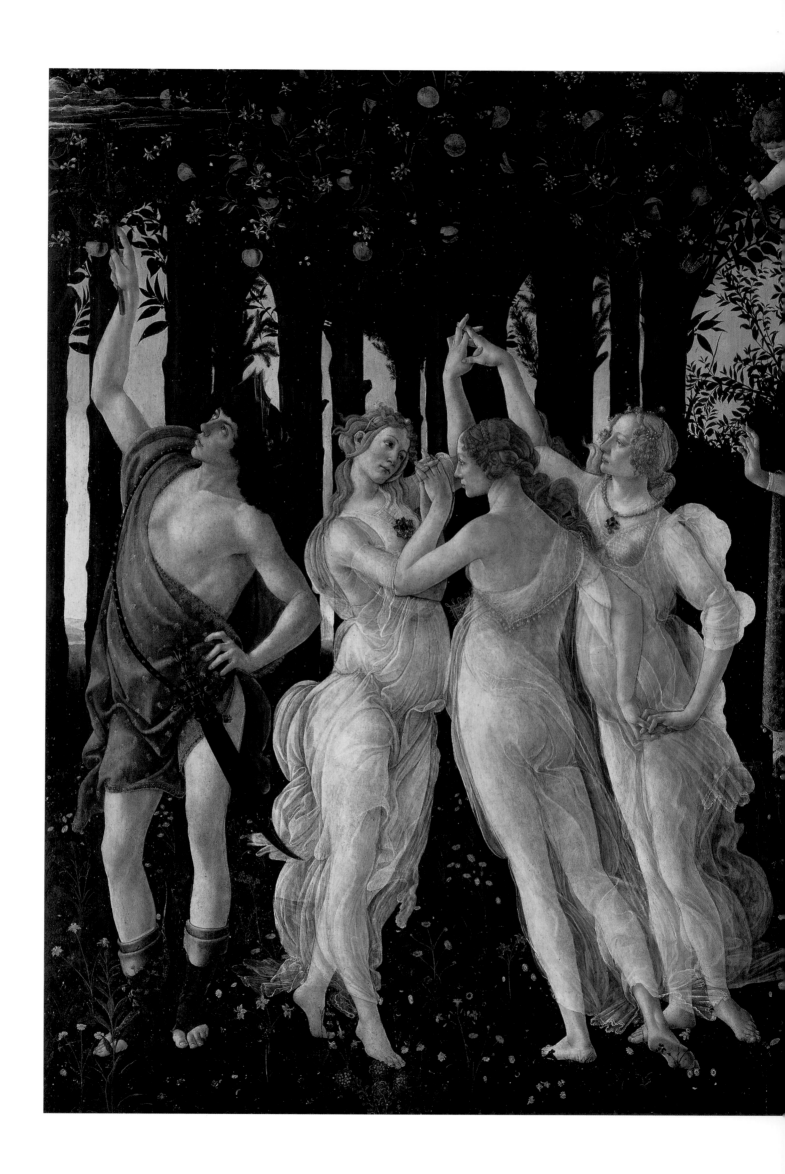

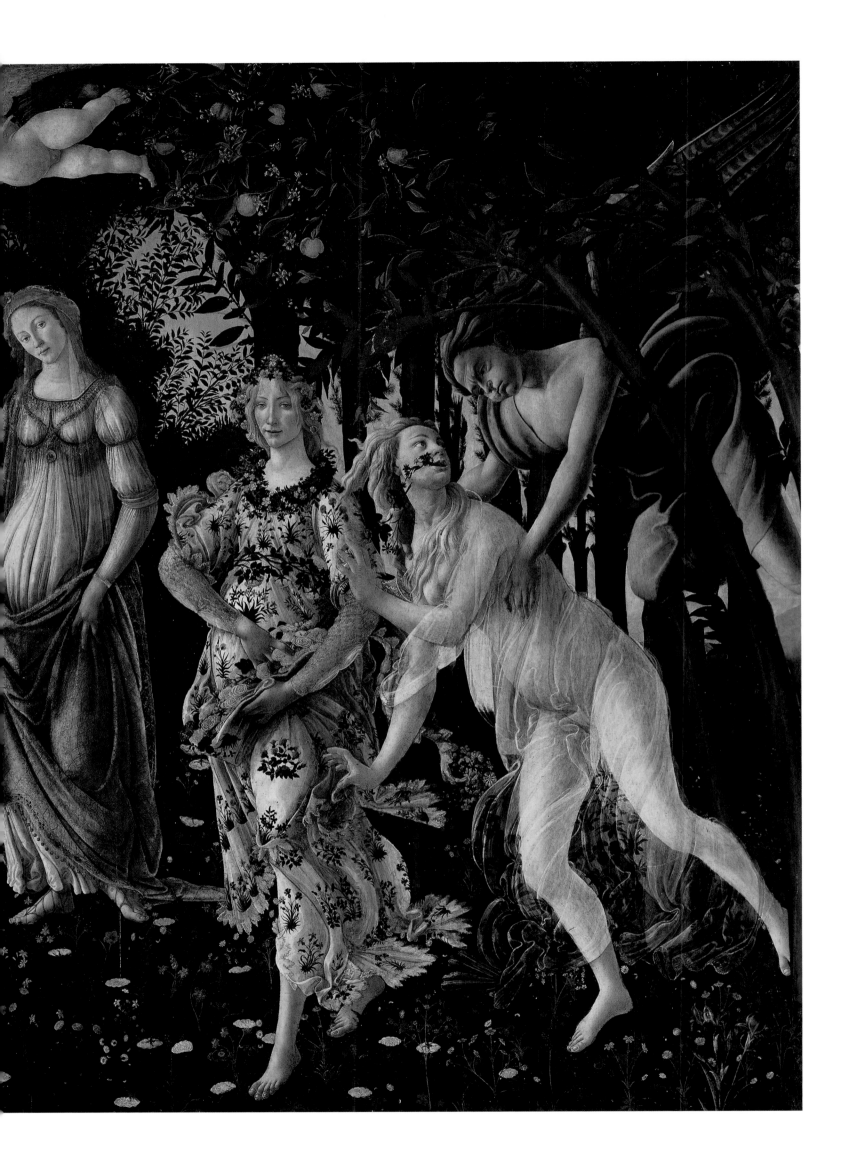

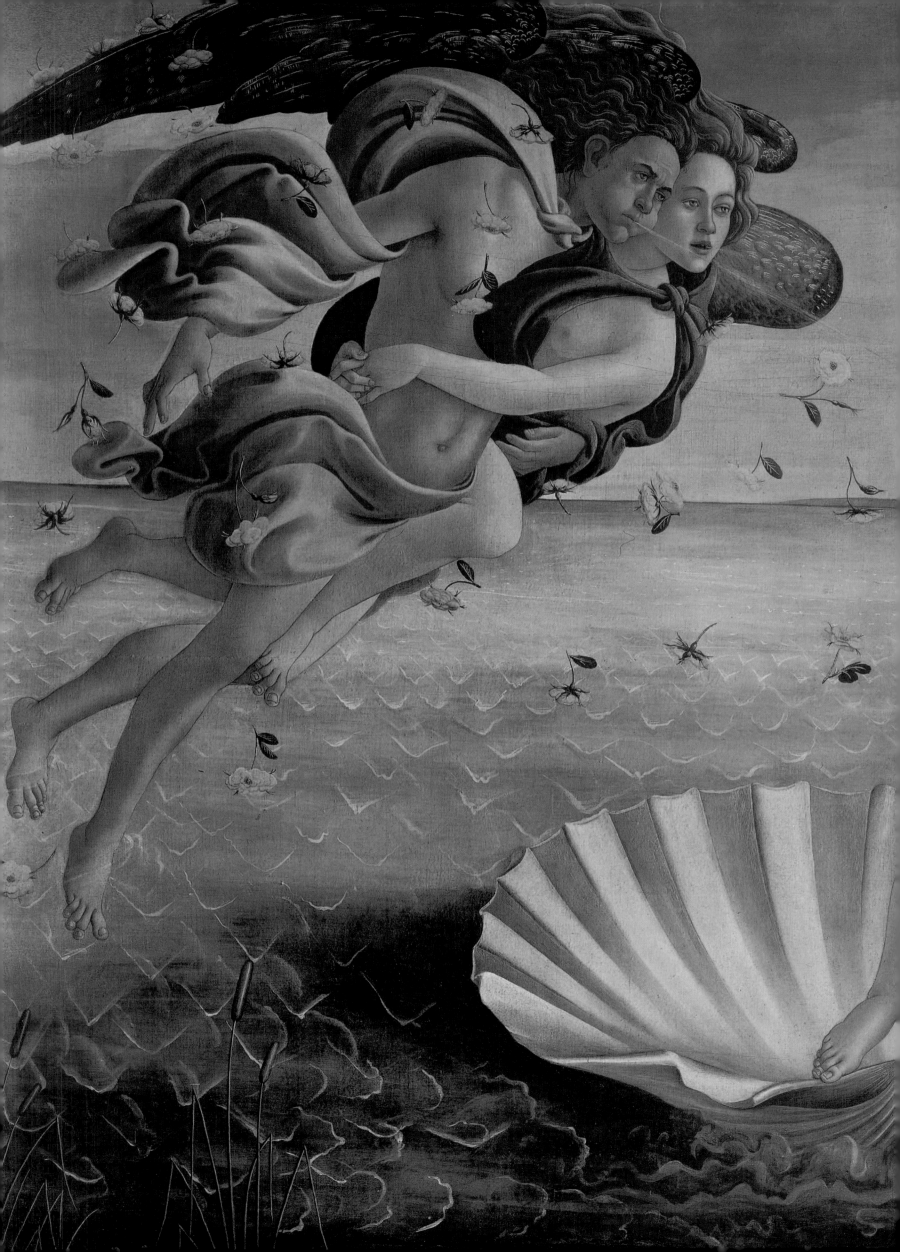

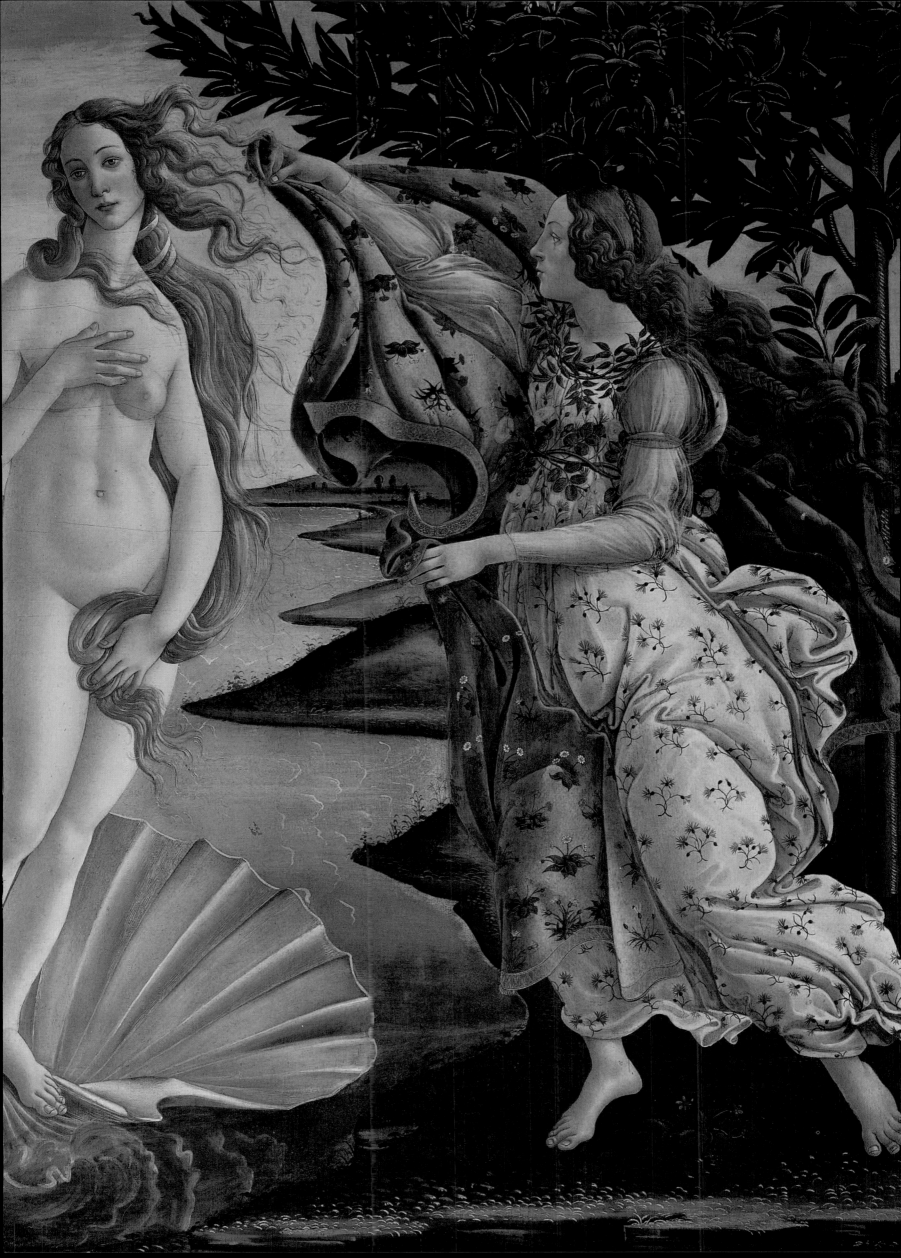

PP. 112–113

Sandro Botticelli (1445–1510).
The Birth of Venus. Ca. 1484.
Tempera on canvas. 68 x 109 ⅝ in.
(172.5 x 278.5 cm).

Collaborating with patrons who
enjoyed literary allusions, Botticelli
took the subject of this exquisite
composition from Ovid's charming
epic poem *Metamorphoses,* as well
as from Pliny's description of a
painting by the celebrated Apelles.
Leonardo warned darkly that
artists who did not make a practice
of copying nature's variety ended
up forever painting themselves—
like Botticelli.

RIGHT

Sandro Botticelli (1445–1510).
*Madonna and Child Enthroned
with Two Angels and Saints.* (Left to
right: Catherine, Augustine,
Barnaby, John the Baptist, Ignatius,
and Michael.) Before 1470.
Tempera on wood. 66 ⅞ x 76 ⅜ in.
(170 x 194 cm).

This *Sacra Conversazione* is set in
an opulent Renaissance interior,
which two of the angels are still
decorating. The other two hold up
the Crown of Thorns and the three
nails, instruments of Christ's
future Passion. The large altarpiece
was commissioned by the Guild of
Doctors and Apothecaries, which
was also the painters' guild, since
all three professions required
preparing mineral and vegetal
substances.

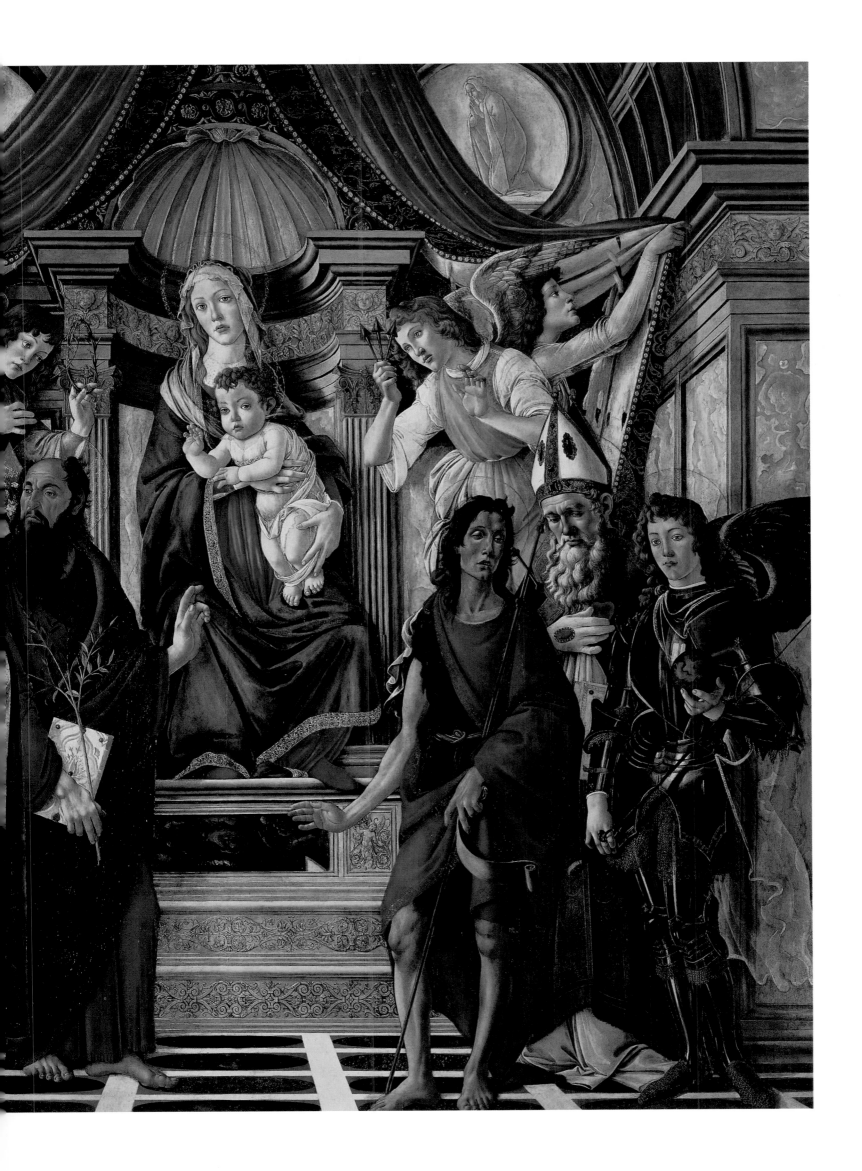

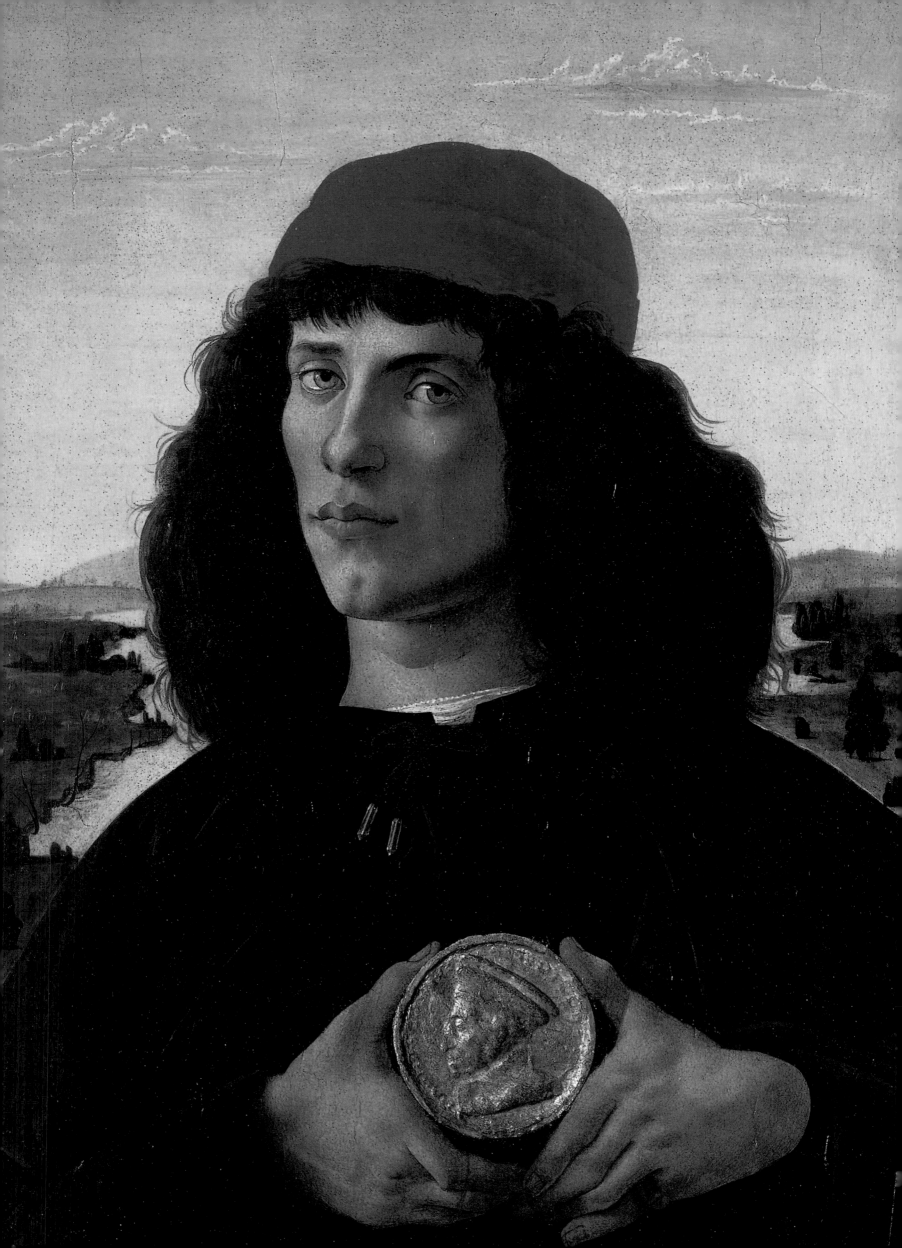

Sandro Botticelli (1445–1510). *Portrait of a Man with The Medallion of Cosimo the Elder.* Ca. 1475. Tempera on wood. 22 ⅝ x 17 ⅜ in. (57.5 x 44 cm).

The identity of the young man remains unknown. Although some scholars have suggested that he was a member of the Medici family, the more intriguing possibility is that he was the goldsmith who made the medal, and specifically Botticelli's brother Antonio. Borrowing a technique from earlier artists, Botticelli gilded the paste medallion and attached it to the panel.

RIGHT

Sandro Botticelli (1445–1510). *Pallas Athena and the Centaur.* 1480s. Tempera on canvas. 81 ½ x 58 ¼ in. (207 x 148 cm).

Even minor Medici were major patrons: this handsome painting was commissioned by a cousin of Lorenzo the Magnificent. The Neo-Platonic theme—also from the Medici circles—is Reason (personified by Athena) defeating the animal appetites. It is as Classical as can be: Botticelli borrowed the centaur from a sarcophagus he saw in Rome.

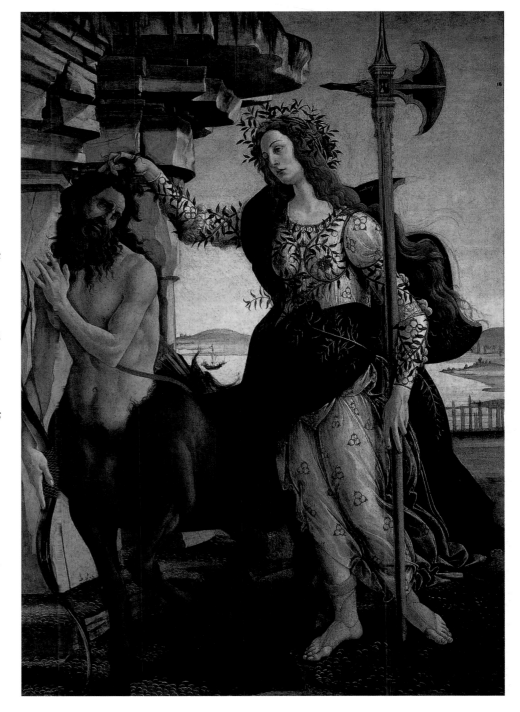

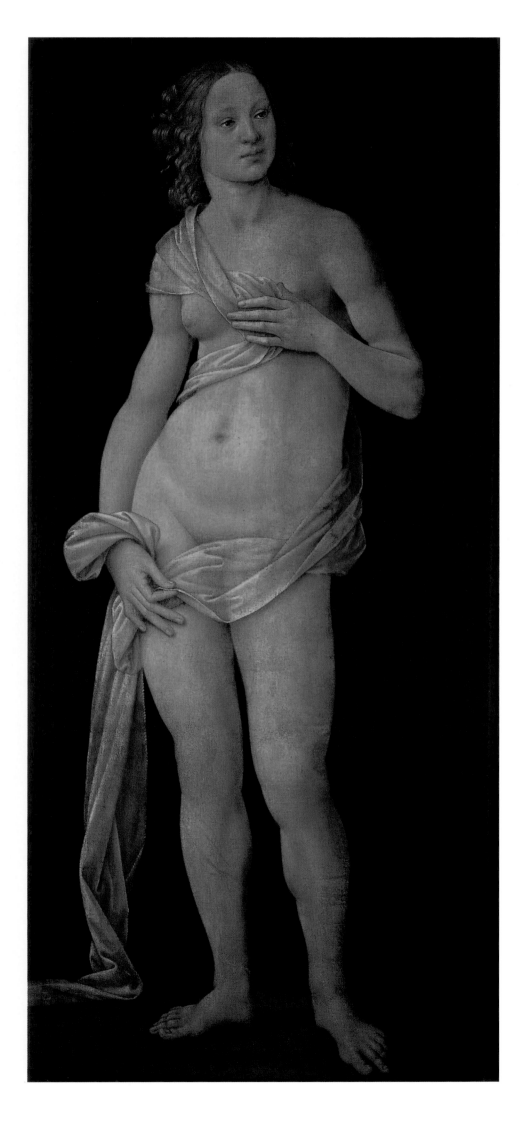

Lorenzo di Credi (1459–1537). *Venus*. Ca. 1490. Tempera on wood. 59 ½ x 27 ¼ in. (151 x 69 cm).

Lorenzo was in Verrocchio's workshop alongside Leonardo, and his rough-and-ready *Venus* displays some of Leonardo's soft contours, but also the startling feet of his studio-mate's Virgin in *The Adoration of the Magi*. The naturalism, cold light, and posture—her "Gothic slouch"—are northern European features. Venus' pug nose and unidealized features suggest that Lorenzo used a model, probably a prostitute.

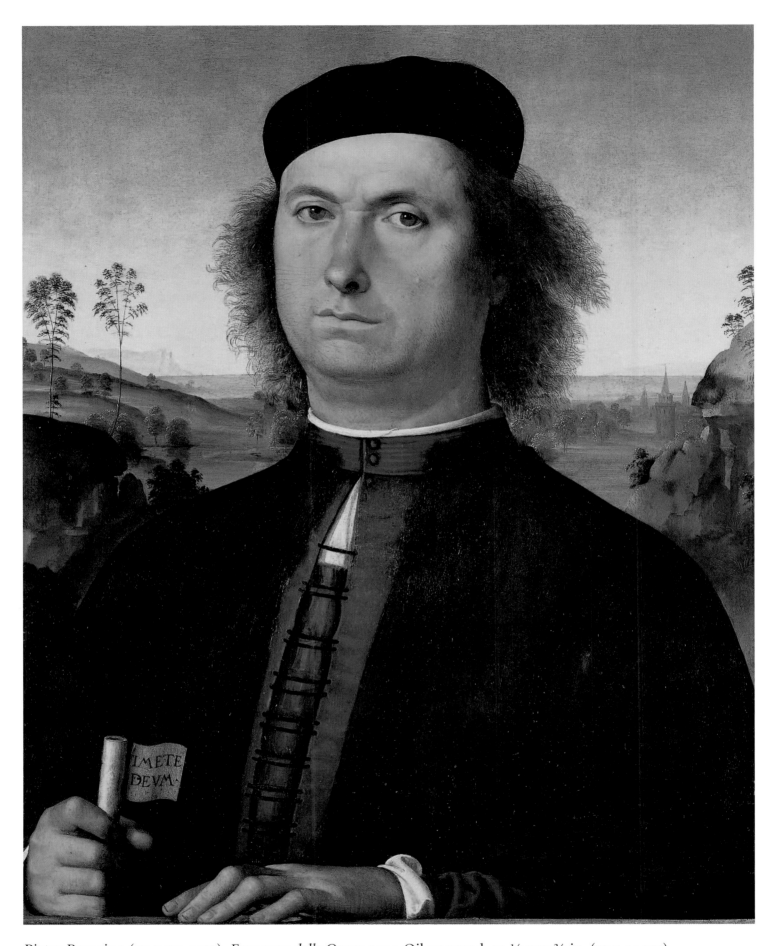

Pietro Perugino (ca. 1450–1523). *Francesco delle Opere*. 1494. Oil on wood. 20 ½ x 17 ⅜ in. (52 x 44 cm).

Pietro from Perugia won his early renown as a frescoist, with work in the Sistine Chapel. Here, in a painting on panel, he portrayed Francesco delle Opere, a wealthy Florentine, as a spiritual person: the sitter's head is above the horizon, against the heavens, and the small scroll he holds reads "Fear God." Perugino's most famous student was Raphael.

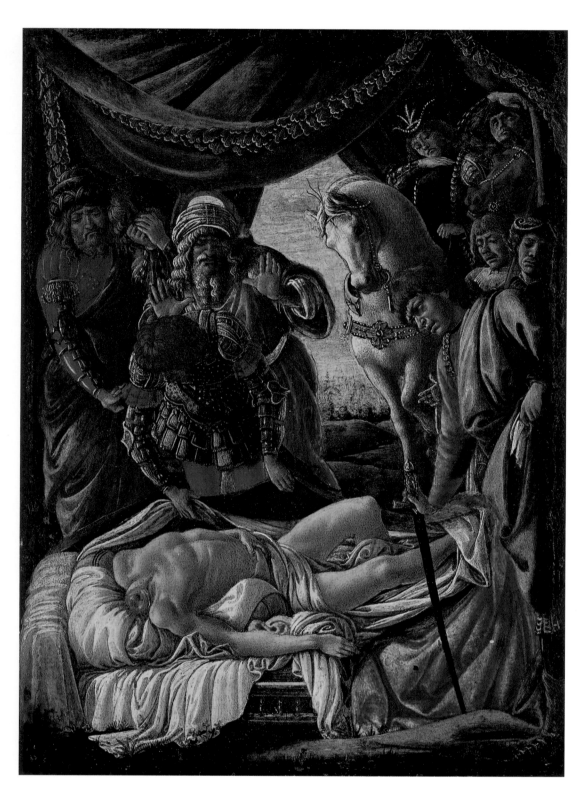

Sandro Botticelli (1445–1510). *The Discovery of the Body of Holophernes.* Ca. 1472. Tempera on wood. 12 ¼ x 9 ⅞ in. (31 x 25 cm).

This and *Judith Returning from the Enemy Camp* once formed a diptych. Their small size would have allowed their owner to appreciate highly decorative and erotic details, such as bedsheets that wind about the grisly cadaver with their almost liquid lines. Overhead, the velvet drape of the tent hangings is heavy above the rumpled bed.

Sandro Botticelli (1445–1510). *Judith Returning from the Enemy Camp.* Ca. 1472. Tempera on wood. 12 ¼ x 9 ½ in. (31 x 24 cm).

The Old Testament heroine leaves the scene of the crime, her maidservant running after her. In one hand, Judith holds the sword with which she beheaded the tyrant Holophernes; with the other, she grasps a laurel branch, symbol of victory. Botticelli expressed the women's haste by rendering their garments with nervous, floating lines.

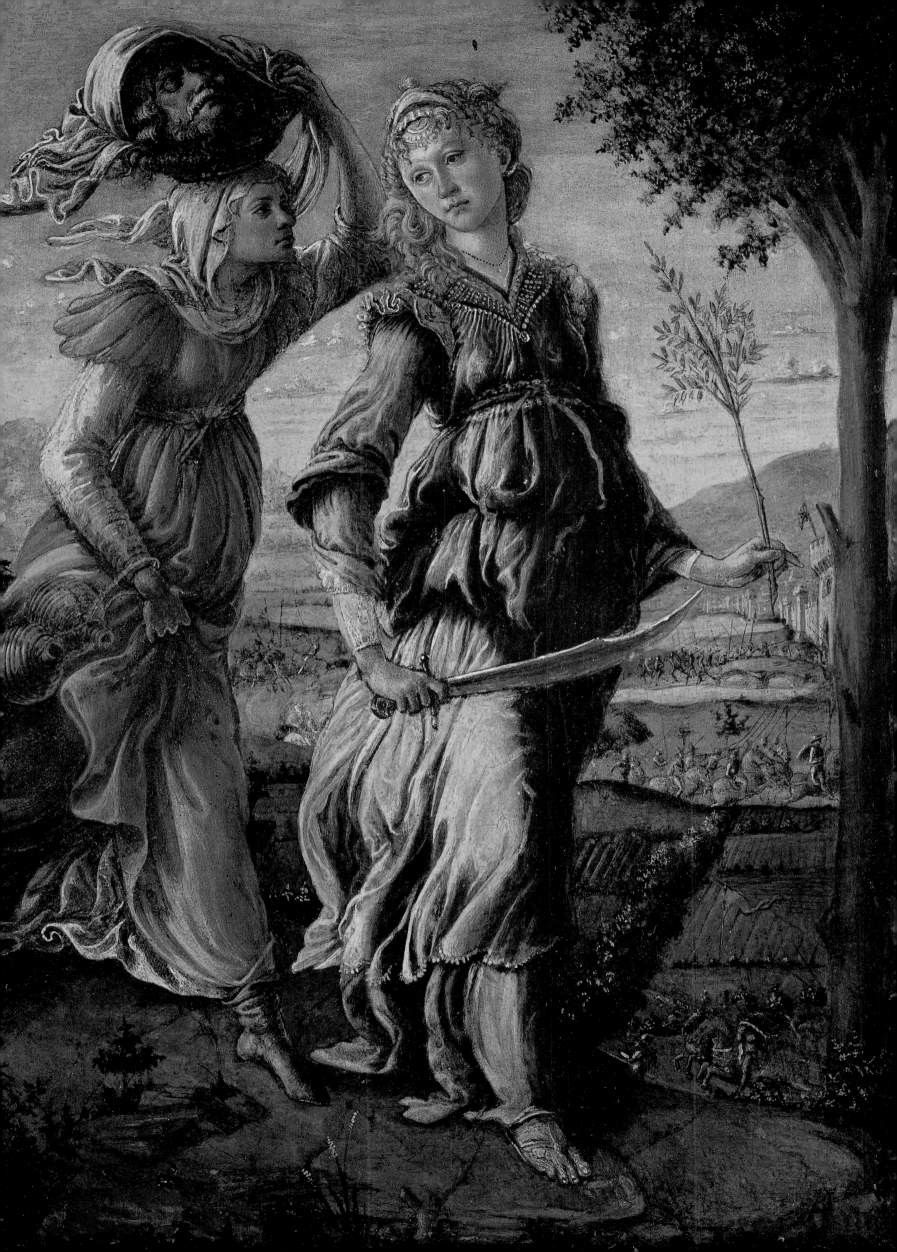

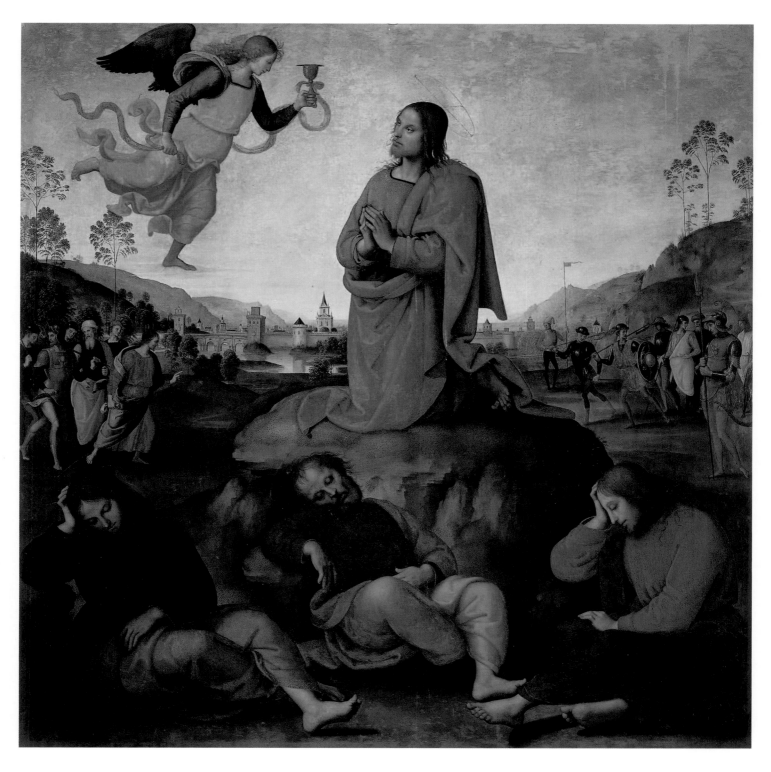

Pietro Perugino (ca. 1450–1523). *Prayer in the Garden.* Ca. 1492. Oil on wood.
65 ⅜ x 67 ⅜ in. (166 x 171 cm).

After the last supper, Jesus asked the apostles Peter, James, and John to accompany him into a nearby garden. In the gospels, the cup represents the agonizing, imminent completion of his human destiny, which Jesus prayed might be removed, then surrendered to the divine will. Leonardo's *sfumato* emphasizes the interiority of Christ's experience.

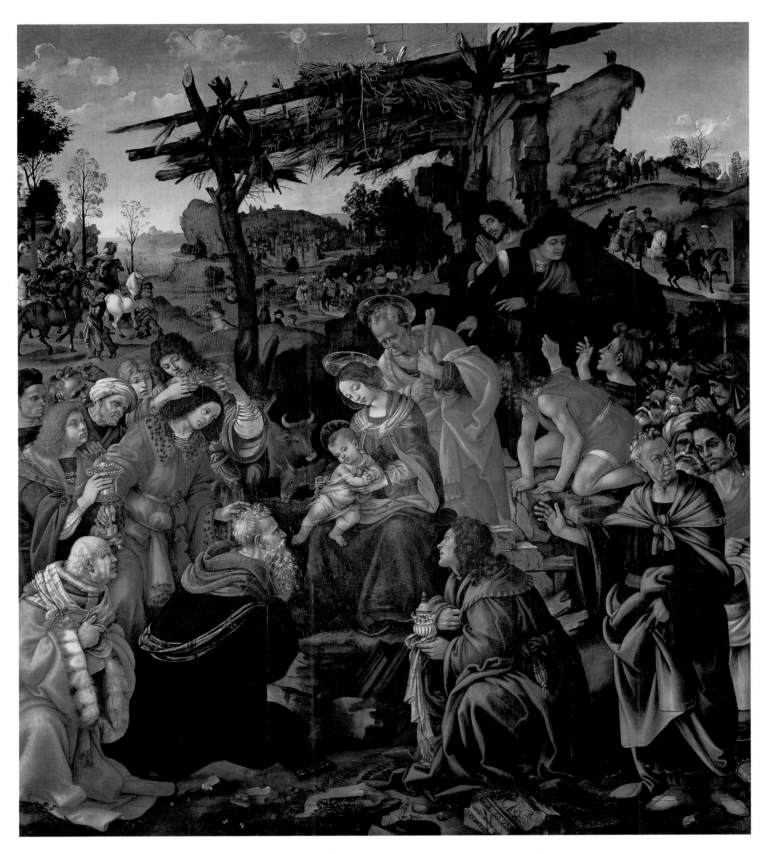

Filippino Lippi (ca. 1457–1504). *The Adoration of the Magi.* 1496. Tempera on wood.
101 ½ x 95 ⅝ in. (258 x 243 cm).

This crowded scene is busy with life and movement in brilliant colors. Several of the faces are clearly portraits: the two younger kings are Lorenzo and Giovanni de' Medici, patrons of Botticelli, the artist in whose workshop Lippi was trained. Lippi was well loved in Florence; it is said that when he died, shops closed as if a great prince had passed away.

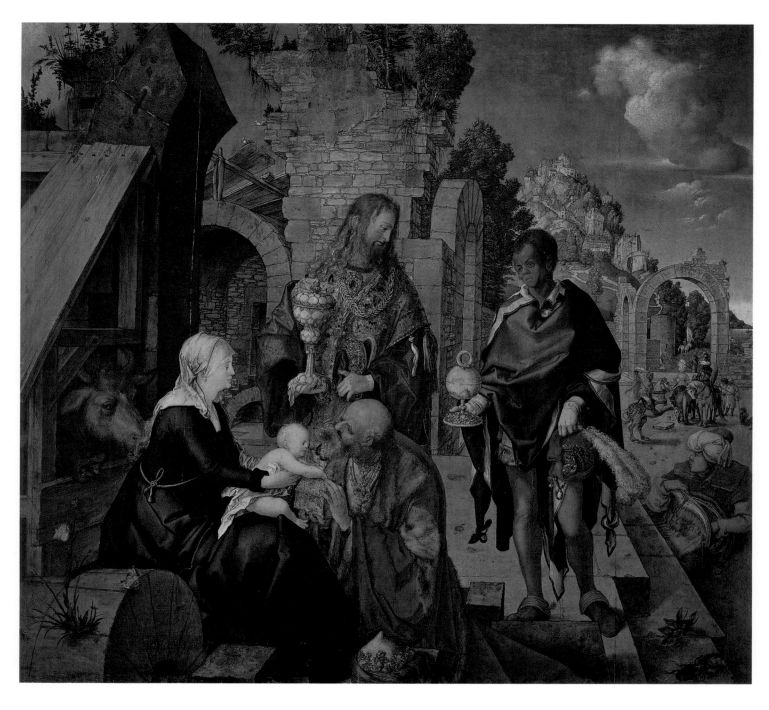

Albrecht Dürer (1471–1528). *The Adoration of the Magi.* 1504. Oil on wood. 39 x 44 ⅝ in. (99 x 113.5 cm).

This daytime scene is strangely spare and low-keyed. Amid the ruins of the old order, The three ages of man, perhaps representing all humanity, make their obeisances. The magi may also stand for the three continents: the old, the new, and Africa. Christ hugs the coffin-like box proffered by the white-haired magus, a presage of the Resurrection.

Vittore Carpaccio (1460/65–1525/26). *Group of Soldiers and Men in Oriental Costume.* Ca. 1515. Tempera on wood. 26 ¾ x 16 ½ in. (68 x 42 cm).

The letters "SPQR" identify the soldiers as Roman, though they mingle with exotic, richly robed figures. The mysterious quality of these waiting soldiers is explained by the fact that this small painting is a fragment of a larger one whose subject is unknown. Carpaccio was Venetian and, like his native textile-manufacturing city, known for his use of many shades of deep reds.

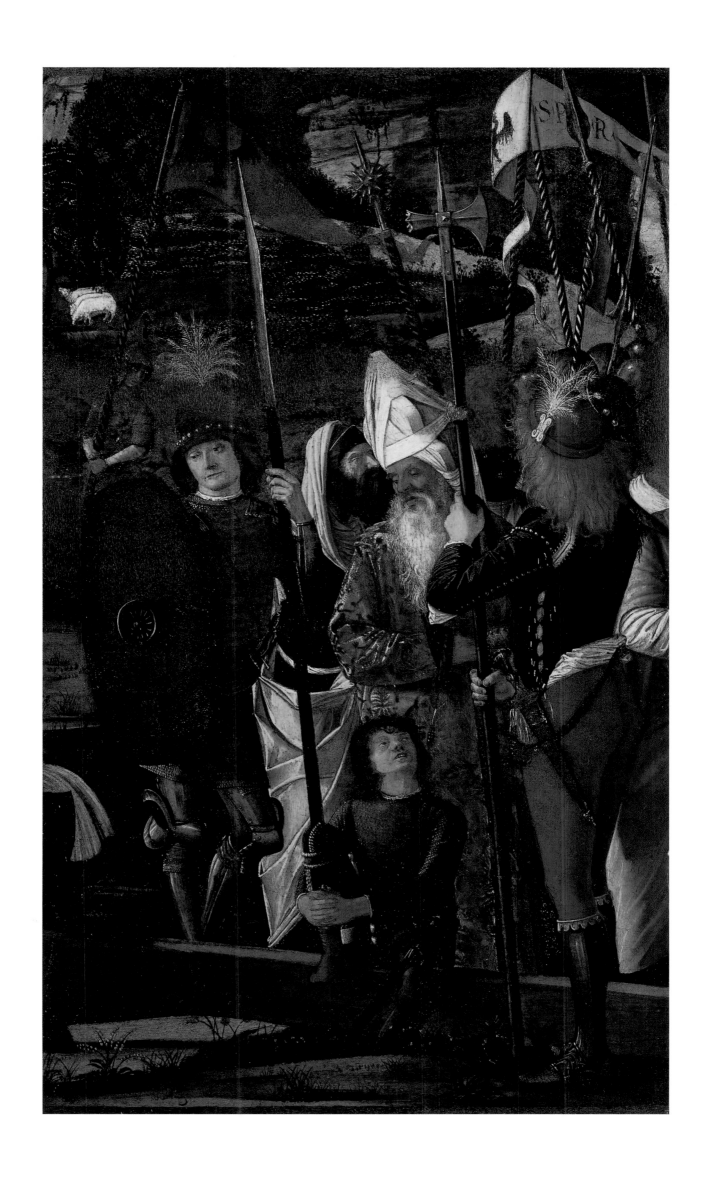

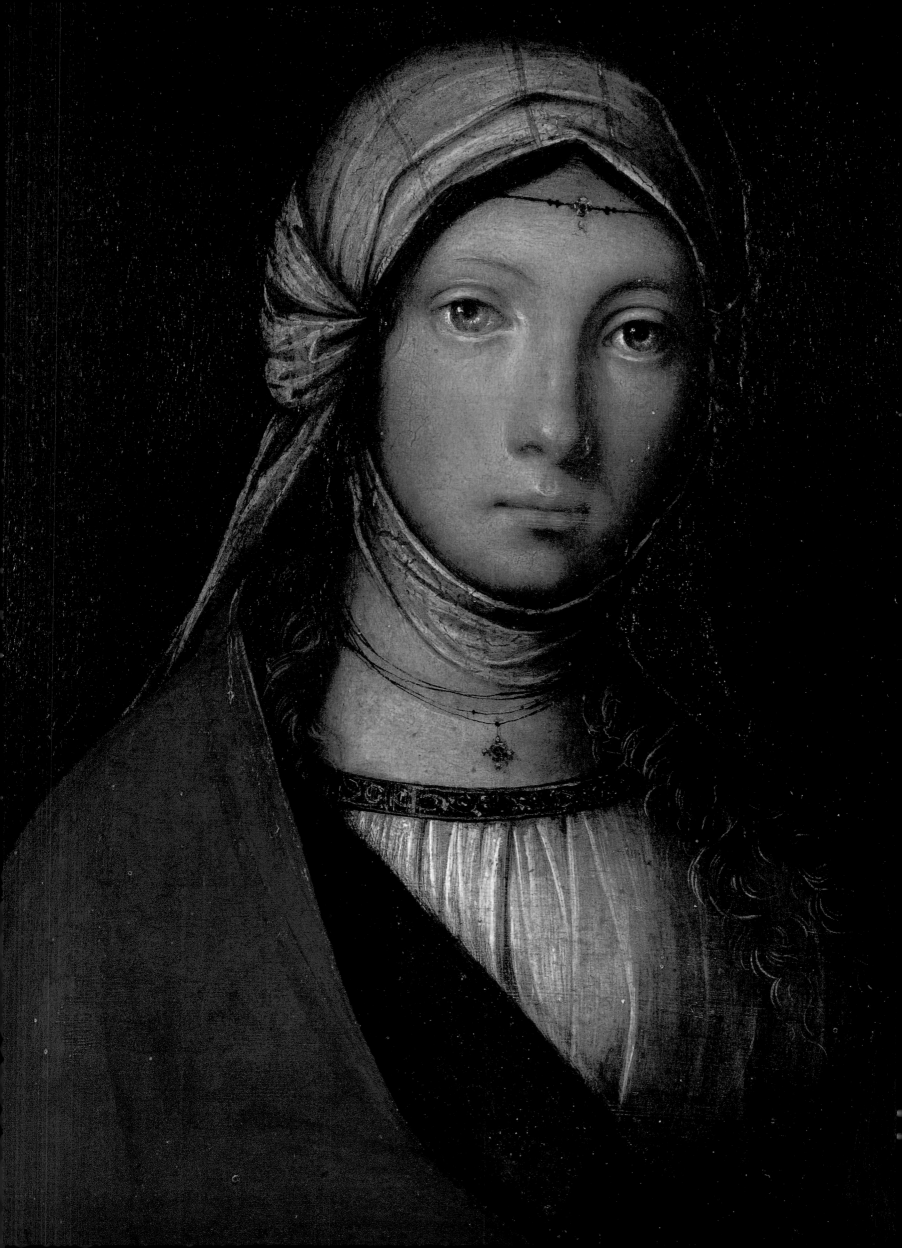

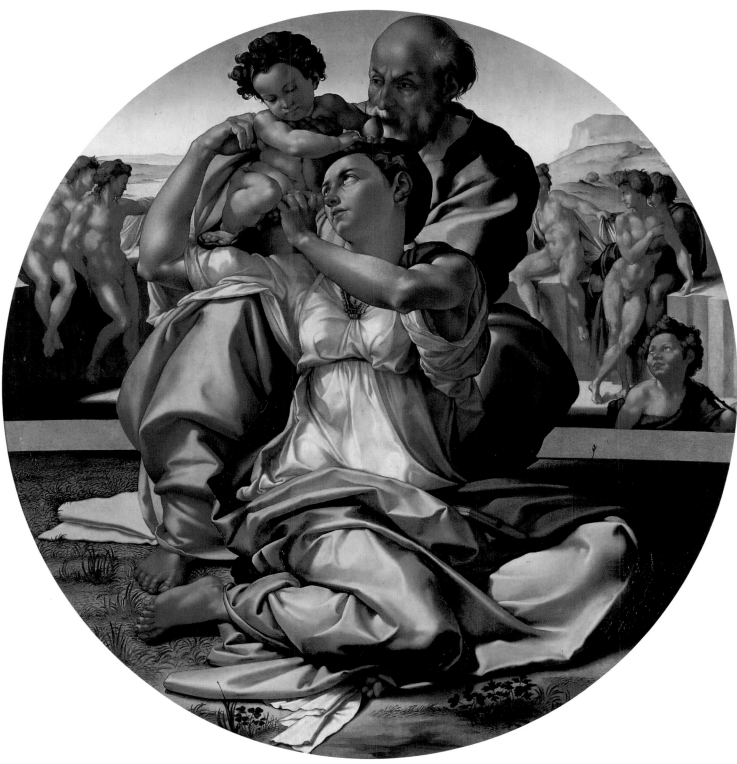

OPPOSITE

Boccaccio Boccaccino (1466?–1525). *The Gypsy Woman*. Ca. 1516–18. Tempera on wood. 9 ⅜ x 7 ½ in. (24 x 19 cm).

This exotically veiled woman with clear, sea green eyes wears modest gold jewelry. Strung on heavy thread, it adds to her picturesque portrayal by the artist; there is, too, an erotic undertone in the strands wrapped about her neck. If she looks familiar, it is perhaps because of her resemblance to Leonardo's portrait of the higher-born Cecilia Gallerani.

ABOVE

Michelangelo Buonarroti (1475–1564). *Holy Family (Doni Tondo)*. Ca. 1507. Oil on wood. Diameter: 68 ⅛ in. (173 cm), with original frame.

Where Raphael was praised for the easy grace of his figures, Michelangelo was admired for the *difficultà* of his, which display the virtuosity of his draftsmanship. The work just as clearly displays Michelangelo's mastery of color. *Tondi*, also called *deschi da parto* (birth trays), were customary gifts celebrating births. This may be one.

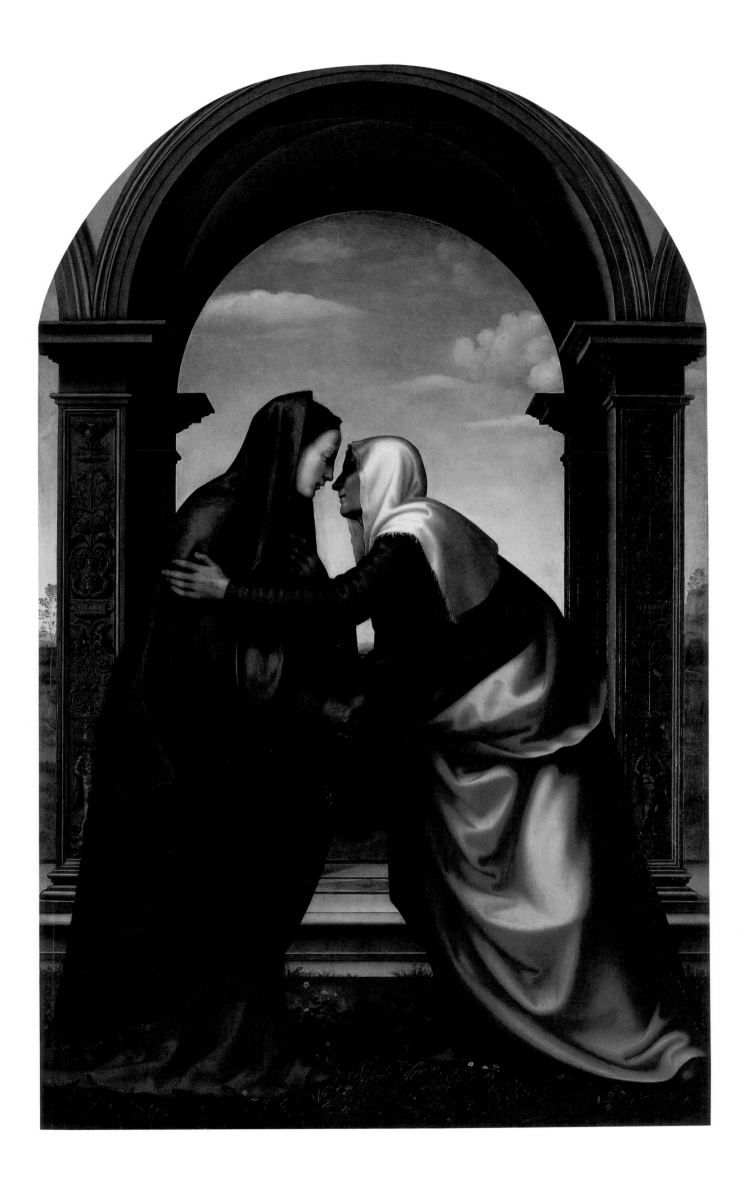

OPPOSITE
Mariotto Albertinelli (1474–1515). *The Visitation*. 1503. Oil on wood. 91 ⅜ x 57 ½ (232 x 146 cm).

The pregnant Mary is greeted by her cousin Elizabeth, who carries her own son, the future John the Baptist. The recently restored, jewel-like colors emphasize the statuesque volumes. Fra Bartolommeo, like Albertinelli a follower of Savonarola, may have painted part of the work, from which every decorative flourish, even of line, has been eliminated. What is left is sweet, severe, and monumental.

ABOVE
Lorenzo Lotto (ca. 1480–1556/67). *Portrait of a Young Man*. Ca. 1505. Oil on wood. 11 x 8 ⅝ in. (28 x 22 cm).

This painting is small, but life-size. Even in this work from his earliest period, the sitter's fully frontal posture is characteristic of Lotto's portraits, and so is the lively sense of personality that emerges from the close-up. Cardinal Leopoldo de' Medici acquired the work in 1665, and it has been in the Uffizi since 1675.

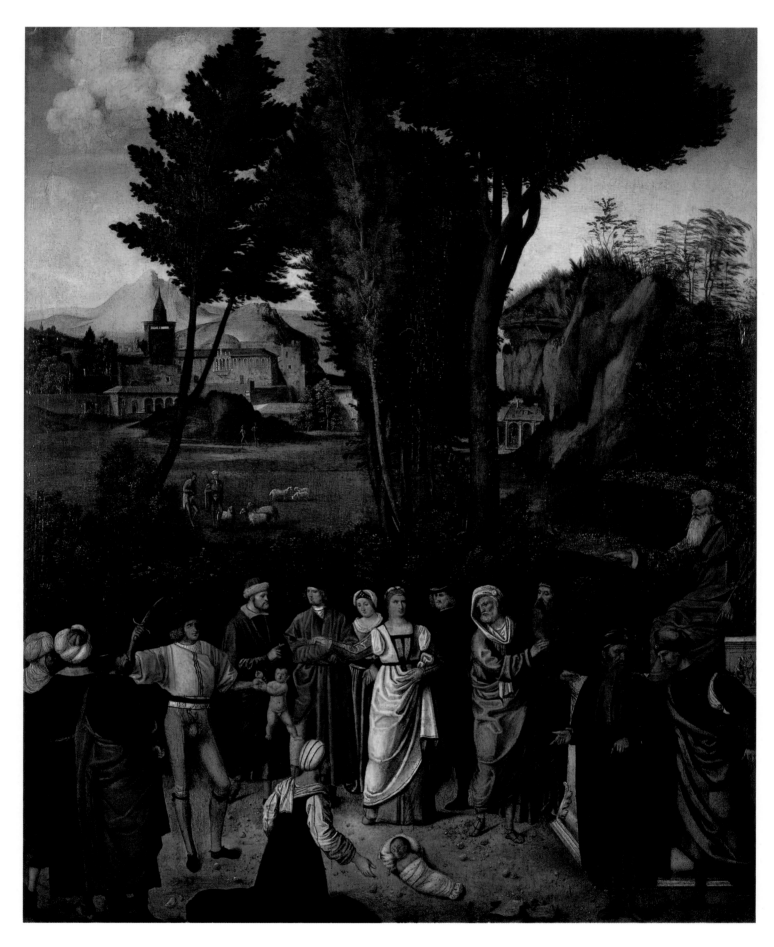

Attributed to Giorgione (1477–1510). *The Judgment of Solomon*. Ca. 1505. Oil on wood. 35 x 28 ⅜ in. (89 x 72 cm).

Giorgione depicted the celebrated story of Solomon's wisdom in one of two pendant paintings. The great king has declared that the living child be—literally—divided between the women claiming him. The babe's mother will cede the child, rather than see him die. An elusive figure, Giorgione made odd works: here, the landscape occupies more than half the panel.

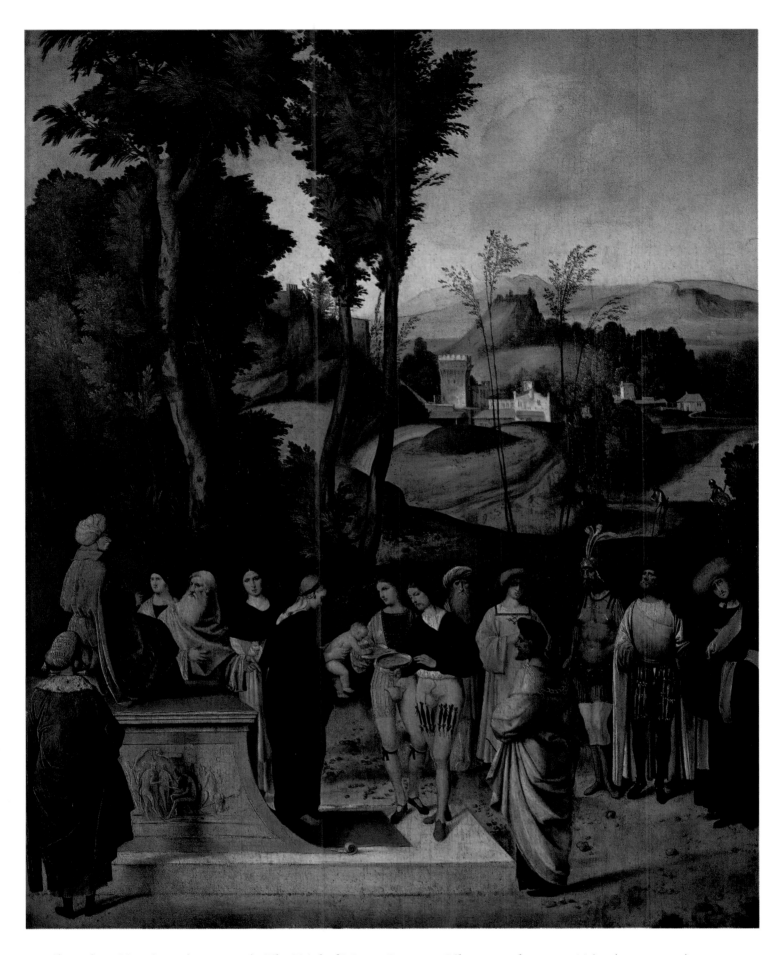

Attributed to Giorgione (1477–1510). *The Trial of Moses.* Ca. 1505. Oil on wood. 35 x 28 ⅜ in. (89 x 72 cm).

Pharaoh, worried by an omen, is subjecting the infant Moses to a test. The Egyptian ruler's daughter, who adopted the baby, holds little Moses before two basins proffered by two Renaissance fashion plates. The child reaches for the burning coals—the correct choice—not the gold. The only literary sources for the tale are several midrashim, or traditional Jewish accounts.

ABOVE

Antonio Allegri, called Correggio (ca. 1489–1534). *Madonna and Child in Glory.*
Ca. 1510. Oil on wood. 7 ⅞ x 6 ⅜ in. (20 x 16.3 cm).

Sorrow and glory are indistinguishable in this intimate work. Even the cloud-angels above are solemn. The music-making angel on the right seems to play to the Child to sweeten the present, and distract him from his awareness of the future. The colors, too, are deep but muted. Correggio's figures occupy more three-dimensional space than those of many of his contemporaries' works.

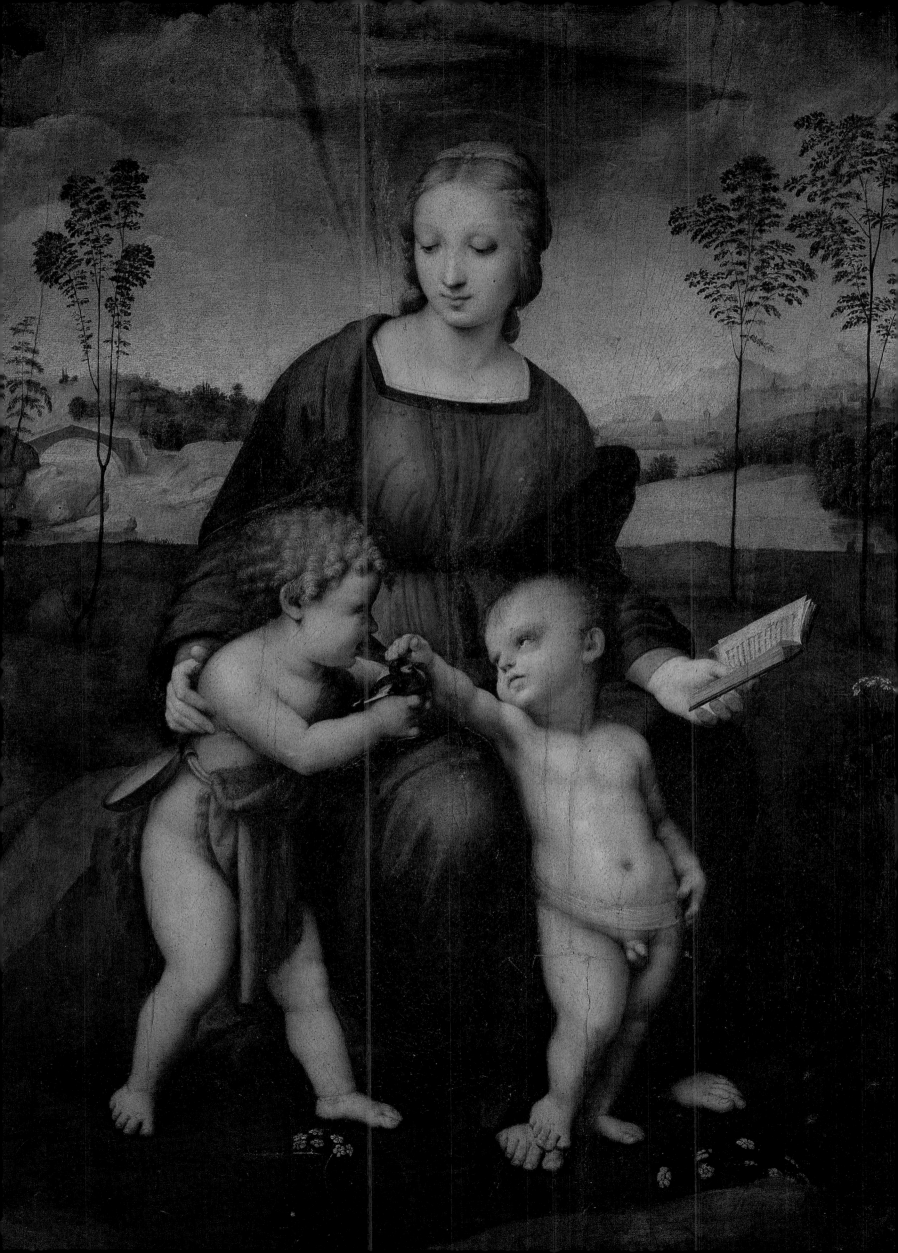

SVA · CVIQVE · PERSONA

P. 133
Raphael (1483–1520). *Madonna of the Goldfinch.* 1505/06. Oil on wood. 42 ⅛ x 30 ⅜ in. (107 x 77 cm).

Made in Florence, this tranquil work was commissioned to celebrate a marriage. Raphael was investigating the modern manner; here, he practiced subtle shading and delicately sinuous postures. The Madonna's head above the horizon and her childbearing body below express her own dual nature. The infant Saint John wears a hermit's robe—complete with begging bowl—foretelling his time in the desert.

LEFT
Attributed to Ridolfo Ghirlandaio (1483–1561). *The Portrait's Box.* 1506–10. Oil on wood. 25 ⅞ x 18 ⅞ in. (65 x 48 cm).

Amid *trompe l'oeil* classical decorations, an inscription reads: "To each his or her own mask." The disturbing "mask" bears a strong resemblance to the lady of the portrait opposite. During the Renaissance, paintings of especial value were protected by curtains or other covers. This one may have been mounted on a track that allowed it to reveal or conceal its pendant.

OPPOSITE
Attributed to Ridolfo Ghirlandaio (1483–1561). *Portrait of a Woman, called "The Nun."* 1506–10. Oil on wood. 25 ⅞ x 18 ⅞ in. (65 x 48 cm).

A serene lady holds a book of Jesuit devotions, identifiable by the abbreviation IHS on the cover. The convent complex in the background may have given rise to the painting's otherwise mystifying alternate title. This work has been attributed to several different artists, including Mariotto Albertinelli, Giuliano Bugiardini, and even Leonardo da Vinci.

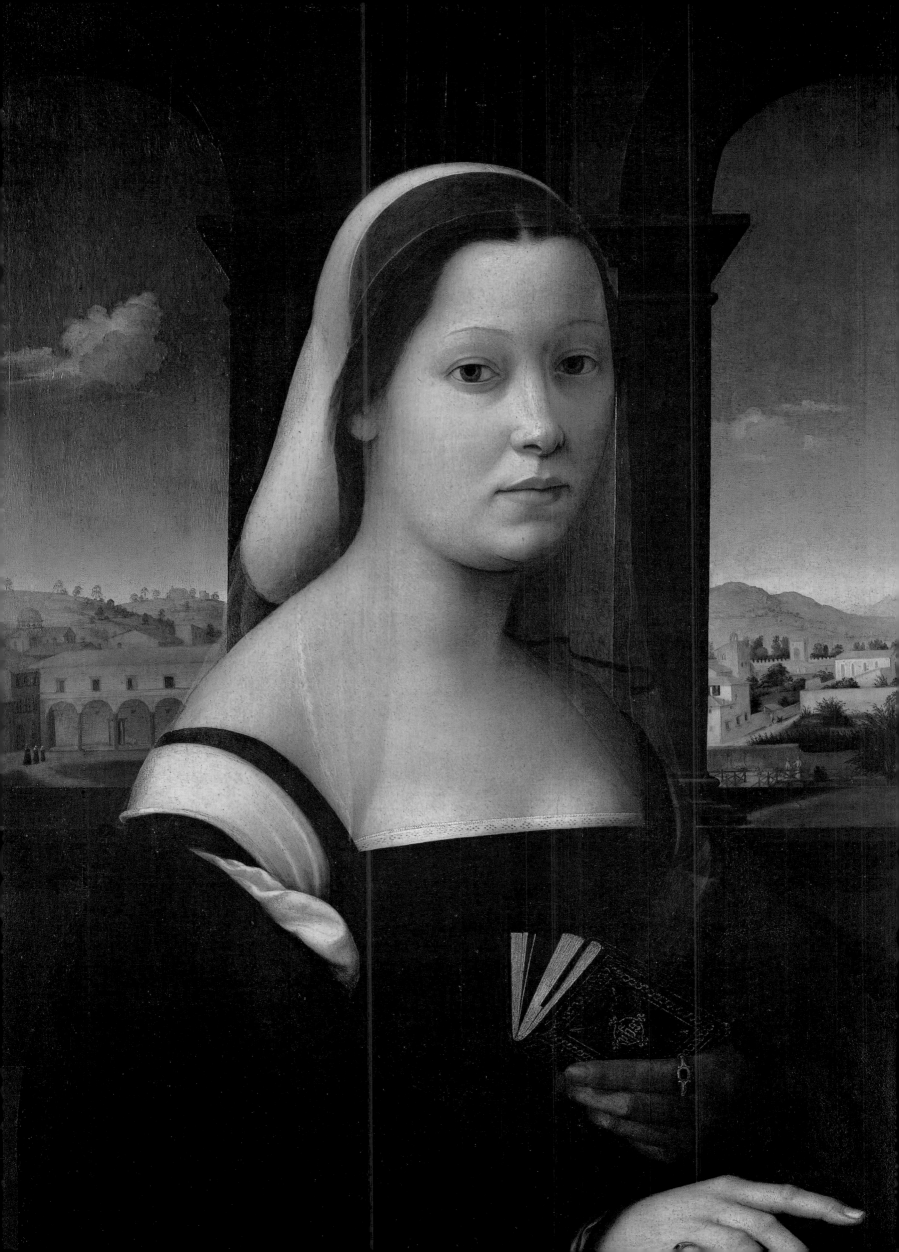

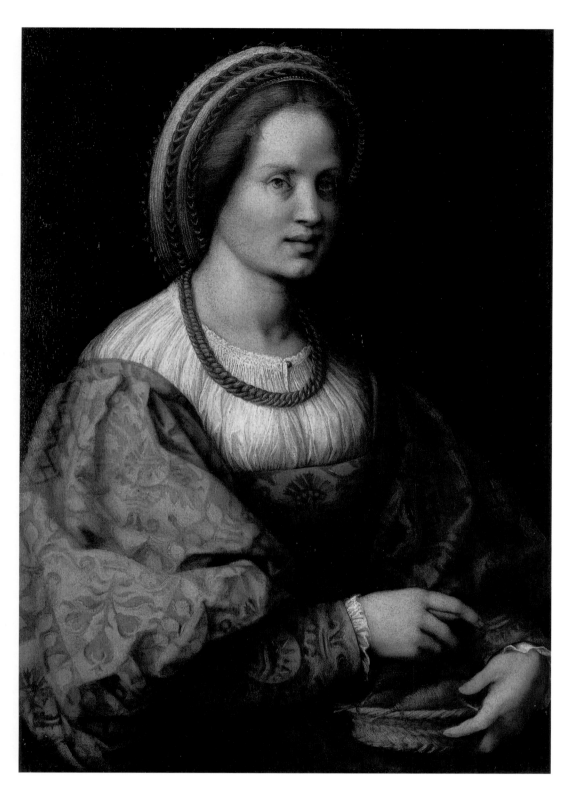

Andrea del Sarto (1486–1530) or Jacopo Pontormo (1494–1556). *Lady with a Basket of Spindles.* Ca. 1514–17. Oil on wood. 30 x 21 ¼ in. (76 x 54 cm).

In this study in reds, the gold that adorns the lady bespeaks her status, as do her voluminous brocade sleeves, woven with the family coat of arms. The spindles—bearing the yarn she presumably spun—suggest a literally hands-on domesticity. This is possibly one of the paintings that Andrea del Sarto began and his assistant Jacopo Pontormo finished.

Raphael (1483–1520). *Pope Leo X between the Cardinals Luigi de' Rossi and Giulio de' Medici.* 1517/18. Oil on wood. 61 ¼ x 47 in. (155.5 x 119.5 cm).

The magnifying glass in his hand suggests that it is more as a connoisseur than as a prince of the Church that the first Medici pope, Leo X, is examining the priceless manuscript before him. This is, after all, the prelate who exclaimed, "God has given us the papacy. Let us enjoy it!" The two ancillary figures were added later.

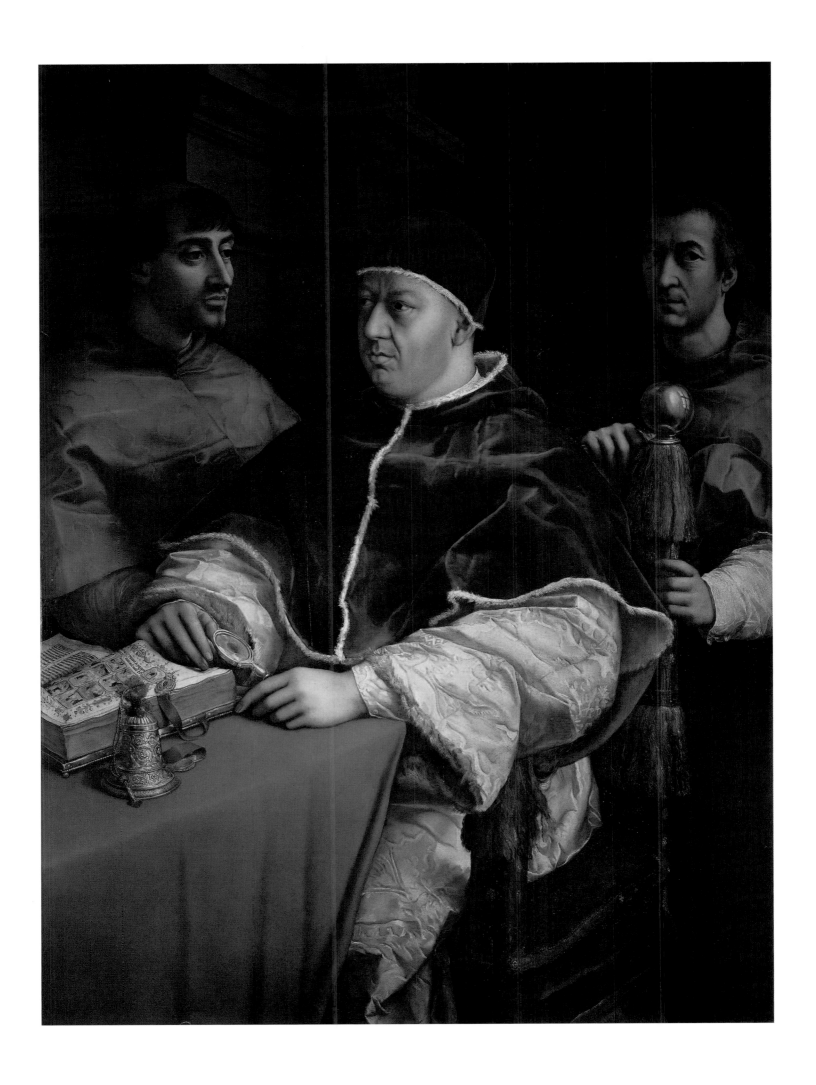

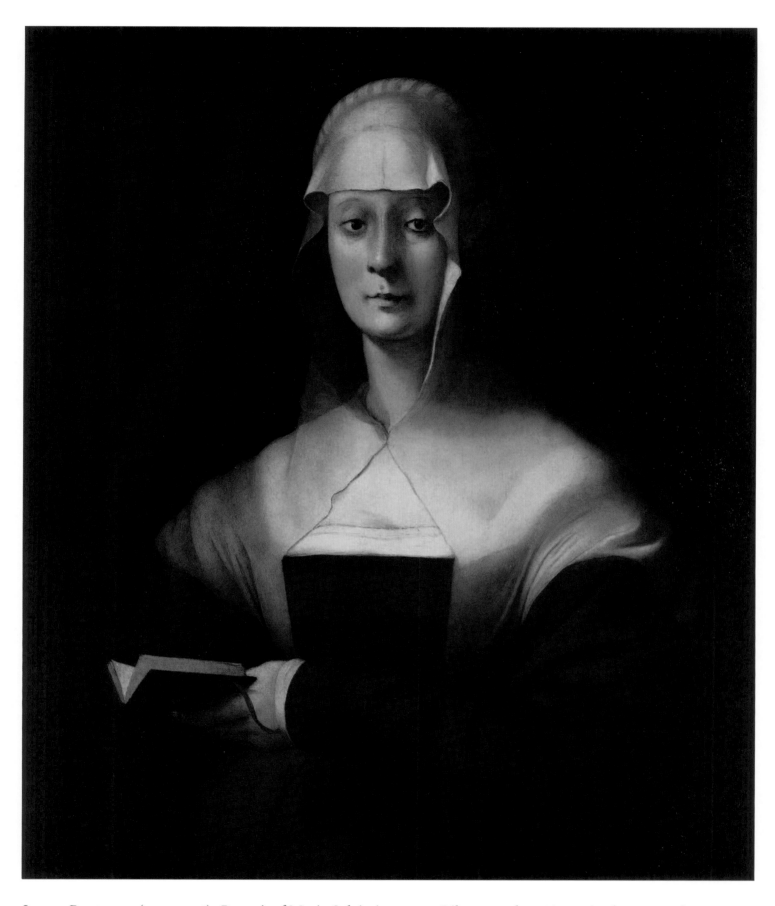

Jacopo Pontormo (1494–1556). *Portrait of Maria Salviati.* 1537–43. Oil on wood. 34 ¼ x 28 in. (87 x 71 cm).

The very modern artist Pontormo portrayed the mother of his principal patron, Cosimo I de' Medici, as a dignified, pious, grieving widow. Pure blacks and filmy whites set off the lady's flesh tones in the painting, whereas in life the proud granddaughter of Lorenzo the Magnificent had ruined her complexion trying to attract her distant and distracted husband and cousin, the legendary condottiere Giovanni delle Bande Nere. (She may have used white lead, a corrosive facial application that women were still employing in the twentieth century.)

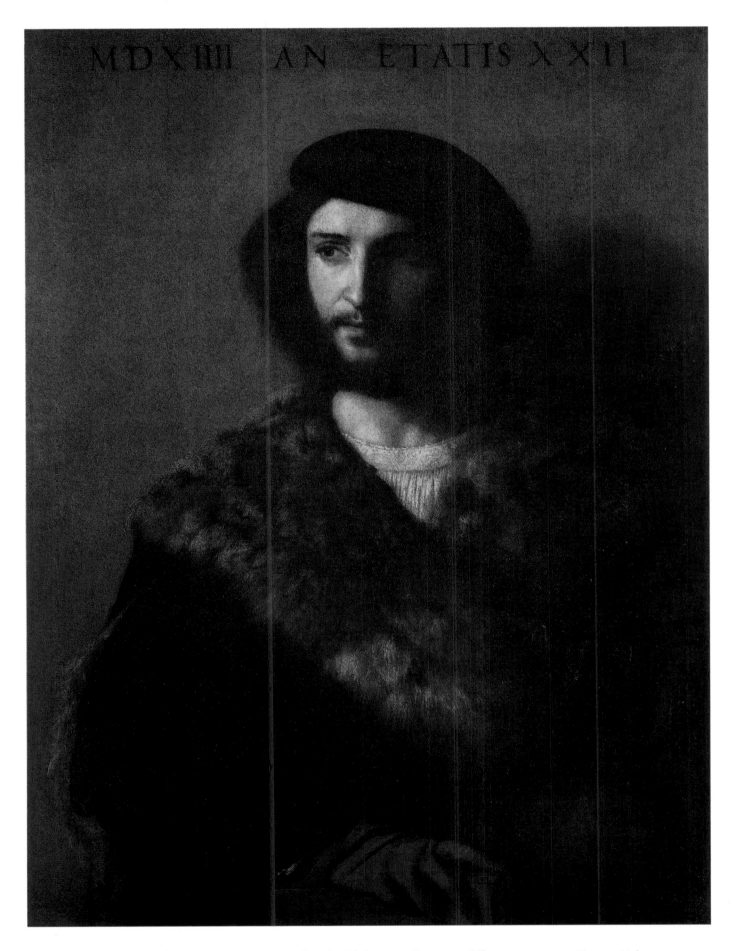

Tiziano Vecelli, called Titian (ca. 1488–1576). *The Sick Man*. Ca. 1514. Oil on canvas. 31 ⅞ x 23 ⅝ in. (81 x 60 cm).

The grave stillness of this painting derives in part from tones so carefully calibrated that the fox red lining of the young man's glove is startling. The same hue points to the book at the bottom edge, a telling variation on the traditional separation of the temporal spaces of viewer and subject. The sitter turns into shadow. The title is not Titian's.

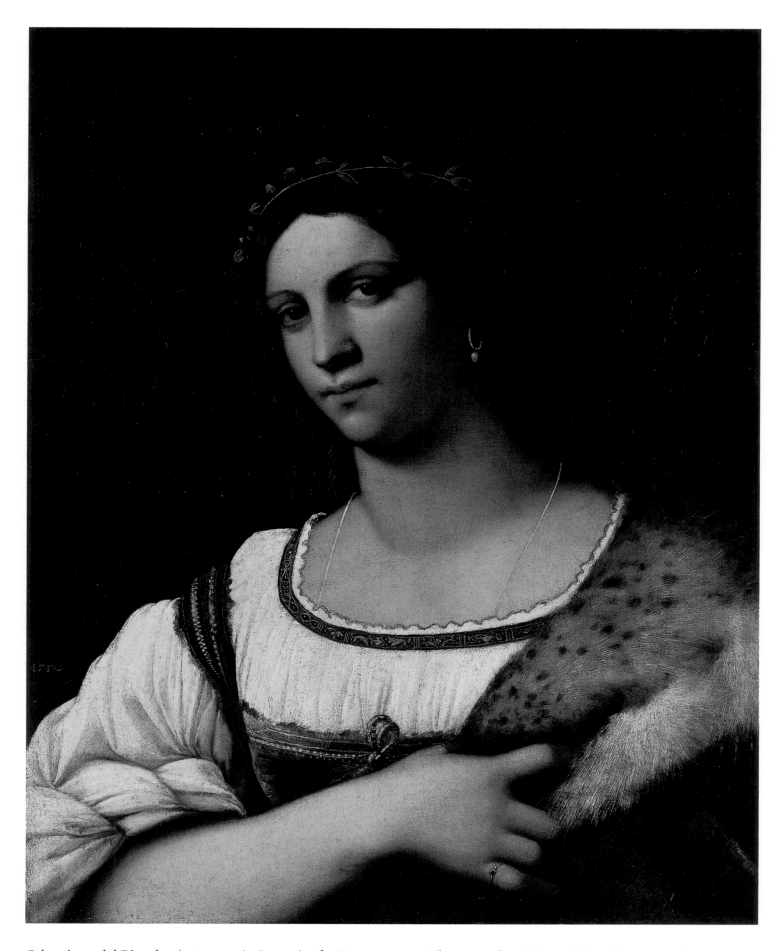

Sebastiano del Piombo (1485–1547). *Portrait of a Woman.* 1512. Oil on wood. 26 ¾ x 21 ⅝ in. (68 x 55 cm).

That she is a lady is clear from her fur, her jewelry, and the trim on her linen, on which classical motifs are embroidered with gold thread. The lessons of Leonardo, Raphael, and Giorgione are here in the shading on skin and pelt, and in the softly modeled contours of the face, with its compelling gaze.

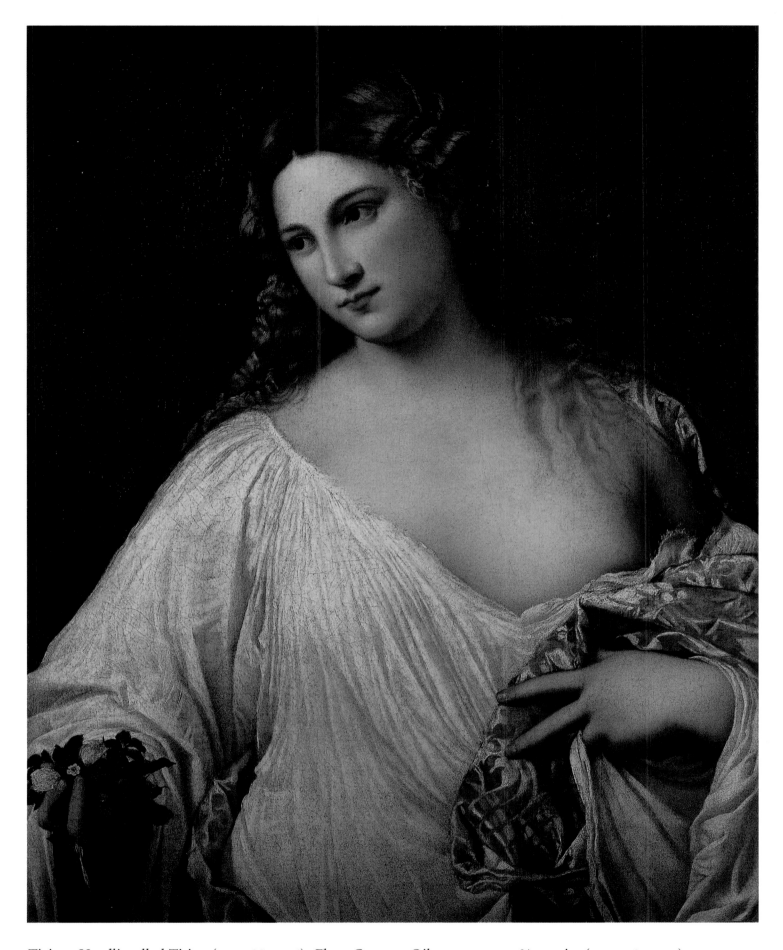

Tiziano Vecelli, called Titian (ca. 1488–1576). *Flora*. Ca. 1520. Oil on canvas. 31 ⅜ x 25 in. (79.7 x 63.5 cm).

The Roman goddess of flowers, in all her nubile abundance, proffers her blossoms. In the High Renaissance, few qualities were as admired in painting as the ability to render flesh, and in this, few among the masters equaled Titian. The whites of skin, slipping shift, and brocade all exhibit the Venetian's keen eye and hand.

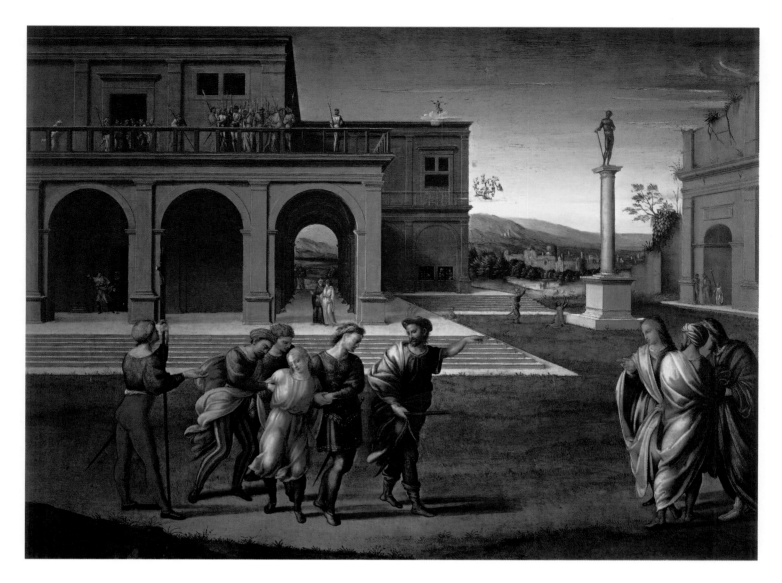

Francesco Granacci (1477–1543). *Joseph Conducted to Prison.* Ca. 1515. Tempera on wood. 37 ⅜ x 88 ¼ in. (95 x 224 cm).

A wealthy Florentine patrician commissioned Granacci and other artists to decorate his bedroom with scenes from the story of Joseph. Here, the hero is being led to prison, an episode that prefigures the arrest of Christ. Granacci's inventive quirkiness appears in a kind of preternatural weightlessness and in sky-borne vignettes, such as the figure plucking an apple from a tree.

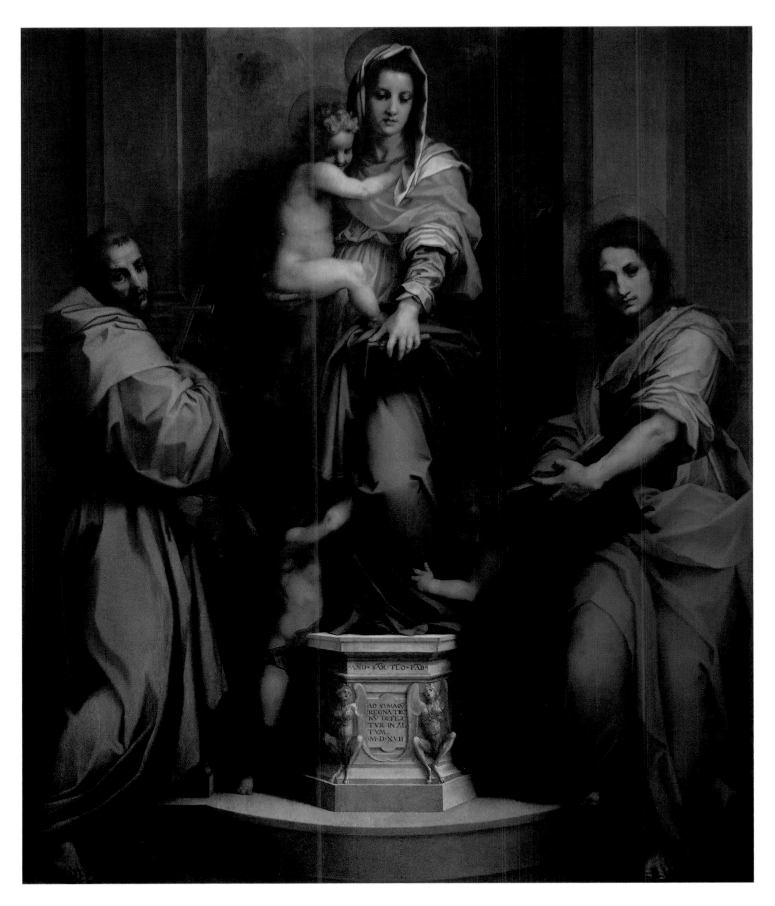

Andrea del Sarto (1486–1530). *Madonna and Child with Saints Francis and John the Evangelist (Madonna of the Harpies)*. 1517. Oil on wood. 81 ½ x 70 in. (207 x 178 cm).

Andrea took Renaissance principles in a new direction. Replacing Raphael's idealized grace is an edginess emphasized by almost garish hues and an almost too precise draftsmanship. During a time when fearful Florentines were anticipating the Apocalypse, Andrea referred to the biblical vision with the small winged figures that give the painting its name. The artist signed this work on the pedestal.

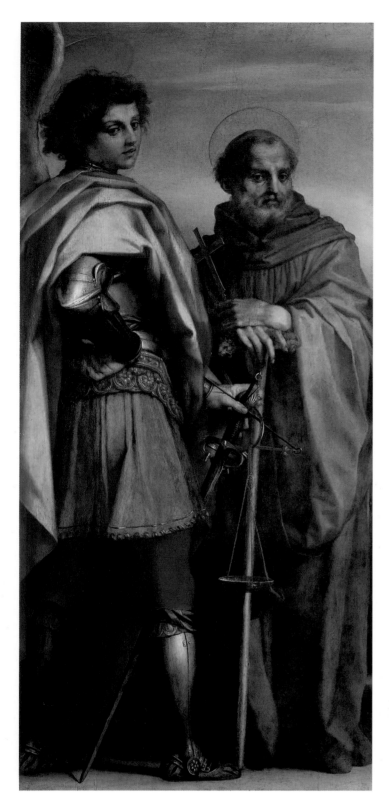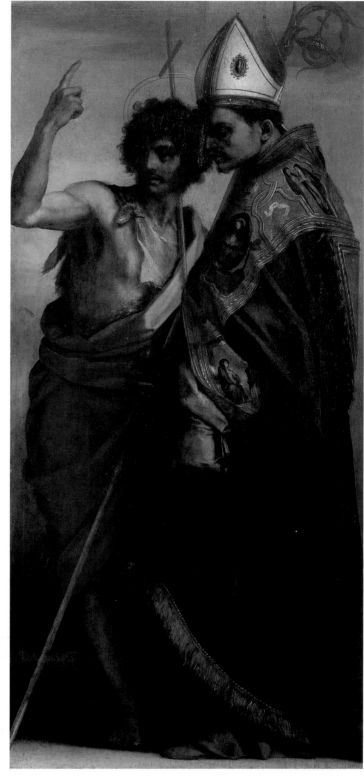

Andrea del Sarto (1486–1530). *Four Saints: Michael, John Gualberto, John the Baptist, and Bernardo degli Uberti.* 1528. Tempera on wood. 72 ½ x 67 ⅝ in. (184 x 172 cm).

This work is part of an altarpiece for the church at Vallombrosa, near Florence, home of the monastic community reformed by Saint John Gualberto in the eleventh century. Even though Saint John is the patron saint of Florence, the date, 1528, is below Saint Michael the Archangel, the highest-ranking figure in this hierarchy.

Lorenzo Lotto (ca. 1480–1556/57). *Susanna and the Elders.* 1517. Oil on wood. 26 x 19 ⅝ in. (66 x 50 cm).

The viewer is a voyeur, implicated in a tangle of sexual extortion, psychological violation, and revenge. The virtuous Susanna exclaims her dilemma, as the rejected, lustful elders bear false witness against her. The tale is from the extra-canonical biblical History of Susanna, which provided the dialogue on the banderoles.

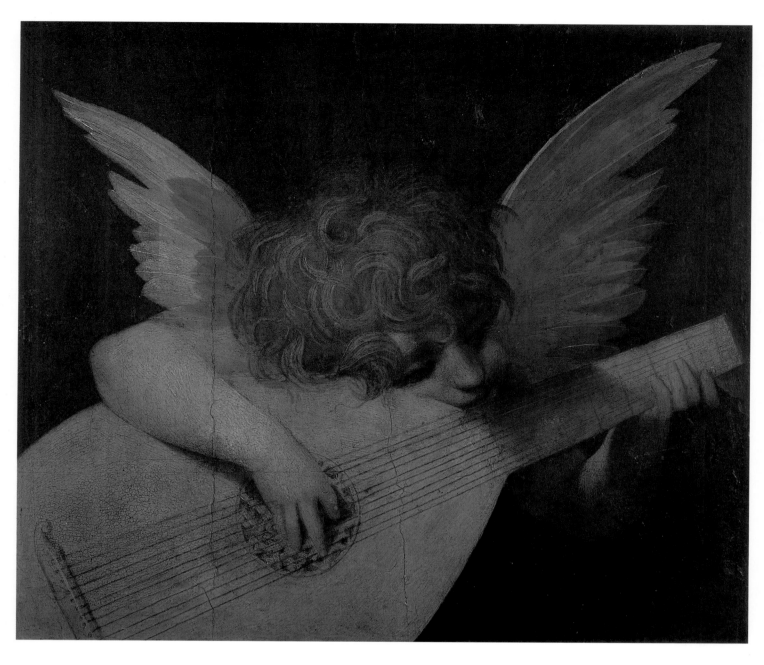

Rosso Fiorentino (1494–1540). *Musical Angel.* 1521. Oil on wood. 15 x 18 ½ in. (38 x 47 cm).

Rosso's confident brushstrokes give added exuberance to the little lute-playing *putto*'s wings. The tiny heavenly creature struggles with an instrument known for its delicacy, and which, at the time Rosso painted it, had just reached its final form. Reflectography showed that the angel was originally part of a larger panel, where it probably appeared at the bottom of the composition.

Andrea del Sarto (1486–1530). *Portrait of a Lady with a Book.* 1514. Oil on wood. 34 ¼ x 27 ⅞ in. (87 x 69 cm).

The lady holds a *petrarchino,* a small, popular edition of the poems written by the scholarly, cosmopolitan monk Francesco Petrarca (Petrarch), who largely set the tone of the secular Renaissance. The lines we see suggest that the *dama* points to poem 152 of the *Rime sparse,* which begins: *"This humble wild thing, a tiger's or she-bear's heart in human or angelic form . . ."*

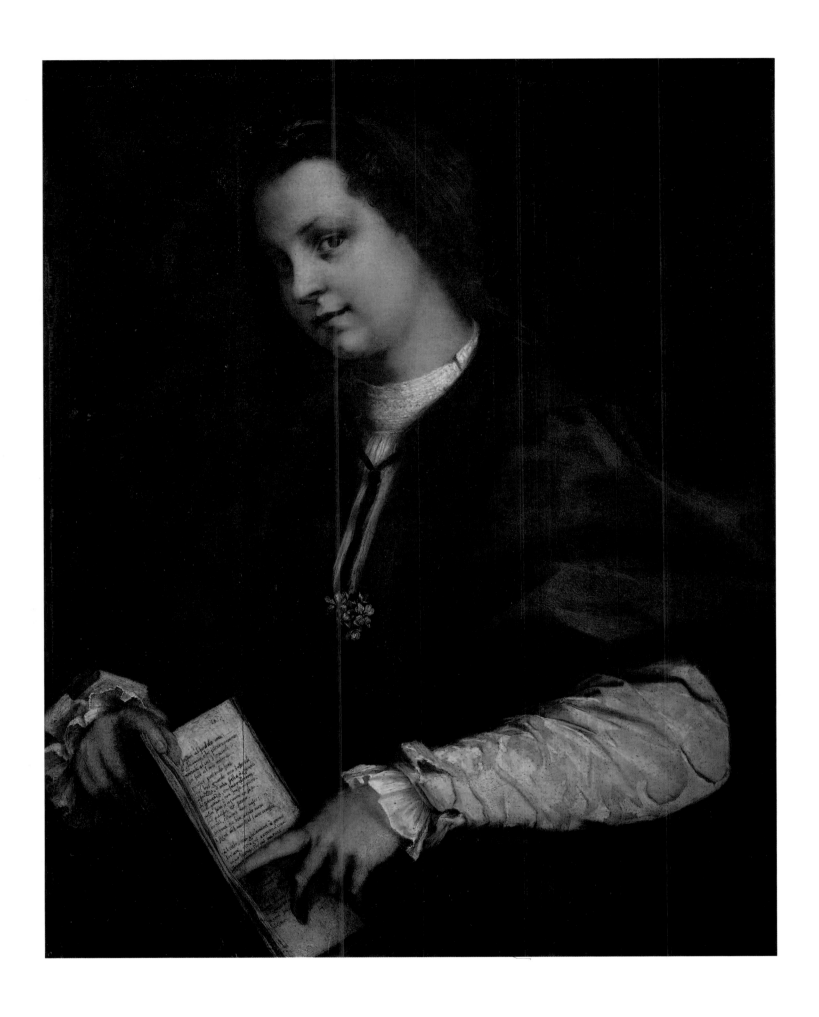

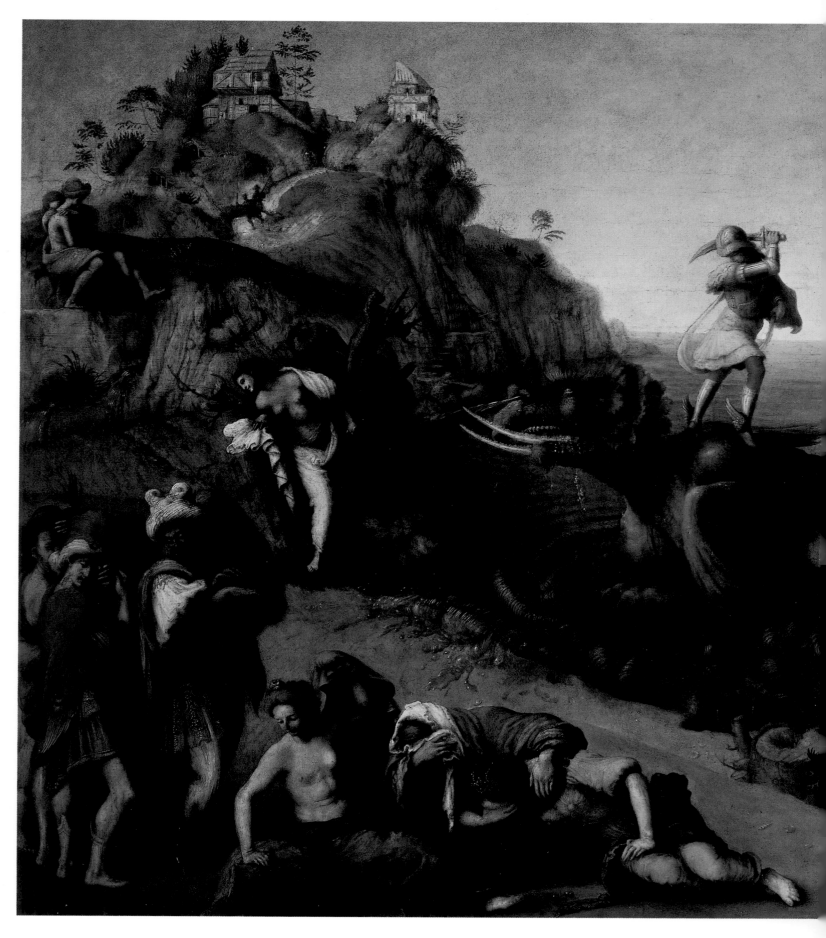

Piero di Cosimo (1461–1521). *Andromeda Freed by Perseus*. Ca. 1513. Oil on wood. 27 ½ x 48 ½ in. (70 x 123 cm).

On the right, Perseus, flying over Ethiopia, falls in love with Andromeda, who is about to be devoured by a fearsome sea monster. In the center, Perseus defeats the beast. He may symbolize the exiled Medici's return to Florence in 1512. The painting was probably a panel on one of the wedding chests, or *cassoni*, for which the artist was famous.

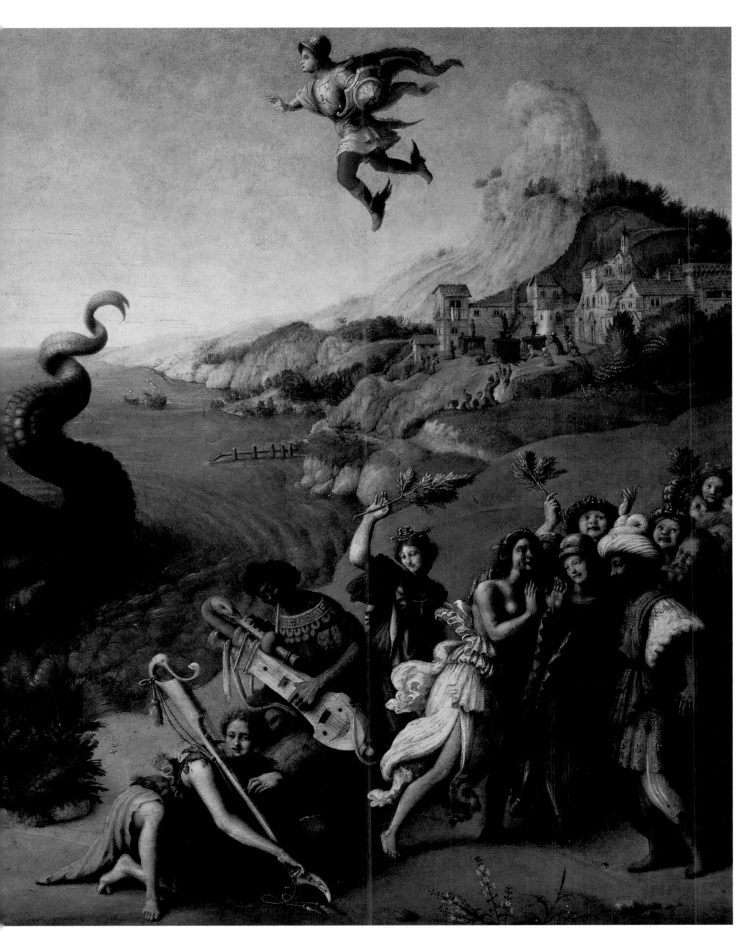

P. 150

Jacopo Negretti, called Palma il Vecchio (1480–1528). *Judith*. Ca. 1525–28. Oil on wood. 35 ½ x 28 in. (90 x 71 cm).

The fair Judith is a Jewish heroine updated to a blonde Venetian beauty, ample with life. The viewer must almost search to discover the haggard face of the dead Holophernes, whose beard Judith holds to steady her grisly prize. The difference in the sizes of their heads may denote a gender distinction, or may refer to David, another biblical tyrant-killer.

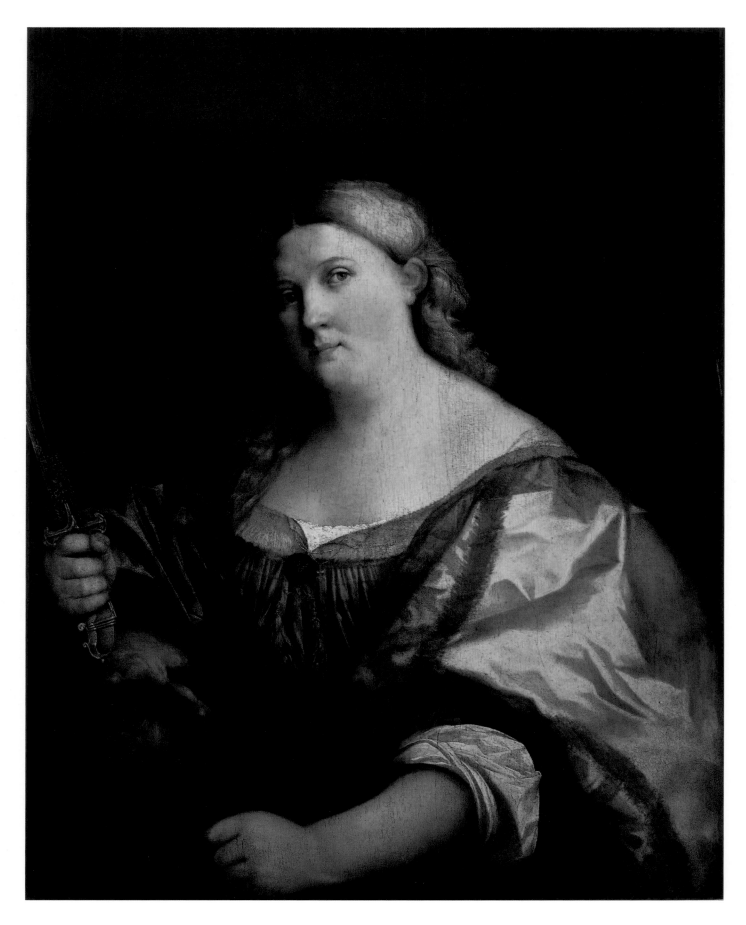

OPPOSITE

Bernardino Luini (1460–1532). *Herodias.* 1527–30. Tempera on wood. 20 x 22 ⅞ in. (51 x 58 cm).

Herodias, Salome's exceptionally young and Leonardesque mother, gloats over the scene. Renaissance spectators would have identified the old lady, perhaps added later, as a procuress, bringing in overtones of venereal disease. John, whose severed head became a cult image, is not only as beautiful as Herodias, but resembles her. The hideousness of the executioner further amplifies the theme of the deadliness of sin.

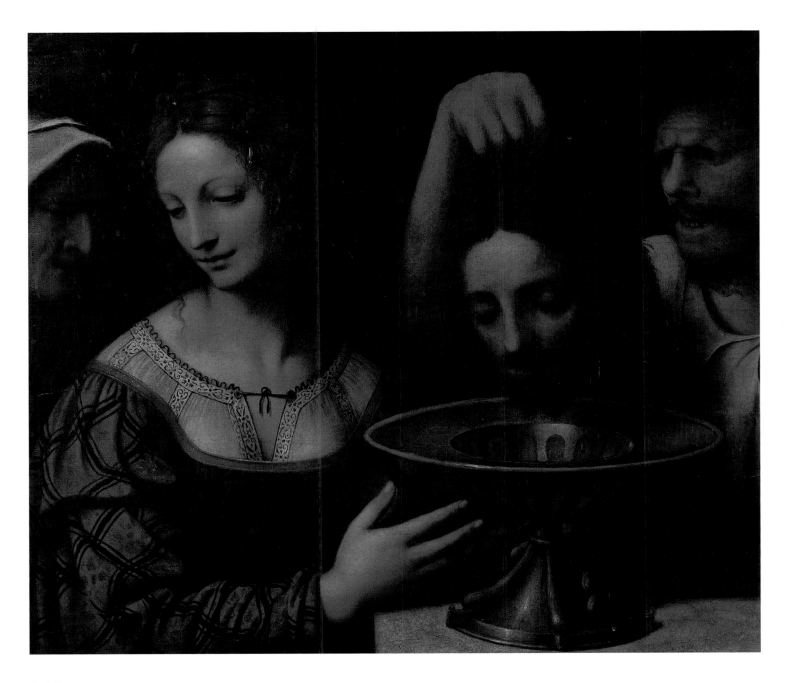

P. 152

Jacopo Pontormo (1494–1556). *The Supper at Emmaus.* 1525. Oil on canvas. 90 ½ x 68 ⅛ in. (230 x 173 cm).

The disciple on the right has recognized the resurrected Christ; the one on the left is about to. On either side of Jesus are some of the Cistercian monks who took Pontormo in when the plague raged in Florence in 1523. The triangle, which represents the Trinity, was painted over a three-headed face when the Roman Catholic Church banned that iconography.

P. 153, LEFT

Lukas Cranach the Elder (1473–1553). *Adam.* 1528. Oil on wood. 67 ¾ x 24 ⅞ in. (172 x 63 cm).

Adam scratches his head doubtfully, his awkward stance also suggesting sincerity. Above him hangs a temptingly perfect apple—the equivalent of a thought balloon in modern-day comic books. He holds a conveniently placed branch to cover his genitals, even though he did not become ashamed, that is, sexual, until *after* he ate the apple.

P. 153, RIGHT

Lukas Cranach the Elder (1473–1553). *Eve.* 1528. Oil on wood. 67 ⅝ x 24 ⅞ in. (172 x 63 cm).

Eve, who has tasted the apple, now *knows.* She "turns a leg," a posture that allowed gentlemen to show a shapely calf. Normally, women's dresses precluded that particular coquetry; here, it enhances her seductive offer of the apple, intimately scored by her little teeth. The Virgin was her counterpart: sermons pointed out that the angel's salutation, "Ave," was Eva spelled backwards.

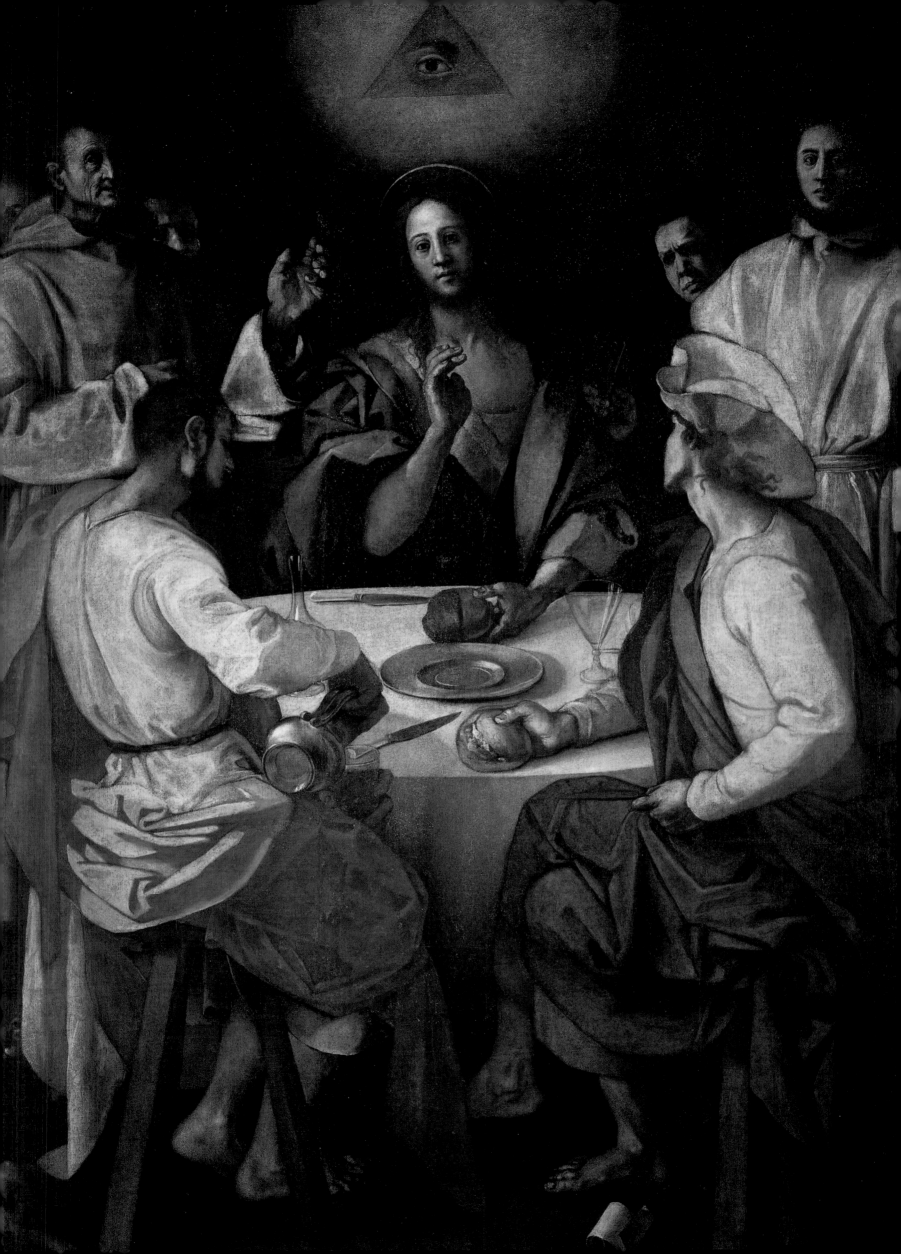

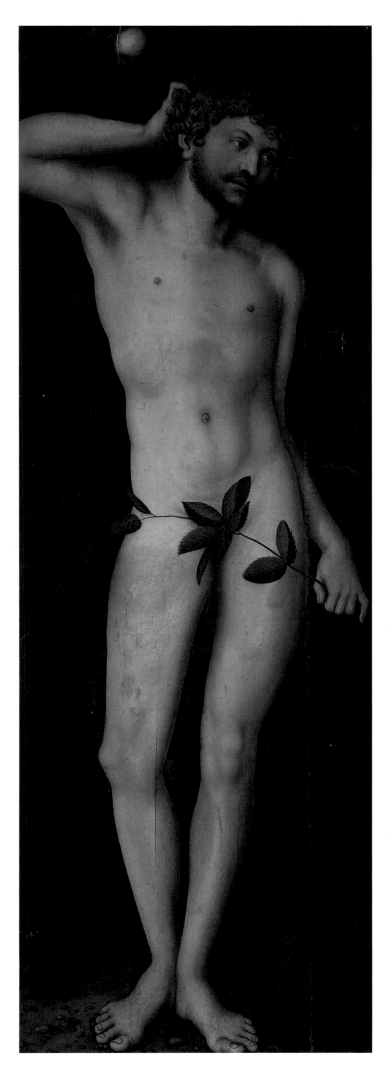
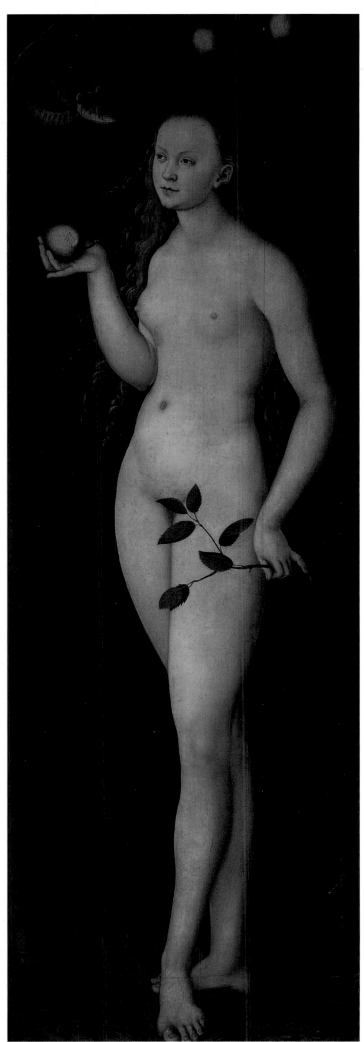

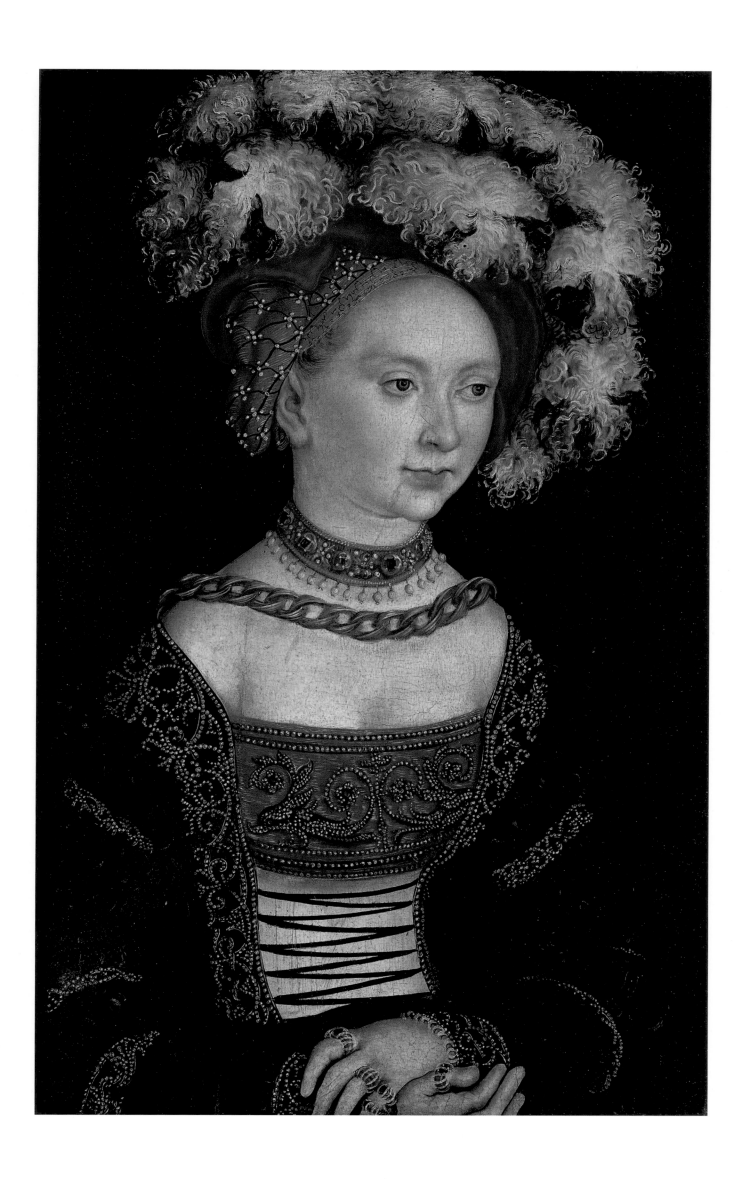

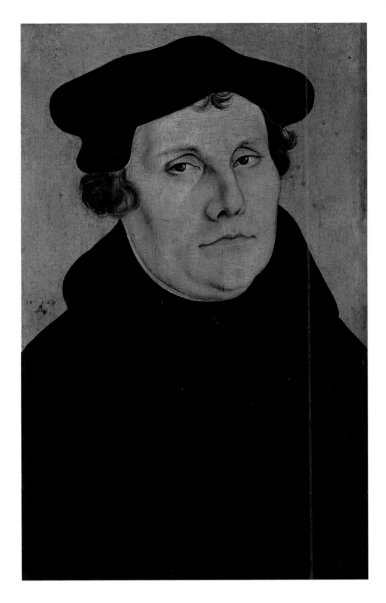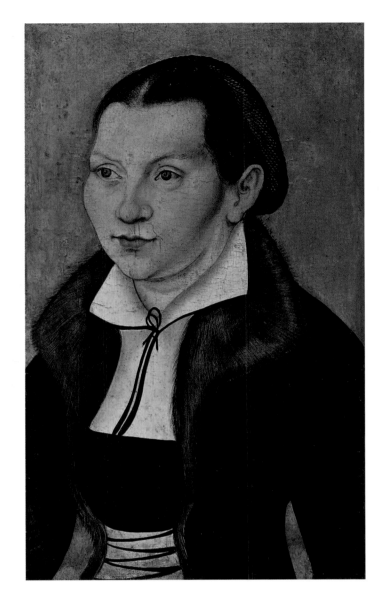

Lukas Cranach the Elder (1473–1553). *Portrait of a Young Woman.* Ca. 1530. Oil on wood.
16 ½ x 11 ½ in. (42 x 29 cm).

The young woman who sat for this portrait arrayed herself in all her finery, perhaps to present herself as well dowered, and so in the best light for a prospective husband. She exhibits wealth on her jeweled hands, around her neck and on her décolletage, and in the plumes that adorn her elaborate coiffure.

Lukas Cranach the Elder (1473–1553). *Martin Luther and his Wife, Katharina von Bora.* 1529. Oil on wood.
14 ½ x 9 in. (37 x 23 cm) (each panel).

Cranach was a friend of the German religious reformer, whom he depicted more than once. Katharina von Bora was one of a group of nuns who left their convent in 1523 and took refuge with the embattled (and excommunicated) Augustinian monk. In 1525, she jokingly proposed to him, causing him to rethink his stand on celibacy.

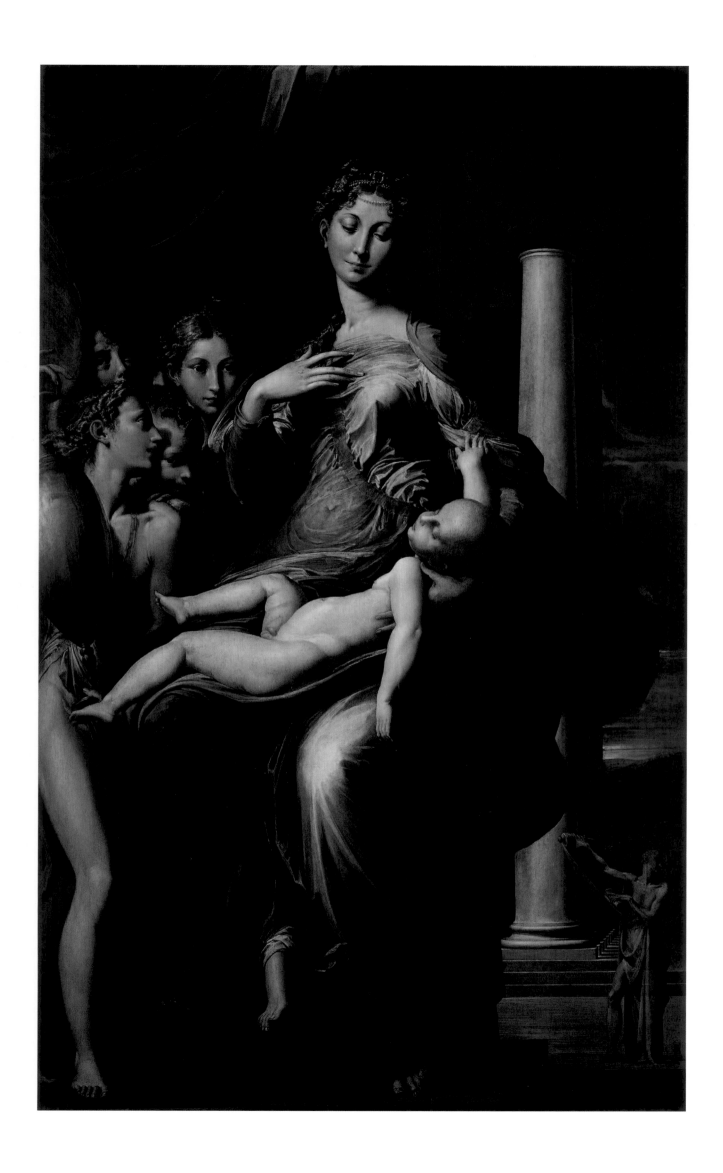

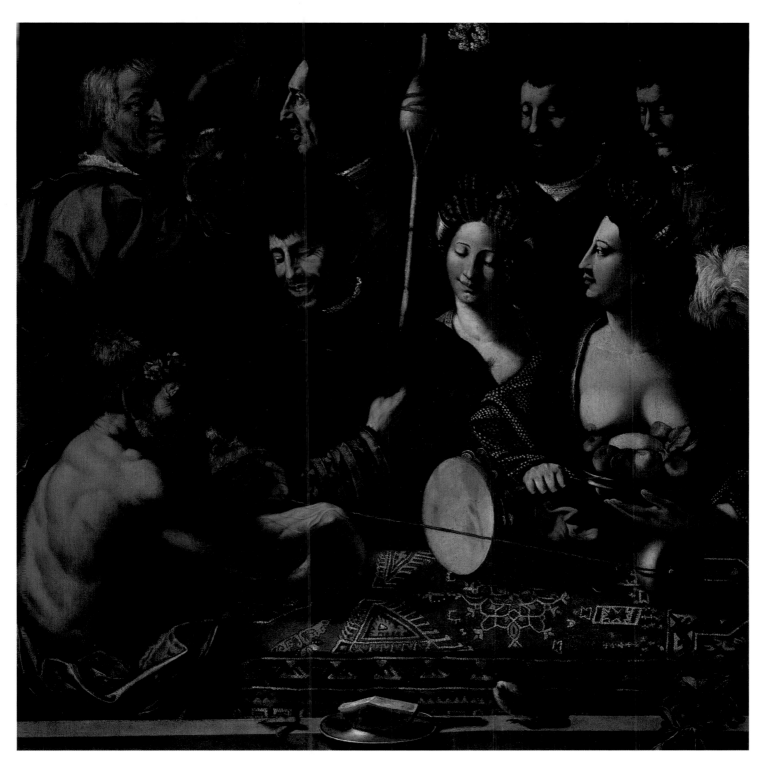

Franceso Mazzola, called Parmigianino (1502–40). *The Madonna of the Long Neck.* 1535–40. Oil on wood. 86 ¼ x 53 ⅓ in. (219 x 135 cm).

The brown patches on the right-hand side of the painting and the inscription behind the small figure reveal that Parmigianino left the work unfinished. Its edgy, exaggerated delicacy in the variously swirling drapery and elongated bodies easily distracts from the traditional references it contains, including the *Song of Songs* and Christ's death, foreshadowed by the baby's slumber.

Dosso Dossi (ca. 1486–1542). *The Allegory of Hercules.* Ca. 1540–42. Oil on canvas. 56 ⅞ x 56 ⅜ in. (144 x 143 cm).

Its grotesque and bawdy qualities suggest that this painting is meant to be comical; its erudite symbols imply that it was made for the nobility. Several of the faces look like portraits: Ercole II, duke of Ferrara, might well have contributed themes to Dossi's intricate web of meaning—a witty, yet poetic conversation piece gently mocking members of the ducal court.

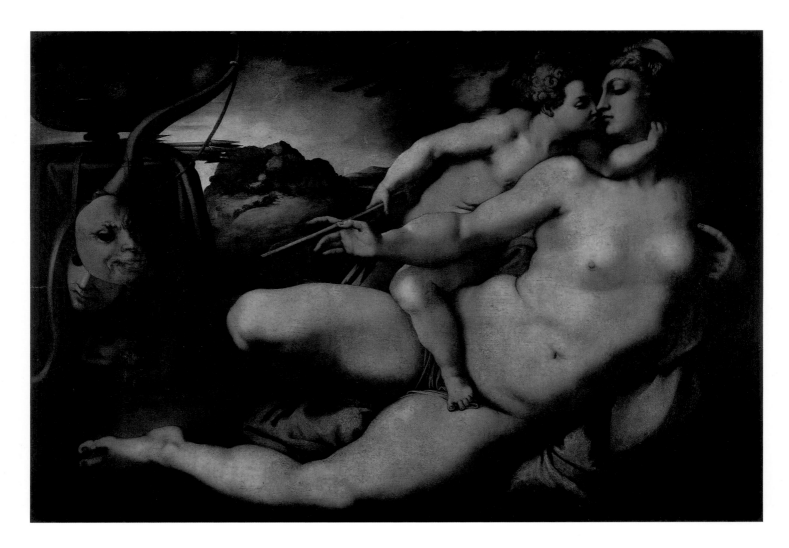

ABOVE

Jacopo Pontormo (1494–1556). *Venus and Cupid.* 1532–34. Oil on wood. 50 ⅜ x 77 ½ in. (128 x 197 cm).

Venus turns her massive body into the picture plane, confronting the viewer with it and with the incestuous kiss she gives her young son—a juxtaposition recalling more conventional allegories of Charity. Her coolly classical face resembles the second of the two masks, symbols of the misleading nature of dreams. Style and content twist together in a troubling synergy.

OPPOSITE

Francesco Salviati (1510–63). *Charity.* Ca. 1543–45. Oil on wood. 61 ½ x 48 in. (156 x 122 cm).

The three theological virtues are Faith, Hope, and Charity, or Love. The conventional representation of Charity consisted of a female figure on whom several small children would depend. Her exposed breast, the cynosure of two of the babes, is full of milk, and Salviati's sensuous draftsmanship and chiaroscuro render this virtue disturbingly ambiguous—if not downright equivocal.

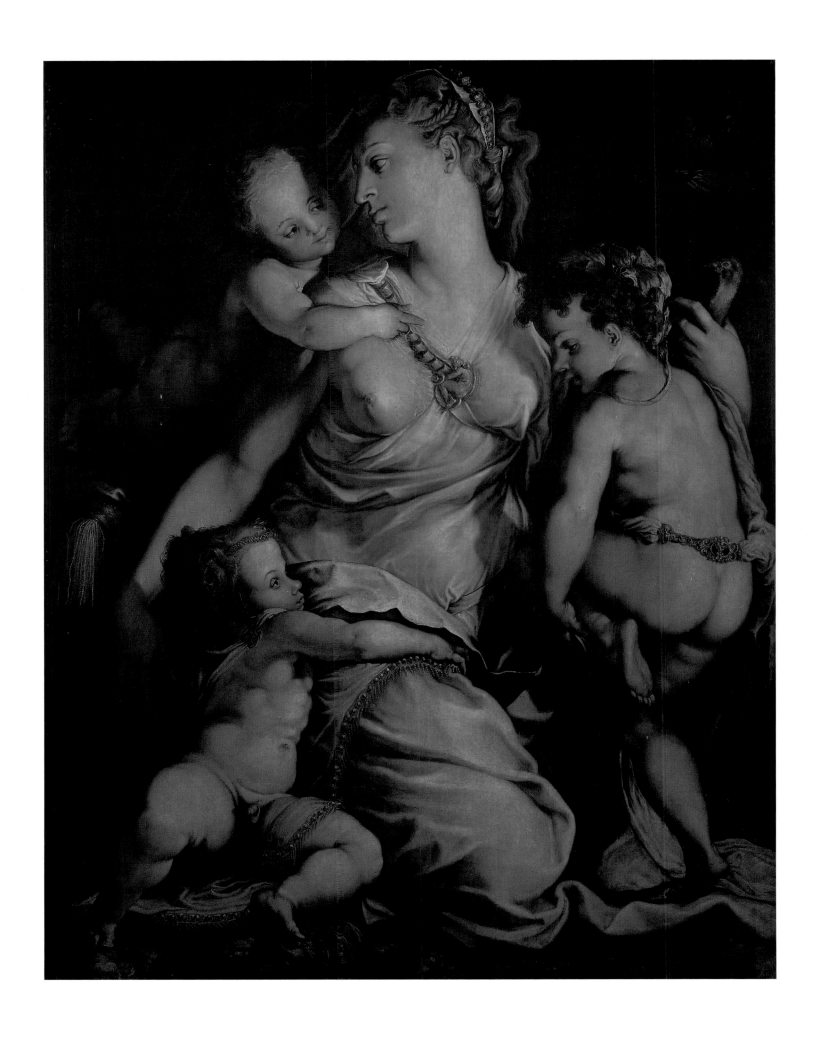

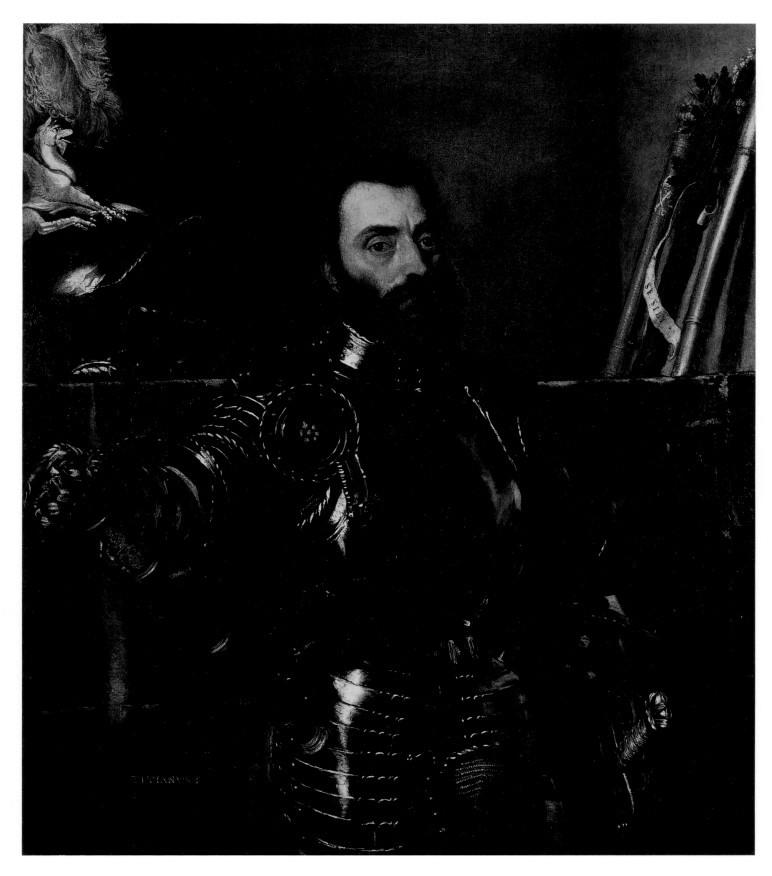

Tiziano Vecelli, called Titian (ca. 1488–1576). *Portrait of Francesco Maria della Rovere, Duke of Urbino*. 1537.
Oil on canvas. 44 ⅞ x 40 ½ in. (114 x 103 cm).

Francesco Maria della Rovere was one of Italy's legendary *condottieri*, or generals-for-hire. The scepters represent his patrons: the one he holds, for example, stands for Venice. There is a dramatic contrast between the gleaming accessories of the duke's public persona—he sent his armor to Venice so that Titian might paint it accurately—and the introspective quality of his facial features.

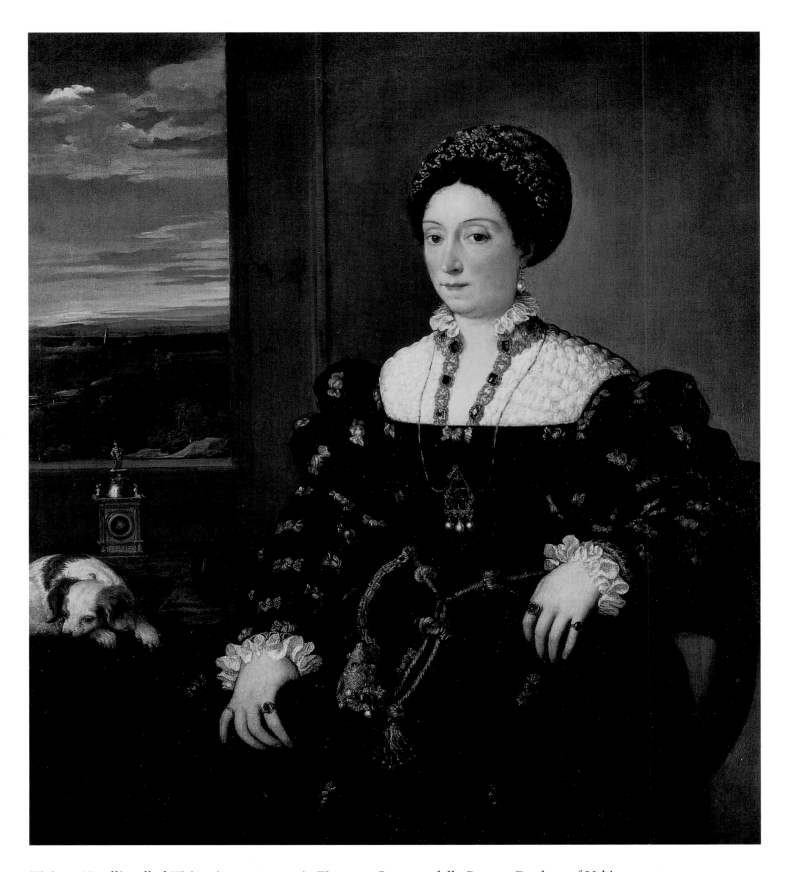

Tiziano Vecelli, called Titian (ca. 1488–1576). *Eleonora Gonzaga della Rovere, Duchess of Urbino*. 1536–37. Oil on canvas. 44 ⅞ x 40 ½ in. (114 x 103 cm).

Titian captured the kind duchess's strong character, noble birth, and status as a woman. In keeping with convention, she sits, while her husband stands in the pendant; a dog amplifies the domesticity, a reliquary expresses piety. The couple had shared the vicissitudes of Renaissance politics for nearly thirty years when Titian painted their portraits, which are related by areas of bright primary colors and rich black.

Tiziano Vecelli, called Titian (ca. 1488–1576). *The Venus of Urbino*. 1538. Oil on canvas. 46 ⅞ x 65 in. (119 x 165 cm).

Frankly autoerotic, Titian's masterpiece of color and texture reveals an important aspect of Renaissance culture. Placed over a nuptial bed (her handmaids are perhaps preparing her wedding garments), the picture of a beautiful woman helped to engender good-looking children. In addition, the prevailing medical opinion was that conception could not take place unless the female climaxed.

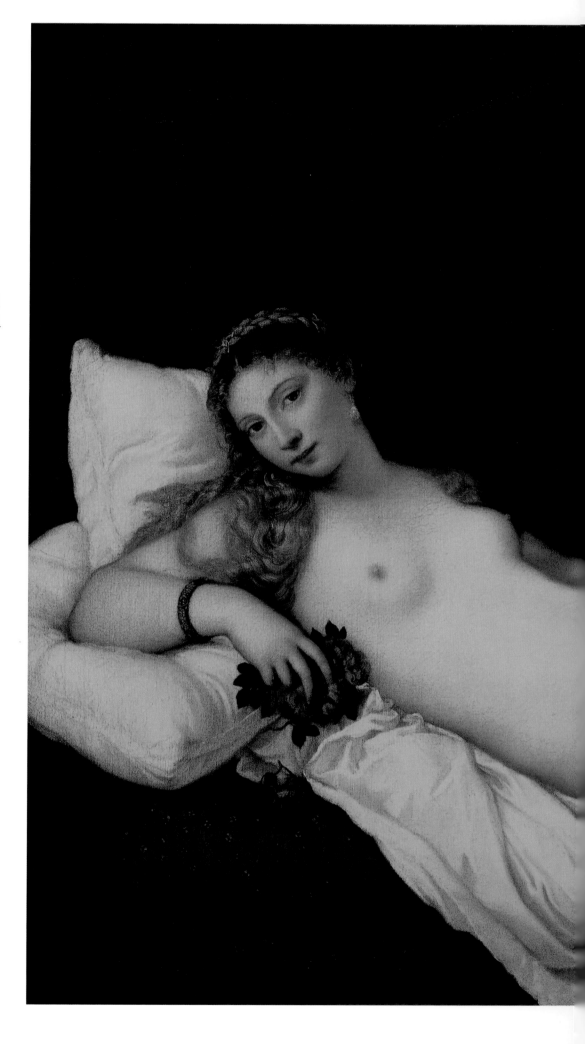

François Clouet (ca. 1516–72) and Workshop. *Henri II of Valois and Caterina de' Medici, King and Queen of France, Surrounded by Members of Their Family.* Probably assembled before 1589. Each miniature, tempera on parchment. 7 ⅞ x 7 ⅞ in. (20 x 20 cm).

This panel, which belonged to Christine of Lorraine, granddaughter of Caterina de' Medici and Henri II, probably accompanied her to Florence for her wedding with Grand Duke Ferdinando I de' Medici. The portraits include: Mary Stuart, future queen of Scots, and her husband, Francis II (upper left), and Francis I and Queen Claude, parents of Henri II (upper right).

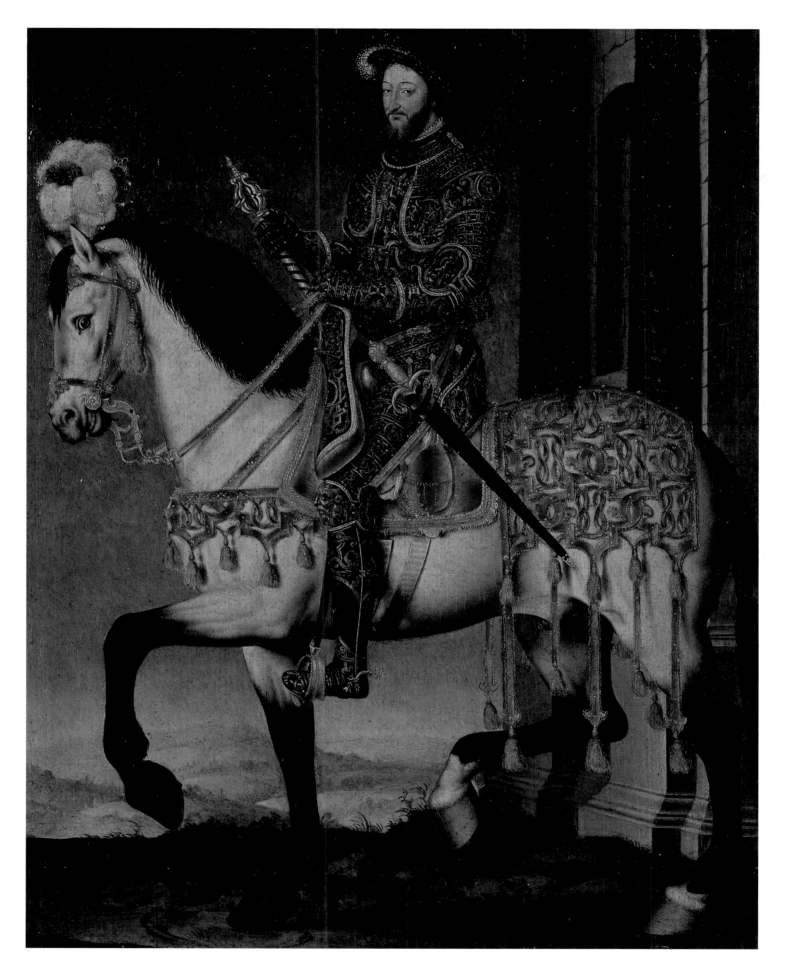

François Clouet (ca. 1516–72). *Portrait of François I of France on Horseback.* Ca. 1540. Oil on wood. 11 x 8 ⅞ in. (27.5 x 22.5 cm).

This equestrian portrait of François I is very small. The jewel hues and insightful characterization are typical of Clouet, who put the horse and his royal rider parallel to the picture plane, an old-fashioned practice. The landscape, however, recalls those by the late Leonardo, whom the king had brought to France early in the century.

Agnolo Bronzino (1503–72). *Portrait of Bartolomeo Panciatichi*. Ca. 1540. Oil on wood. 41 x 33 in. (104 x 84 cm).

The intellectual Panciatichi belonged to aristocratic circles; his family coat of arms is prominent on the right. The number three is repeated throughout this painting. Panciatichi's left hand, for example, displays the number in the Italian fashion; this may refer to a heterodox opinion concerning the Trinity. A few years after this portrait was made, Cosimo I de' Medici shielded Panciatichi from the Inquisition.

Agnolo Bronzino (1503–72). *Portrait of Lucrezia Panciatichi.* Ca. 1540. Oil on wood. 40 ⅛ x 34 ½ in. (102 x 85 cm).

Bronzino's cool light illuminates the sitter with implications of chastity, and, though her straightforward gaze meets the viewer's, her body is turned toward her husband in the pendant portrait. The book Lucrezia holds may be a book of devotions; even a soberly illuminated manuscript such as this one would have been a prized personal possession in the age of printing.

Paolo Veronese (1528–88). *The Holy Family with Saints Barbara and John.* 1550. Oil on canvas. 33 ⅞ x 48 in. (86 x 122 cm).

All is golden glory in this effulgent yet sober *conversazione*, which includes either Catherine of Alexandria or Barbara, both of whom were wealthy martyrs. With its—and Joseph's—focus on the infant's genitals, the subject is the Incarnation, his sleep, a harbinger of his death. The warm network of gazes and gestures connecting all the participants is characteristic of Veronese's style.

Giorgio Vasari (1511–74). *The Prophet Elisha.* 1541. Oil on wood. 15 ¾ x 11 ⅜ in. (40 x 29 cm).

Elisha is one of the biblical prophets whose miracles prefigured those of Christ. A man in the middle ground carries a basket, because Elisha has miraculously multiplied the available food. In response to Protestant claims to have returned to the primitive Christian Church, the Church of Rome increasingly encouraged artists to draw from the Old Testament for their themes.

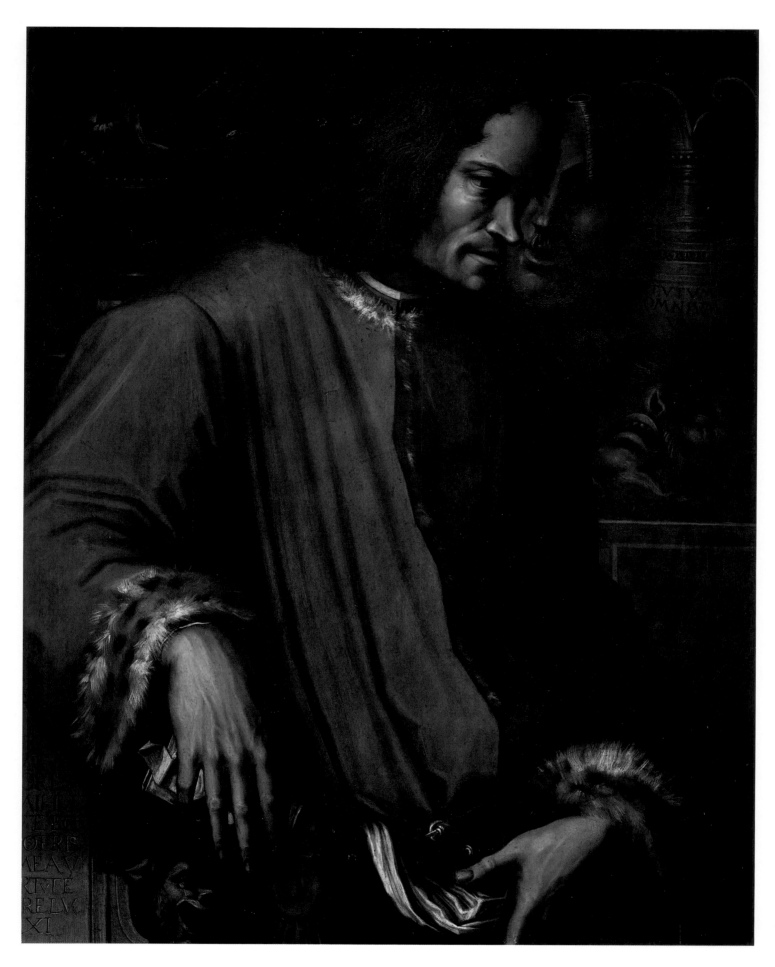

Giorgio Vasari (1511–74). *Lorenzo il Magnifico.* 1534. Oil on wood. 35 ½ x 28 ⅜ in. (90 x 72 cm).

In his posthumous, poetic portrait of Lorenzo il Magnifico, Vasari highlighted his subject's notoriously anguished moodiness. One of the allegorical masks stands for vice defeated, another for virtue. The urn, also referring to Lorenzo, is inscribed VASE OF ALL VIRTUES. Il Magnifico, who specialized in antique vases, was one of the first lavish Medici collectors, and a scholar as well.

Jacopo Pontormo (1494–1556). *Cosimo il Vecchio*. 1518–19. Oil on wood. 33 ⅞ x 25 ⅝ in. (86 x 65 cm).

Pontormo may have painted this moody posthumous study of the first Cosimo for the birth of the second. The artist cited the profile portraiture of the first Cosimo's time, but gave the body a stylized twist. The gnarled hands bespeak the old man's arthritis; his intensely inward gaze and the banderole with a quotation from the *Aeneid* recall his devotion to learning.

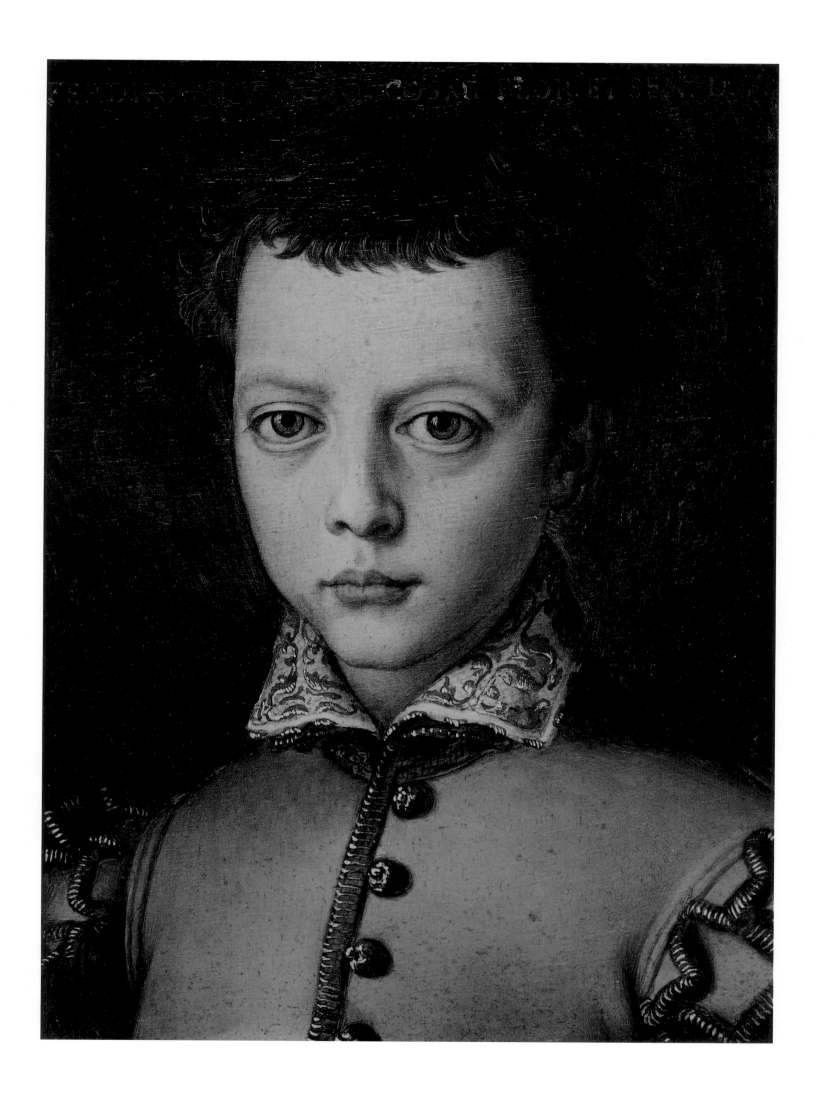

 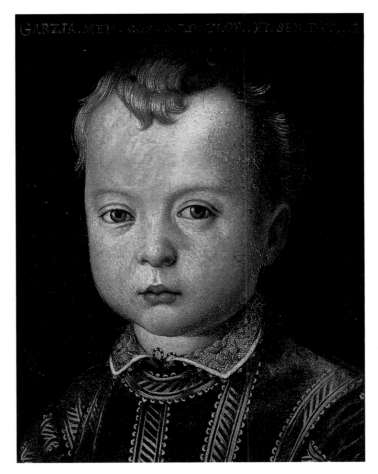

OPPOSITE

Workshop of Agnolo Bronzino (1503–72). *Ferdinando de' Medici.* 1555–65. Oil on tin. 5 ⅞ x 4 ¾ in. (15 x 12 cm).

When Ferdinando I succeeded Francesco in 1587, he renounced his cardinalate and married the French princess Christine of Lorraine. Continuing his brother's organization of the family collections in the Uffizi, Ferdinando opened the galleries, upon request, to visitors outside his personal or political acquaintance, thus making the Uffizi the world's first museum.

ABOVE, LEFT

Workshop of Agnolo Bronzino (1503–72). *Alessandro de' Medici.* 1555–65. Oil on tin. 5 ⅞ x 4 ¾ in. (15 x 12 cm).

His chain mail recalls the war that confirmed Alessandro's rule over Florence. In 1532, he became the first Medici duke, the result of a pact between his father, now Pope Clement VII, and the Holy Roman Emperor Charles V. The tyrannical and illegitimate duke, whose African features suggest his mother's origins, was murdered by his pretender-cousin, the wicked Lorenzaccio, when he was twenty-six years old.

ABOVE, RIGHT

Workshop of Agnolo Bronzino (1503–72). *Garcia de' Medici* (1547–62). 1555–65. Oil on tin. 5 ⅞ x 4 ¾ in. (15 x 12 cm).

Garcia recalls in his name his mother's background. Daughter of the wealthy viceroy of Spain at Naples, Eleanora brought a consciousness of station to the newly elevated Medici. Cosimo would lose Eleanora, fifteen-year-old Garcia, and another son, Giovanni, all in 1562.

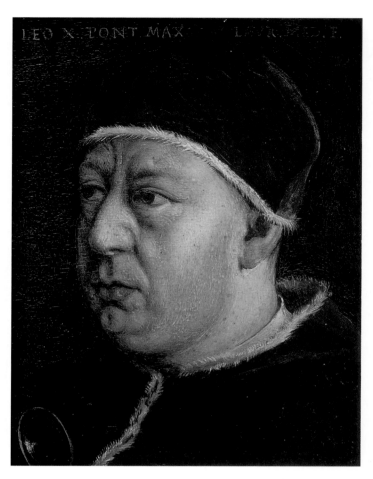

ABOVE, LEFT

Workshop of Agnolo Bronzino (1503–72). *Portrait of Pope Clement VII.* 1564–70.
Oil on wood. 23 ⅝ x 15 ⅜ in. (60 x 39 cm).

The heavy-lidded Pope Clement VII, the illegitimate son of the dashing Giuliano de' Medici, brother of Lorenzo the Magnificent, succeeded his first cousin Giovanni, who reigned as Leo X, in no less tumultuous times. The present work is derived from Raphael's triple portrait of the Medici prelate-cousins.

ABOVE, RIGHT

Workshop of Agnolo Bronzino (1503–72). *Pope Leo X.* 1555–65. Oil on tin.
5 ⅞ x 4 ¾ in. (15 x 12 cm).

This close-up is a copy of Raphael's much-copied portrait in the Uffizi of the erudite and pleasure-loving Medici pontiff who restored his family to power in 1512. Leo X reigned during a dramatic time in the Roman Catholic Church: in October 1517, a young Augustinian monk named Martin Luther nailed his challenge to a church door in Wittenberg.

OPPOSITE

Workshop of Agnolo Bronzino (1503–72). *Lucrezia di Cosimo.* 1555–65. Oil on tin.
5 ⅞ x 4 ¾ in. (15 x 12 cm).

Lucrezia's mother, the duchess Eleanora, was also very fond of pearls. Lucrezia wears a stylishly slashed gown; the stiff collar close to the neck is in the constraining Spanish fashion—like the girl's upbringing. The youngest ducal daughter married Alfonso II d'Este in 1560, the last duke of Ferrara, and grandson of Lucrezia Borgia.

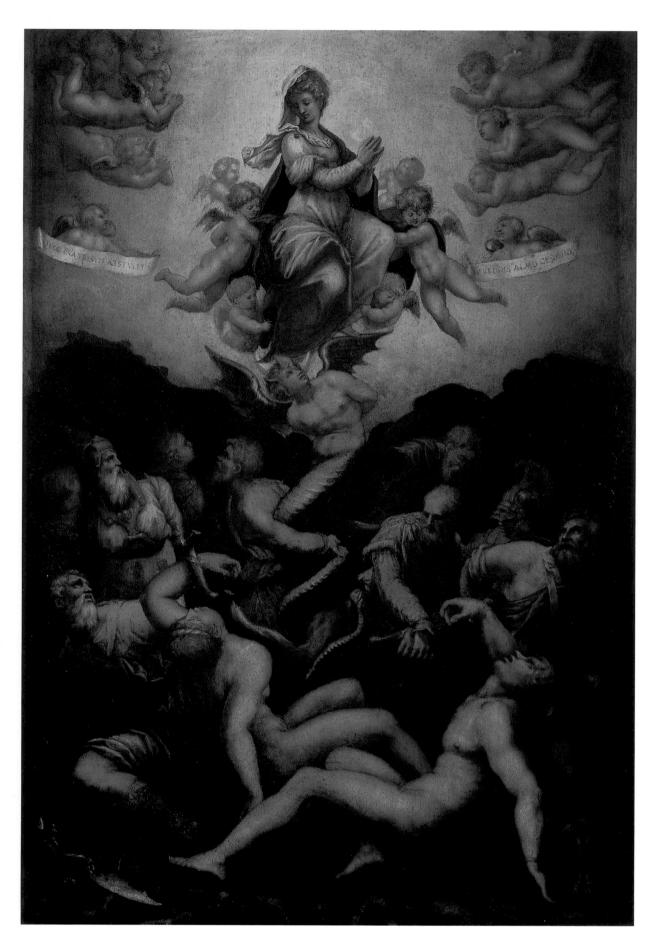

Giorgio Vasari (1511–74). *Allegory of the Conception*. 1541. Tempera on wood. 22 ⅞ x 15 ⅜ in. (58 x 39 cm).

Mary's gesture and gaze show her as beneficent intercessor, aware of the suffering of her fellow mortals, a role she assumed at the moment she conceived Jesus. She has often been represented with her foot on a serpent or on a crescent moon (signifying Satan and pagan worship), but never in just such a writhing update of medieval Hell imagery.

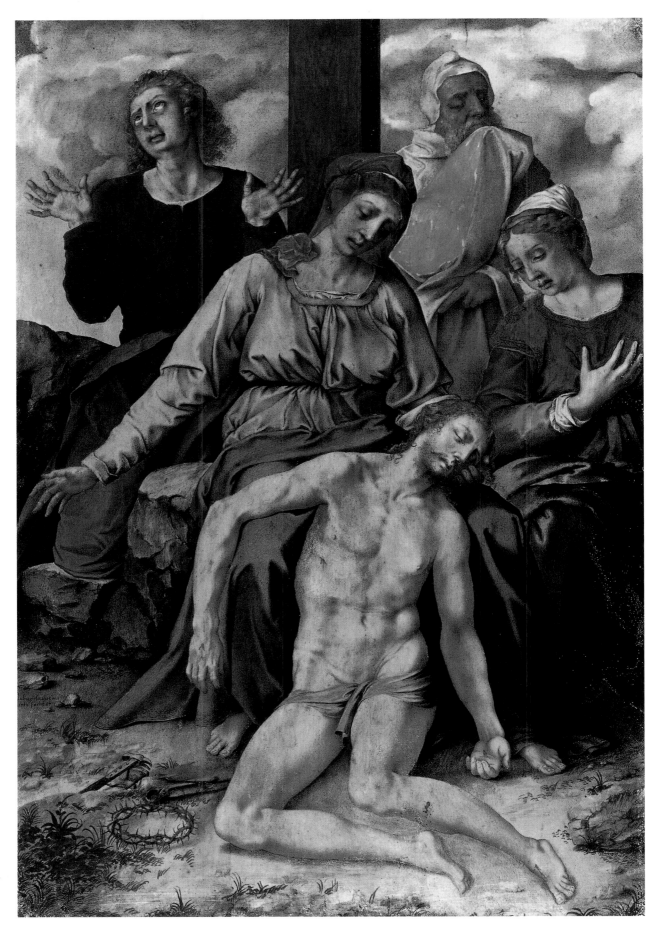

Giulio Clovio (1498–1578). *Pietà*. 1550s. Water-based tempera over metal point on parchment on wood.
14 ½ x 10 ⅛ in. (36.8 x 25.7 cm).

The Croatian-born Giulio Clovio was the last of the great miniaturists, bringing the fulsome forms of the Late Renaissance into manuscript illustration—a medium rendered rarefied by the currency of printed books. Clovio, a daring colorist, was a friend of Michelangelo and the teacher of El Greco. These various currents are visible in this virtuoso example of sixteenth-century expressionism.

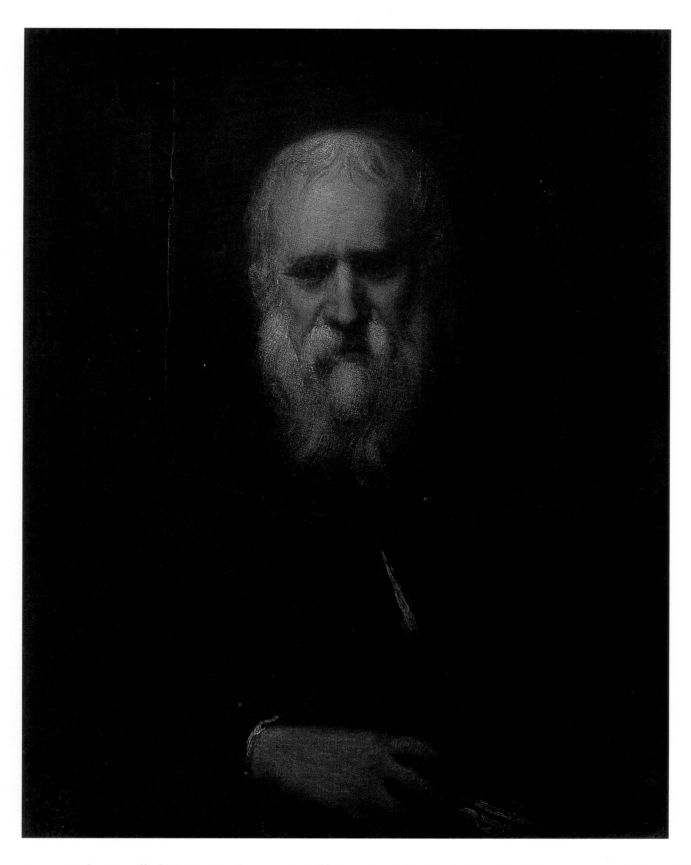

Jacopo Robusti, called Tintoretto (1519–94). *Self-Portrait with a Book.* Ca. 1585. Oil on canvas. 28 ½ x 22 ⅝ in. (72.5 x 57.5 cm).

Robusti's father had been a dyer in Venice, a *tintore;* the son was therefore *tintoretto.* The book he holds recalls that he was a member of a Venetian literary academy; he would join a second one in the 1590s. Tintoretto was maligned by some for working quickly and spontaneously—note the brushstrokes used for linen and hair.

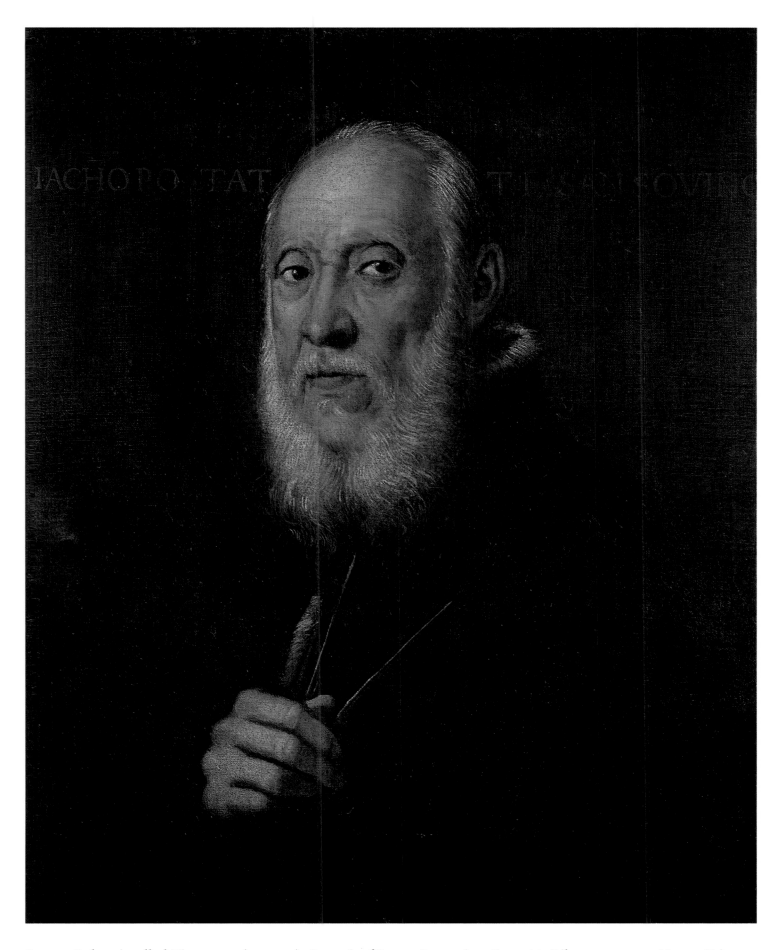

Jacopo Robusti, called Tintoretto (1519–94). *Portrait of Jacopo Sansovino*. Ca. 1566. Oil on canvas. 27 ½ x 25 ¾ in. (70 x 65.5 cm).

Renaissance idealization was a distant memory when Tintoretto portrayed the architect and sculptor who brought the High Renaissance to Venice. The painter was in his early seventies; Sansovino, around eighty. The inscription behind him gives his birth name, Jacopo Tatti, and his teacher's surname, Sansovino, which he adopted, in traditional fashion.

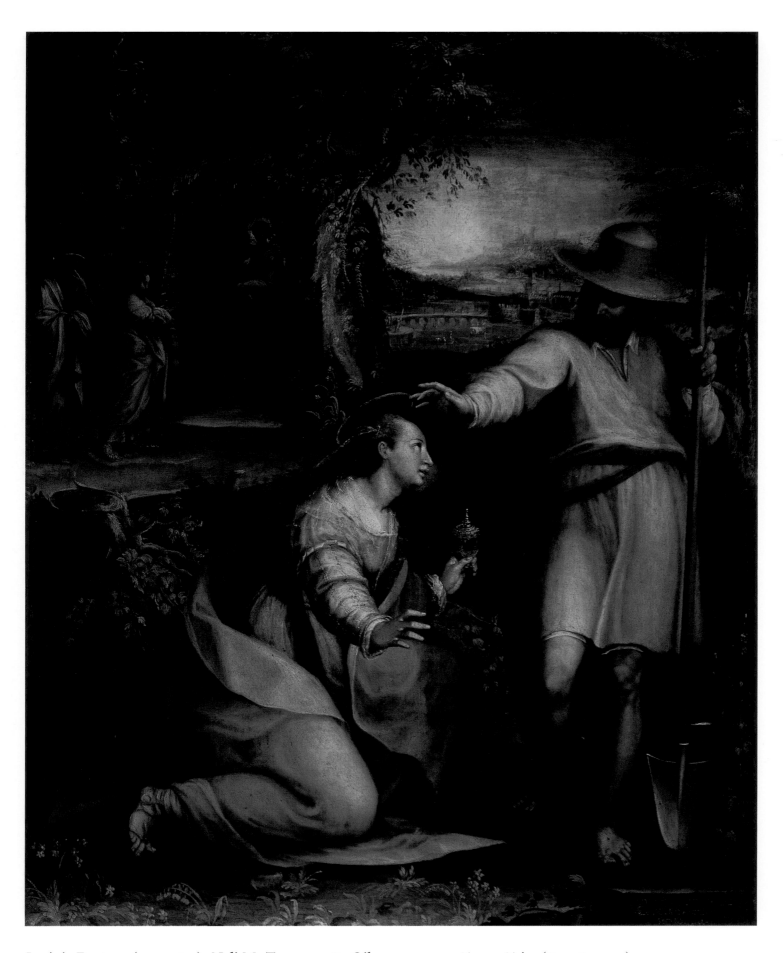

Lavinia Fontana (1552–1614). *Noli Me Tangere.* 1581. Oil on canvas. 31 ½ x 25 ¾ in. (80 x 65.5 cm).

The weeping women in the background are about to learn that Christ has risen. In the foreground, the disciple Mary Magdalen, after mistaking him for a gardener, has just embraced Jesus' knees, exclaiming, *"Rabboni!"*— "Master!" to which he replied, "Do not touch me." Fontana inserted herself into the scene: her married name, to which the shovel points, was Zappi, or "hoes."

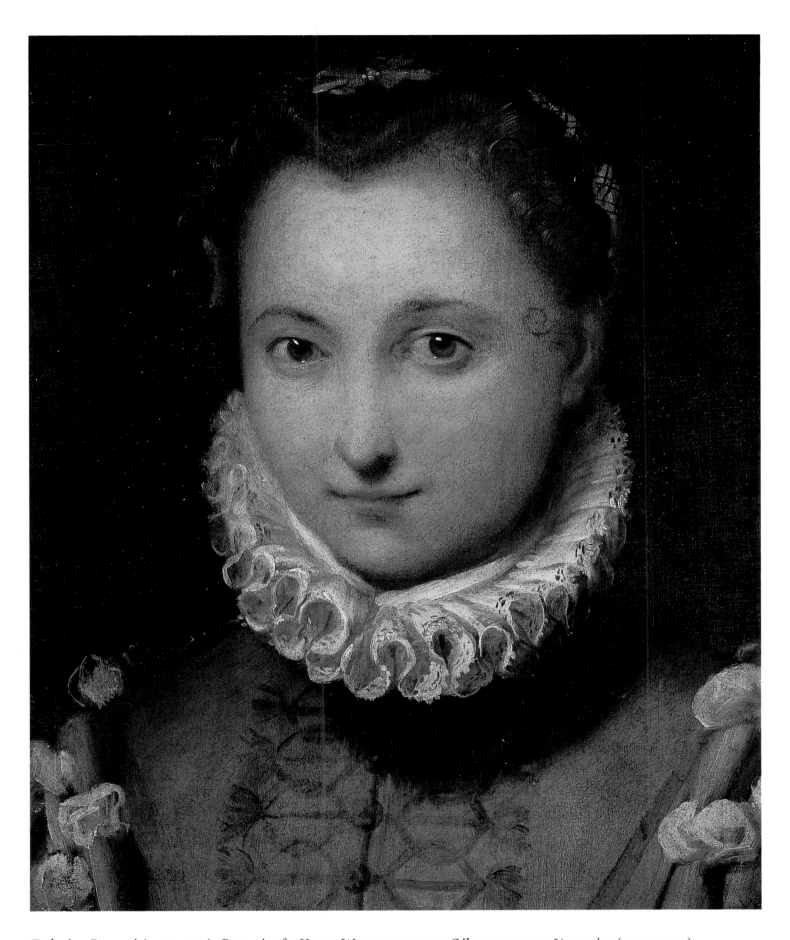

Federico Barocci (1528–1612). *Portrait of a Young Woman.* 1570–75. Oil on paper. 17 ⅝ x 13 in. (45 x 33 cm).

Her heart-shaped face accentuated by her coiffure, this young woman's expression is more intriguing than her peaches-and-cream complexion might imply. Her coloration is typical of Barocci in these years, to the point that she strongly resembles both a soldier and an angel in other works. This portrait was in Ferdinando de' Medici's collection of small paintings.

Jacopo Bassano (1510/15–92). *Two Dogs*. Ca. 1555. Oil on canvas. 33 ⅜ x 49 ⅝ in. (85 x 126 cm).

By the mid-sixteenth century, dogs were making cameo appearances in art—as were cats, monkeys, parrots, elephants, and others—but a canine double portrait, even as a genre picture, was unusual indeed. The palette floats the opalescent blue greens of a distant landscape above the browns of land, hut, and hounds outside a castle wall.

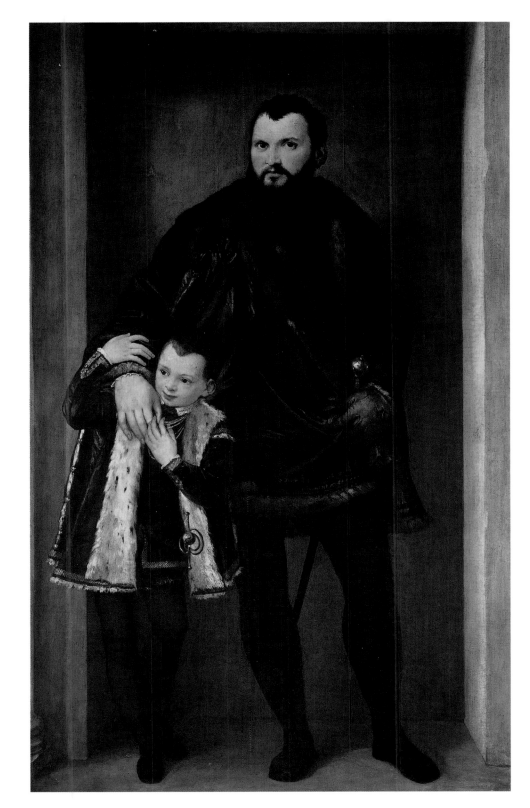

ABOVE
Paolo Veronese (1528–88). *Portrait of Count Giuseppe da Porto with his Son Adriano.* Ca. 1551. Oil on canvas. 97 ¼ x 52 ⅜ in. (247 x 133 cm).

The Count da Porto stands tall, his relaxed attitude emblematic of courtly nonchalance. His stance and intense gaze are in complex relation with the affectionate play with his son and heir, little Adriano, whose ermine and sword bespeak his status in miniature. Veronese's gift for conveying deep but aristocratically contained emotions is evident, even in this early work.

Cristofano dell'Altissimo (ca. 1530–1605). *Alchitrof, Emperor of Ethiopia.* 1568.
Oil on wood. 23 ¼ x 16 ½ in. (59 x 42 cm).

If Alchitrof does not look Ethiopian, it may be because this ancient land extended into present-day Tanzania; in Christian Europe, it was both a place of legend and the historical site of the early years of the Church. Alchitrof appears at once exotic and fully human, reflecting the age of exploration during which this painting was made.

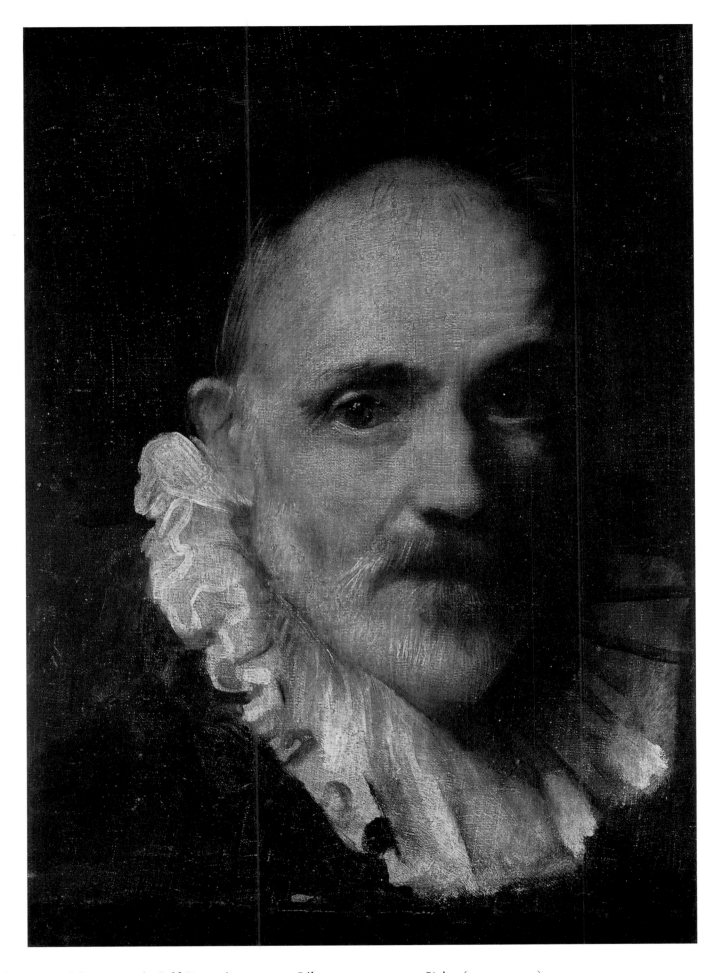

Federico Barocci (1528–1612). *Self-Portrait.* 1570–75. Oil on canvas. 13 x 9 ⅞ in. (33 x 25 cm).

The poignant naturalism of the aging painter's rheumy eyes calls attention to his skill, and also to the heightened emotion of the Baroque age, which Barocci fostered in his altarpieces and other religious subjects. By this time, a successful artist could present himself as a gentleman; Barocci, in his slightly bedraggled linen ruff, chose not to aspire quite that high.

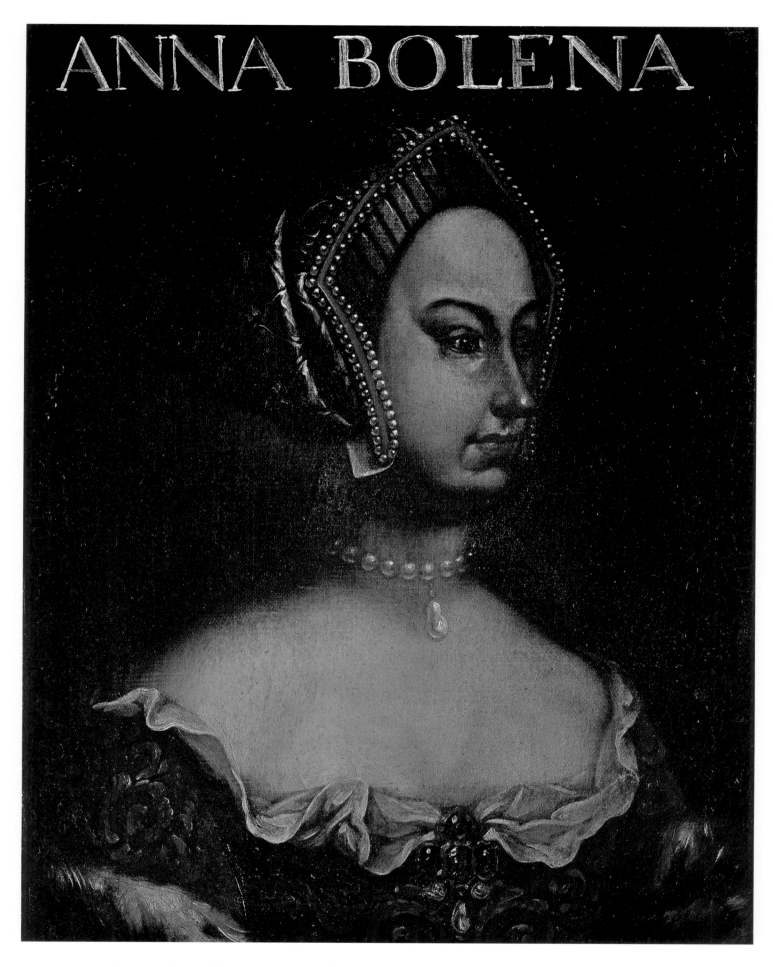

ANNA BOLENA

Anonymous. *Portrait of Anne Boleyn.* 1610–20. Oil on canvas. 23 ⅝ x 18 ⅞ in. (60 x 48 cm).

Her small mouth characterizes several portraits of the young queen, doomed by Henry VIII's desire for an heir. The unusual orientation suggests that this portrait was copied from a print, which would have reversed the direction of the original painting. When this posthumous work was done, Anne's daughter, the great Elizabeth, had recently died.

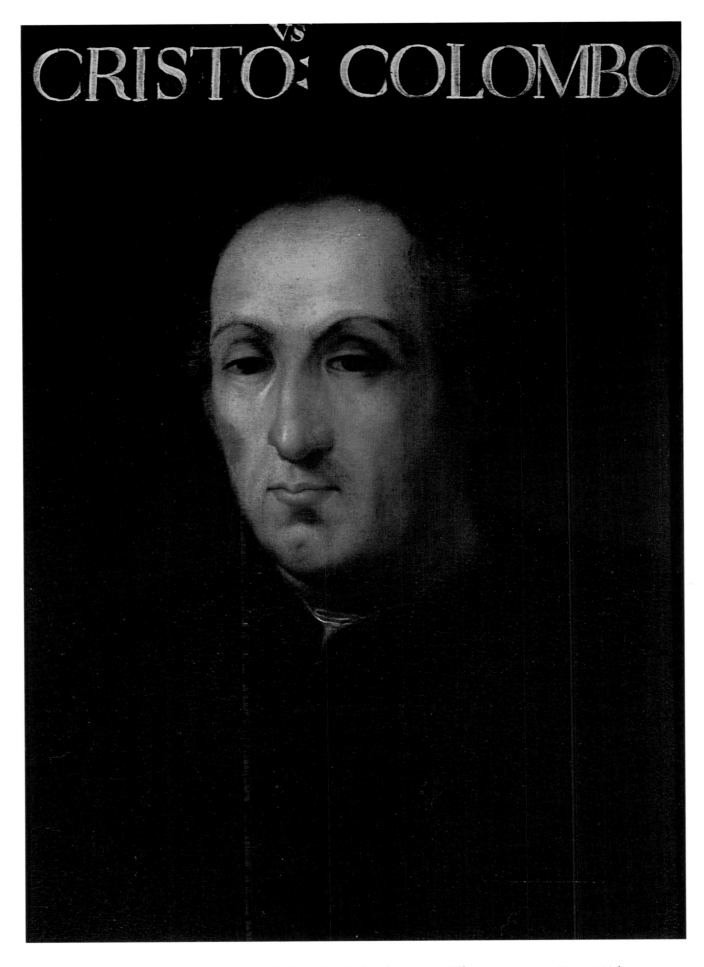

Cristofano dell'Altissimo (1552–1605). *Portrait of Christopher Columbus*. 1556. Oil on canvas. 23 ¼ x 16 ½ in. (59 x 42 cm).

Christopher Columbus had died a half century earlier. There are no certain contemporary images of the navigator, who was only one among many when he first set out in ships funded in part by Medici money. Here, he is the subject of one in a collection of paintings of illustrious women and men, a type of series much in vogue in the mid-sixteenth century.

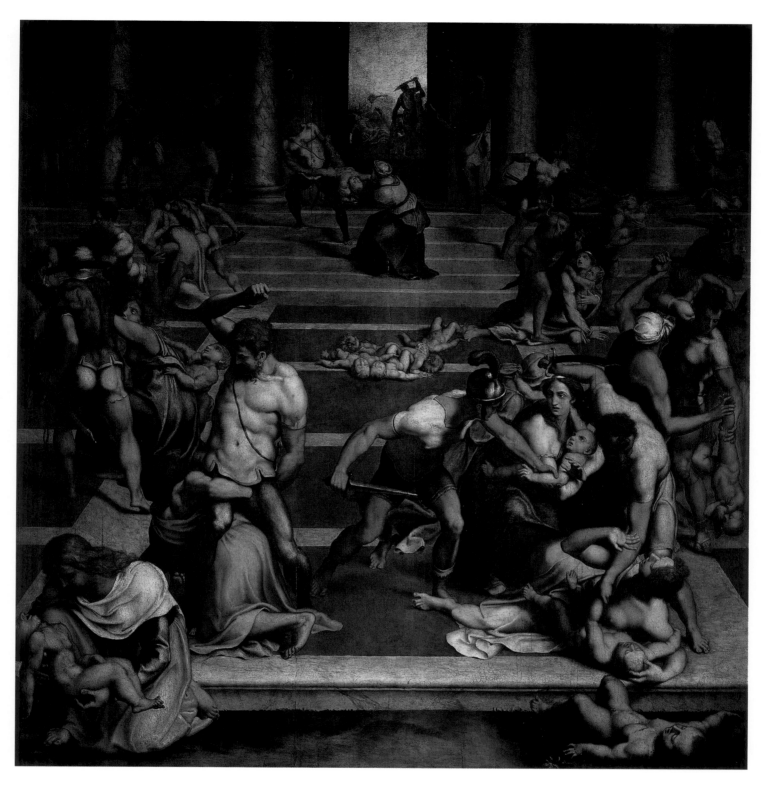

ABOVE

Daniele da Volterra (1509–66). *Massacre of the Innocents*. 1557. Oil on wood. 20 x 16 ½ in. (51 x 42 cm).

Best-known as the man who painted loincloths on Michelangelo's Sistine nudes at papal insistence, Volterra here delivered a nightmare scene in a very classically composed fashion. The central axis, recalling the construction of some of Raphael's frescoes in the Vatican, draws the eye deep into the dreadful space. The religious wars in Europe would soon bring such horrors to life.

OPPOSITE

Federico Barocci (1528–1610). *The Madonna of the People*. 1579. Oil on wood. 142 x 99 ⅛ in. (359 x 252 cm).

The lively crowd shows Barocci's joyous sweetness, while Mary-as-intercessor asserts the necessity of the church as intermediary, a hot-button theme during the emergence of Protestantism. This work was originally surmounted by a painting representing God the Father. The Trinity—Father, Son, and Holy Spirit—would have been complete. Artists traveled from all over Italy to study this influential altarpiece in Arezzo.

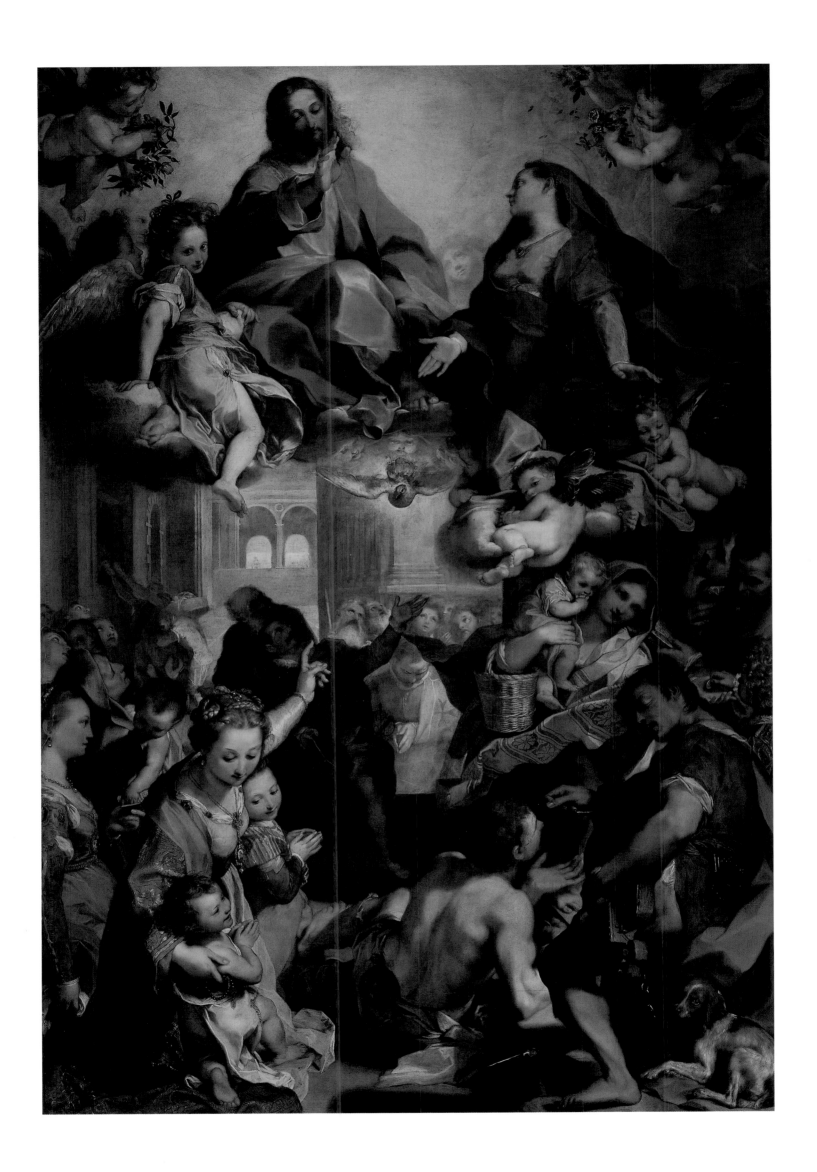

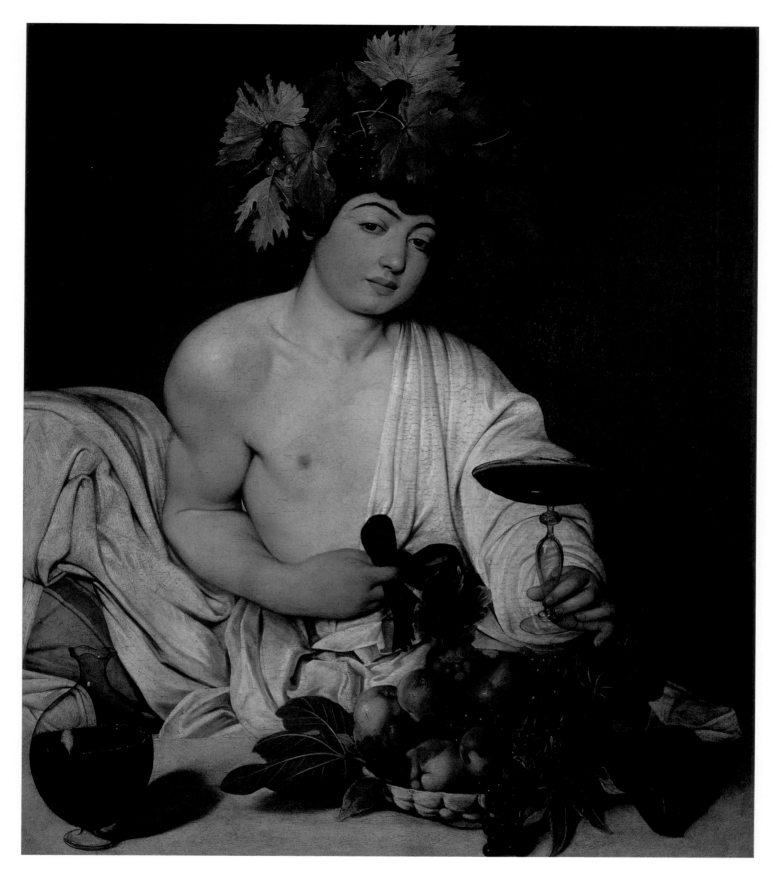

Michelangelo Merisi, called Caravaggio (1571–1610). *Young Bacchus*. 1589. Oil on canvas. 37 ⅜ x 33 ⅜ in. (95 x 85 cm).

Caravaggio's sensual naturalism, meant for his patrons' private pleasure, still has the power to shock. More masquerade than allegory, his lascivious Roman adolescent represents the ancient Roman god of wine and its disinhibiting effects. The ripe and rotting fruit and fragile glass bespeak a corruption that both repels and attracts.

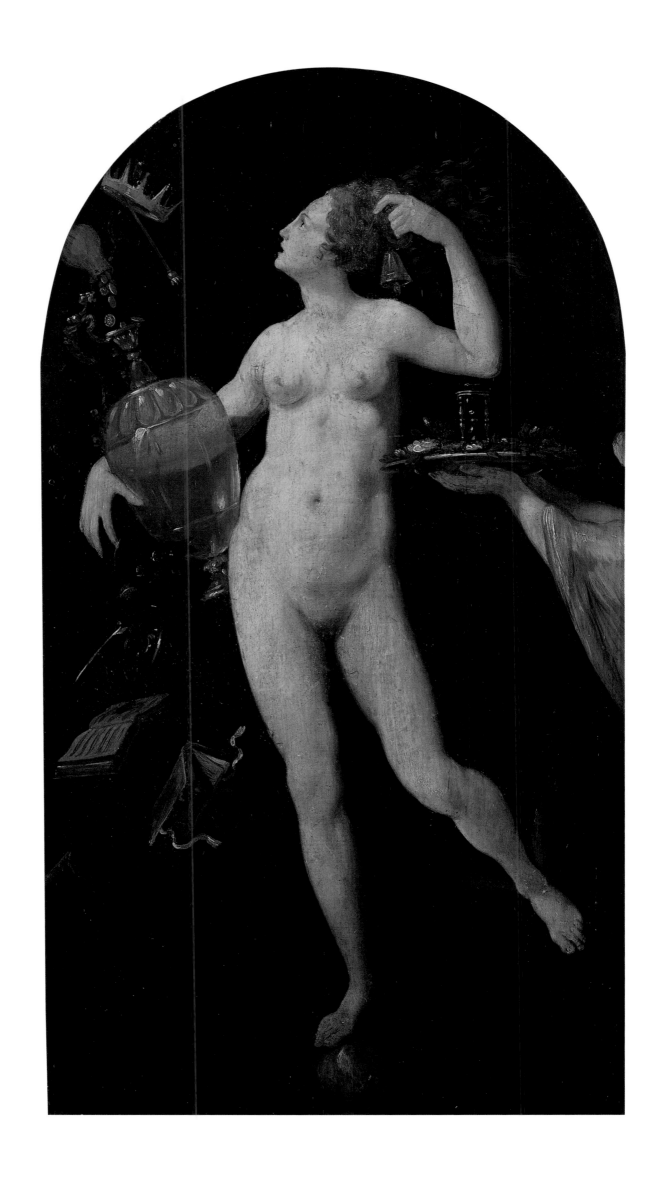

P. 191

Italian, 16th century. *Fortune.* Oil on wood. 18 ⅛ x 10 ⅝ in. (46 x 27 cm.)

This allegorical panel was in the Medici villa La Petraia in 1649, its slightly naïve composition perhaps deemed appropriate for the country. Fortune—a goddess in ancient Rome—was an important Renaissance notion. Here, the hourglass reminds that time brings down the mighty, especially when power and wealth distract from wisdom. Such Stoic philosophy also befits the aesthetic of *disinvoltura,* or aristocratic nonchalance.

BELOW

Alessandro Allori (1535–1607). *Portrait of Bianca Cappello, Second Wife of Francesco I de' Medici.* Ca. 1580. Fresco. 29 ½ x 20 ½ in. (75 x 52 cm).

Grand Duke Francesco I de' Medici was a man of profound and obsessive passions. The Uffizi galleries, which he established, were one. Bianca Capello, his second wife, was the other. The Venetian beauty had owned Botticelli's *Stories of Judith* in her own home, the Casino di San Marco, named after her native city's patron saint.

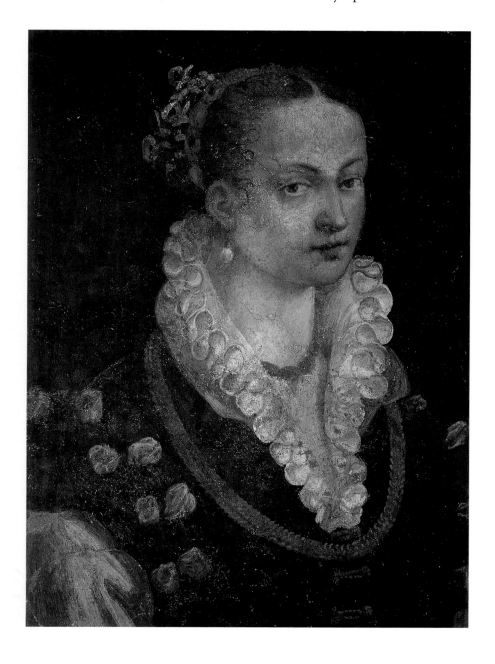

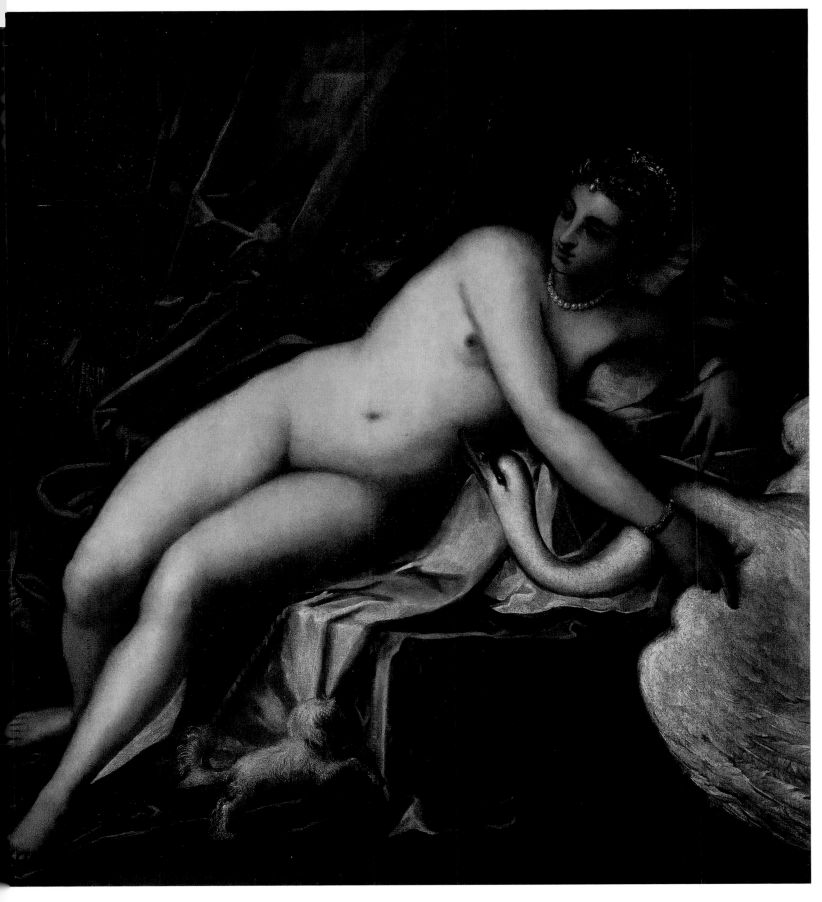

Jacopo Robusti, called Tintoretto (1519–94). *Leda and the Swan.* Ca. 1570. Oil on canvas. 63 ¾ x 85 ⅞ in. (152 x 218 cm).

The Uffizi owns two virtually identical works of this subject; the other lacks the servant on the left. There is little grace but much tension in Tintoretto's electric Mannerism, with its acid hues. The plunging diagonal of fabrics and flesh seems to express Leda's voluptuous surrender to the lustful, disguised Zeus.

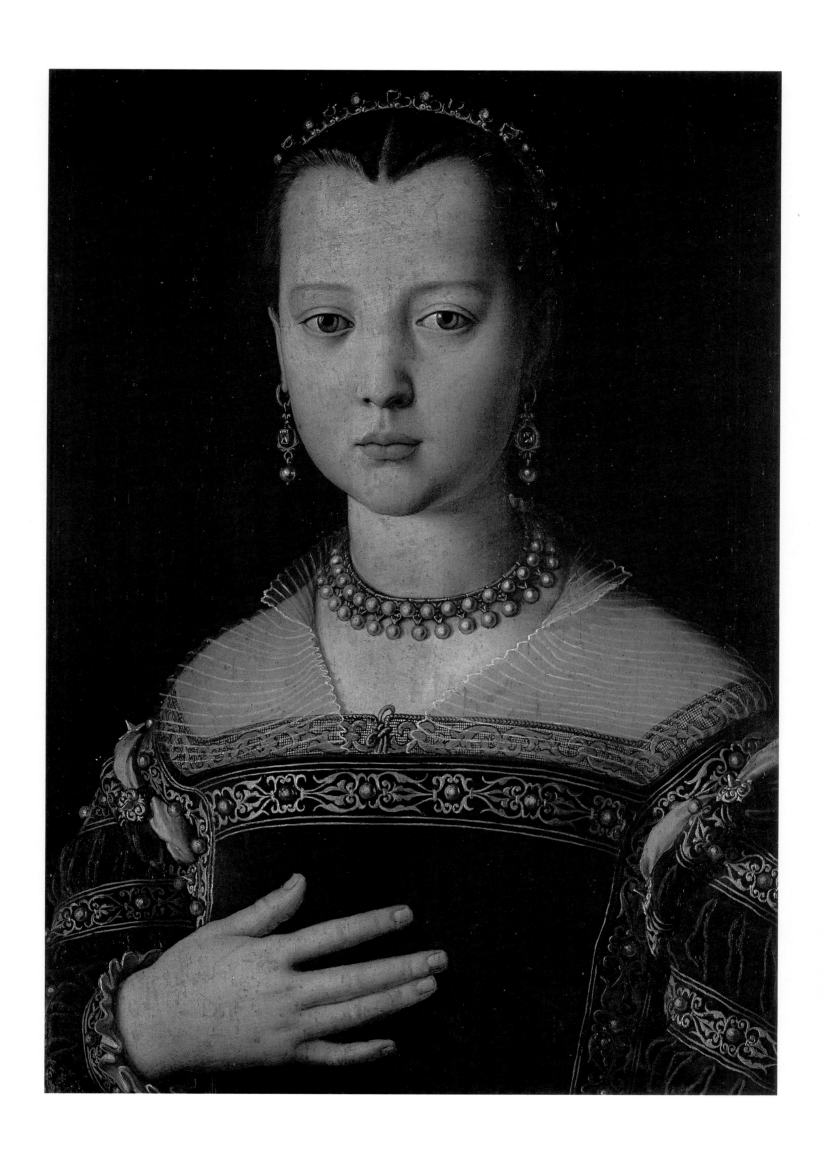

Agnolo Bronzino (1503–72). *Portrait of Marie de' Medici*. Ca. 1550. Tempera on wood. 20 ⅝ x 15 in. (52. 5 x 38 cm).

Here, the daughter of Cosimo I and Eleanora of Toledo is about ten years old. There is still something childish about the face, but her gesture—showing off her hands—and her jewels and gown—its bodice smooth over the corset beneath—are entirely womanly. This may be the portrait Cosimo wept before, after Maria died of malaria at seventeen.

Lavinia Fontana (1552–1614). *Self-Portrait in a Tondo*. 1579. Oil on copper. Diameter: 6 ¼ in. (15.7 cm).

The artist depicted herself in a studio, preparing to draw from figurines using metal-point and coated paper. Her opulent costume tells of her success and her noble clientele. Fontana learned her trade in her father's workshop and married one of his assistants, who then assisted her. Her partner also participated in domestic tasks, which were many—the couple had eleven children.

School of Fontainebleau. *Portrait of Gabrielle d'Estrées with Her Sister.* Last half of the 16th century. Oil on wood. 50 ¾ x 38 ¼ in. (129 x 97 cm).

This and a more frankly erotic version in the Louvre are generally described as portraits of Gabrielle d'Estrées. She was the great love of King Henri IV, who had intended to marry her—hence the gesture toward the ring finger. Though nudity had auspicious overtones of fertility and was a more socially acceptable state than it is in today's Western culture, this painting was certainly meant to arouse.

ABOVE
Annibale Carracci (1560–1609). *Bacchanal.* Ca. 1588. Oil on canvas. 44 x 56 in. (112 x 142 cm).

Let the bacchanal begin! Venus's astonishing flesh tones blush voluptuously at her pressed glutei, a popular motif and proof of the painter's skill. A teasing tug of war over a covering cloth is taking place between the goddess of love and the lascivious half-man.

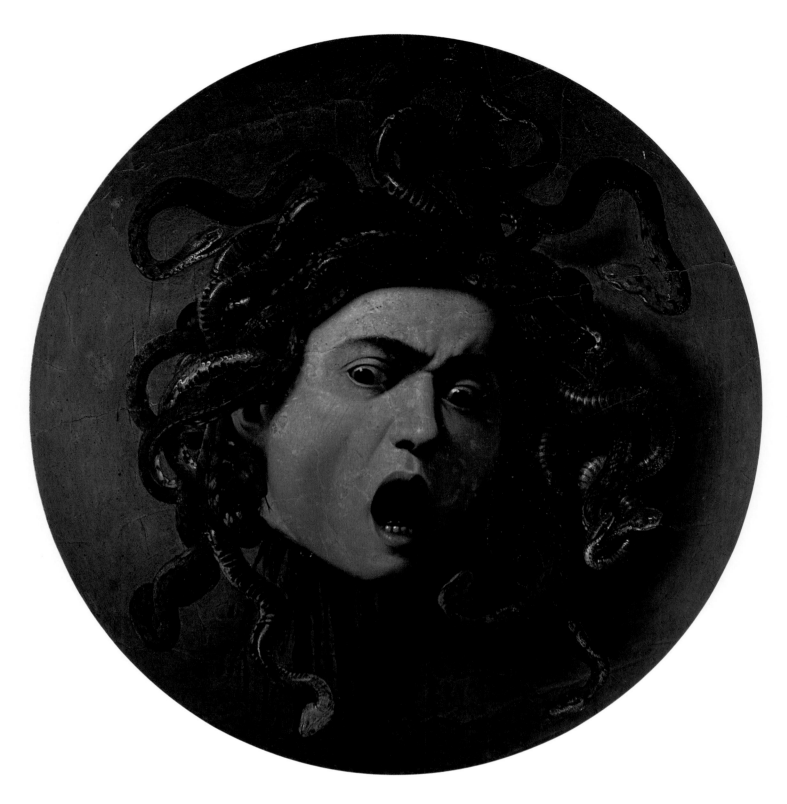

Michelangelo Merisi, called Caravaggio (1571–1610). *Head of the Medusa.* 1590–1600. Oil on canvas glued to wood. Diameter: 21 ⅝ in. (55 cm).

Caravaggio here achieved operatic emotion and irony. The gaze of the mythical Gorgon Medusa turned human beings to stone, but the artist fixed her own horrified awareness of her imminent decapitation by the hero Perseus. This singular piece entered the Uffizi armory in 1631 as a companion piece to a gift of Persian armor from one of the Safavid shahs.

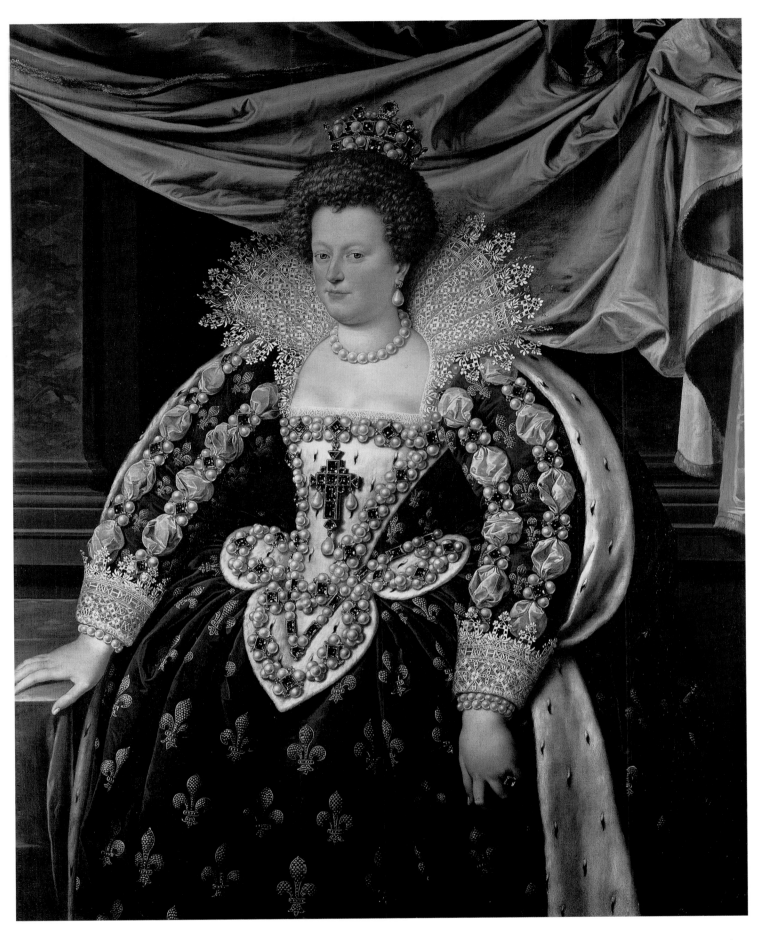

Frans Pourbus the Younger (1569–1622). *Portrait of Maria de' Medici*. 1611. Oil on canvas. 56 x 50 in. (142 x 127 cm).

Ermine, royal blue velvet embroidered with gold thread, and exquisite lace against pearly pink skin, the recently widowed, now regent Maria de' Medici had herself portrayed in her coronation dress. The daughter of Grand Duke Francesco I de' Medici identified so completely with her country of adoption that even her pearl-and-jewel-studded stomacher is shaped like the French fleur-de-lys.

Lodovico Buti (1550/60–1611). *The Architect*. 1558. Fresco with tempera and gold.

Adorned by grotesques borrowed or inspired from those of ancient Rome, Buti's frescoes in the Uffizi rooms once dedicated to arms and armor illustrate various aspects of the military arts. Here, architects wield compasses to design bastions. Two gentlemen examine a model of such a defensive structure, derived perhaps from Michelangelo's star-shaped solution above the Pitti Palace.

Lodovico Buti (1550/60–1611). *Preparation of Gunpowder.* 1558. Fresco with tempera and gold.

Various artisans use different kinds of machinery to pound the ingredients for the explosive mixture to the desired fineness. In the last stage, the powder is sifted. It is a peaceable scene for such a deadly pursuit, but constant warfare provided steady work—as did the nobility's increasingly extravagant fireworks displays.

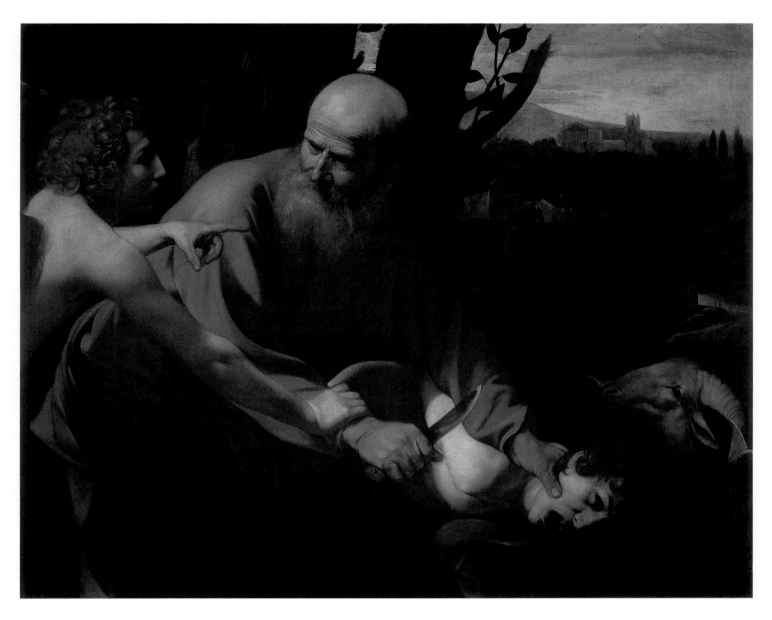

Michelangelo Merisi, called Caravaggio (1571–1610). *Sacrifice of Isaac*. Ca. 1603. Oil on canvas.
41 x 53 ⅛ in. (104 x 135 cm).

The angel's speech and the boy Isaac's cry to us for help give disturbing dimension to this biblical account, an especially significant one, because it prefigured the Crucifixion, when the heavenly Father would sacrifice *his* only son. Caravaggio's deft deployment of light and dark—the *chiaroscuro* that influenced artists for centuries—endows the momentous event with poetic resonances.

Artemisia Gentileschi (1593–1652). *Judith Beheading Holophernes*. Ca. 1620. Oil on canvas. 78 ⅜ x 64 in.
(199 x 162.6 cm).

The heavy silence of a sleeping military encampment surrounds this evocation of liberation and female valor.
On either side of the determined vertical, formed by the maidservant and the fateful sword, are the countervailing diagonals of the writhing Assyrian and the reaching Jewish heroine. It took Galileo's intervention for the painter to receive the fee promised her by the late Cosimo II.

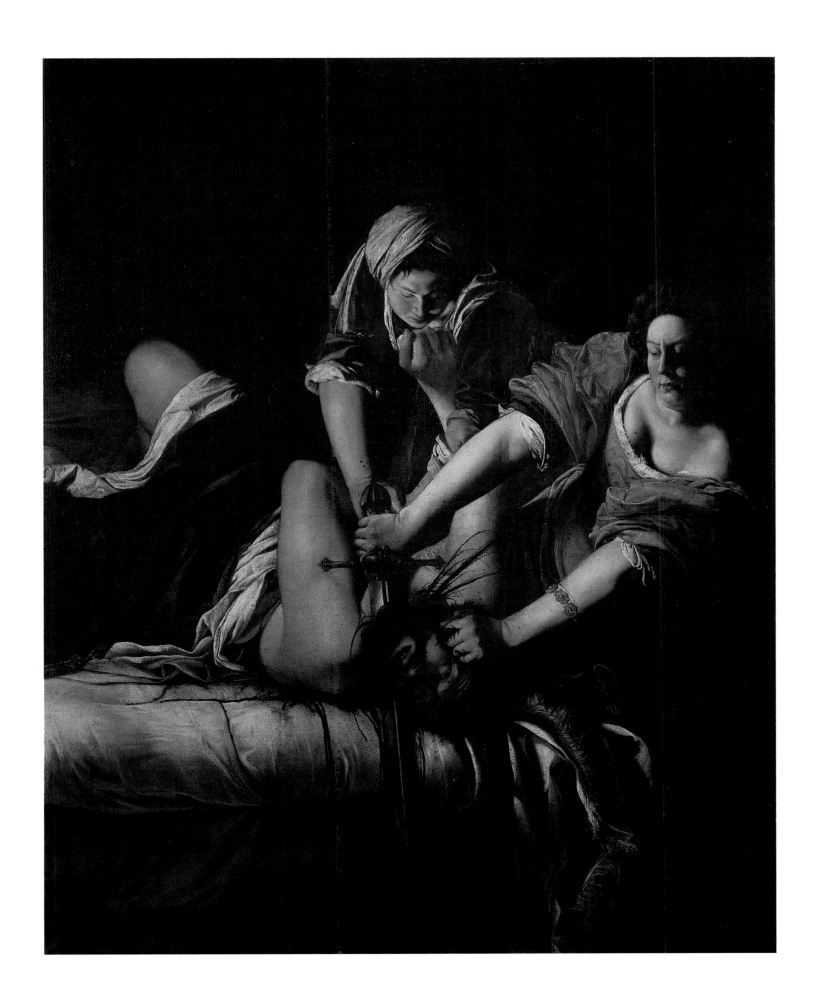

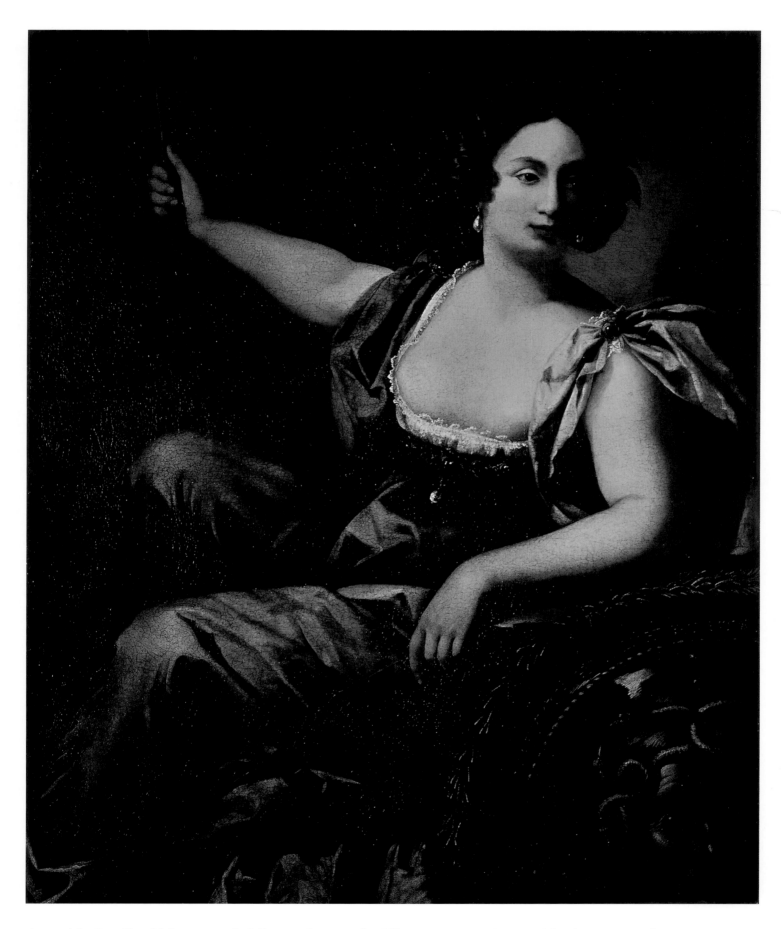

Artemisia Gentileschi (1593–1652). *Minerva*. Late work. Oil on canvas. 51 ½ x 40 ½ in. (131 x 103 cm).

Looking to classical sculpture for the deity's pure profile and posture, Gentileschi produced an opulent and very humanized portrait of the goddess of war. The bronze Medusa shield in the lower right was one of her attributes. Gentileschi, a court artist of the Grand Duke Cosimo II, was the first woman admitted to the Florentine Academy of Drawing and Design.

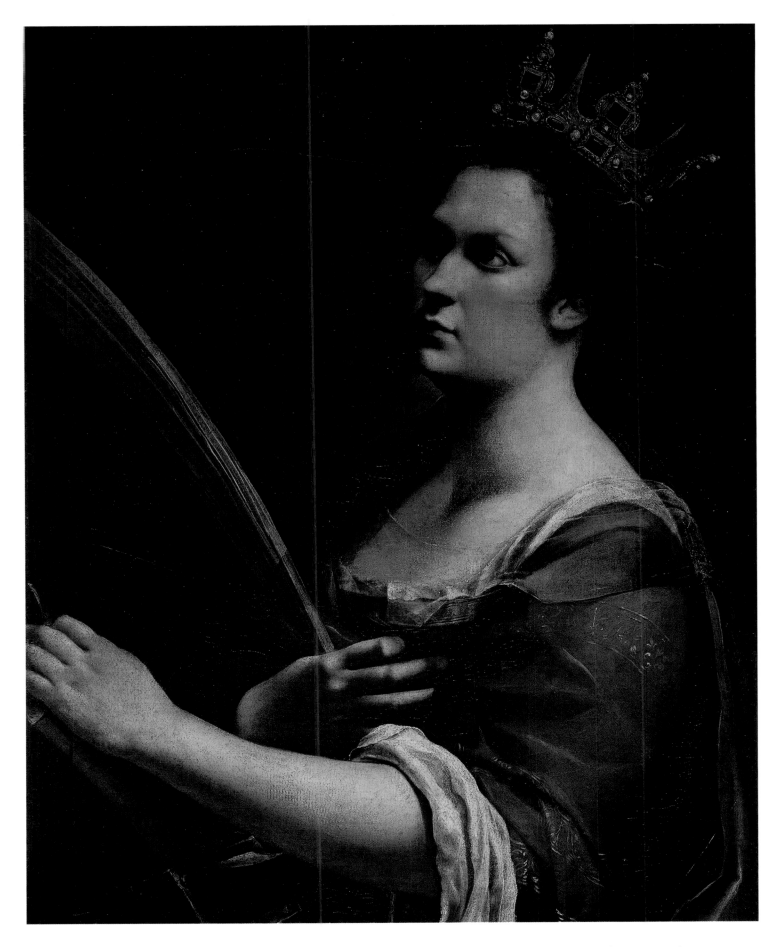

Artemisia Gentileschi (1593–1652). *Saint Catherine.* Ca. 1620. Oil on canvas. 30 ⅜ x 24 ⅜ in. (77 x 62 cm).

Saint Catherine is identifiable by the portion of the spiked wheel that was the (unsuccessful) instrument of her martyrdom. Her legend describes her courage and intellectual prowess: she defeated the arguments of fifty pagan philosophers. This bold, Caravaggesque work displays virtuosity in the rendering of the veil that covers the saint's breast, and strong diagonals that reinforce Catherine's upward gaze.

ABOVE

Domenico Theotocopoulos, called El Greco (1541–1614). *Saints John and Francis.* Ca. 1600. Oil on canvas. 43 ⅜ x 33 ⅞ in. (110 x 86 cm).

The dragon in the goblet held by the figure on the left is from a legend of the life of John the evangelist and apostle; the turbulent heavens behind him express divine inspiration. Against a serene sky, Francis displays his wounded hands—the saint is said to have miraculously received the stigmata of Christ on the Cross.

P. 207

German School. *Portrait of Sigismund III Vasa, King of Poland*. 1585. Oil on canvas. 72 ⅞ x 37 in. (185 x 94 cm).

Sigismund was the crowned ruler of Sweden for some five years. This fashionable portrait shows the gentleman-king of Poland in up-to-the-minute neck ruff and high-crowned hat, and with a well-turned leg. Only the inscription identifies his status. This may be because Poland's monarchy became elective in 1572. The painting was in the Medici collection, because the king was an in-law.

Hercules Pietersz Segher (ca. 1590–ca. 1638). *Rocky Landscape.* Ca. 1620–30. Oil on canvas applied to wood. 21 ⅝ x 39 in. (55 x 99 cm).

Peace and plenty characterize this scene, which may combine real and imagined places. Though landscapes ranked low in the official hierarchy of subjects because they did not aspire to elevate the viewer, their defenders claimed that they portrayed God's creation, and hence deserved attention. In 1656, the year of Rembrandt's bankruptcy, this was one of several paintings by Seghers in Rembrandt's collection.

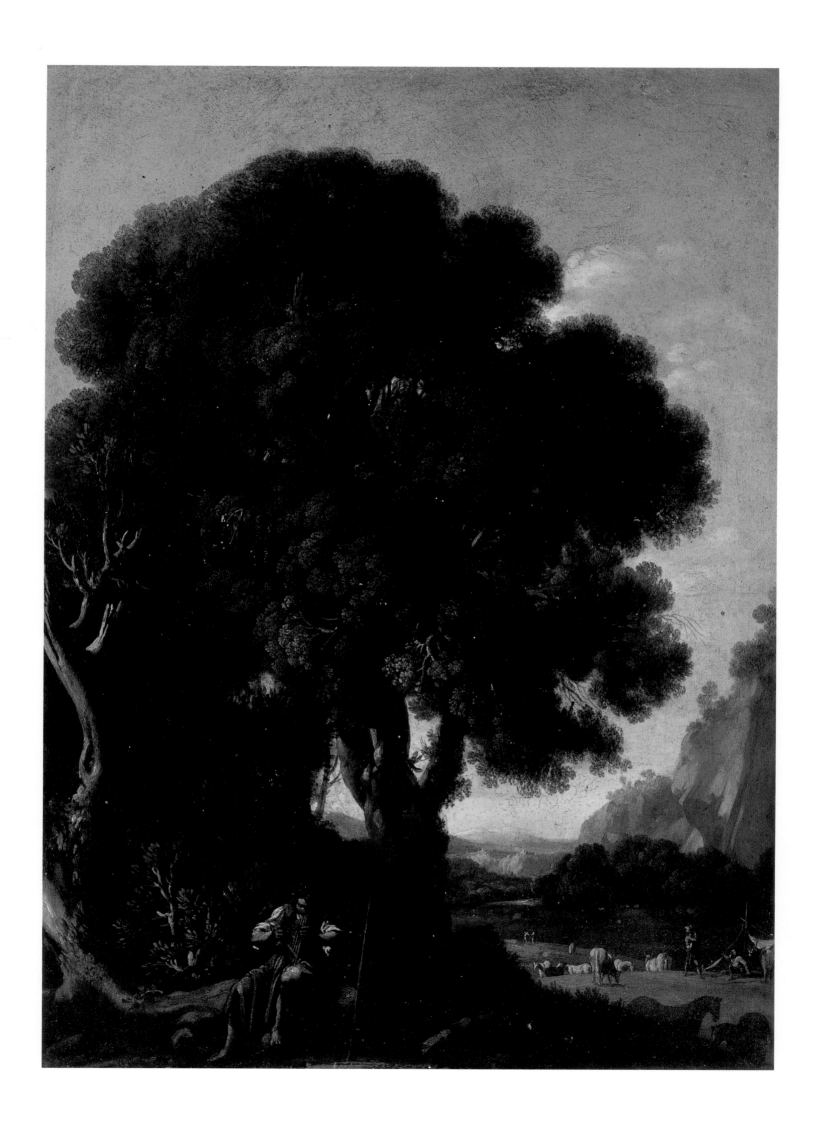

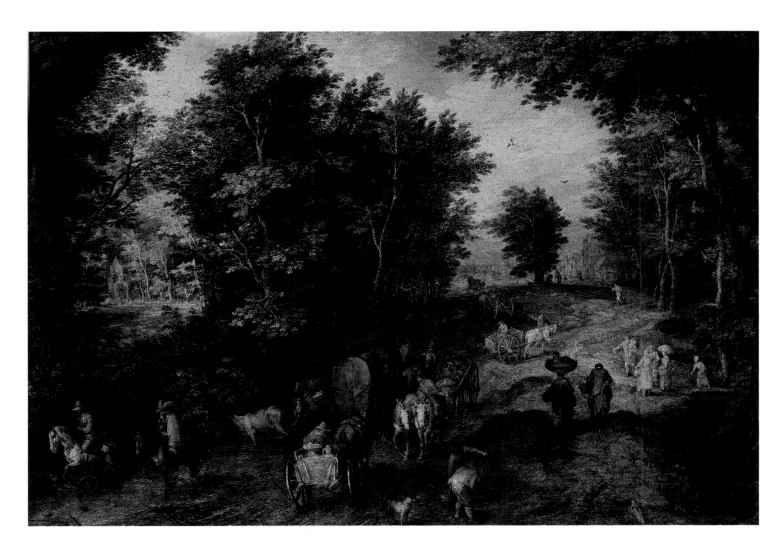

Adam Elsheimer (1578–ca. 1620). *Apollo and the Cattle of Admetus*. Ca. 1620. Oil on copper. 10 ¼ x 7 ¾ in. (26 x 19.7 cm).

Like most works, this small, glowing painting received its title from someone other than its author. Apollo, in the foreground, plays rustic pipes rather than his noble lyre. In the background are cattle, but not Admetus's. The episode, from Book 2 of Ovid's *Metamorphoses*, concerns a cunning rube named Battus who fails to get the better of the gods.

Jan Breughel the Elder (1568–1625). *The Caravan*. 1607? Oil on canvas. 9 ½ x 13 ¾ in. (24 x 35 cm).

Known as "Flower" Brueghel, because of the subject matter he was famous for, as well as "Velvet" for his blossoms' texture, Jan, son of Peter the Elder, was also known for his peopled landscapes. Like other specialists, he often collaborated on paintings with other artists, such as Peter Paul Rubens.

Gerrit von Honthorst (1590–1656). *Dinner with Lute Player*. Ca. 1617. Oil on canvas. 54 ⅜ x 80 in. (138 x 203 cm).

Cosimo II de' Medici commissioned this merry moment, which delivers a conventional moral. At an hour when decent folks are sleeping, lute music and candlelight seduce. The future of the pretty girl who carelessly sells her favors is personified in the toothless bawd. The verticals surrounding the man at the right tell the tale.

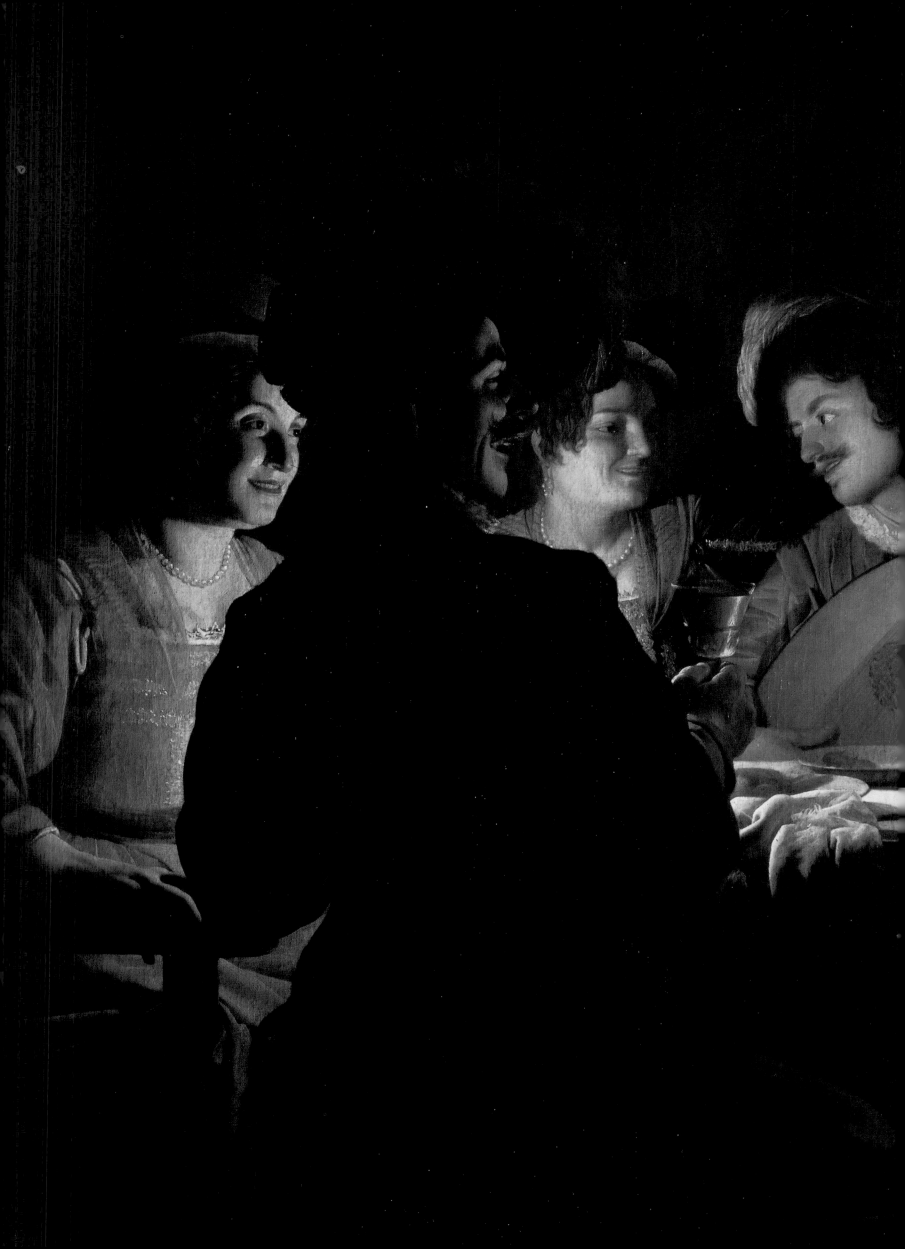

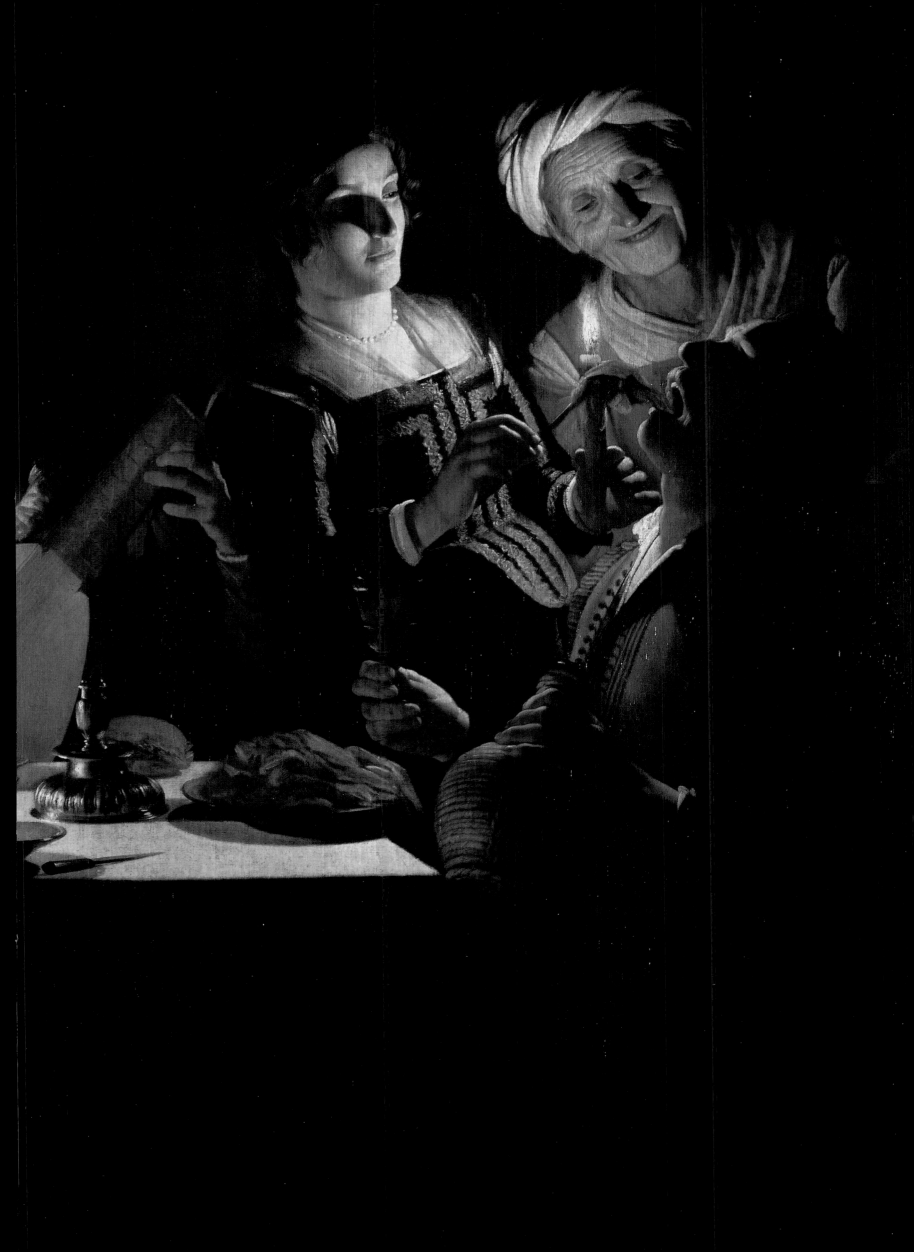

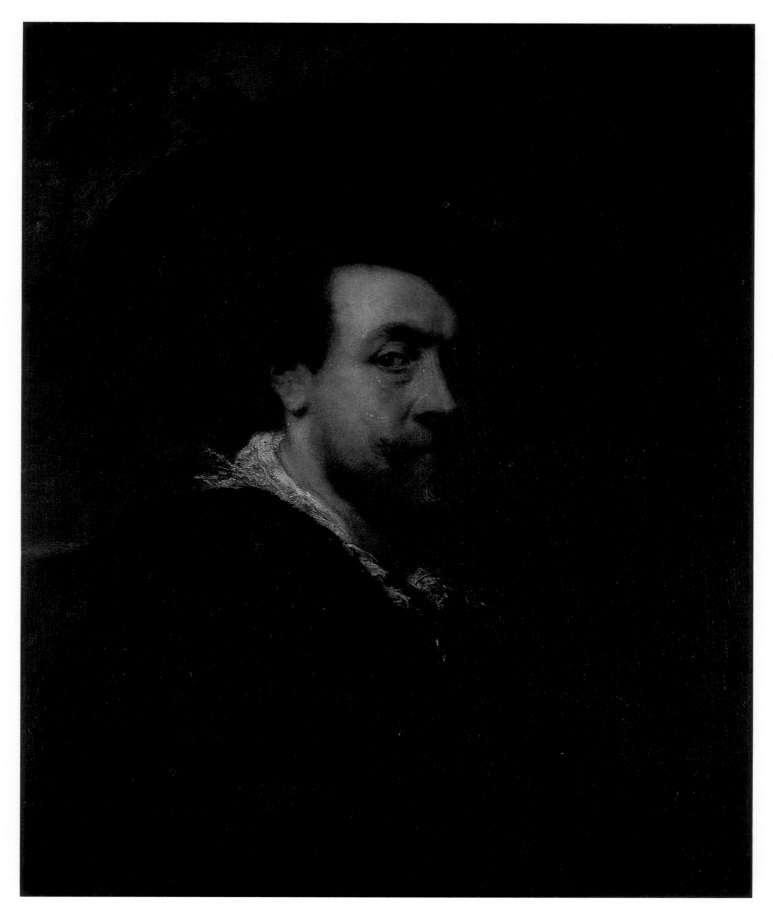

Peter Paul Rubens (1577–1640). *Self-Portrait With a Hat.* 1623–25. Oil on wood.
33 ⅜ x 24 in. (85 x 61 cm).

His broad hat identifies the painter as a bit of a dandy, while the brushwork representing his collar displays his skill and the virtuoso modernity he learned from Titian—convincing from a distance, the illusion dissolves into painterly substance from close up. Rubens was in his early fifties and enjoyed a continent-wide reputation in Europe's Catholic and Protestant countries alike.

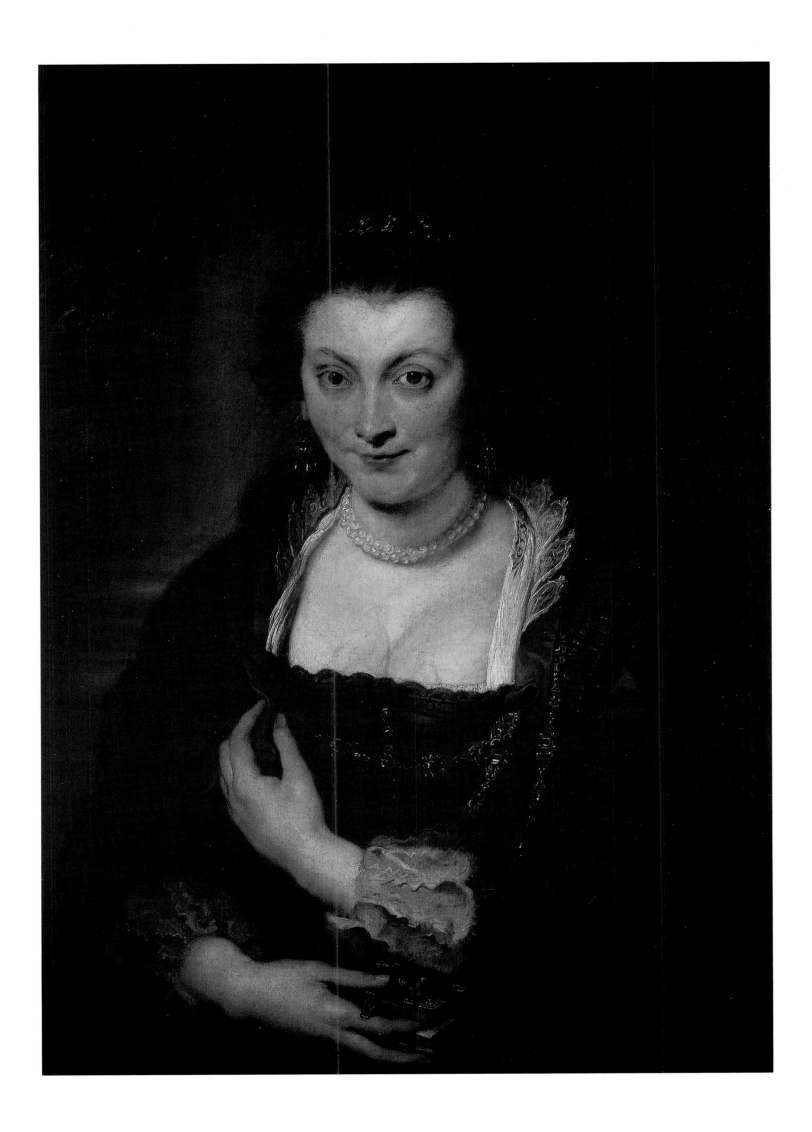

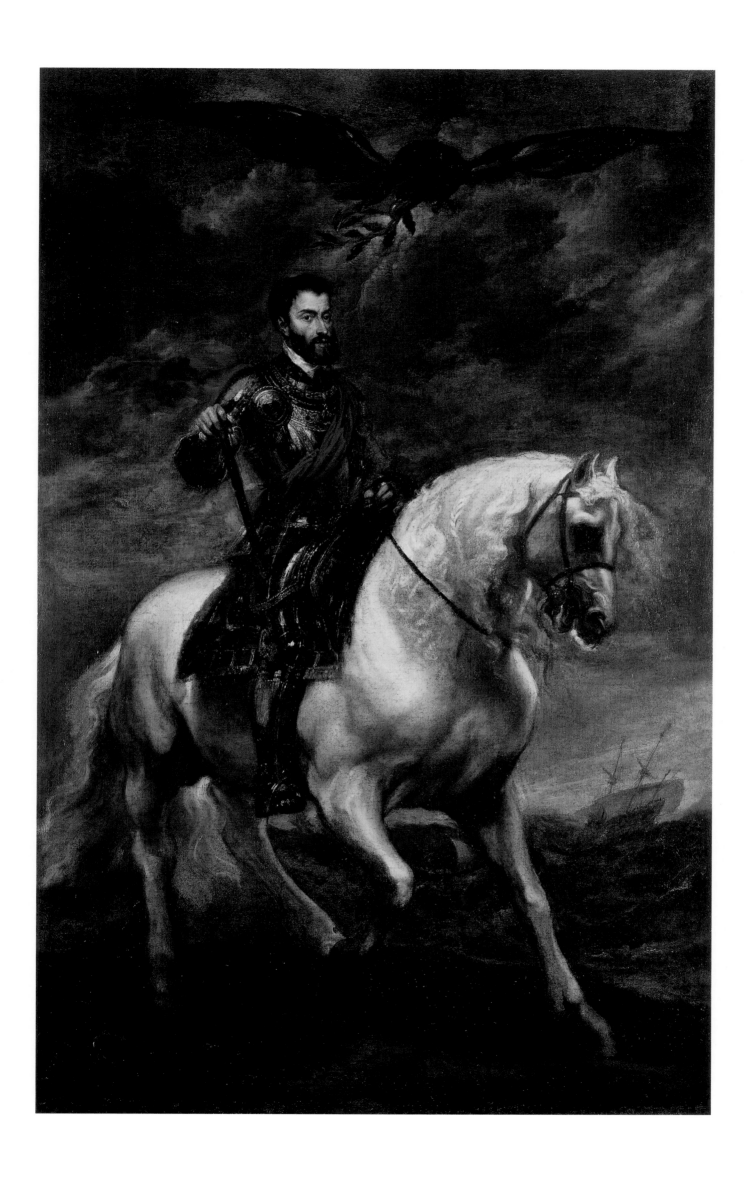

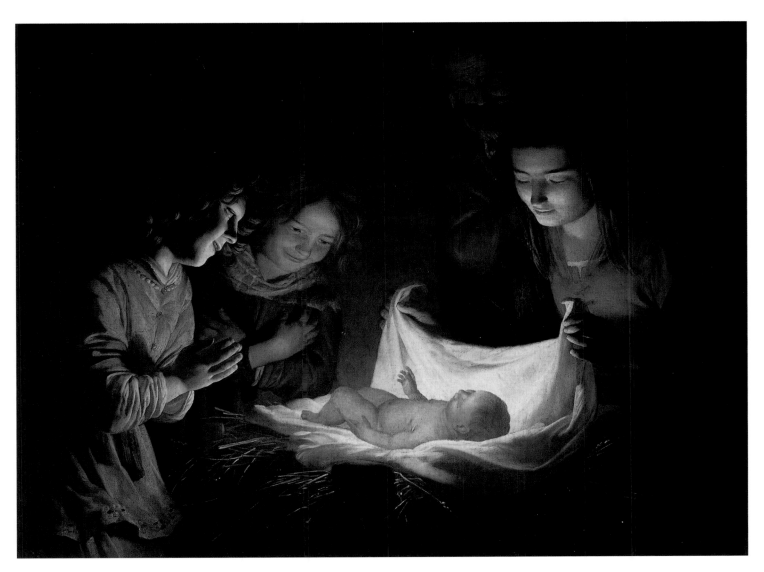

P. 215
Peter Paul Rubens (1577–1640). *Portrait of Isabella Brant.* Ca. 1625–26. Oil on wood. 33 ⅞ x 24 ⅜ in. (86 x 62 cm).

Within a year of his return to Antwerp from Italy in 1609, Rubens had met and fallen in love with Isabella Brant. His portraits of his wife emphasize her intelligence and humor, her "goodness and honesty," as Rubens wrote after she died in 1626, probably of the plague. "Truly I have lost an excellent companion. . . ."

OPPOSITE
Anthony van Dyck (1599–1641). *Portrait of Charles V on Horseback.* Ca. 1620. OIl on canvas. 75 ¼ x 48 ½ in. (191 x 123 cm).

In some ways a prodigy, Van Dyck was no more than twenty-one when he painted the most important man in Christendom. Charles was precocious, too: king of Spain, then Holy Roman emperor before he was twenty. During the religious wars, this Catholic sovereign of much of Europe made peace with the Protestants and captured Rome and the second Medici pope, Clement VII.

ABOVE
Gerrit van Honthorst (1590–1656). *Adoration of the Child.* Ca. 1620. Oil on canvas.
37 ½ x 51 ½ in. (95.5 x 131 cm).

Honthorst was celebrated for his night scenes A joyous sweetness suffuses this Nativity, presented in intimate close-up, and charming understatement colors it: the smiling children might be angels. As tradition decreed, Joseph is a shadowy figure in the background: the white linen foretells the shroud of the crucified Christ, and the straw beneath the babe presages the Eucharist.

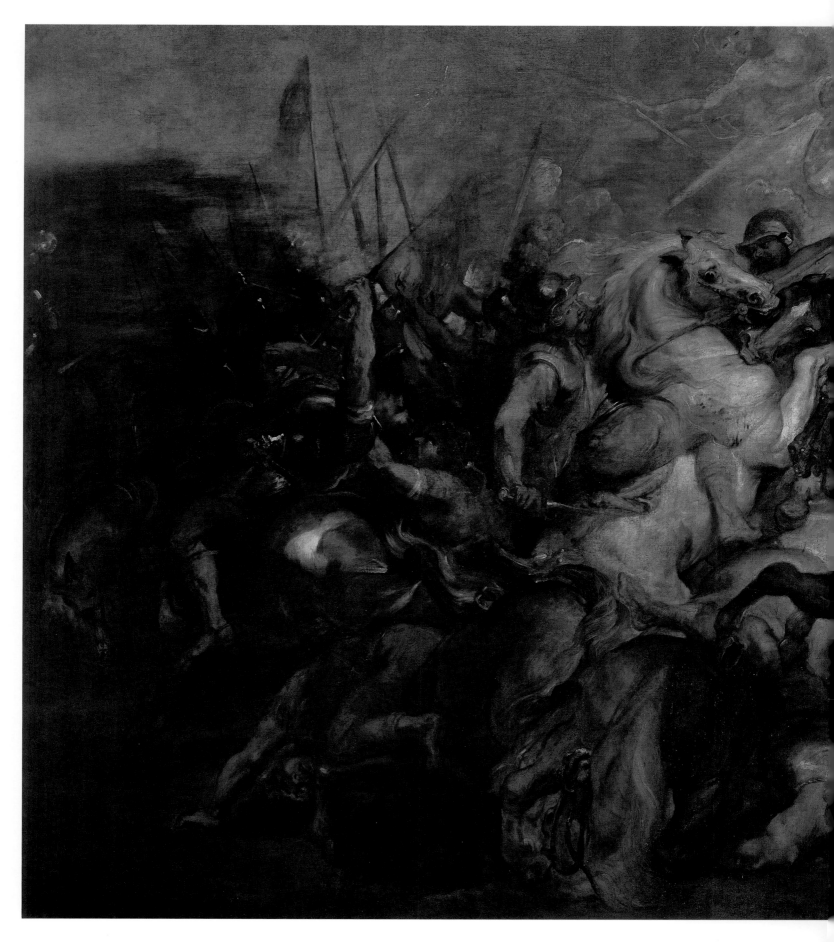

Peter Paul Rubens (1577–1640). *Henry IV at the Battle of Ivry.* 1627–30. Oil on canvas.
157 x 272 ⅞ in. (367 x 693 cm).

In the 1620s, Marie de' Medici, widow of Henry IV, commissioned two unprecedentedly ambitious series of paintings celebrating the alliance between the house of Medici and the French throne—and, incidentally, her continuing authority. This vast preparatory oil sketch recounts Henry's decisive battle as the head of the Huguenot army, a victory that paradoxically led to him being crowned king of the Catholic nation.

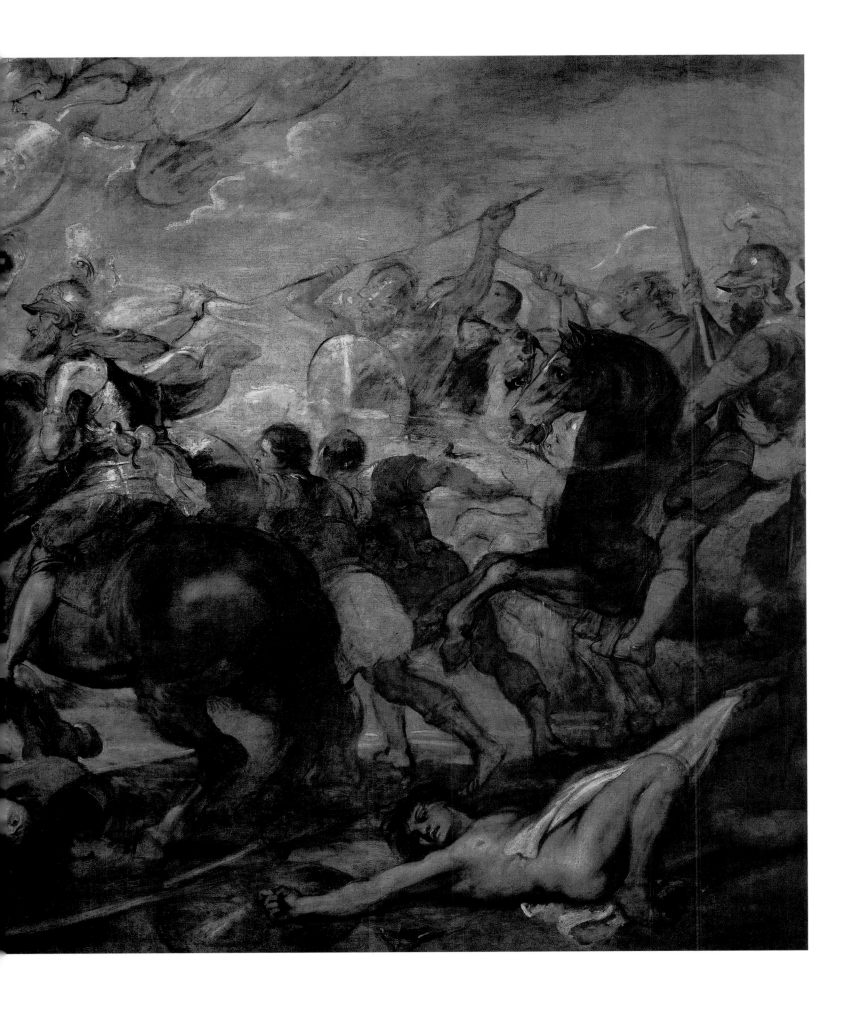

Gian Lorenzo Bernini (1598–1680). *Self-Portrait*. Ca. 1635. Oil on canvas. 24 ⅜ x 18 ⅛ in. (62 x 46 cm).

Best-known for being one of the artists who formulated the Baroque in sculpture and architecture, Bernini was also, as this informal portrait shows, an accomplished painter. In at least one case, he used a self-portrait as a study for the emotions he wished to portray in a sculpted bust, so this work may be such an exploration.

ABOVE

Nicolas Regnier (1591–1667). *Guessing Game*. Ca. 1620–25. Oil on canvas. 67 ¾ x 91 ⅜ in. (172 x 232 cm).

This moral tale places a budding young woman amid a—literally—shady group located in a gambling hell. The virginity of the fresh-faced protagonist is signaled by the immaculate linen apron draped across her lap; the threats to it are all around, beginning with the bawd behind the fortune teller. Sixteenth-century explorations brought Africans increasingly into public consciousness and art.

P. 222

Sebastiano Ricci (1659–1734). *Hercules at the Crossroads*. Ca. 1706. Oil on canvas. 25 ⅝ x 15 in. (65 x 38 cm).

The Greek hero was a popular subject, especially during the Baroque era and after, because his adventures allowed painters to display familiarity with anatomy and motion. Taking a leaf from the moralizing secular paintings of northern Europe, Ricci shows his hero in a dilemma, caught between Virtue's arduous road and Vice—with the latter conveniently frontal.

P. 223

Simon Vouet (1590–1649). *The Annunciation*. Ca. 1650–60. Oil on canvas. 47 ½ x 33 ⅞ in. (120.5 x 86 cm).

The conception is on a subtle diagonal from the window down Mary's red robe, echoed by the bodies of the hovering large angels. Mary hears, but does not see, the archangel Gabriel. The banderole, which traditionally carries the angel's salutation to the Virgin, here addresses the faithful with an adaptation from Job 33:7—"Let it not lie heavy on you to venerate the Mother."

Rembrandt van Rijn (1606–69). *Self-Portrait as a Young Man.* Ca. 1634. Oil on wood. 24 ⅝ x 21 ¼ in. (62.5 x 54 cm).

In 1634, life was still good. Rembrandt married his beloved Saskia that year and was doing well with portraiture and biblical subjects, both paintings and prints. This work displays his range: he was equally skilled at rendering character and material textures. He also loved costumes—the metal gorget was a piece of armor, but Rembrandt was never a soldier.

Anthony van Dyck (1599–1641). *Self-Portrait.* Ca. 1632. Oil on canvas. 31 ⅛ x 24 ⅜ in. (79 x 62 cm).

King Charles I knighted the Flemish painter in 1632; the chain may be a gift from their royal majesties. The protrait sits within an oval, its neutral background a departure from the allegorical, aristocratic drapes and proto-Romantic landscapes usually adorning his portraits. Here, Rubens's prize pupil appears to have been more inspired by Titian's emphasis on the mystery of the self.

Pierre Mignard (1612–95). *Portrait of Françoise-Marguerite, Countess of Grignan.*
Second half of the 17th century. Oil on canvas. 26 ⅝ x 21 ⅞ in. (67.5 x 55.5 cm).

Mignard's specialty was prettiness in the Italian style—see how the contours of the countess's shoulders merge
with the shadows behind her. Her vaguely classical garb, trimmed with flowers adorning her bosom, might suggest
an identity as Flora, Roman goddess of blossoming spring. Françoise-Marguerite's mother was Madame de
Sévigné, whose daily letters provide unmatched treasures of insight into life under Louis XIV.

Francisco de Zurbarán (1598–1664). *Saint Anthony Abbott.* After 1640. Oil on canvas. 69 ⅝ x 46 in. (177 x 117 cm).

The old man's gesture suggests that this was one of two paintings flanking a central image. Zurbarán's naturalism, from Anthony's eyes, alight with inner vision, to the creamy white of his wool habit, is entirely devoted to conveying the piety of the much-bedeviled saint. The wolf-like creature at his ankles recalls a particular episode in *The Golden Legend.*

ABOVE

Gabriel Metsu (1629–67). *Woman Tuning a Mandolin*. Ca. 1660–65. Oil on wood. 12 ¼ x 10 ⅞ in. (31 x 27.5 cm).

A proper, prosperous Dutch lady daydreams as she tunes the title instrument; the viewer is invited to complete the story. The child is likely her son, and the making of music is a traditional reference to sexual love—perhaps love lost, as her slightly wistful gaze suggests. The "tuning" may be the bringing of past and present into harmony.

P. 229
Anthony van Dyck (1599–1641). *Margaret of Lorraine, Duchess of Orléans.* Ca. 1634. Oil on canvas. 80 ⅜ x 46 in. (204 x 117 cm).

Here, Margaret, a very self-possessed teenager of the ducal family of Lorraine, married Gaston of Orléans, the oldest surviving brother of Louis XIII of France, in 1632. Full-length portraits were reserved for royalty and the highest nobility; the curtain, in royal red, adds movement and indirectly calls attention to the rich black fabric of the princess's dress.

LEFT
Claude Lorraine (1600–82). *Harbor with Villa Medici.* 1637. Oil on canvas. 40 ⅛ x 52 ⅜ in. (102 x 133 cm).

Early morning light filters over a poetic and wholly imaginary scene, an exquisite example of the style of Claude from Lorraine. The Villa Medici, bought in 1576 by then Cardinal Ferdinando de' Medici, is actually on Rome's Pincian Hill. Originally in the Palazzo Pitti, the Medici residence, this breathtaking work went to the Uffizi in the eighteenth century, under the Lorraine dynasty.

P. 232
Diego Velázquez (1599–1660). *Self-Portrait.* Ca. 1645. Oil on canvas. 40 ¾ x 32 ½ in. (103.5 x 82.5 cm).

The painter's aristocratic stance carries over into the *sprezzatura*, or courtly nonchalance, of his brushwork. Two examples: a few dryer strokes at the neck for his linen, and a more charged brush for sword hilt and belt. Court artists, like Velázquez, were between two worlds: members of the upper strata, they remained artisans, as the painter's ungloved hand perhaps reminds us.

OPPOSITE

Andrea Pozzo (1642–1709). *Self-Portrait.* Ca. last decade of the 17th century. Oil on canvas. 63 x 46 in. (160 x 117 cm).

Pozzo points to a preparatory painting on canvas for his illusionistic decoration of Rome's Church of Sant'Ignazio; the monochrome sketch emphasizes the realism of Pozzo's self-portrait, commissioned by Cosimo III. Pozzo was also an architect, stage designer, and decorative artist, as well as a Jesuit lay brother and art theorist whose major publication was translated into numerous languages, including Chinese.

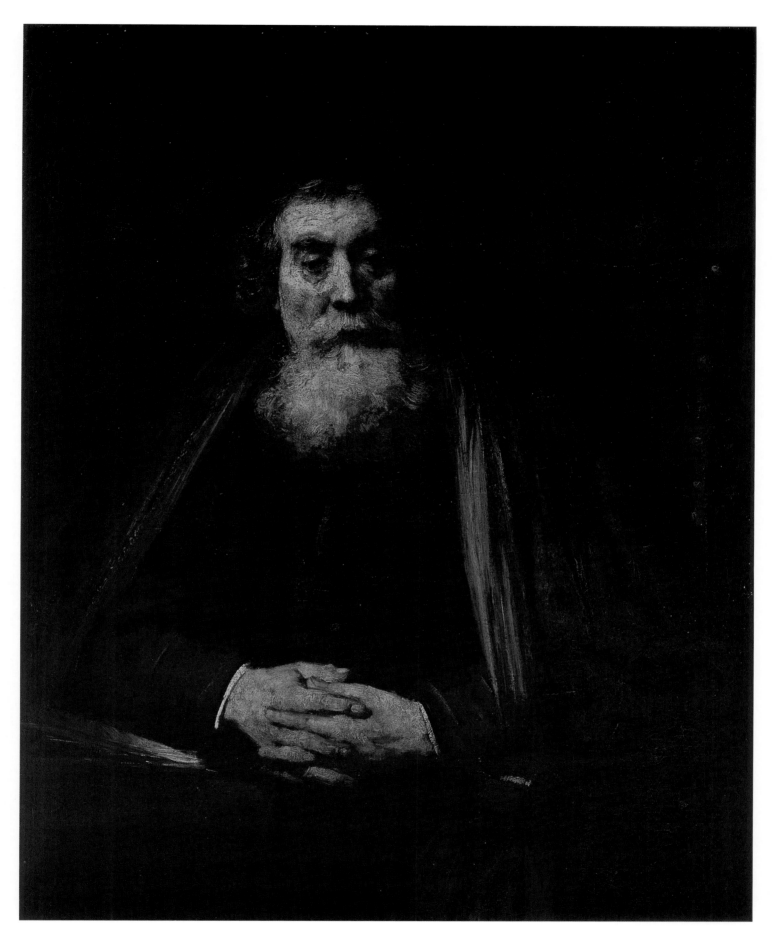

Rembrandt van Rijn (1606–69). *Portrait of an Old Man.* 1665. Oil on canvas. 41 x 33 ⅞ in. (104 x 86 cm).

Rembrandt often used light to indicate a divine connection; the cloak and beard lend the subject an additional biblical quality. In the aftermath of his bankruptcy, Rembrandt sold most of his work to connoisseurs outside Holland. He was much appreciated in Italy; Cosimo III de' Medici visited him in Amsterdam in 1669, the year of the artist's death.

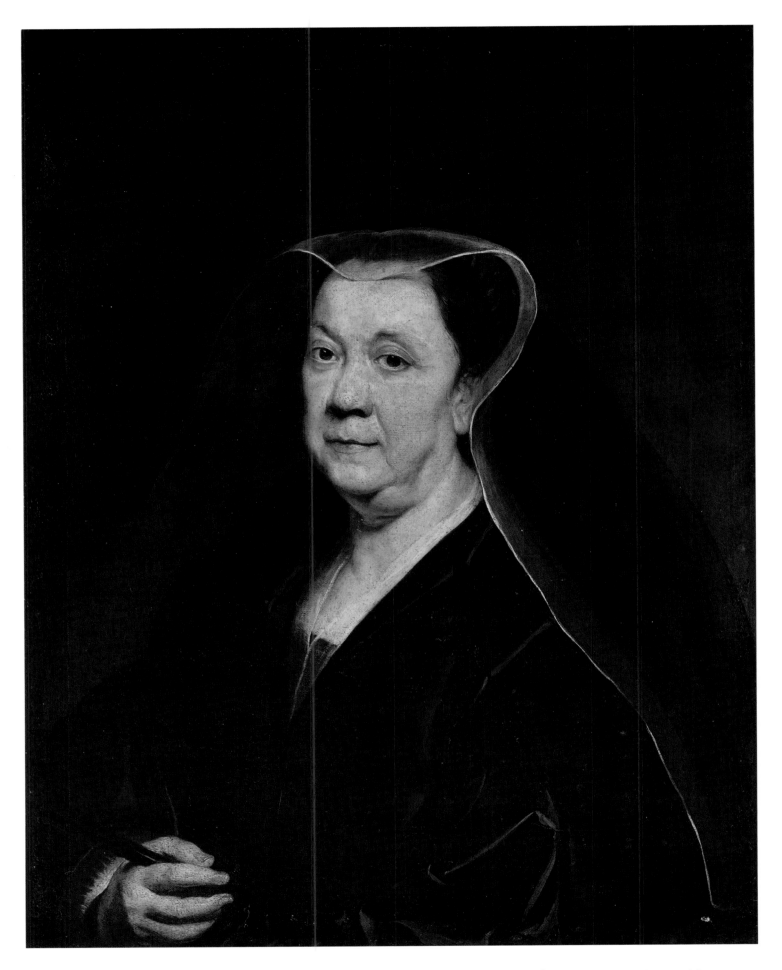

Attributed to Jacob Jordaens (1593–1678). *Portrait of a Gentlewoman.* Ca. 1660. Oil on canvas. 26 ¾ x 19 ⅝ in. (68 x 50 cm).

Her fine, transparent veil coming forward in a "widow's peak" tells us that the lady was a widow when she sat for one of Flanders' most popular painters. She was frankly middle-aged, yet vigorous and fully present. Jordaens's portrait of her mysteriously allows the viewer to see the beautiful young woman at the matron's heart.

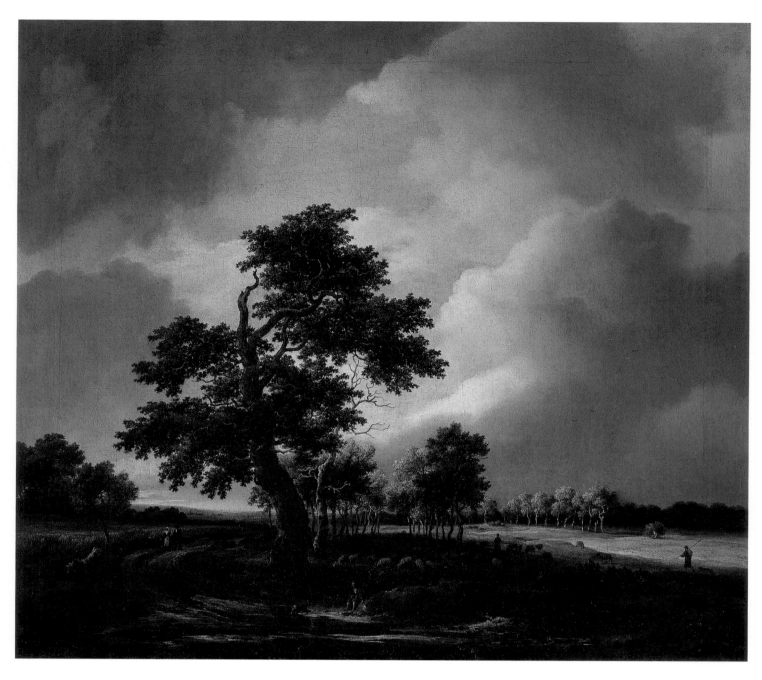

Jacob van Ruysdael (1628/29–82). *Landscape with Shepherds and Peasants.* 1660–70? Oil on canvas. 20 ½ x 23 ⅝ in. (52 x 60 cm).

One of the greatest of the Dutch landscape painters, Ruysdael satisfyingly balanced allegory and plausibility in this very likely invented rural scene. Beneath a Baroque sky, with its implications of heavenly grace, a flourishing tree—the Tree of Life?—anchors the composition. Though Protestant Amsterdam shunned overtly religious subjects, a work such as this might answer to spiritual sentiments.

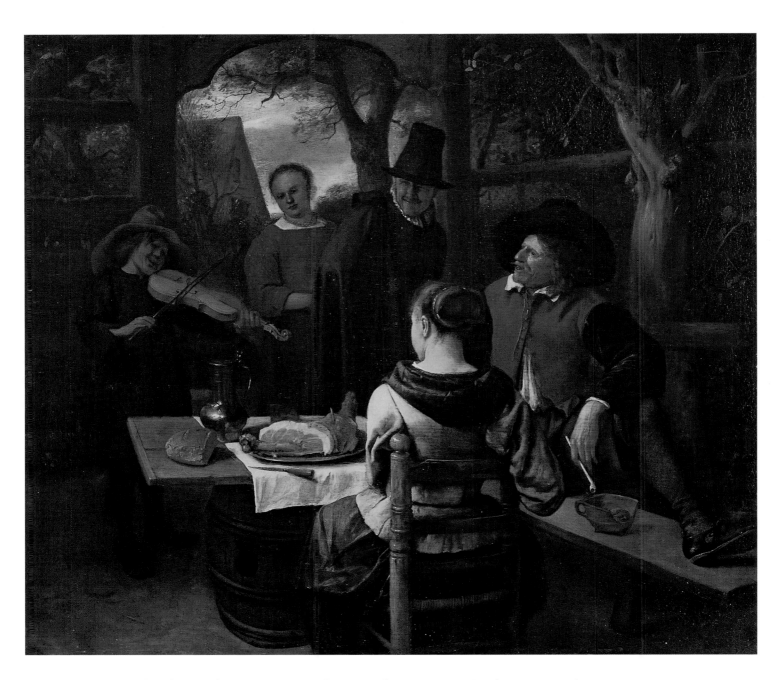

Jan Steen (1626–79). *The Meal.* Ca. 1650–60. Oil on wood. 16 ⅛ x 19 ½ in. (41 x 49.5 cm).

This bucolic meal, set for one, contrasts with Steen's usual jolly, rowdy repasts. The smiling bumpkin violinist plays; the man on the bench—perhaps the seated young woman's father—sings. The gentleman in black leers. A servant looks skeptical. We do not see the expression of the young woman in the foreground—the gentleman's meal?—as her feelings are probably irrelevant.

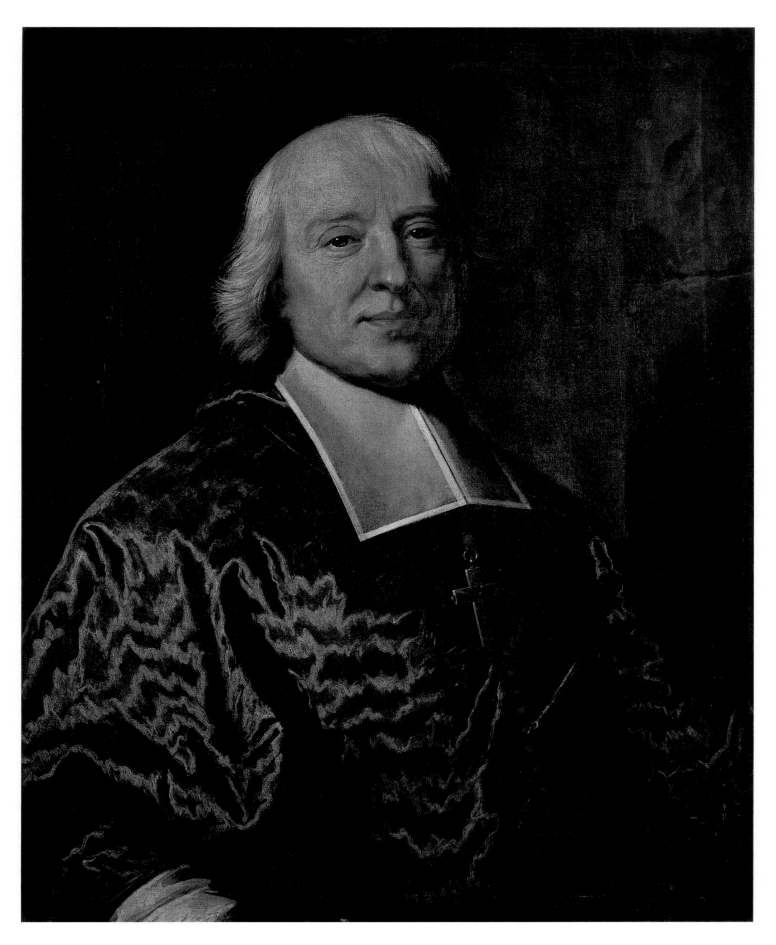

Hyacinthe Rigaud (1659–1743). *Portrait of Jacques-Bénigne Bossuet.* 1698. Oil on canvas. 28 ⅜ x 23 in. (72 x 58.5 cm).

Over seventy when Hyacinthe Rigaud painted his portrait, the bishop and tutor to the *dauphin* was a celebrated preacher, whose funeral orations were published and enthusiastically circulated. Well aware of his worth, he wears a fortune in silk moiré. For all his air of benevolence, Bossuet was instrumental in shaping the French Catholic Church and the absolute monarchy.

Gerrit Berckheyde (1638–98). *The Great Market in Haarlem.* 1693. Oil on canvas.
21 ¼ x 25 ¼ in. (54 x 64 cm).

The fifteenth-century Church of Saint Bavo, which became Dutch Reformed after the Wars of Religion, stands at the corner of Haarlem's neat, lively, cobblestone square. This was the site of the great market—the permanent fish stalls wrap around the corner of the Gothic structure. Berckheyde specialized in city scenes, which were popular with civic-minded Dutch patrons.

Rosalba Carriera (1675–1757). *Self-Portrait Holding a Portrait of Her Sister*. 1709.
Pastel on paper. 28 x 22 ½ in. (71 x 57 cm).

This double portrait shows the artist displaying her technique and the medium she was instrumental in popularizing. Pastels were made by kneading ground pigments with water and a small amount of gum; the mixture was rolled, allowed to dry, then rolled in paper. Here, Carriera paints her sister's lace, but we see the final effect decorating Carriera's own work clothes.

Giuseppe Maria Crespi (1665–1747). *The Courted Singer*. Early 18th century (?). Oil on canvas. 22 ⅝ x 18 in. (57.6 x 45.7 cm).

A winking chorus invites us to see the central scene as it really is: for all the coyness and gallantry, it is a purely mercantile affair. The comic theatricality adds to the rococo painter's worldly observation—like the portrait of a beauty on the wall, which suggests the gentleman is a collector in every sense of the word.

ABOVE

Rachel Ruysch (1664–1750). *Basket of Flowers.* 1711. Oil on wood. 18 ⅛ x 24 ¼ in. (46.2 x 61.6 cm).

Ruysch's flowers seem to glow with inner light, even as their gently wilted petals and overgrown blossoms exhibit the passage of destructive time. Loveliness romantically doomed had long been a theme of the literary and visual arts, but rarely so poignantly and luminously rendered. Tulips, once the objects of an unprecedented investment boom and bust, emphasize the moral point.

Rachel Ruysch (1664–1750). *Still Life with Fruit and Insects.* 1711. Oil on wood.
17 ⅜ x 23 ⅜ in. (44 x 60 cm).

This luscious sample of life on Earth represents at least two passions of its time: taxonomy (or categorization) and still lifes, which emphasize the pleasure of the senses and their ephemerality. Ruysch was court painter to the elector palatine Johann Wilhelm, who gave this painting and its pendant to his father-in-law, Cosimo III de' Medici.

OVERLEAF
Canaletto (1697–1768). *The Ducal Palace and Piazza San Marco.* 1755. Oil on canvas.
20 x 32 ⅝ in. (51 x 83 cm).

The Ducal Palace is the graceful block on the right of the *piazzetta*, the canal-side heart of Venice. Saint Theodore, atop the left-hand column, was replaced as patron saint of Venice by the more prestigious Mark, one of the evangelists, whose emblem—the winged lion—crowns the right-hand pillar. Hangings and other public punishments were once conducted between these columns.

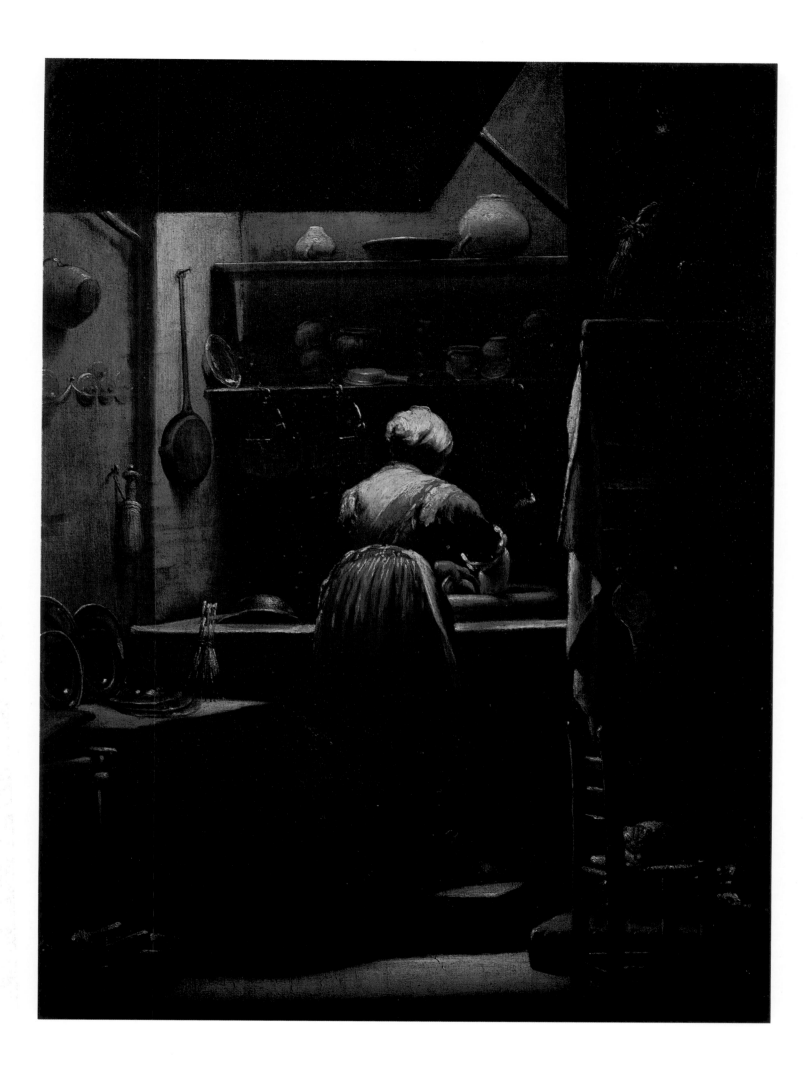

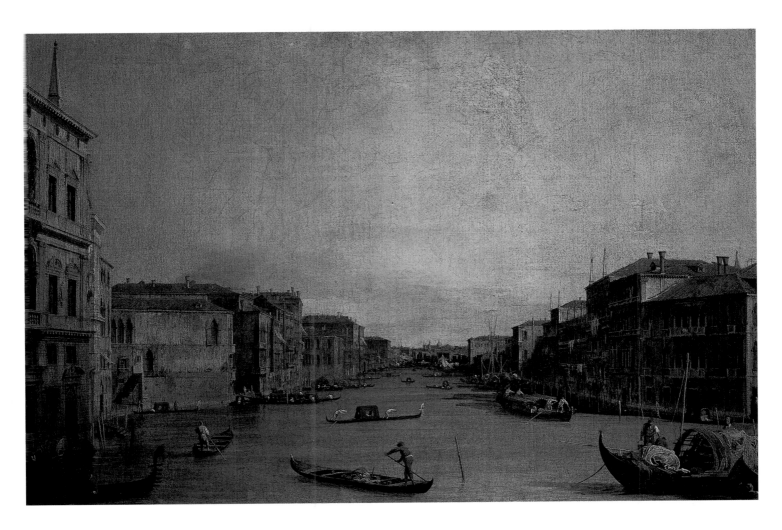

Giuseppe Maria Crespi (1665–1747). *Woman Washing Dishes*. 1722. Oil on canvas. 20 ½ x 17 in. (52 x 43 cm).

This domestic scene would have been so unfamiliar to Crespi's patrons as to be exotic. The transitions from light to dark, no longer operatically Baroque, enhance the narrative. His treatment of textures—glass, pottery, marble, fabrics, and skin—are understated but impeccable. Crespi's realistic descriptions of life below stairs were early examples of the realism that would rule European and then American art.

ABOVE
Canaletto (1697–1768). *The Grand Canal*. Late 1720s. Oil on canvas. 17 ⅝ x 28 ¾ in. (45 x 73 cm).

Canaletto's loose brushwork lends a dreamy air to the gondolas' comings and goings. Against the tumult of a global era, Venice had become a sort of aristocratic theme park, known for its laissez-faire moral codes. New trade routes had taken the mercantile wealth elsewhere, but tradesfolk continued with their more modest daily commerce.

P. 248
Alexis Grimou (1678–1733). *Young Pilgrim Girl*. 1725/26. Oil on canvas. 32 ¼ x 25 in. (82 x 63.5 cm).

The title girl's identity is made manifest by her pilgrim's staff and scallop shell, symbol of the shrine of Santiago—Saint James—in Compostela, Spain. Not a portrait, this was one of Grimou's most popular subjects, which he sold with its pendant, a young pilgrim boy. The artist's vastly appreciative public evidently enjoyed his mixture of sentimentality and coy lubricity.

P. 249
Rosalba Carriera (1675–1757). *Portrait of Felicita Sartori*. Ca. 1730–40. Pastel on canvas. 29 ½ x 21 ⅝ in. (75 x 55 cm).

This informal portrait is a sensuous marvel of brilliant hues and varied textures. Sartori was a printmaker, active in Venetian publishing; the mask identifies her with that city. Carriera, who began her career designing patterns for her mother, a lace maker, found acclaim at the royal court of France, where she was instrumental in the formulation of the pretty artifices of Rococo.

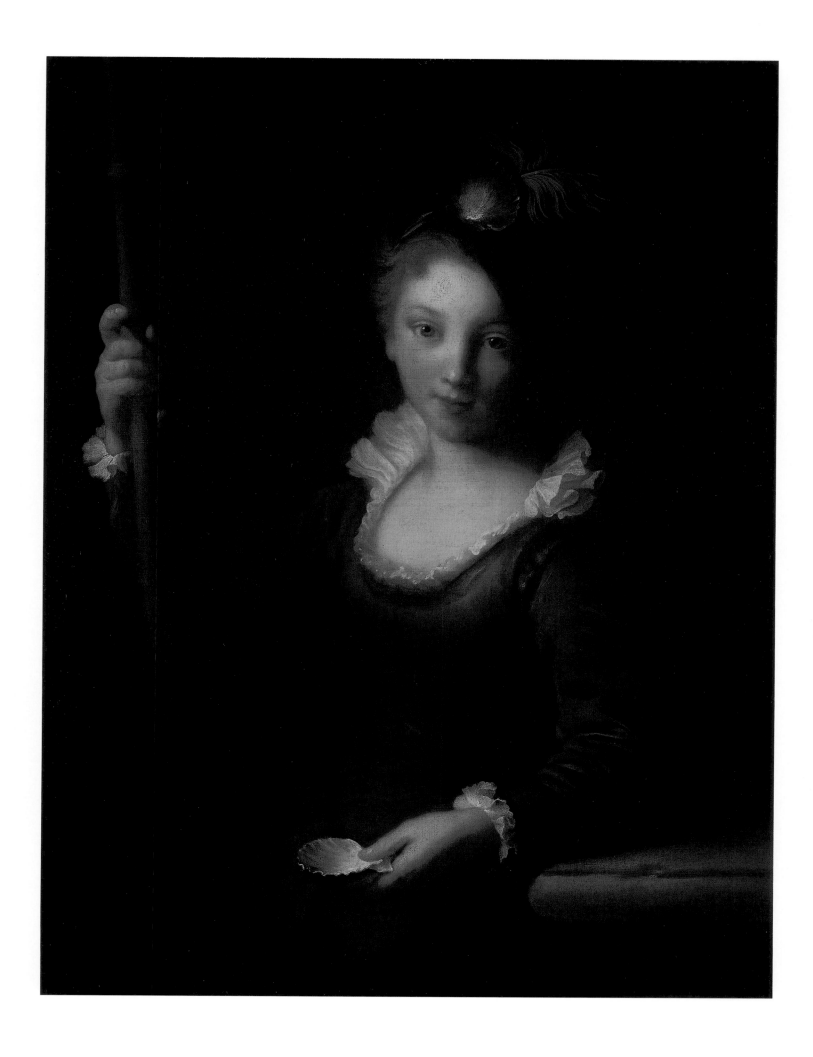

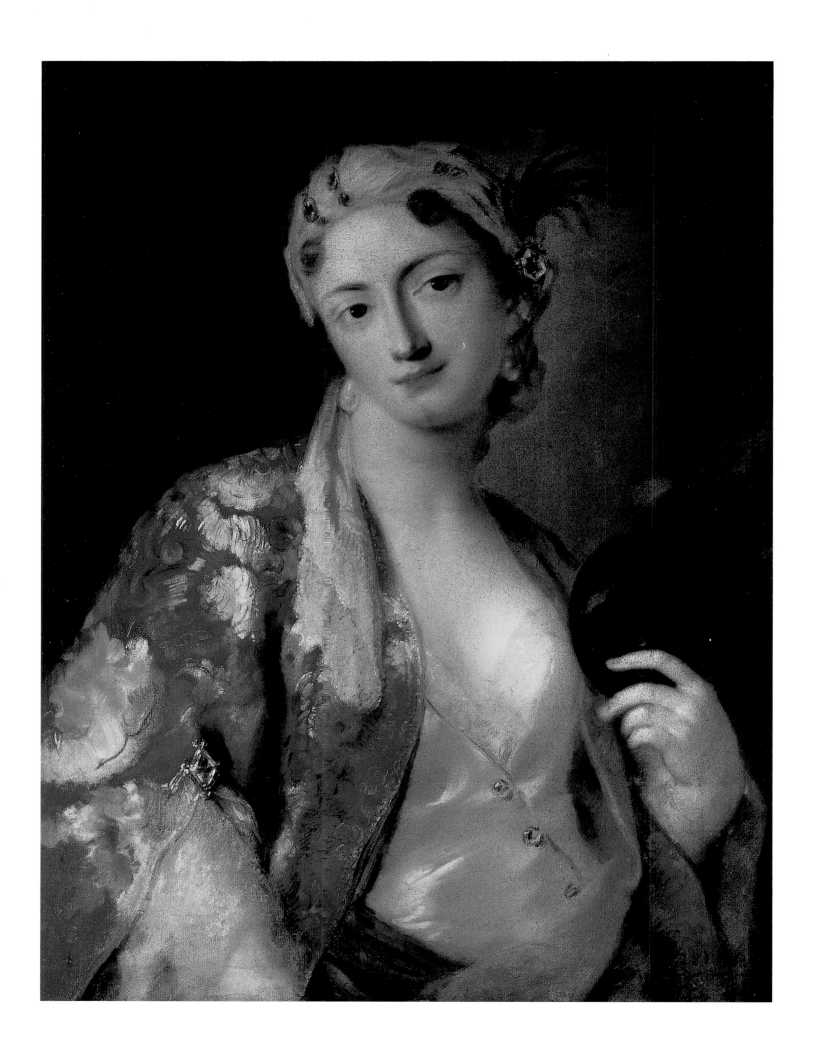

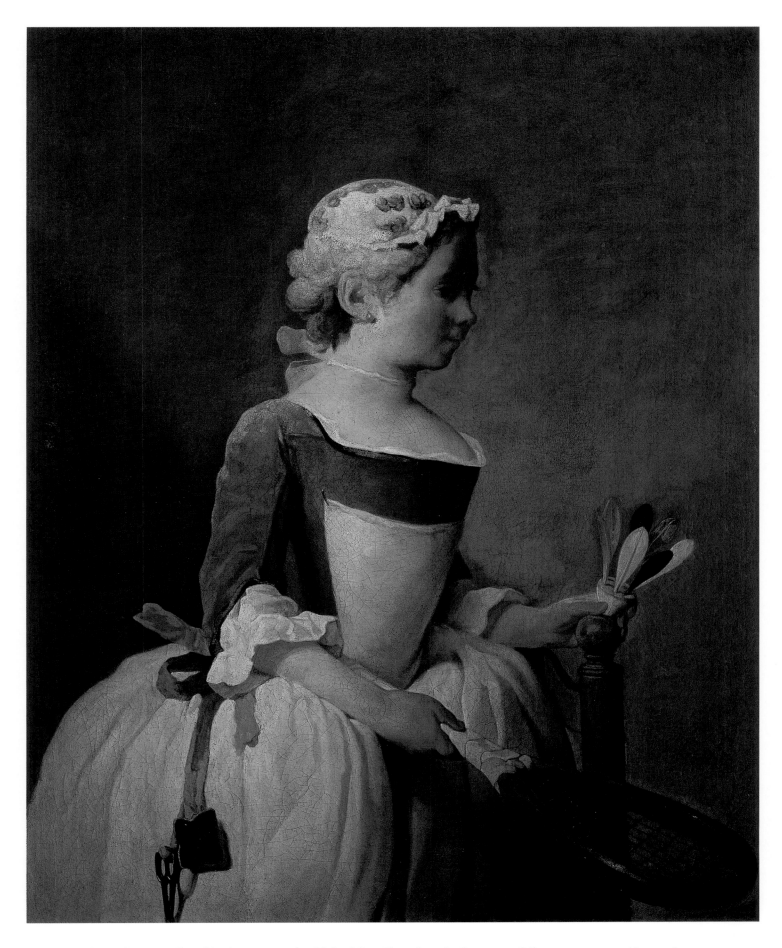

Jean-Baptiste-Siméon Chardin (1699–1779). *Girl with a Shuttlecock*. Ca. 1740. Oil on canvas. 32 ¼ x 26 in. (82 x 66 cm).

Her flushed cheeks suggest that this neat child of the upper middle class is returning from a rousing game of badminton, which caused powder from her hair to fall on her shoulders. She wears wide panniers on either side of her brown day dress, protected by an apron. Small sewing scissors and a pin cushion hang from her belt.

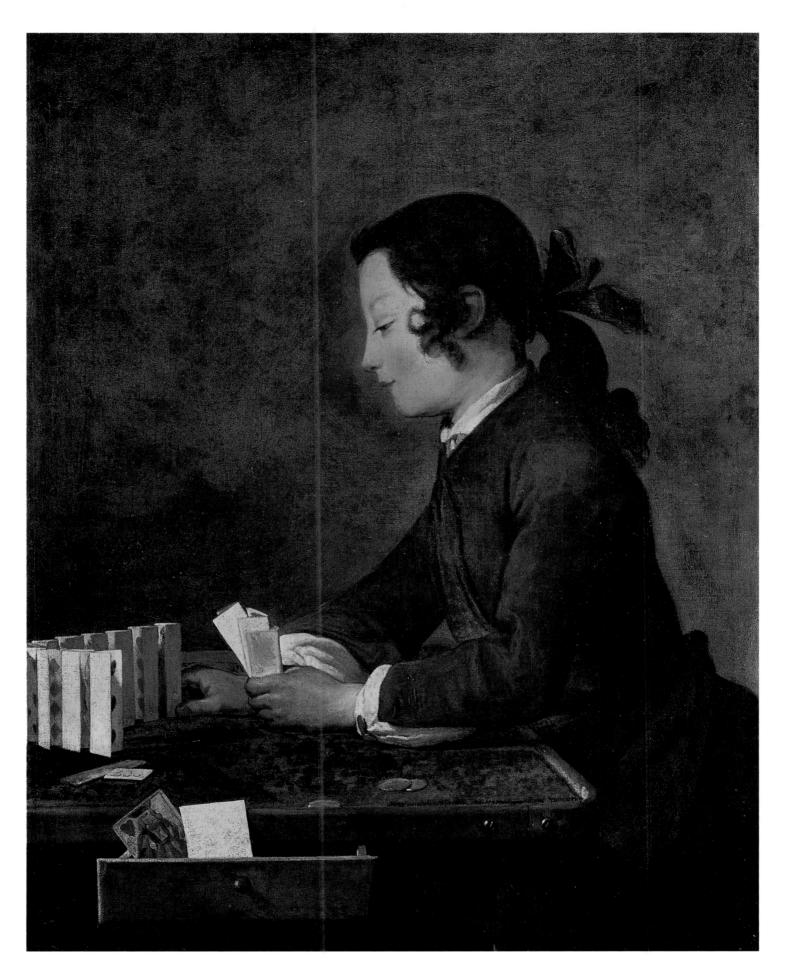

Jean-Baptiste-Siméon Chardin (1699–1779). *Young Boy Playing Cards.* Ca. 1740. Oil on canvas. 32 ¼ x 26 in. (82 x 66 cm).

The coins on the table predict that what is a child's game today will be gaming tomorrow: the ubiquitous pastime, even obsession, of the French ruling elite was gambling. Running a close second was *l'amour*—which the jack of hearts, facing us from the drawer of the card table, foretells for the absorbed and handsome lad.

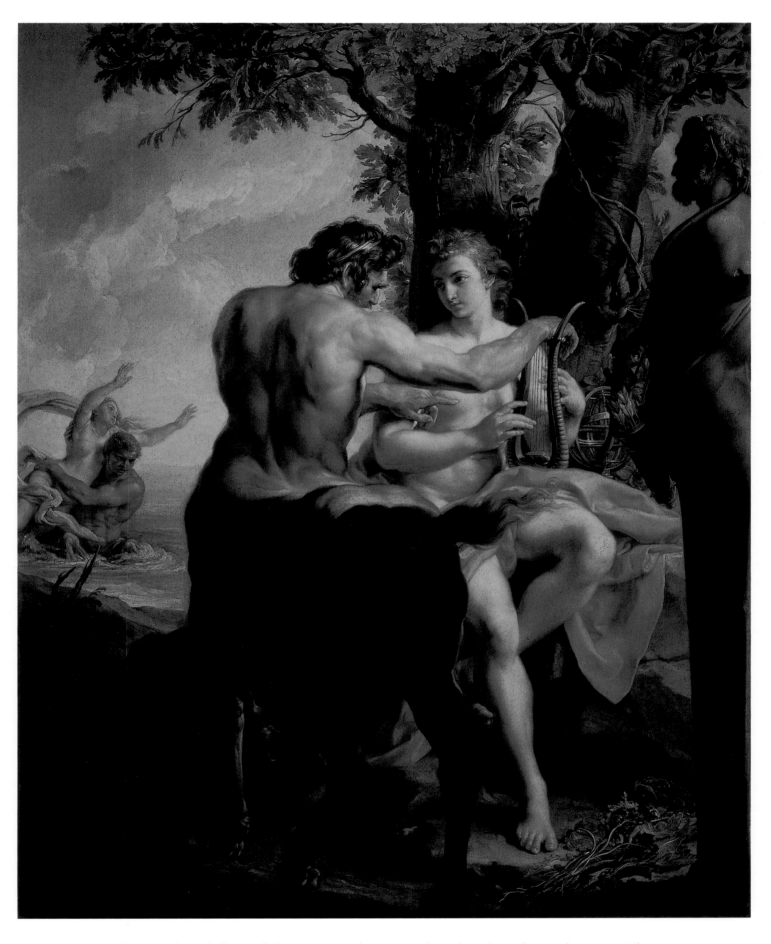

Pompeo Batoni (1708–87). *Achilles and the Centaur Chiron,* or *The Education of Hercules.* 1746. Oil on canvas. 62 ⅜ x 49 ¾ in. (158.5 x 126.5 cm).

A modest Neoclassical drape covers the young pupil's lap, while a more ambiguous quiver hangs from the herm at the right. Unlike others of his savage mythical kind, the centaur Chiron was educated in the civilized arts—not only music but medicine, as the herbs at the foot of the painting show.

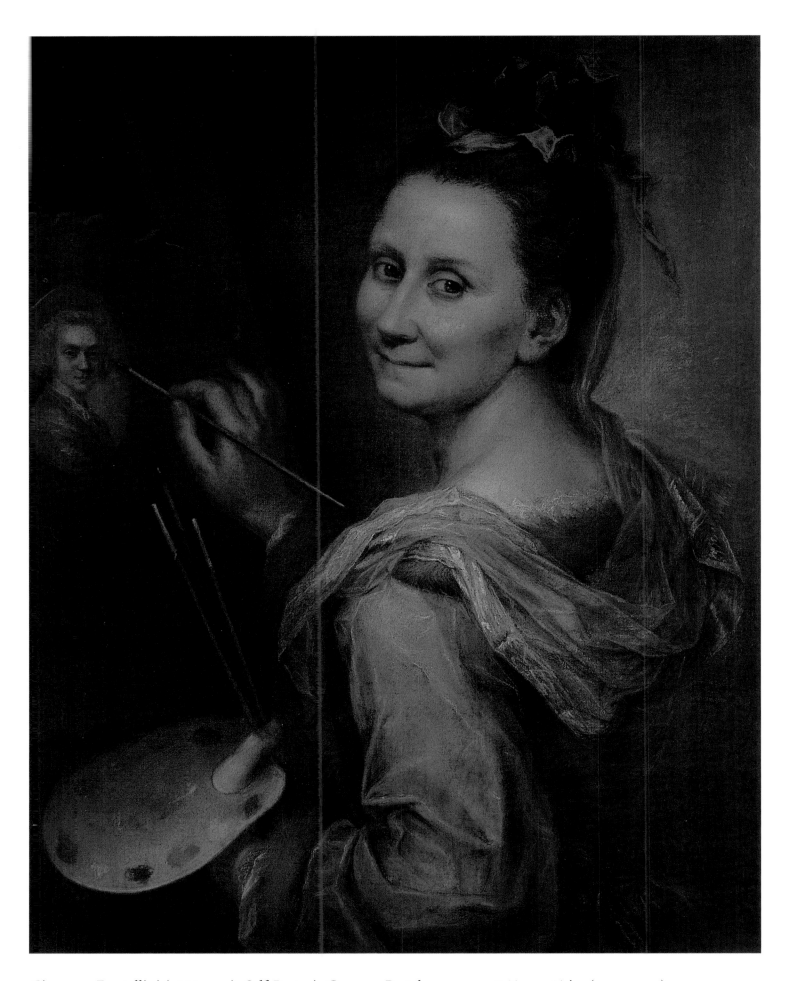

Giovanna Frastellini (1666–1731). *Self-Portrait.* Ca. 1720. Pastel on paper. 28 ⅜ x 22 ½ in. (72 x 57 cm).

Though she depicted herself working with oil paint, Frastellini was considered the second-greatest pastelist in Florence—after her teacher, Domenico Tempesta. Legend has it that the subject of the miniature was her son Lorenzo, a promising artist who died in 1729. Frastellini's signature elements were the fluttering ribbons she is jauntily wearing.

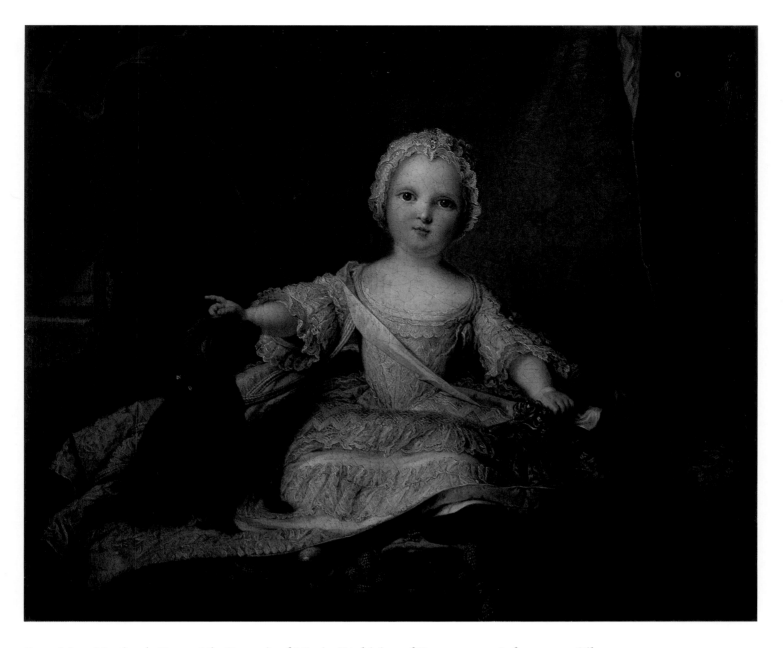

Jean-Marc Nattier (1685–1766). *Portrait of Marie-Zéphirine of France as an Infant.* 1751. Oil on canvas. 27 ½ x 32 ¼ in. (70 x 82 cm).

Born in 1750, this royal tot, dressed as an adult as the times required, sits on a pillow of regal blue, embroidered in gold with the French fleur-de-lys. The granddaughter of Louis XV and the sister of Louis XVI, this tiny princess would not live to see the Revolution.

Jean-Marc Nattier (1685–1766). *Marie Henriette of France as Flora.* 1742. Oil on canvas. 37 ¼ x 50 ½ in. (94.5 x 128.5 cm).

The garland she assembles allows the viewer to appreciate the French princess's delicate pink fingers, and associates her in a relaxed, Neoclassical kind of way with Flora, the ancient goddess of blossoms. The exquisite refinement that Nattier achieved was a taste introduced by Rosalba Carriera and promulgated by Madame de Pompadour, the king's official mistress.

Giovanni Battista Tiepolo (1696–1770). *Rinaldo Sees Himself in Ubaldo's Shield.*
Ca. 1750–55. Oil on canvas. 27 ¼ x 52 in. (69 x 132 cm).

Torquato Tasso's *Jerusalem Delivered* of 1581, an epic poem about knightly valor, magic, and true love during the Crusades, was an international bestseller, interpreted in opera and in operatic scenes like this. Rinaldo, bewitched by a sorceress, sees his degradation mirrored in his friend's shield. This was one of the Uffizi canvases that Hitler took for his museum at Linz.

Francesco Guardi (1712–93). *Town with a Bridge.* Ca. 1750. Oil on canvas. 11 ¾ x 20 ⅞ in. (30 x 53 cm).

This small, loosely brushed, atmospheric work is a good example of Guardi's *capricci.* These imaginary scenes sold very well to Venetian buyers, who in many cases appreciated the artist's inventiveness—*invenzione*—more than Canaletto's more topographical paintings. The fashionably mantled pair in the foreground, typical of Guardi's *capricci,* delicately call attention to his skill as a colorist.

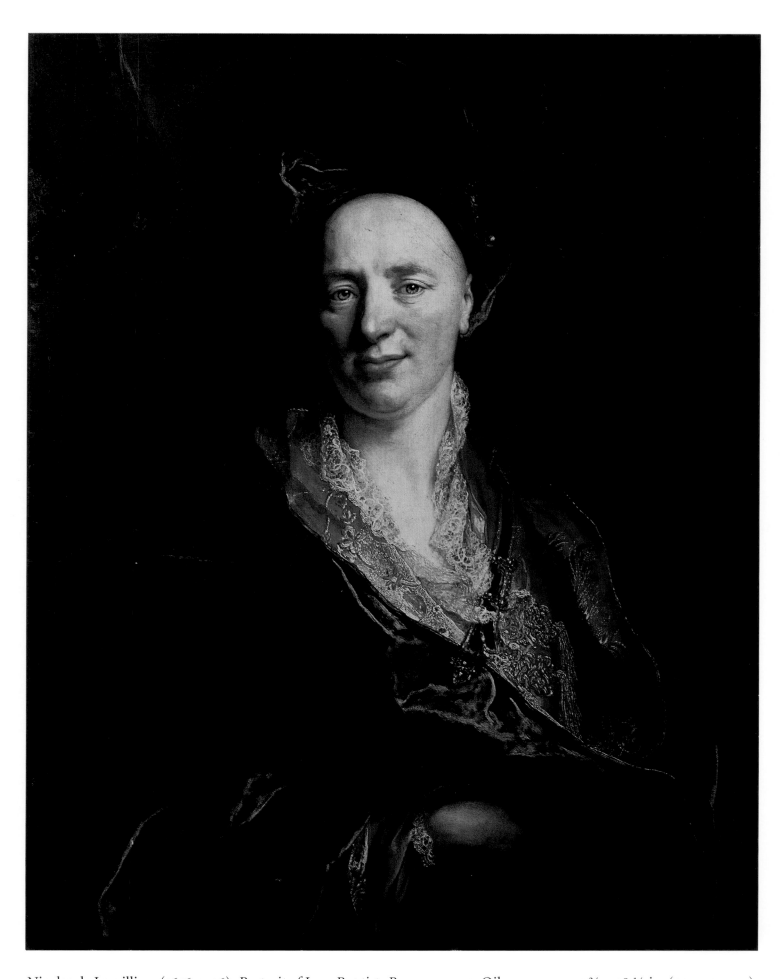

Nicolas de Largilliere (1656–1746). *Portrait of Jean-Baptiste Rousseau.* 1710. Oil on canvas. 35 ⅜ x 28 ½ in. (90 x 72.5 cm).

This nonchalant realism is a style that Largilliere helped develop. The massive drape of the poet's cloak accentuates the confident, subtle colors and detail on the lapel and sleeve, which in turn support the expressiveness of the face and hand. Around 1712, in the last years of Louis XIV's long reign, Rousseau was banished for satirical barbs aimed at fellow literati.

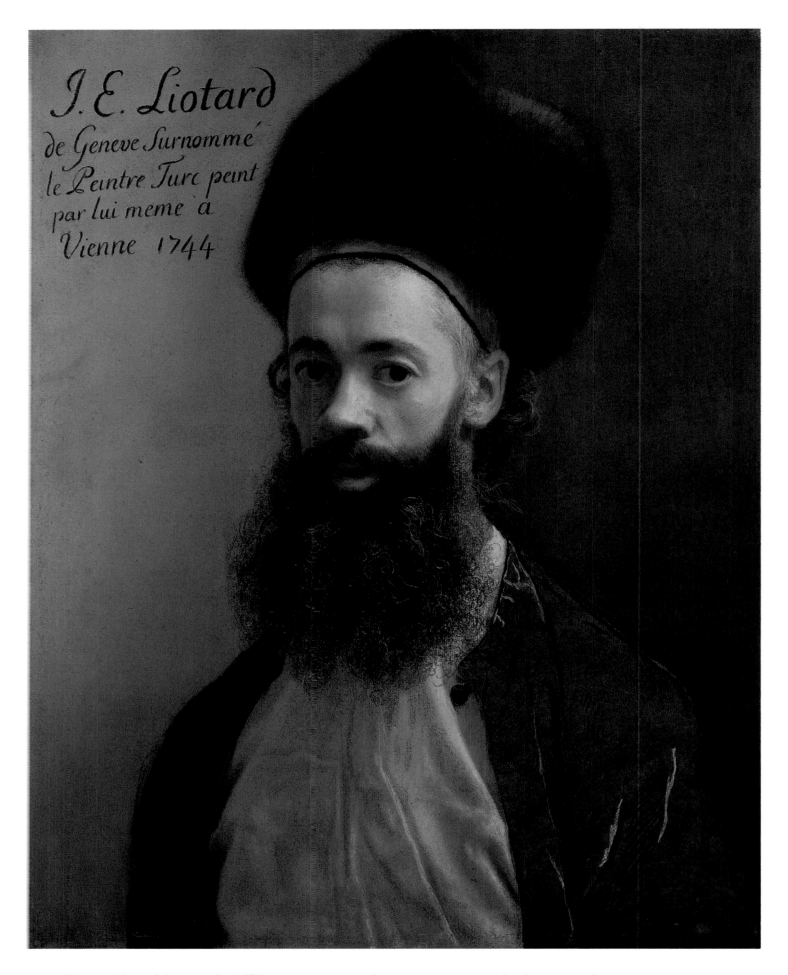

Jean-Etienne Liotard (1702–89). *Self-Portrait.* 1744. Pastel on paper. 24 x 19 ¼ in. (61 x 49 cm).

Liotard was an inveterate traveler. In particular, he lived in Istanbul—then Constantinople—for four years. Like other European expatriates, he adopted local dress, but unlike them he continued his exotic ways upon his return, and was known as "the Turkish painter." He portrayed the prolific royal families of France, England, and Austria, and made many self-portraits throughout his career.

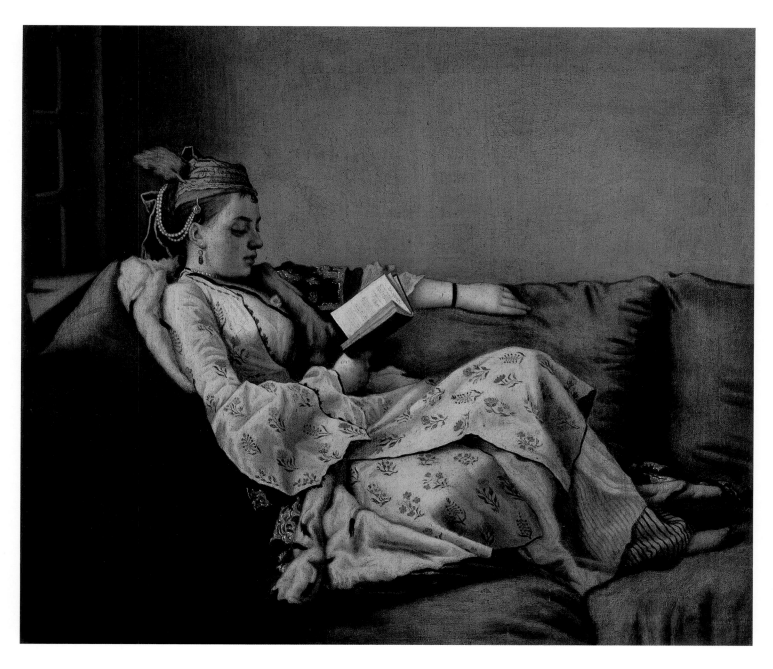

Jean-Etienne Liotard (1702–89). *Marie-Adélaïde of France Dressed in Turkish Costume.* 1753. Oil on canvas. 19 ⅝ x 22 in. (50 x 56 cm).

With the Ottoman menace receding, Europe began to romanticize its exotic, comfy pleasures. Marie-Adélaïde's status is conveyed by the ermine lining of her gold-embroidered red velvet coat. Her embroidered white gown is probably cotton, a costly fabric imported from Asia. The fantasy of this small, intimate portrait is enhanced by bars at the window, suggesting a seraglio.

Alessandro Longhi (1733–1813). *Portrait of a Lady.* Ca. 1770. Oil on canvas. 39 ⅜ x 31 ½ in. (100 x 80 cm).

This Venetian lady displays the fine products of the city's artisans, including Venice's legendary lace and black garments, which the nobility was required to wear to advertise the dyers' skill to the foreign elite. The mask temporarily parked atop her hat will have protected madama's delicate complexion from the sun, or allowed her to enjoy incognita the plebeian antics of commedia dell'arte.

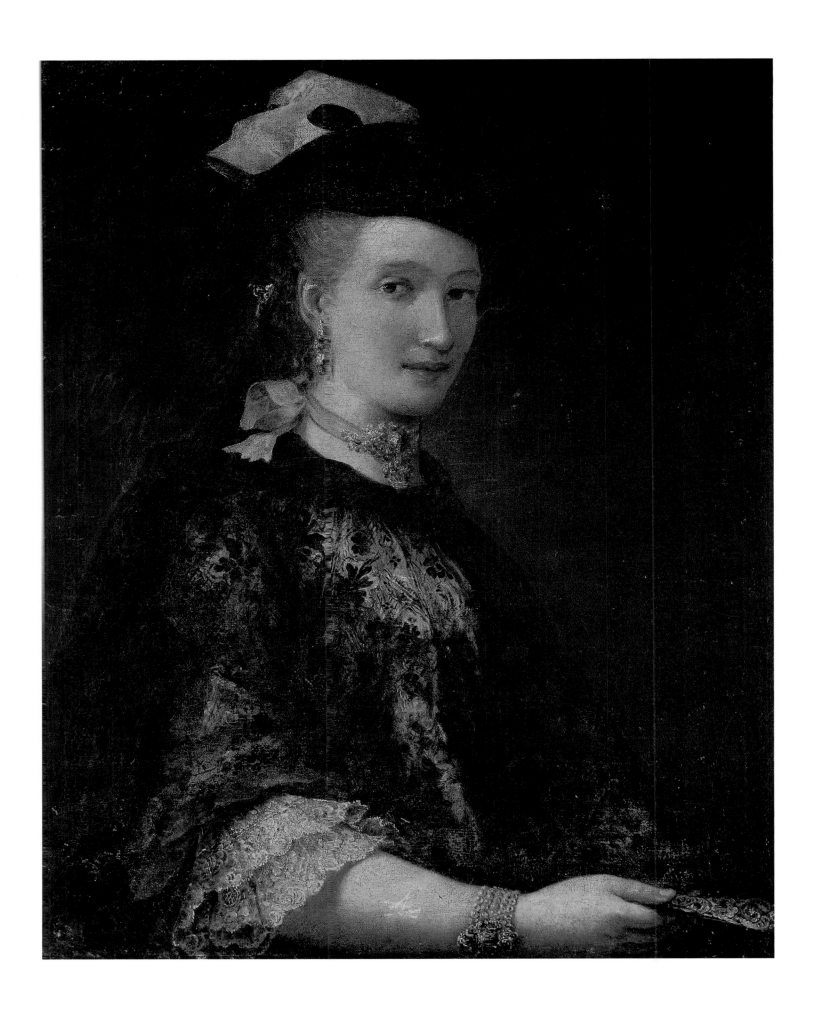

Antonio Canova (1757–1822). *Self-Portrait*. 1790. Oil on canvas. 26 ¾ x 21 ½ in. (68 x 54.5 cm).

Seemingly surprised at his easel, the artist was in fact best known as a sculptor. In the eyes of many, his austere, contained interpretations of the classical style eclipsed the traditional popularity of more sensuous Hellenistic works, such as the *Medici Venus*. After the fall of Napoleon, Canova worked indefatigably for the return of Italian art from the Louvre.

Thomas Patch (1725–82). *View of the Arno with the Bridge at Santa Trinita*. Ca. 1755–80. Oil on canvas. 34 ¼ x 50 in. (87 x 127 cm).

The fact that Patch could have painted this view any time between the year he settled in Italy and two years before his death says that this was a winning formula. The Grand Tour was *de rigueur*, and scenes like this were popular souvenirs, though Patch was also famous for his adaptation to portraits of the Italian tradition of caricature.

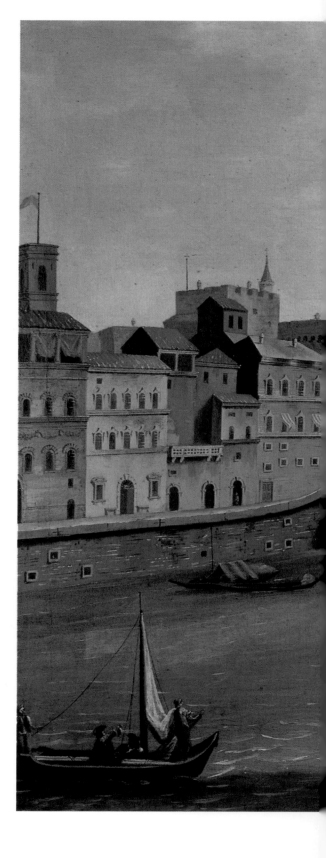

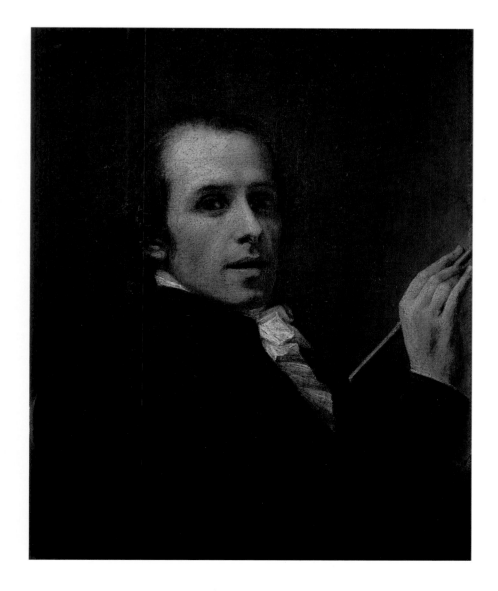

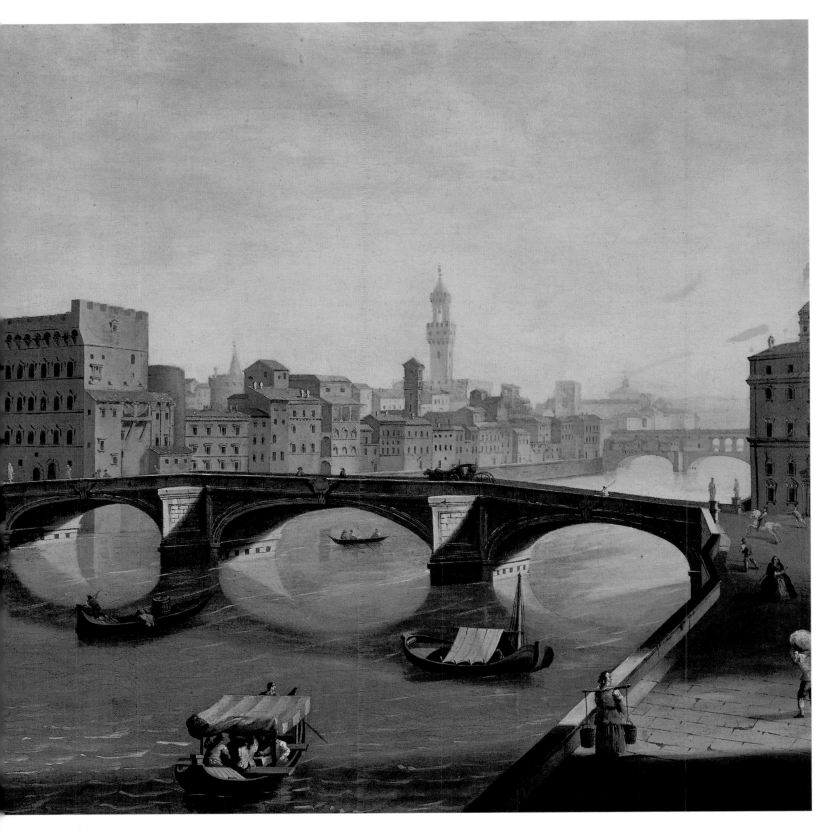

P. 264
Sir Joshua Reynolds (1723–92). *Self-Portrait.* 1775. Oil on canvas. 28 ⅛ x 22 ⅞ in. (71.5 x 58 cm).

The paper he holds reads "Disegni del Divino Michelagnolo Bon . . ." (Drawings by the Divine Michelangelo Buon. . . .). His country's premier portraitist, Reynolds was also the greatest English dealer and collector of his age, using his acquisitions to illustrate his lectures at the Royal Academy. The dramatic swath of light, rich color, and Old Masterly stance are typical of his style.

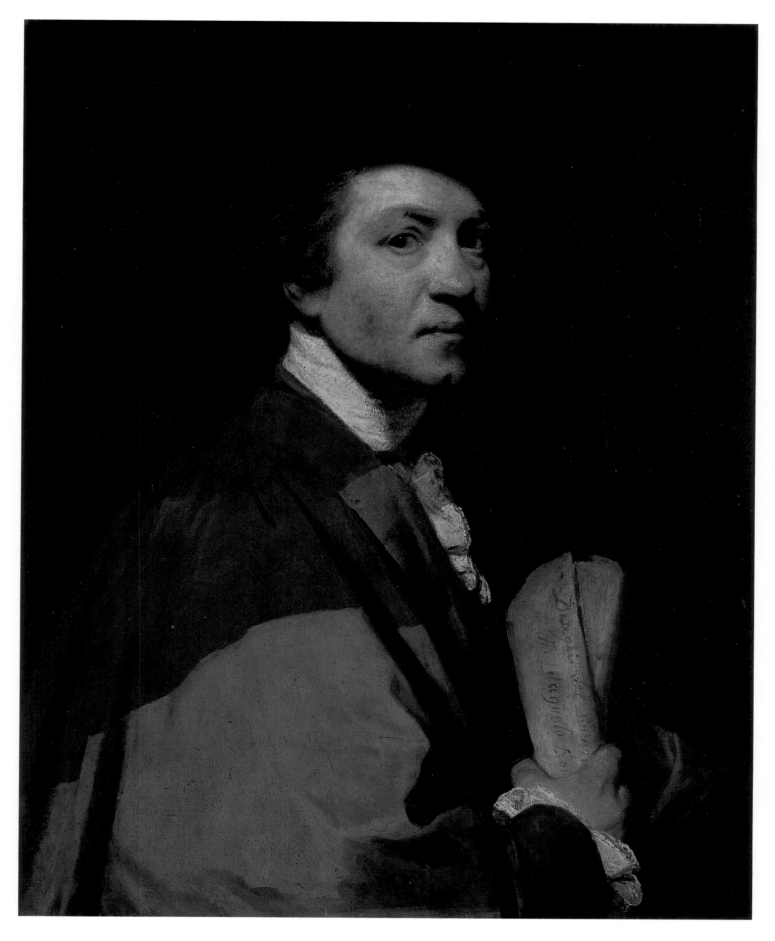

Francisco Goya (1746–1828). *Portrait of Maria Theresa of Vallabriga on Horseback.*
1783. Oil on canvas. 32 ½ x 24 ⅜ in. (82.5 x 61.7 cm).

This equestrian portrait was probably commissioned by the sitter or her husband. They were Goya's first high-ranking patrons, and he painted this lady and her children a number of times. The profile view was a fashionable format, which harks back to the Renaissance and its revival of the antique.

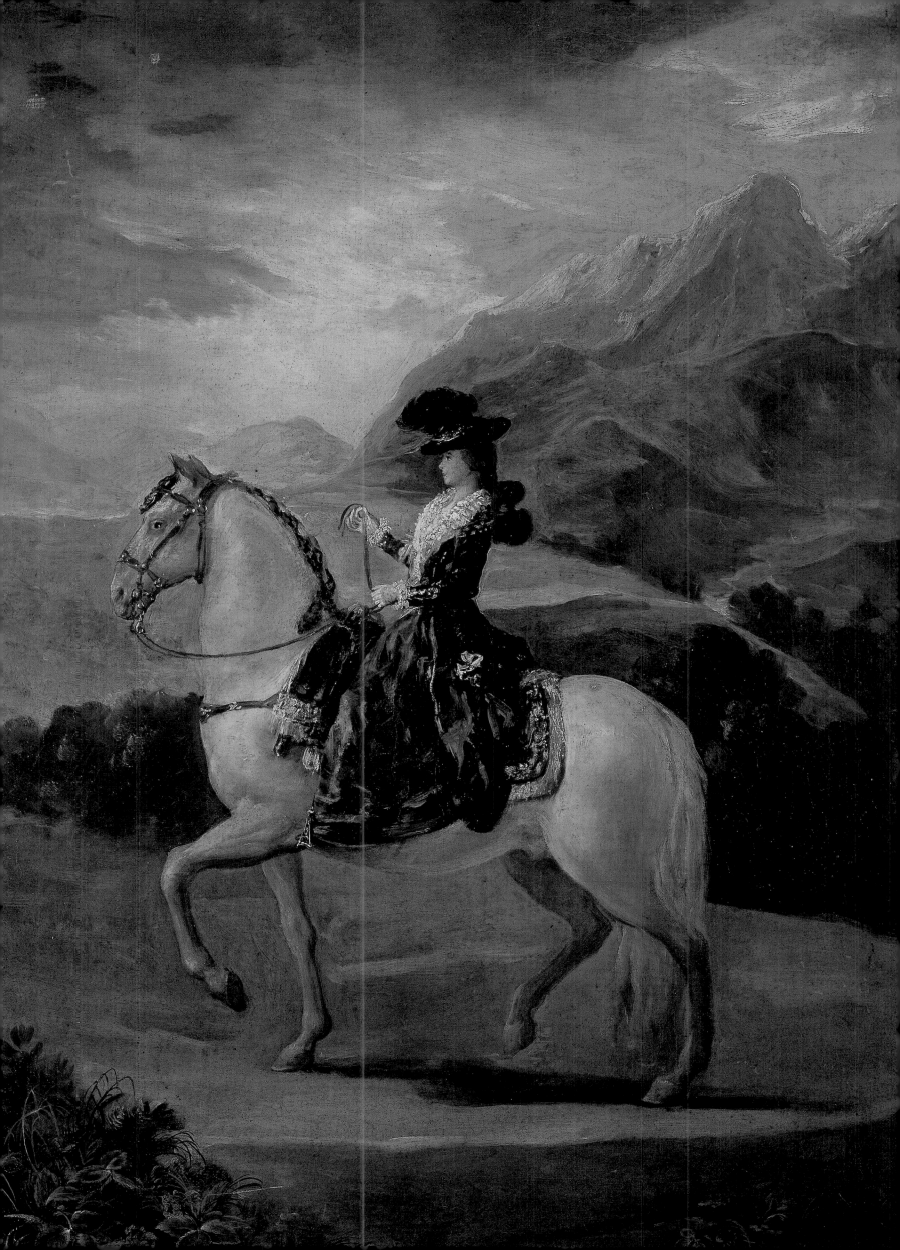

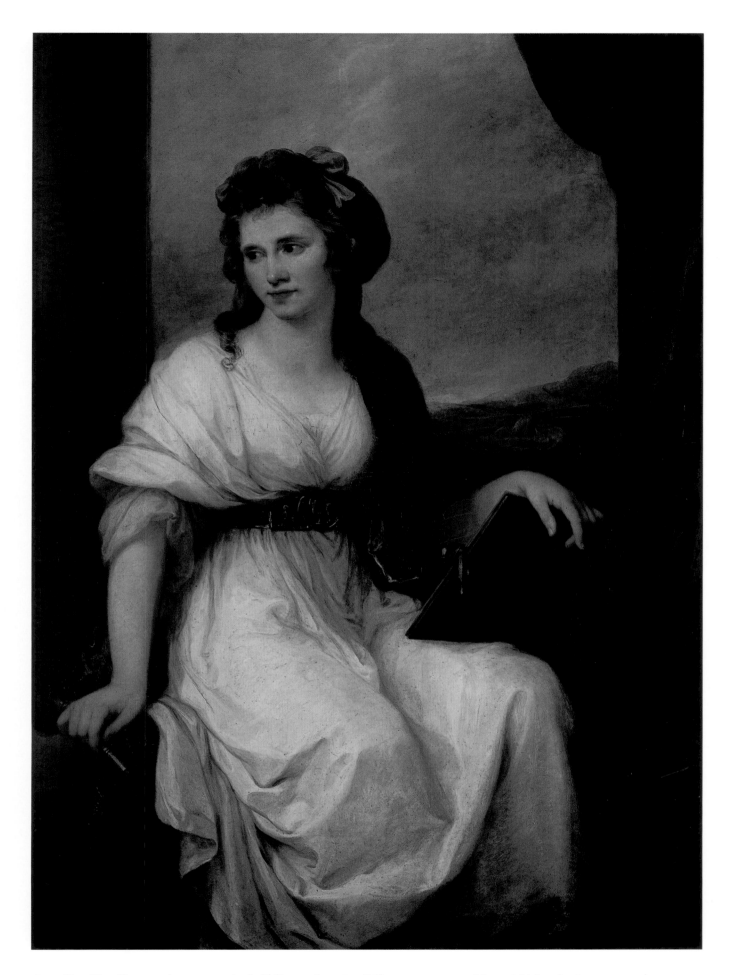

Angelica Kauffmann (1741–1807). *Self-Portrait.* 1787. Oil on canvas. 50 ⅜ x 36 ⅞ in. (128 x 93.5 cm).

The plush purple drapery behind her may refer to the high-born Europeans and Russians who commissioned portraits by Kauffmann and acquired her history paintings. It surely represents the refined colors for which she was famous. Kauffmann, one of two female founders of the British Royal Academy, submitted this flamboyantly Neoclassical work for the Uffizi's grand ducal gallery of artists' self-portraits.

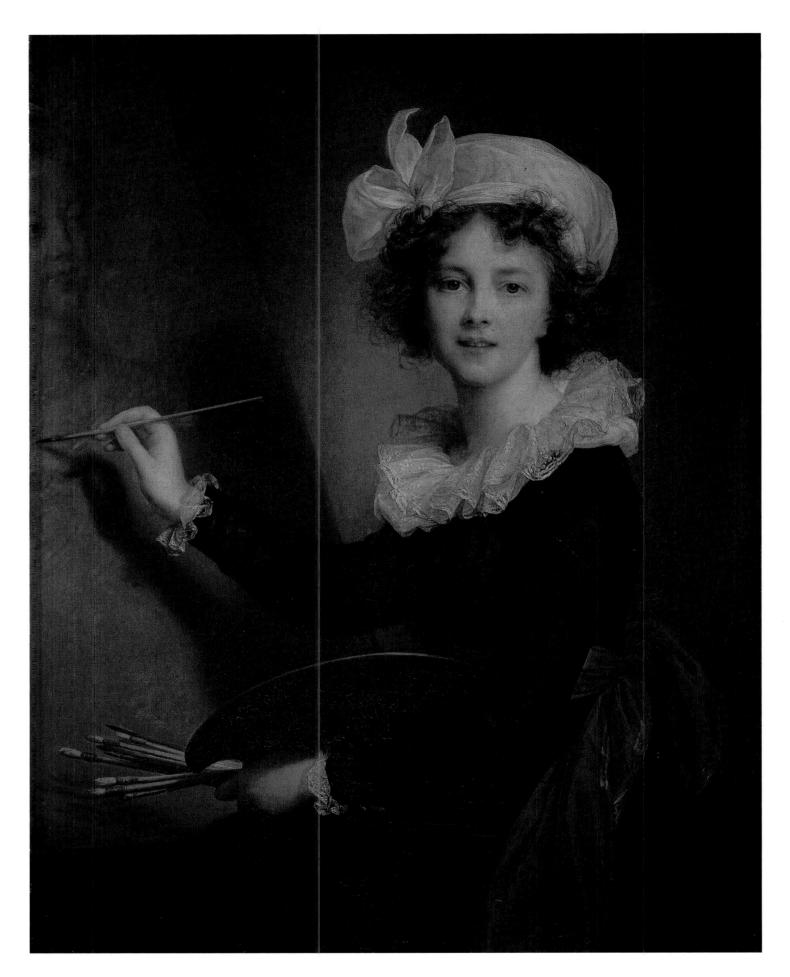

Elisabeth Vigée Le Brun (1755–1842). *Self-Portrait.* 1790. Oil on canvas. 39 ⅜ x 31 ⅞ in. (100 x 81 cm).

Charming immediacy almost eclipses technical skill, in this painting made for the Medici collection of artists' self-portraits the year after the artist left revolutionary France. Working between reality and representation, Vigée Le Brun exhibits her wit; her exploring gaze studies us as if we were her sitter, but the portrait on the easel resembles Marie-Antoinette, the famous painter's most famous subject.

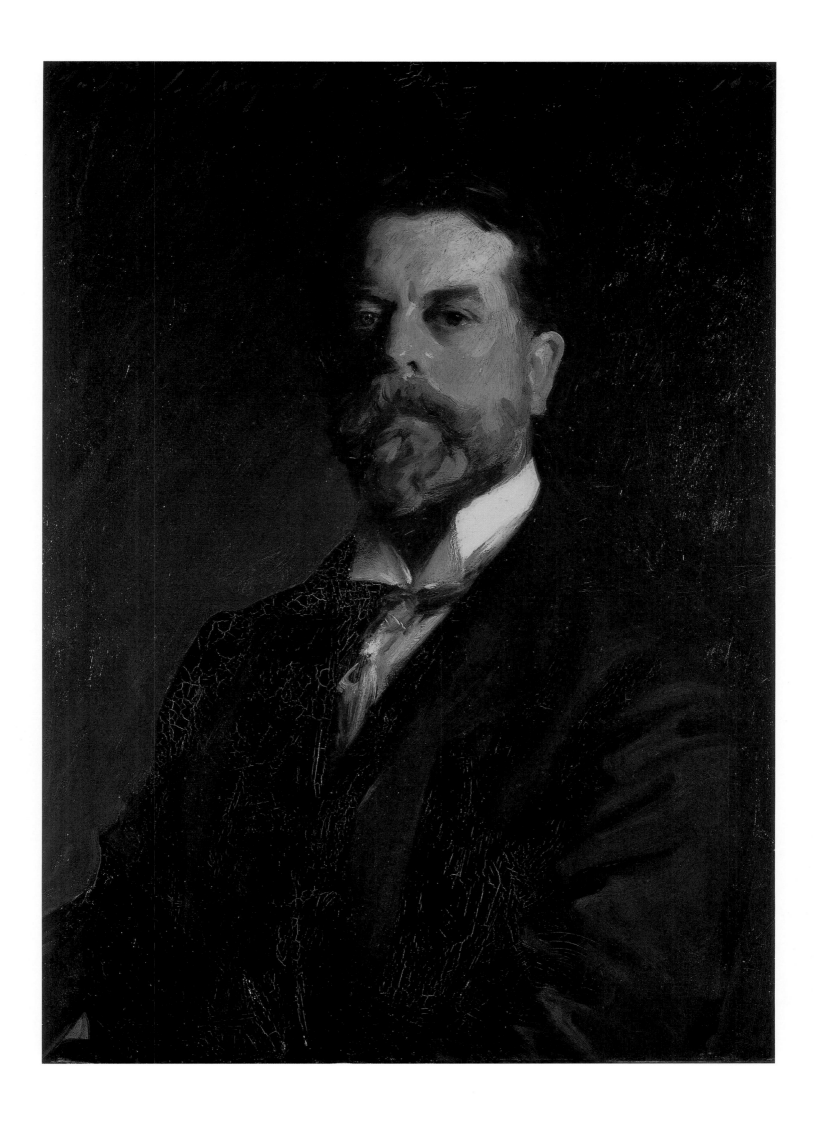

John Singer Sargent (1856–1925). *Self-Portrait.* 1906. Oil on canvas. 27 ½ x 20 ⅞ in. (70 x 53 cm).

In his self-representation for the Uffizi, Sargent is every inch the buttoned-up Edwardian gentleman. In truth, he had been so fervent an experimental painter that he nearly lost his career to scandal—in Paris, no less. His admiration for Velázquez shows in the brown background and the confident swipe of a dry brush for the highlight on his tie.

Francisco Goya (1746–1828). *Portrait of the Marchioness of Boadilla del Monte.* Ca. 1801. Oil on canvas. 86 ⅝ x 55 ⅛ in. (220 x 140 cm).

This is the second portrait that the painter made within a few years of the sitter's marriage—a political alliance that freed the Marchioness María Teresa from the cloister. Her loose organza gown in the high-waisted French style may conceal a pregnancy; the miniature she displays prominently on her wrist may depict her husband or perhaps the king, Charles IV.

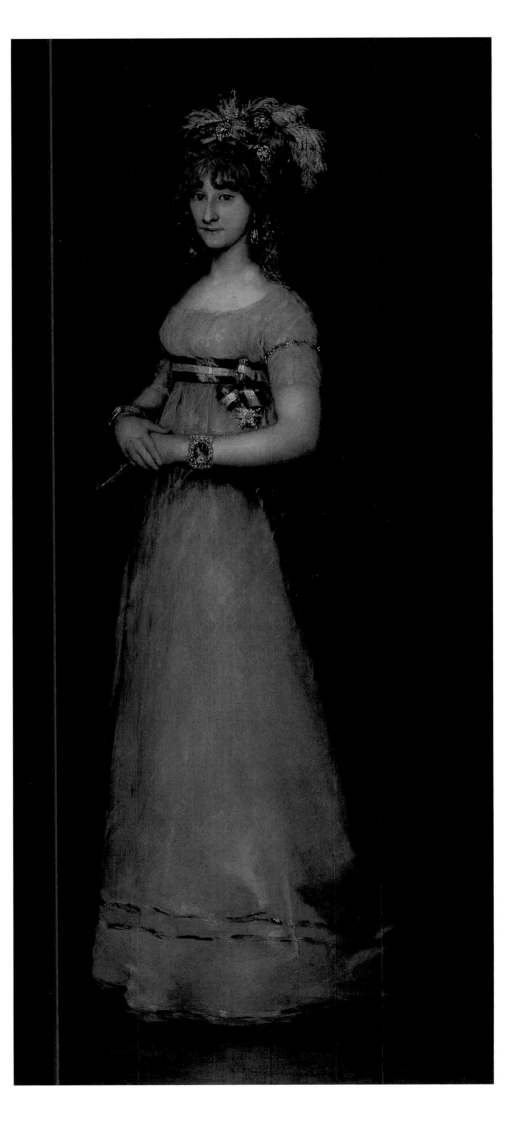

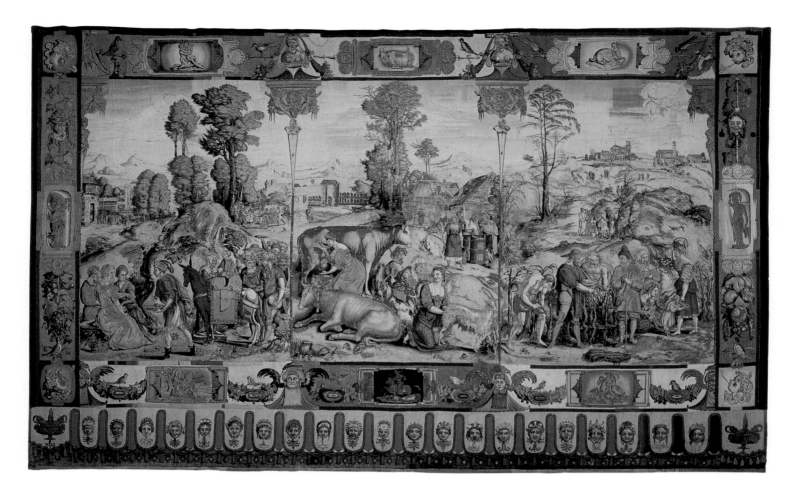

ABOVE

The Months of the Year: May, April, and March. Cartoon by Bachiacca. Woven by Niccolò Karcher. 1552. Silk, gold, silver, and wool; lined with canvas. 106 x 172 ⅞ in. (269 x 439 cm).

Slender herms divide the landscape into three scenes, one for each month. Above each scene is the zodiacal sign for the month. In the background, the buildings from right to left refer to: monks and nuns, the peasantry, and the aristocracy. Cosimo I took the painter and designer Bachiacca into his service because he was very good at rendering animals.

OPPOSITE

Tapestries of Caterina de' Medici. *Festival on the Water.* Designed by Antoine Caron, cartoons by Lucas de Heere, 1582. Woven by Joos van Herseel and Franchoys Sweerts, or François Spiering, before 1585. Woven of silk, gold, silver, and wool; lined with canvas. 158 ⅝ x 133 ½ in. (403 x 339 cm).

Caterina de' Medici, queen of France, gave her beloved granddaughter Christine of Lorraine a group of eight arrases, the Valois Tapestries, when Christine came to Florence to marry her kissing cousin Ferdinand I. All but one of the hangings depict a series of *magnificences* that Caterina produced in the 1560s and 1570s. The "Indians" on the island may be actors. At right are Henry III and Louise of Lorraine.

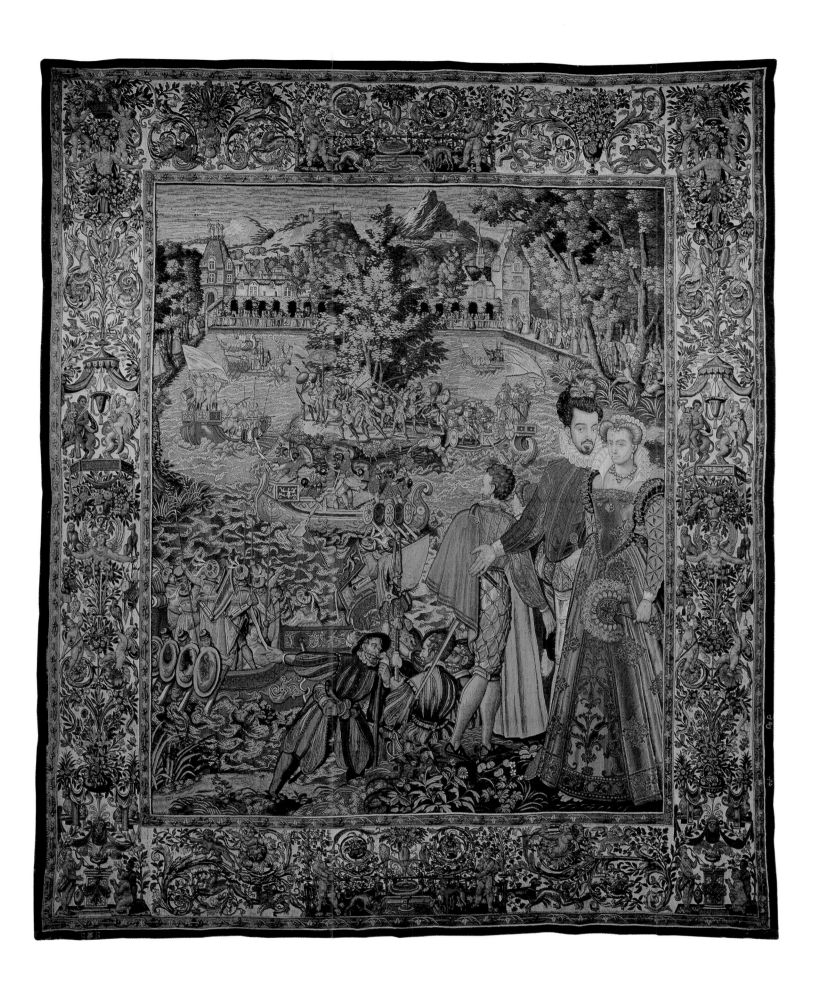

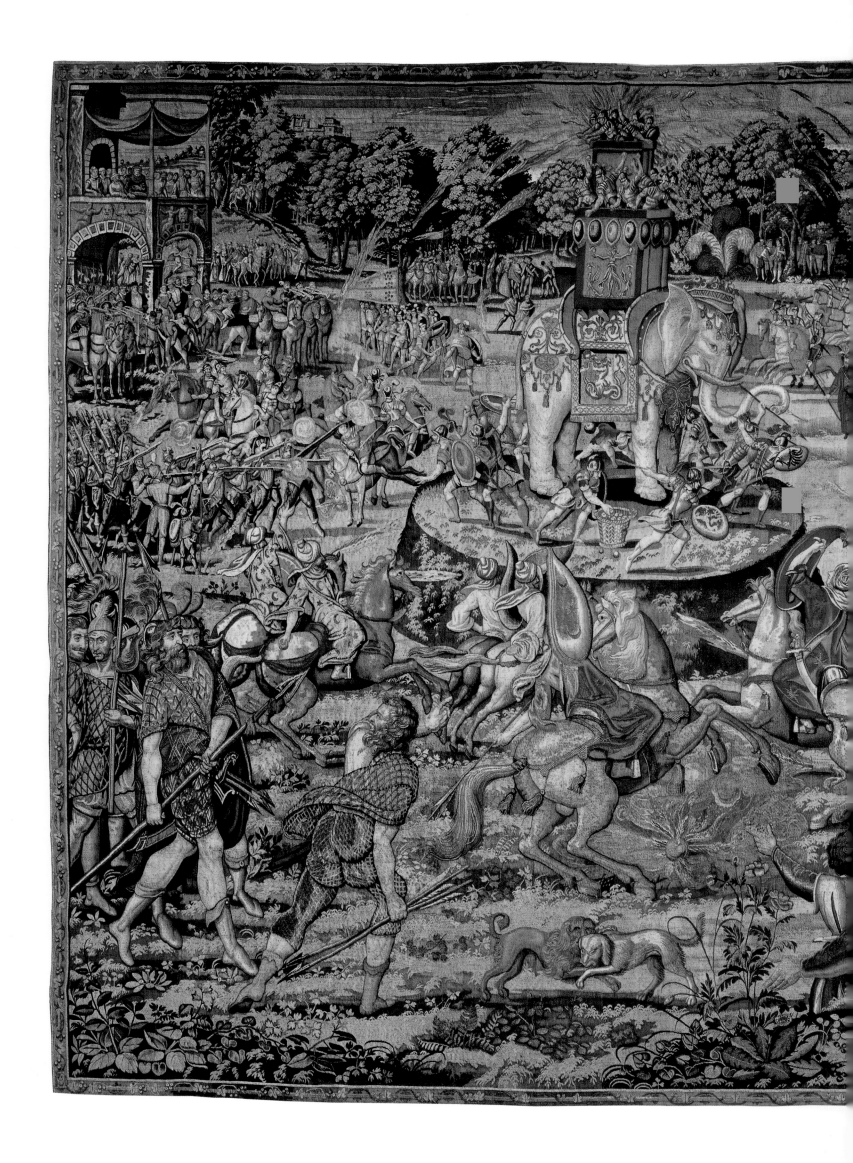

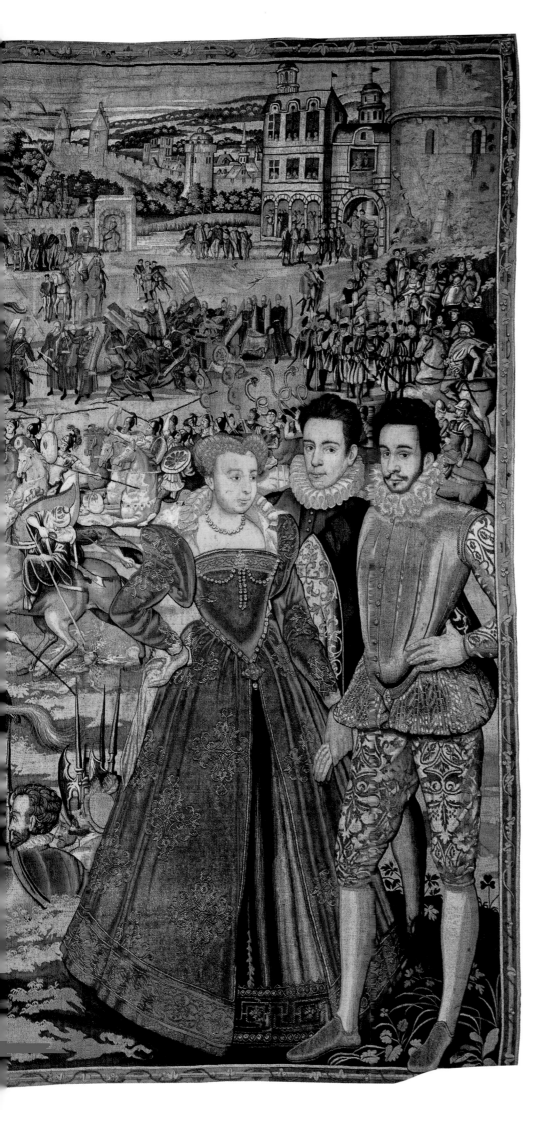

Tapestries of Caterina de' Medici. *Assault of a Turreted Elephant.* Designed by Antoine Caron, cartoons by Lucas de Heere, 1582. Woven by Joos van Herseel and Franchoys Sweerts, or François Spiering, before 1585. Woven of silk, gold, silver, and wool; lined with canvas. 153 ½ x 212 ⅛ in. (390 x 539 cm).

This choreographed melee features fancifully costumed soldiers, including Roman *milites* keeping the elephant—certainly a gift from a distant ruler—quiet with a basket of fruit. From the howdah, others launch fireworks, a popular part of such entertainments. The widowed Caterina is the black-swathed figure in the loggia in the left background.

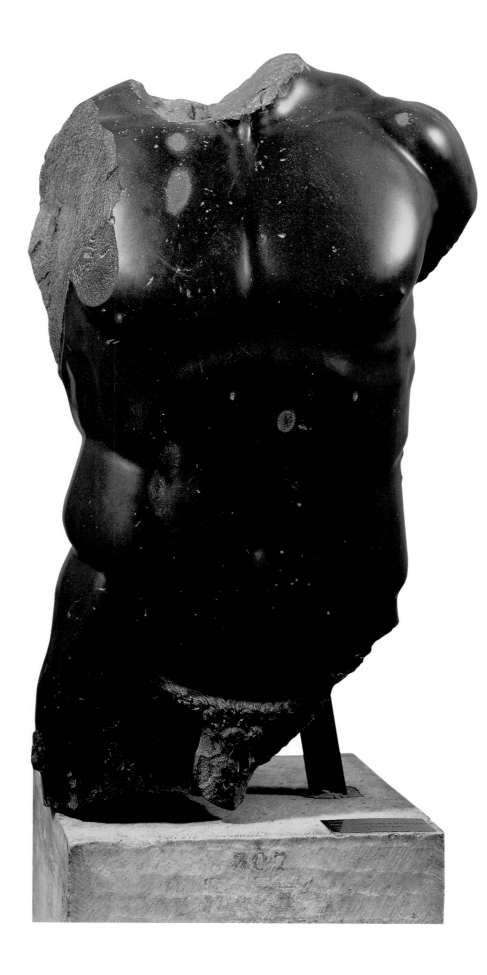

LEFT

Polyclitus. (5th century B.C.E.)
Doryphoros. Ca. 445 B.C.E. Green
basalt. Height: 44 ½ in. (113 cm).

This torso of a lance-bearer
illustrated the canon of perfect
proportions for artists of antiquity
and the Renaissance. Polyclitus—
who literally wrote the book, titled
Canon—was an architect as well as
a sculptor during the Greek Golden
Age, a period when architecture
was also based on the proportions
of the human figure. Contemporary
viewers will appreciate the sleek and
masterly abstraction of the piece.

OPPOSITE

Crouching Venus. Roman copy of a
Greek original by Doidalsas.
Marble. Height: 30 ⅝ in. (78 cm).

Also known as *Bathing Venus*, this
statue was the most famous ancient
Roman variant of the third-
century Greek figure to be
unearthed in the Renaissance, and
was displayed in the Tribuna of the
Uffizi, amid the most prized
objects in the Medici collections.
The original white marble is
heavily stained, so the subsequent
restoration is clearly evident.

P. 276

Boy with a Thorn. Roman copy of
a Greek original. Marble. Height:
33 ¼ in. (84.5 cm).

The unselfconscious liveliness and
the sense of a moment captured
are characteristic of Greek
sculpture in the Hellenistic period,
which followed the age of
Alexander the Great. His vast and
cosmopolitan empire allowed
styles to flow and fuse, and yet
come down to earth with grace and
charm. This figure is the elusive
type of ephebe, fluctuating
between boyhood and manhood.

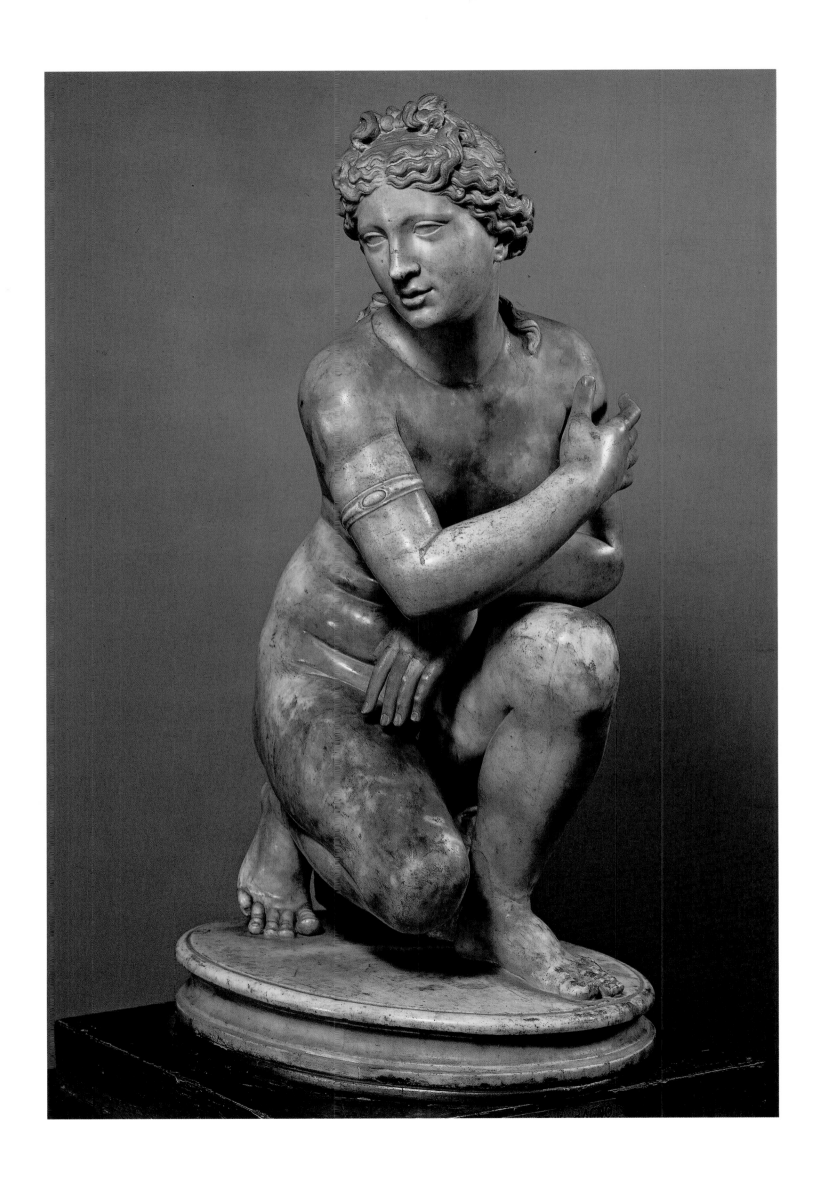

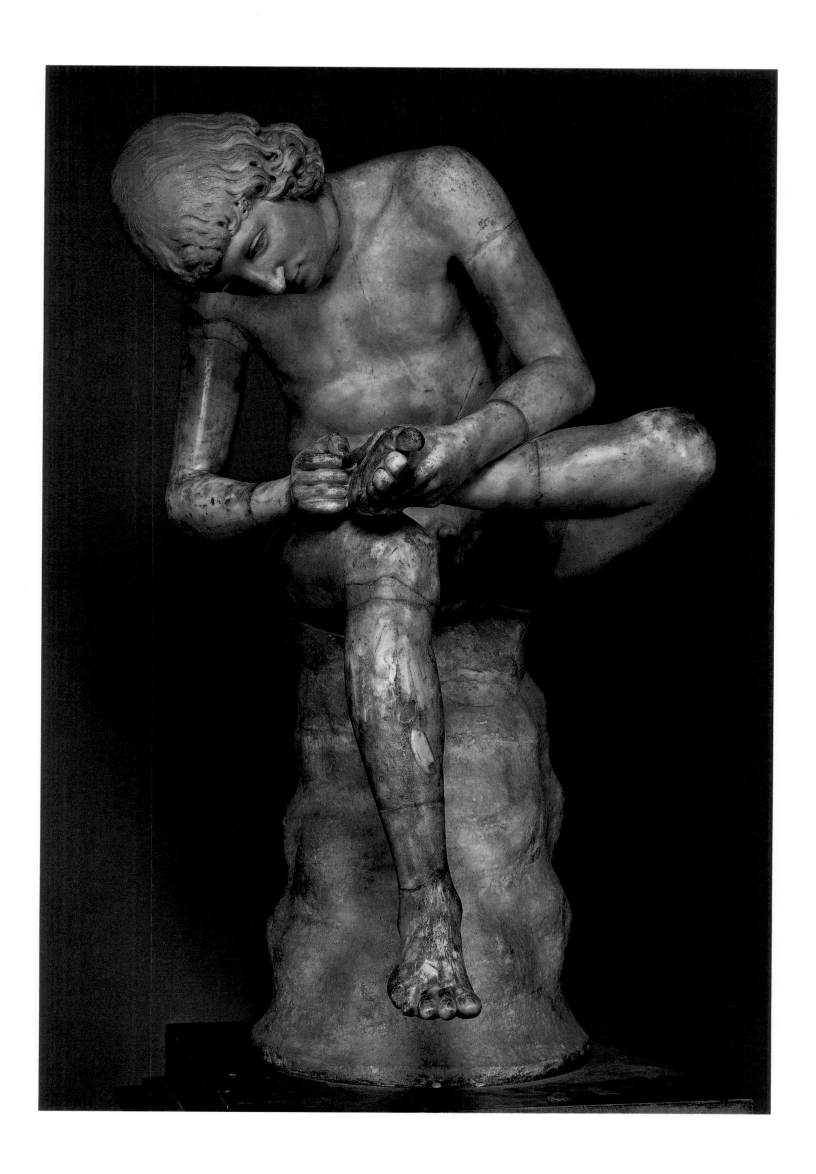

EIGHT

The Dying Alexander. Roman copy of a Greek original. Marble. Height: 28 ⅜ in. (72 cm).

Madame de Staël, eighteenth-century French writer, saw in the young conqueror's expression "astonishment and indignation at being unable to vanquish nature." The legendarily beautiful Macedonian king died of fever in Babylon in 323 B.C.E. at thirty-three, about a generation before the Greek original was made. A hero of fantastic tales during the Middle Ages, Alexander, who had studied with Aristotle, represented the enlightened prince to the Renaissance.

P. 278

Kleomenes. Mid-1st century B.C.E. *The Medici Venus.* Marble copy of a Greek original attributed to Praxiteles. Marble. Height, without the base: 60 ¼ in. (153 cm).

Queen of the Uffizi's Tribuna, the so-called *Medici Venus* is a Hellenistic copy of an original attributed to the great Praxiteles. She has become an emblem of the Medici and of Florence, where Cosimo III brought her, along with *The Hermaphrodite*, from the Villa Medici in Rome in 1677. The base bears the sculptor's name: KLEOMENES, SON OF APOLLODOROS OF ATHENS.

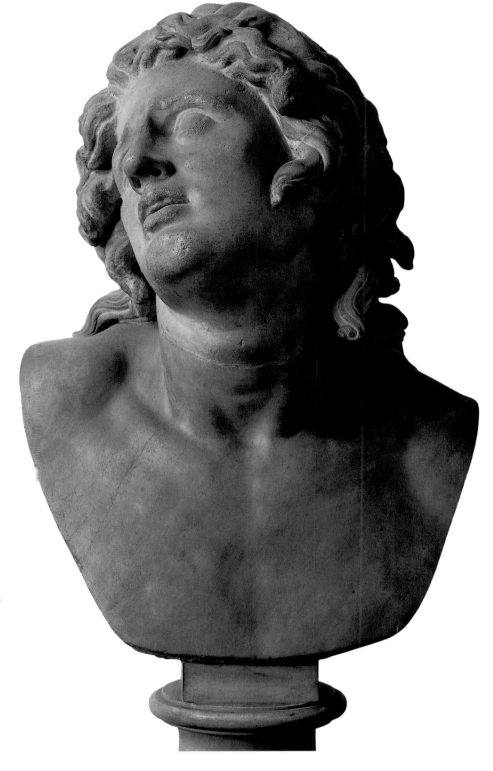

P. 279, TOP

Giovanni Lorenzo Bernini (1598–1680). *The Martyrdom of Saint Lawrence.* Ca. 1614–15. Marble. 26 x 42 ½ in. (66 x 108 cm).

Bernini sculpted his name saint as a pious demonstration of his skill. As innovative as he was precocious, Bernini carved flames and smoke—effects hitherto limited to painting—out of marble. His ecstatic Counter-Reformation martyr, glimpsing Heaven, is far from the jocular figure of medieval sermons, who told his tormentors, "Turn me over, I'm done on this side!"

P. 279, BOTTOM

The Hermaphrodite. Roman copy of a Greek original. Marble. Length: 59 ⅞ in. (152 cm); width: 26 ¾ in. (68 cm).

Ovid's *Metamorphoses* tells how the son of Hermes and Aphrodite was joined in one body with the nymph Salmacis. Besides its erotic overtones, perfect for the sensuous Hellenistic style, the notion of male and female together is resonant, recalling Plato's wistful description in the *Symposium* of human beings as half of an original whole, ever seeking our complement.

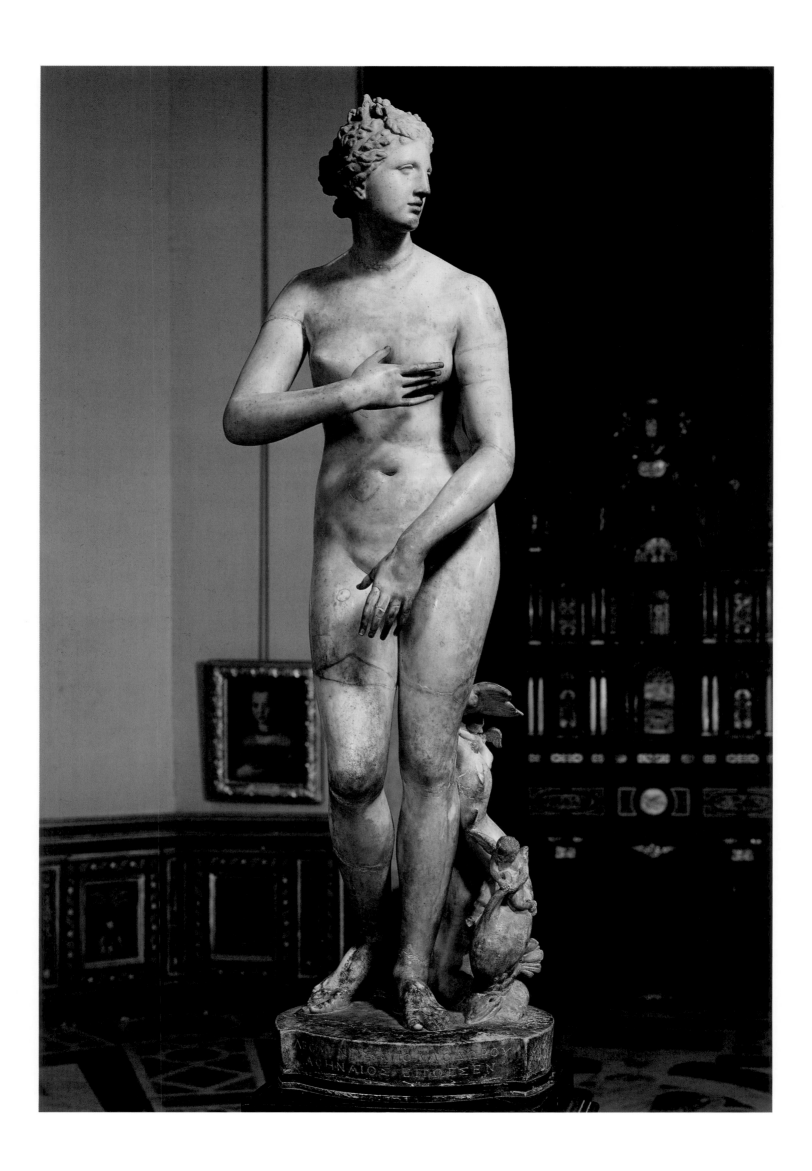

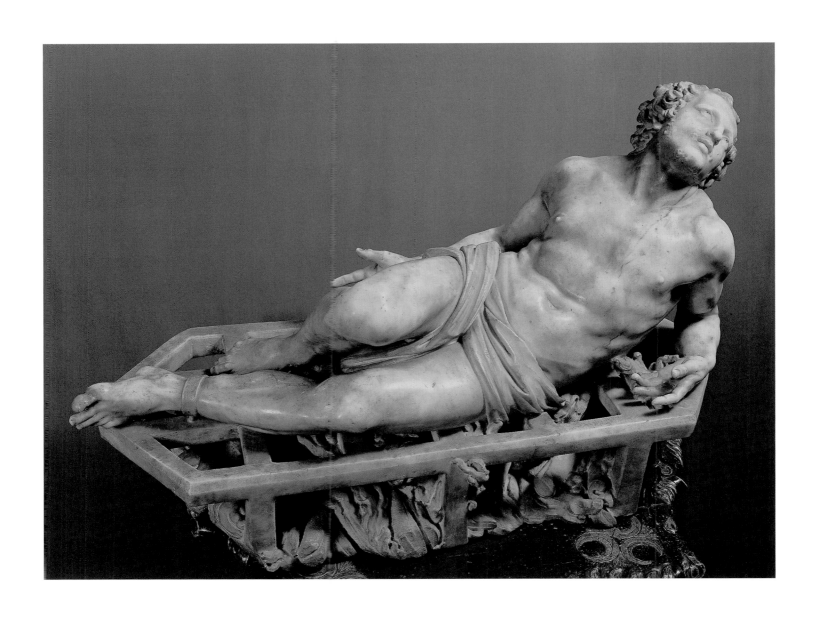

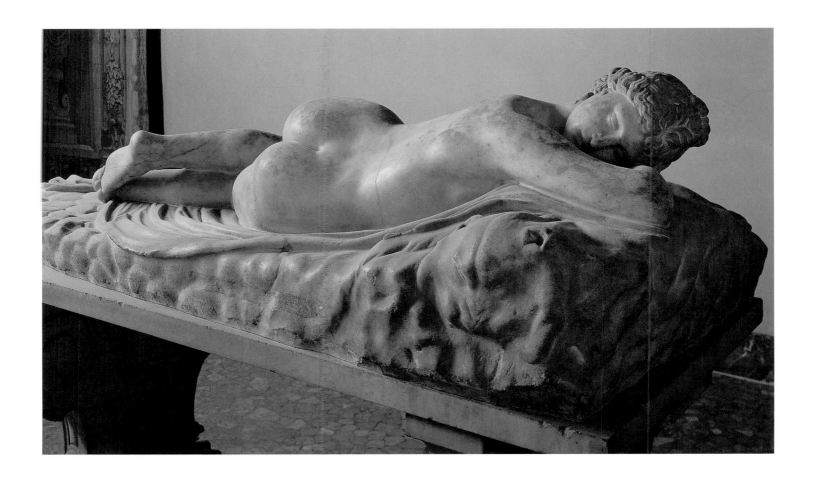

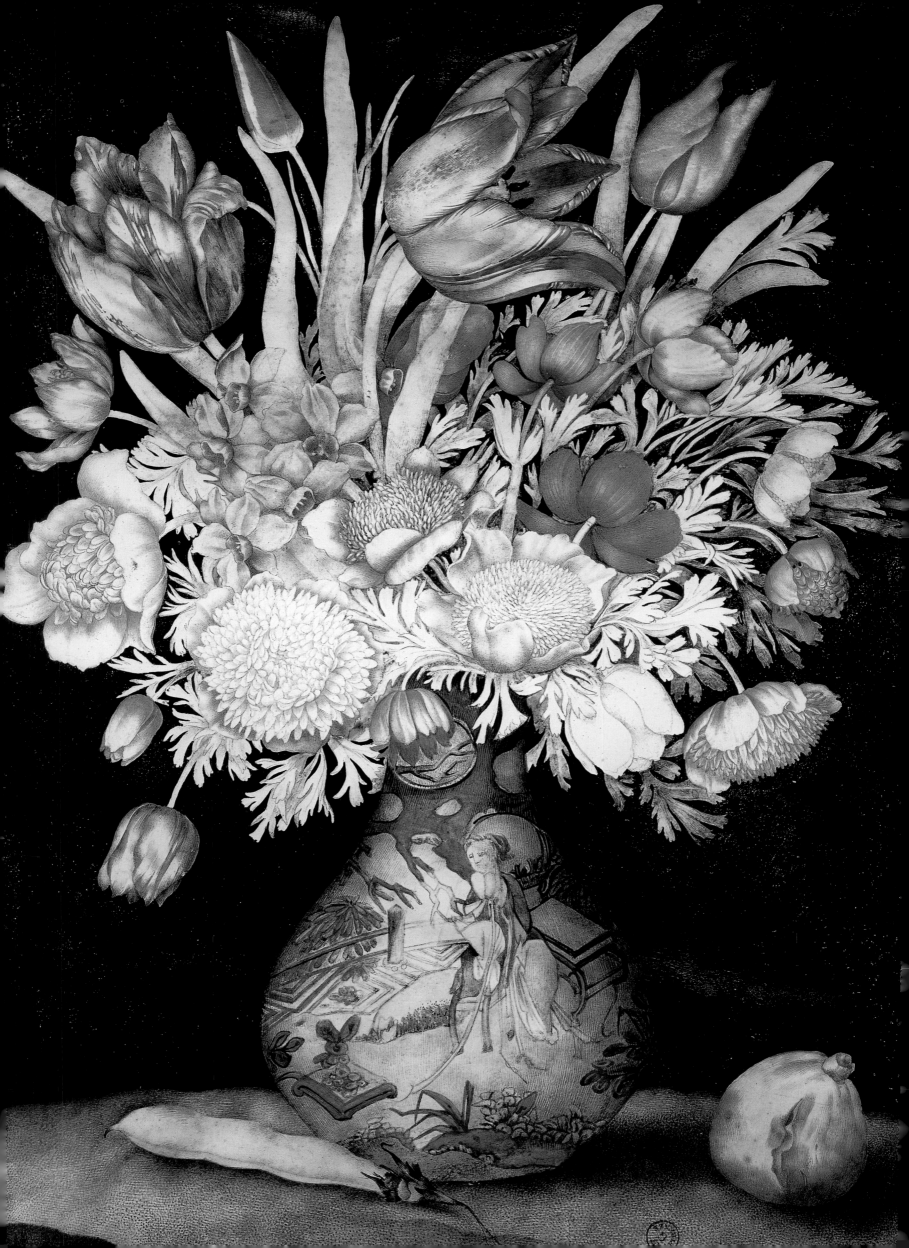

Il Gabinetto Disegni e Stampe
Drawings

Where the Medici theater once received a sumptuously appareled audience, the department of drawings and prints today houses one of the world's greatest such assemblages. Giorgio Vasari used the word *disegno* to mean a combination of concept and drawing, and indeed the visible sign of the artist's hand permits us to trace the creative process itself. Media range from chalks to ink to pigments; supports include vellum and white and tinted papers; and the types of drawings include meditative sketches illustrating the development of an idea, studies of details or stubborn problems in perspective, and finished presentation drawings of sculptural or architectural projects.

OPPOSITE
Giovanna Garzoni (1600–70). *Chinese Vase with Flowers, a Fig, and a Bean.* Second quarter of the 17th century. Watercolor and traces of black pencil on parchment. 20 ⅟₁₆ x 14 ½ in. (51 x 36.9 cm).

Garzoni achieved an unequalled luminosity by stippling richly pigmented watercolor on vellum, a fine-grained lambskin, kidskin, or calfskin prepared especially for writing. Once used for the finest manuscripts, vellum had been largely replaced by paper in bookmaking. Garzoni's medium of choice was ideal for an era dedicated to direct observation—rendered with style.

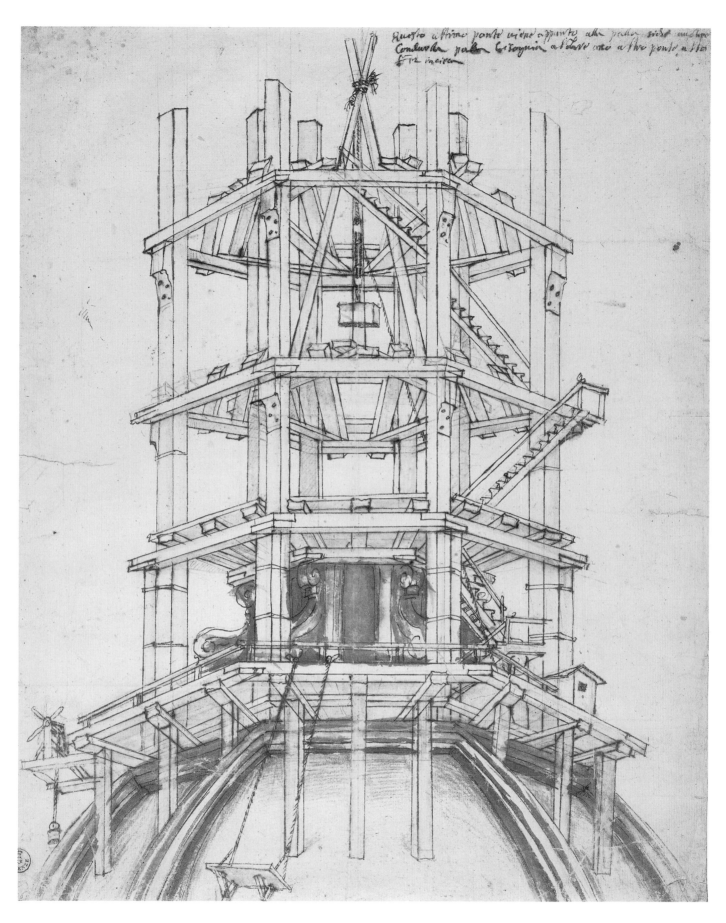

ABOVE

Attributed to Gherardo Mechini (active ca. 1580–ca. 1620). *Drawing of Scaffolding around the Lantern of Santa Maria del Fiore* (detail). 1601. Pen and ink and wash and traces of pencil.

The dome of Santa Maria del Fiore, the cathedral of Florence, was (and remains) an unmistakable feature of the city's skyline. At the turn of the seventeenth century, the Brunelleschi-designed lantern —the uppermost element allowing light to fall on the altar—was struck by lightning. The design of the scaffolding erected for the repair of the lantern was crucial to the lives of the workers restoring Brunelleschi's 1471 masterpiece.

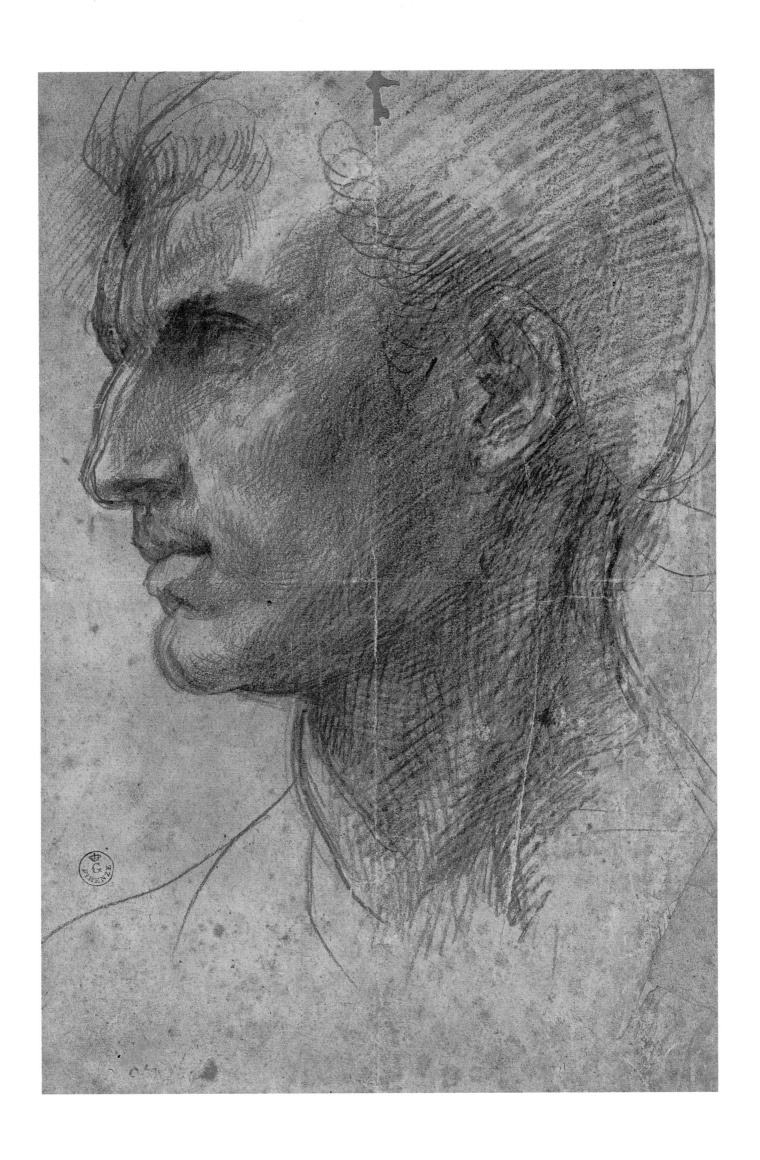

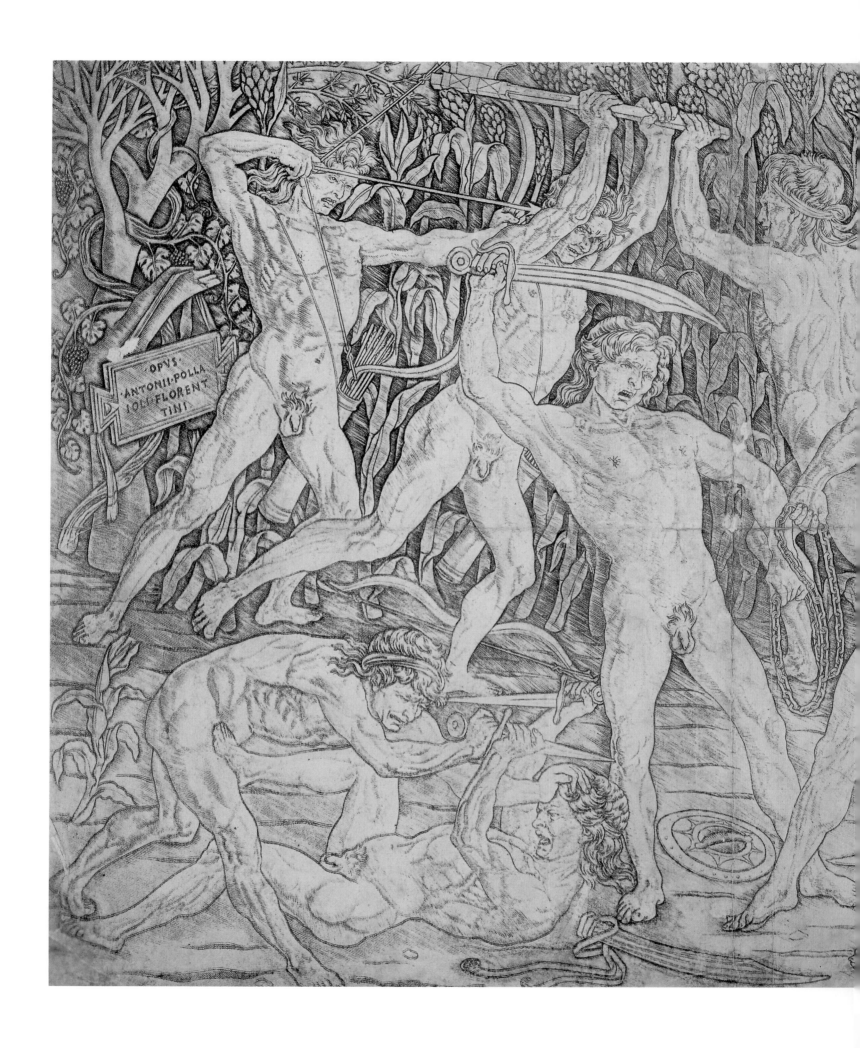

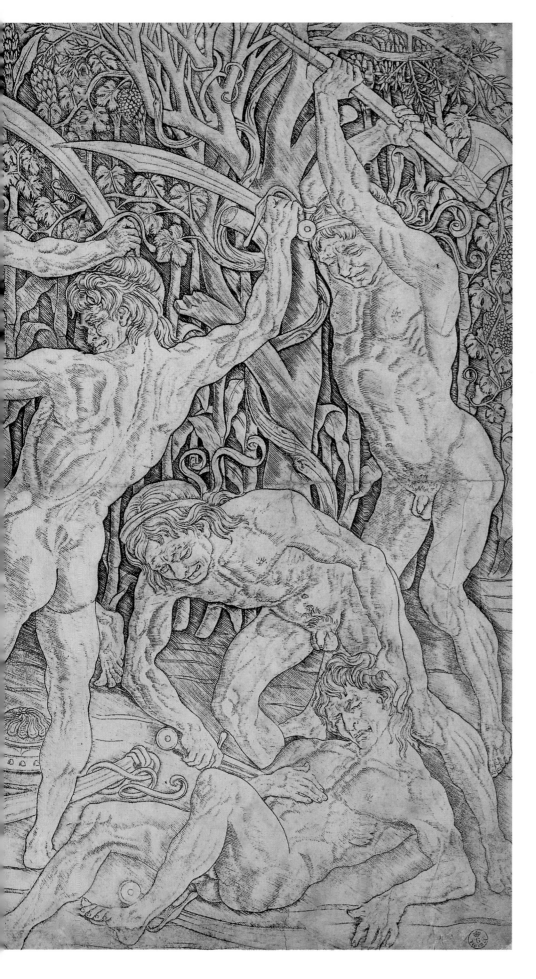

P. 283

Andrea del Sarto (c. 1487–1530). *Head of a Man in Profile Facing Left.* Before 1517. Charcoal on paper. 14 ½ x 9 ½ in. (36.9 x 24.2 cm).

This study from life is a preparatory drawing for the figure of Saint Peter Martyr in Andrea del Sarto's *Disputation on the Trinity*, in the Galleria Palatina. Andrea used strong lines, shading, and cross-hatching to intensify the powerful features, which express passionate attention, intellect, and faith—an effect in the final work that Vasari admired for its *terribilità*, or fierceness.

LEFT

Antonio del Pollaiuolo (1433–98). *Battle of the Ten Nudes.* Ca. 1470–75. Engraving. 15 ¹⁄₁₆ x 23 ⁷⁄₁₆ in. (38.3 x 59.5 cm).

Owing its shallow space to ancient Roman reliefs, this print probably served as a showpiece, a compendium of studies of postures and musculature, or both. Del Pollaiuolo was an accomplished silver worker, whence the finesse of his modeling. This was the largest engraving made in Florence in the fifteenth century; the artist proudly inserted his name and origin into the scene.

P. 286

Fra Filippo Lippi (1406–69). *Preparatory Drawing for Madonna with Child and Two Angels.* 1465. Metal point, white lead, traces of black charcoal or chalk, and brown wash on prepared orange-pink paper. 13 x 9 ⁷⁄₁₆ in. (33 x 24 cm).

Touches of white lead highlight solemn, graceful contours in this very finished work, no doubt made to get final approval from the patron, who remains unknown. The most noticeable difference between the painting and this draft is that here the landscape is absent—it was perhaps filled in by an assistant specialized in the genre.

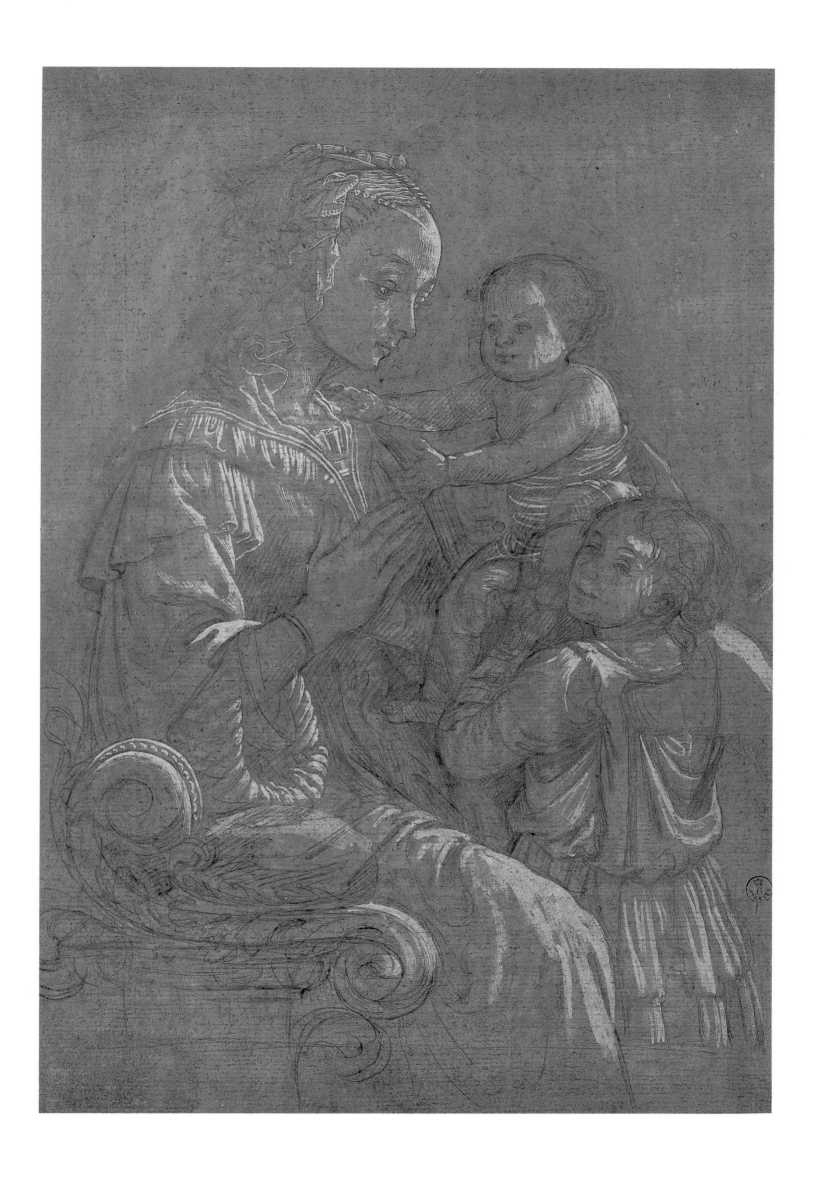

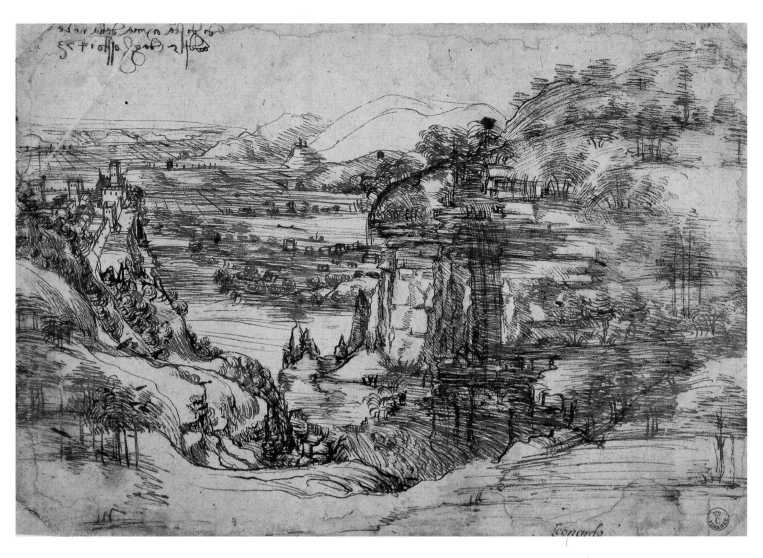

ABOVE

Leonardo da Vinci (1452–1519). *Landscape Study*. Dated August 5, 1473. Pen and ink on paper.

Leonardo noted the feast day—Santa Maria della Neve, which commemorates a miraculous snowfall in August—and the date on this sketch from life, which has somewhat over excitedly been called "the first true landscape drawing in western art." Leonardo, a young apprentice in Andrea del Verrocchio's workshop, spent the holiday in the countryside, studying the visual effects of atmosphere on nature.

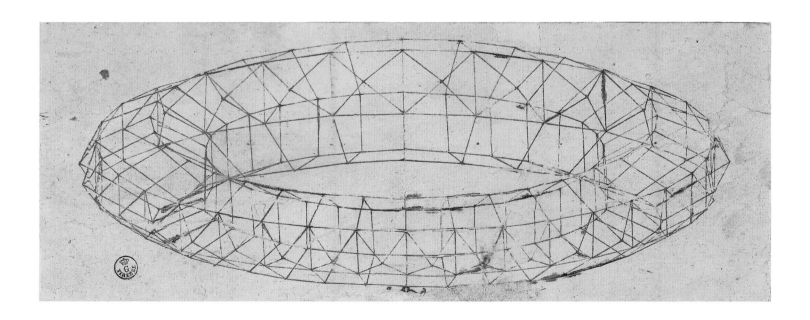

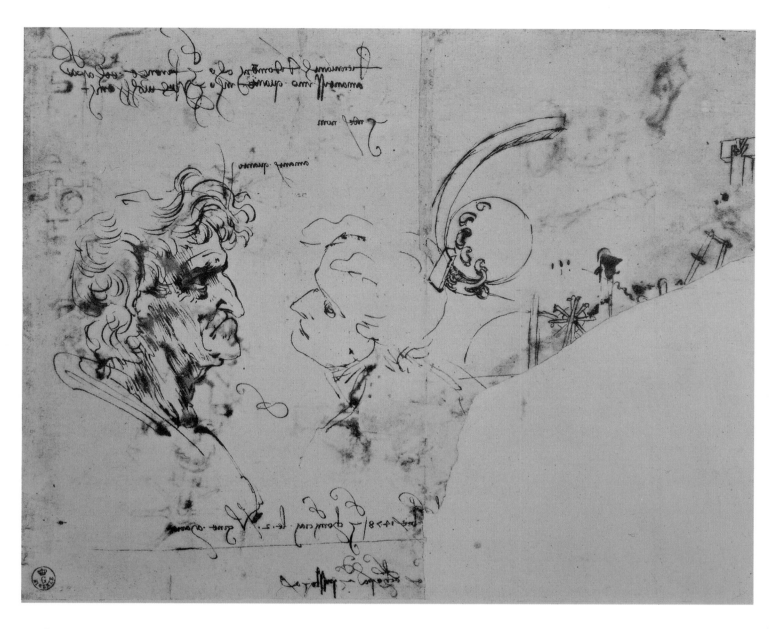

P. 287, BOTTOM

Paolo Uccello (1397–1475). *Mazzocchio.* 15th century. Pen and ink on white paper. 4 x 10 ½ in. (10.2 x 26.6 cm).

Giorgio Vasari, the great Renaissance art historian, criticized Uccello for being obsessed with the mathematics of perspective. The *mazzocchio*, originally made of wicker or wood, appears atop many a male Renaissance head; with its many planes, it provided an ideal opportunity to exercise the then new representational mode, derived from intarsia, or inlaid-wood work.

ABOVE

Leonardo da Vinci (1452–1519). *Old and Young Man.* Ink on paper. 1478.

Might these faces be the same man at different ages? The page is eloquent: the seam down the middle shows where two sheets were attached, and the variety of images interspersed with verbal notations indicates that paper was still expensive enough to be used parsimoniously. The fine calligraphy recalls that Leonardo was a notary's son.

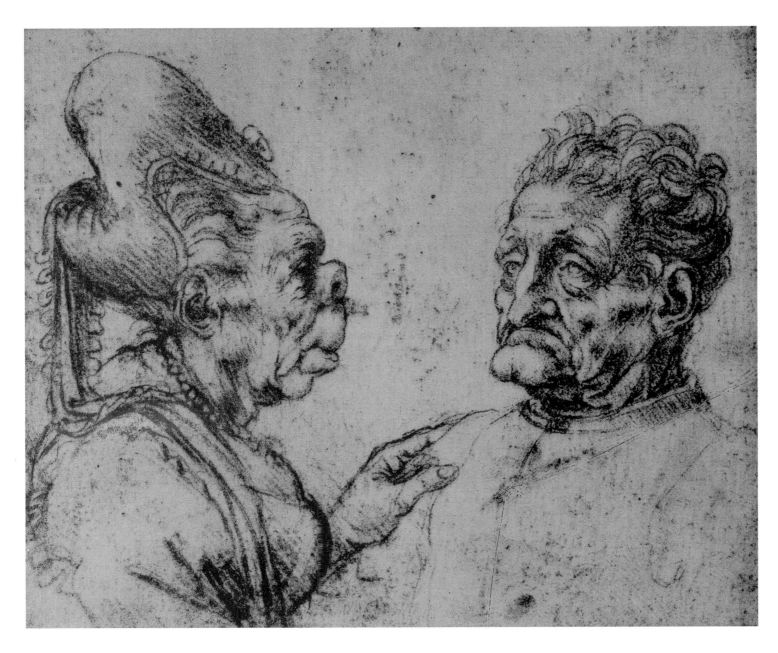

ABOVE

Leonardo da Vinci (1452–1519). *Caricature*. Pen and ink on paper.

Leonardo wrote on a group of anatomical drawings: "If intercourse is entered upon with great love and desire on both sides, the child will be very intelligent, witty, lively, and graceful." The famously beautiful artist was perhaps thinking of himself, the welcome love child of unmarried parents. The circumstances of his birth may have barred him from entering his father's profession as a notary.

P. 290

Leonardo da Vinci (1452–1519). *Female Head*. Charcoal or black chalk, red chalk, and white lead on paper.

This lovely drawing might have served for a Madonna or one of Leonardo's androgynous angels, smiling with divine inner knowledge. To model the delicate features, he used quick single lines, close hatching, and stumping, which is smudging the soft charcoal or chalk. His revolutionary innovation is most visible on the left part of the face, where the contour merges into shadow.

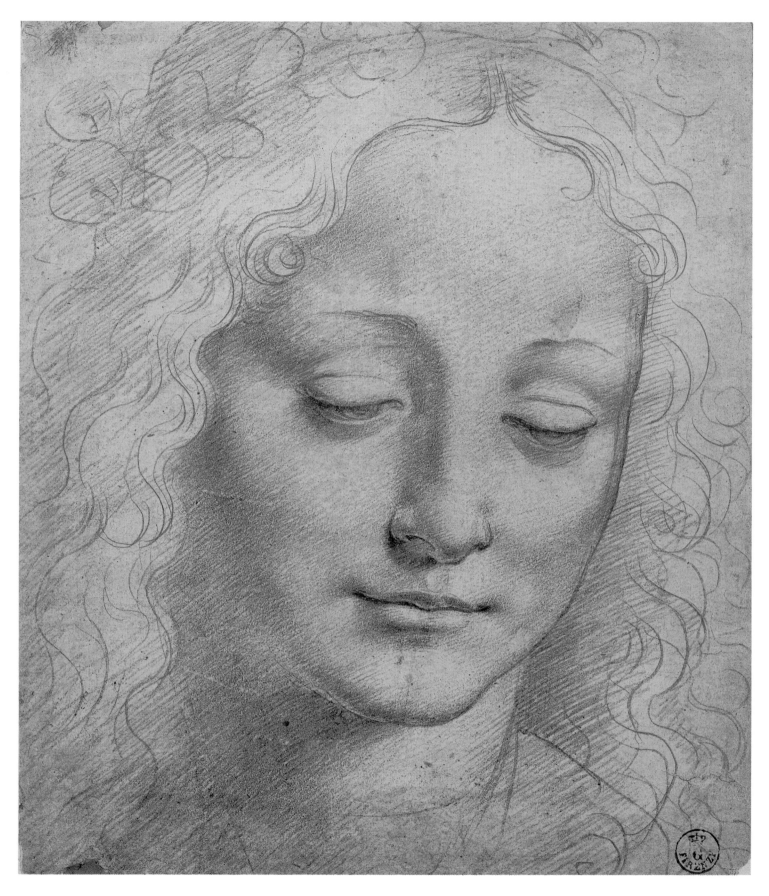

OPPOSITE
Leonardo da Vinci (1452–1519). *Two Heads.* Ca. 1490–95. Red chalk on paper.

For Leonardo, drawing was often a way of studying the world, seeking and finding correspondences in the great book—or machine—of nature. One example is the similarity between his ringlets and a study of an eddy. The area in front of the young man's face shows signs of an earlier stage of the drawing.

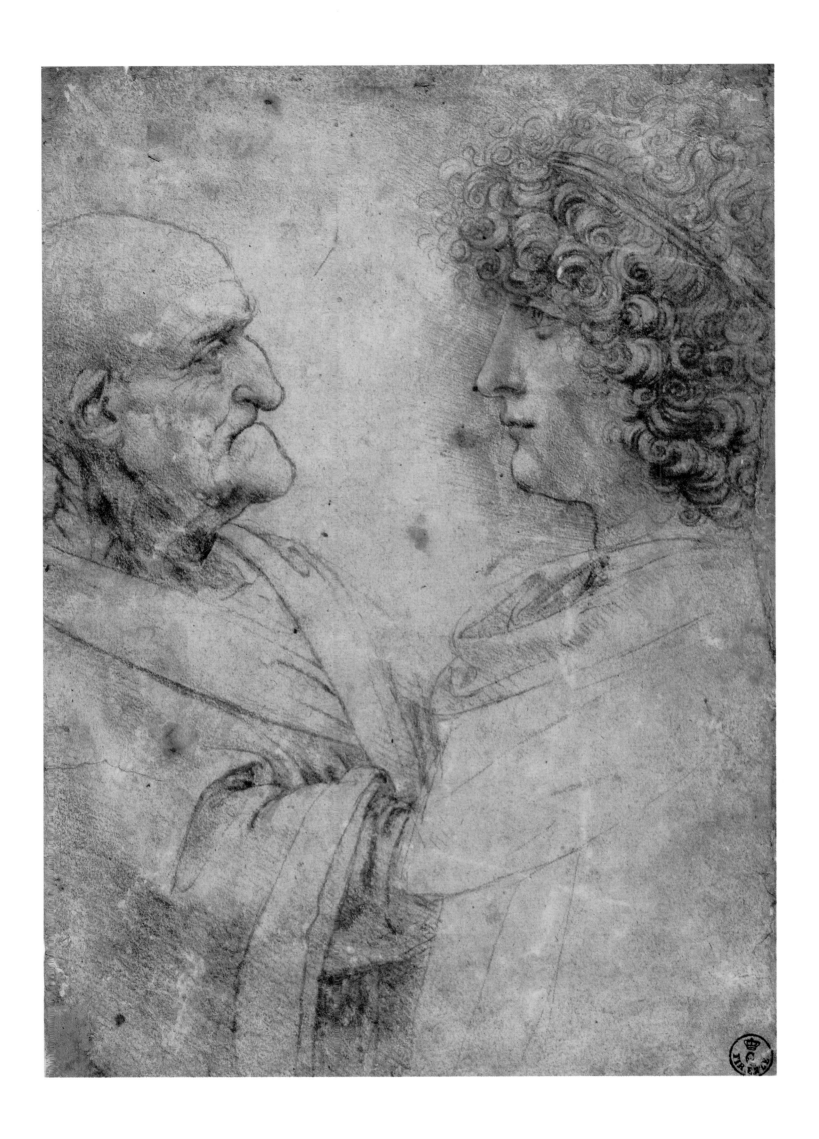

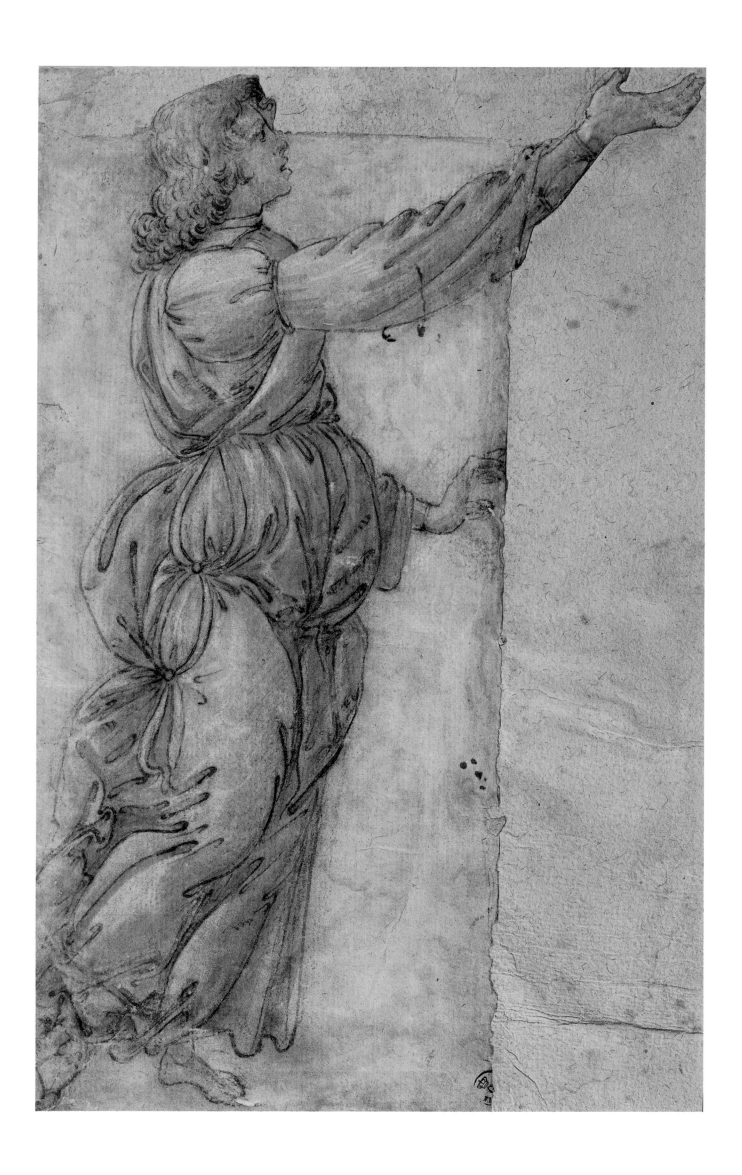

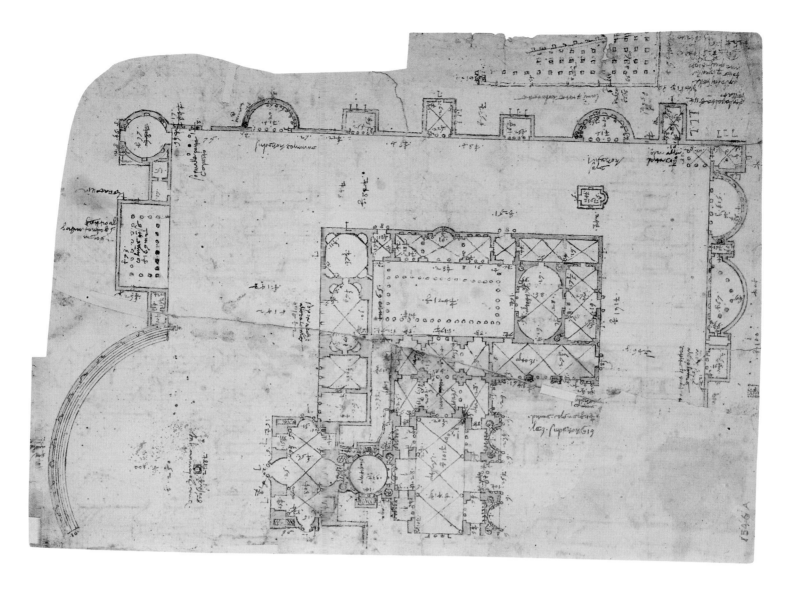

Sandro Botticelli (1445–1510). *Angel.* Ca. 1490. Pen and ink and wash over traces of black charcoal or chalk with white lead highlights. Sheet: 10 ⅝ x 7 ¹⁄₁₆ in. (27 x 18 cm).

Billowing volumes announce the celestial origin of this graceful visitor, dated to later in Botticelli's career because of the "agitation and convulsion in his line." Specialists in drawings could hypothesize a history of the object's vicissitudes from the condition of the original and support sheets—note the left and right edges of the laid paper—and the halved Uffizi stamp.

Antonio da Sangallo the Elder (ca. 1455–1534). *Plan of the Complex of the Diocletian Baths in Rome.* After 1494. Pen and ink on paper.

This plan of the great public baths built by the ancient Roman emperor Diocletian reveals careful measurements and the use of compasses, rulers, and freehand details. Sangallo added units after the numerals for clarity—different cities employed different units. The great number of plans he left behind suggests that, like Leonardo, the act of drawing stimulated his visual sense.

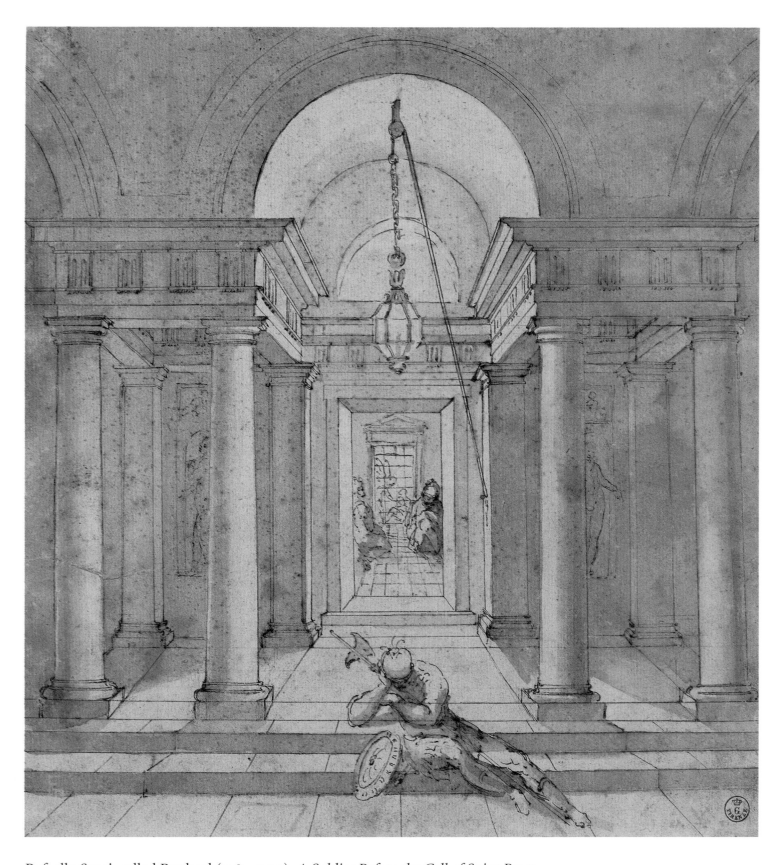

Rafaello Santi, called Raphael (1483–1520). *A Soldier Before the Cell of Saint Peter.*
Pen and ink and wash on white paper. 10 ¾ x 10 in. (27.4 x 25.4 cm).

The Liberation of Peter from Prison occurs in the Acts of the Apostles; Raphael translated its imagery of light and shadow. The fresco of the subject, done for Pope Julius II, commemorated the soldier-pontiff's imprisonment before rising to the papacy. This presentation drawing, which differs from the final work, may represent a stage in the discussions between patron and painter.

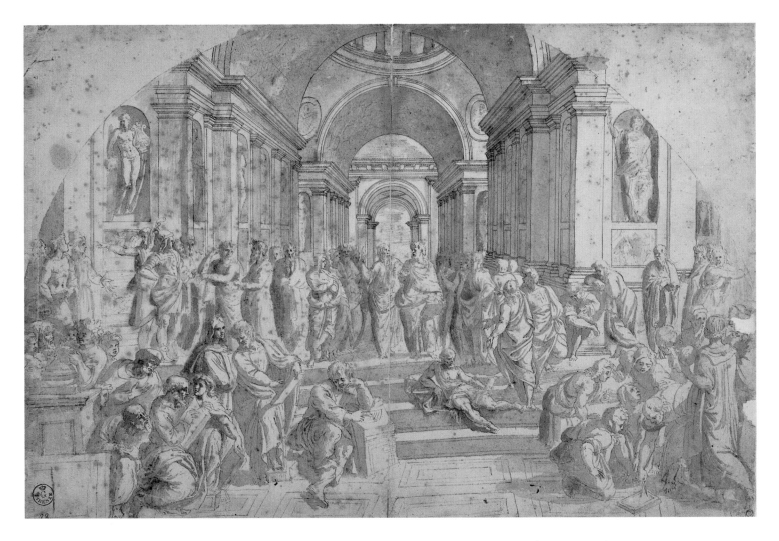

School of Raphael. *The School of Athens*. Pen and ink and wash. 11 ⁷⁄₁₆ x 16 ¹⁵⁄₁₆ in. (29 x 43 cm).

Carefully ruled architectural verticals set off a lively variety of attitudes signifying the excitement of ideas. This was probably a copy of Raphael's *School of Athens* in the Vatican's Stanza della Segnatura, rather than a study for it. The drawing shows the brooding, isolated figure in the left foreground—sometimes identified as Michelangelo—that Raphael only added after the fresco was finished.

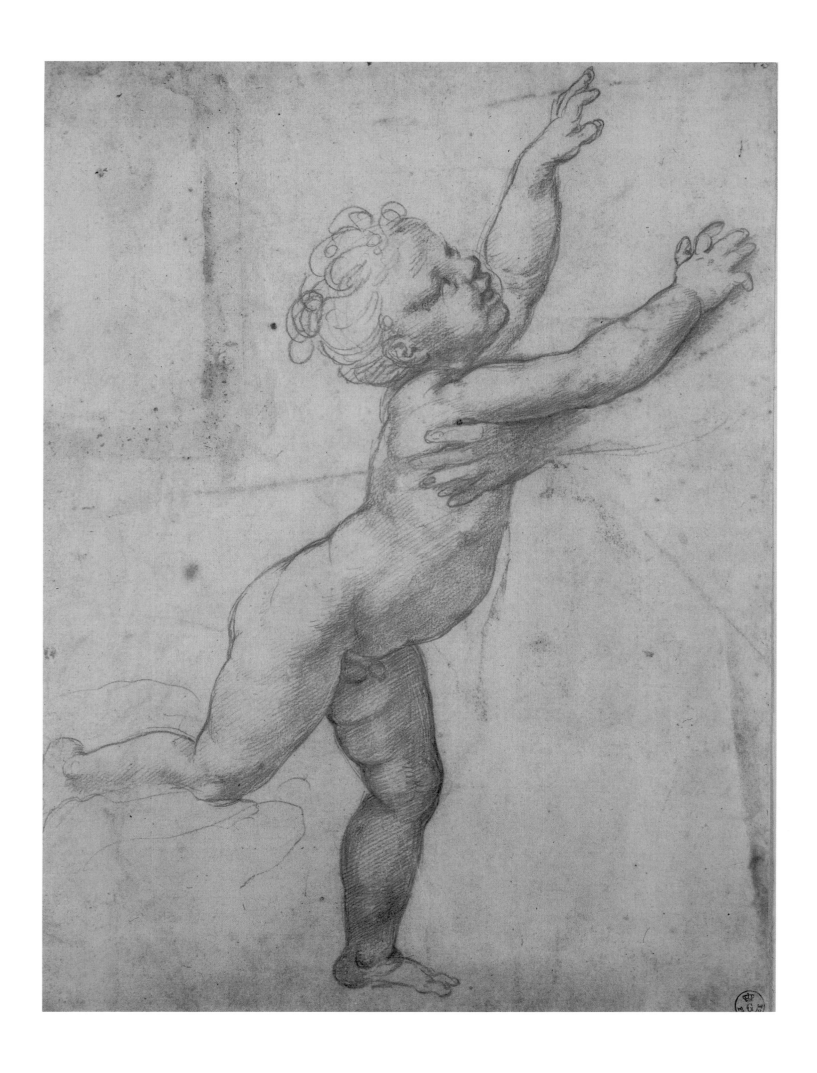

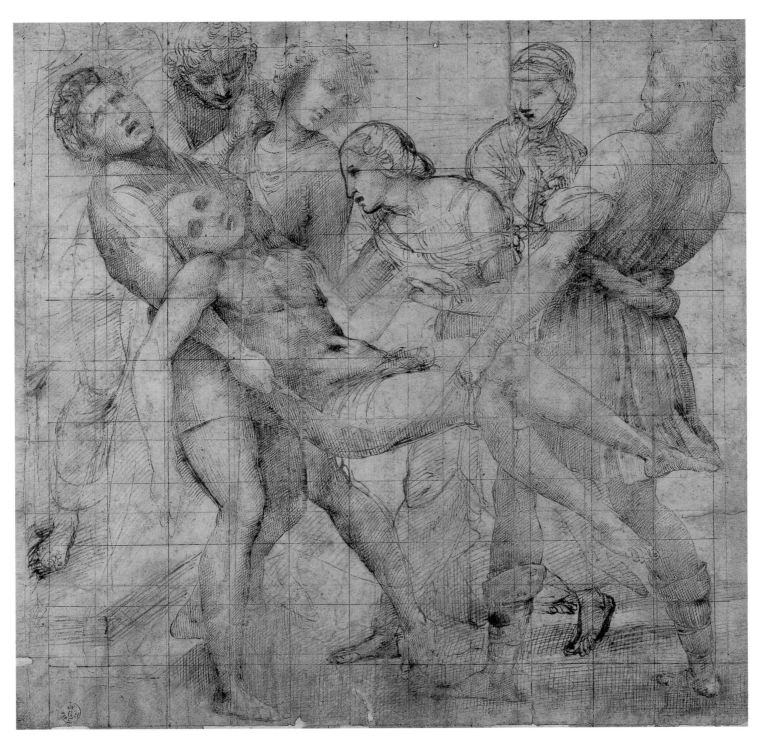

Rafaello Santi, called Raphael (1483–1520) or Giulio Pippi, called Giulio Romano (probably 1499–1546). *Nude Child with Open Arms*. Red chalk on white paper. 10 ⅝ x 8 ¼ in. (27 x 20.9 cm).

Pope Leo X commissioned *The Holy Family*, for which this sketch was made, and sent it to France, perhaps in celebration of a royal birth. When the art historian Frederick Hartt was in Florence immediately after World War II, he attributed the drawing to Raphael's close associate Giulio Romano, author of other figures in the painting.

Rafaello Santi, called Raphael (1483–1520). *Deposition (Study for the Painting in the Borghese Gallery)*. 1507. Pen and ink over traces of black chalk on paper. 11 ⅜ x 11 ¾ in. (28.9 x 29.8 cm).

The final painting is almost six times the size of this sheet, which is virtually a dictionary of transfer techniques: it has been squared using a pen, red chalk, and a stylus. The drawing shows every stage from the black-chalk sketch of Christ's left arm to the complex hatching of the costume of the man on the right.

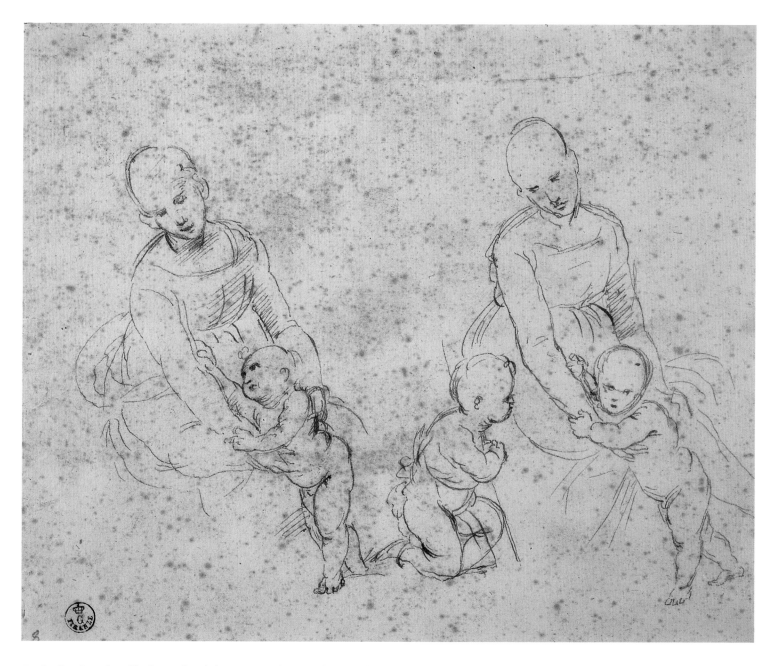

Rafaello Santi, called Raphael (1483–1520) or School of Raphael. *Madonna and Child and the Young Saint John.*
Pen and ink on paper. 6 ¹³⁄₁₆ x 8 ¼ in. (17.3 x 21 cm).

This drawing is constructed in the solidly grounded pyramidal shape that Raphael learned from Leonardo.
With just a few strokes, the artist produced—and reproduced—extraordinarily expressive postures and gestures.
The very dark areas in the small of the first baby's back and elsewhere may be abrasions produced by too much
acid in the ink.

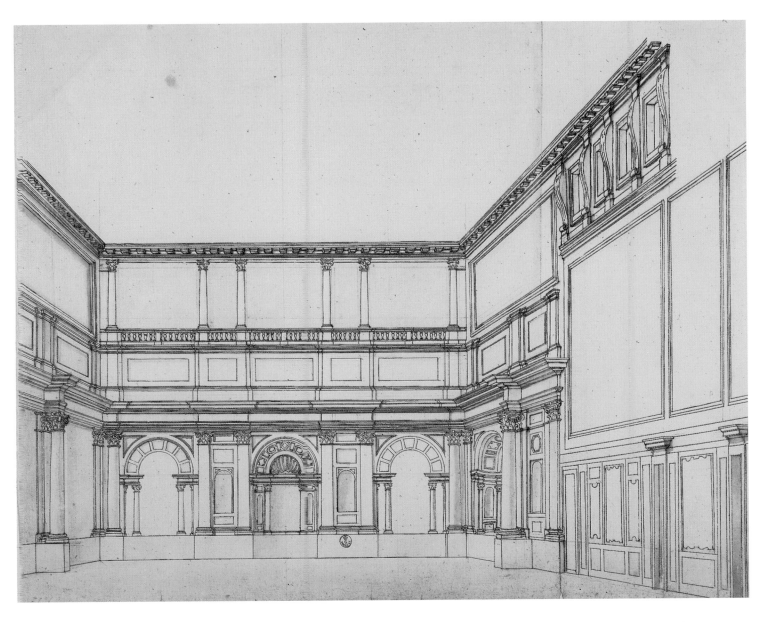

Anonymous. 16th century. *The Hall of the 500*, or, *The Audience Chamber*. Pen and bister and black pencil on white paper. 20 ⅞ x 16 ½ in. (53.1 x 42 cm).

The ducal family of Cosimo I and Eleanora of Toledo had the former town hall renovated as their private palazzo. Fifty years earlier, during the Republic, this room was one of the most famous interiors in Europe, due to be frescoed by both Michelangelo and Leonardo. Neither painting was completed, but the sketches for them influenced generations of artists.

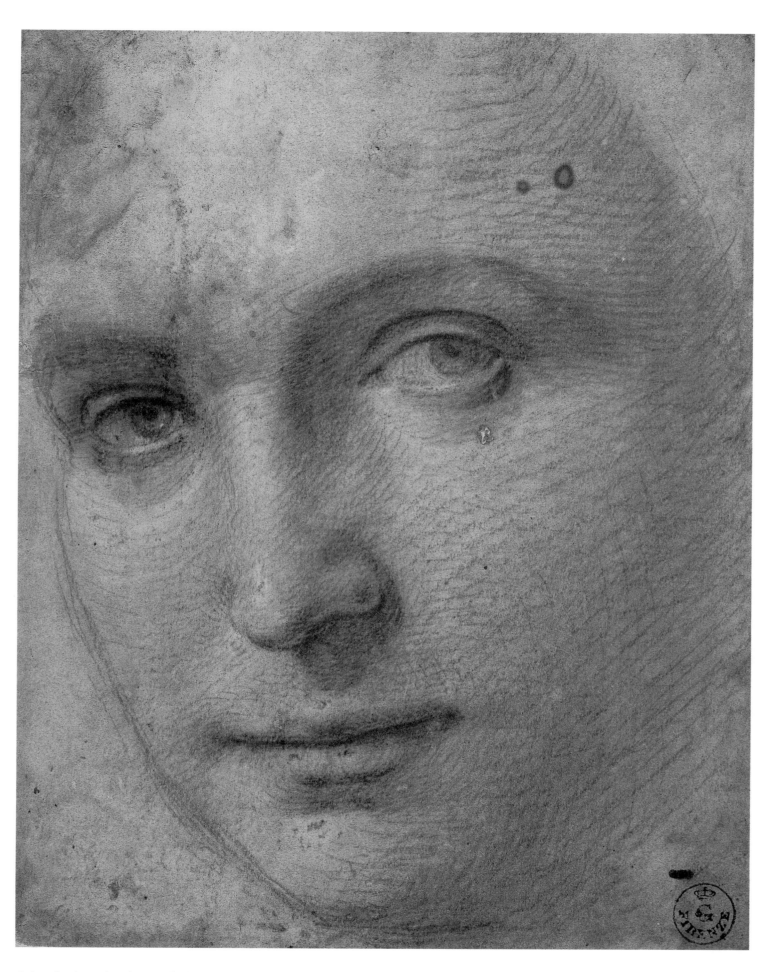

School of Raphael. *Head of a Youth.* Early 16th century. Red chalk on white paper. 7 ⅝ x 5 ⅞ in. (19.3 x 15 cm).

Raphael's paintings are models of apparently effortless grace, but his drawings reveal their careful preparation. Leonardo da Vinci had pioneered the use of red chalk, with its warm, well-defined line. Here, the shading at the corners of the mouth also suggests Leonardo's influence on a teenage Raphael.

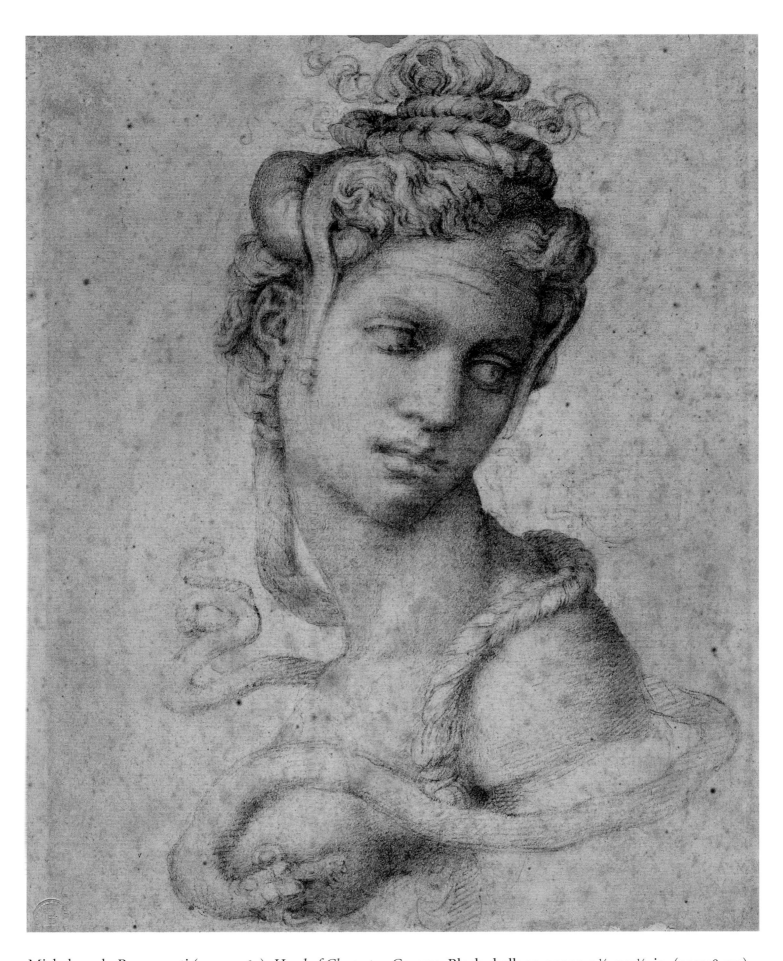

Michelangelo Buonarroti (1475–1564). *Head of Cleopatra.* Ca. 1533. Black chalk on paper. 9 ⅟₁₆ x 7 ⅟₁₆ in. (23 x 18 cm).

This highly decorative, virtuoso drawing was one of a series of gifts for Tommaso de' Cavalieri, a young artist whom Michelangelo wished to teach and of whom he was deeply fond. The elder painter's celebrated draftsmanship is visible in the extreme twist of head and neck, known as *serpentinata*—perhaps a play on words, given the fatal, coiling asp.

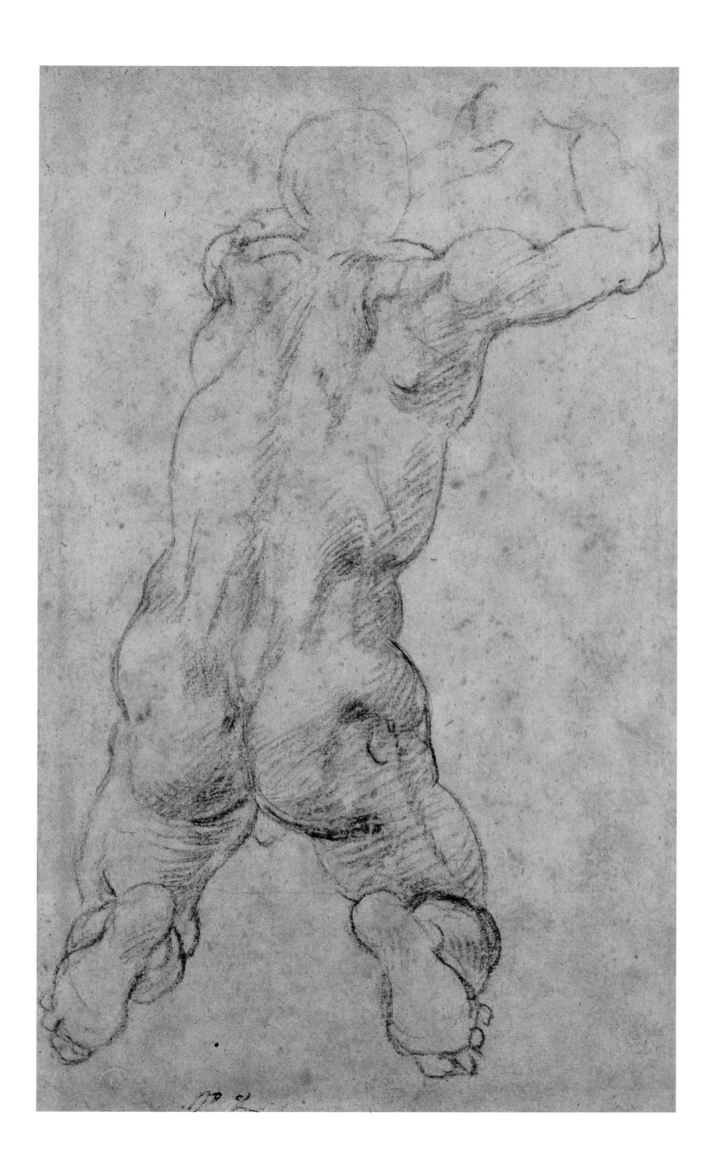

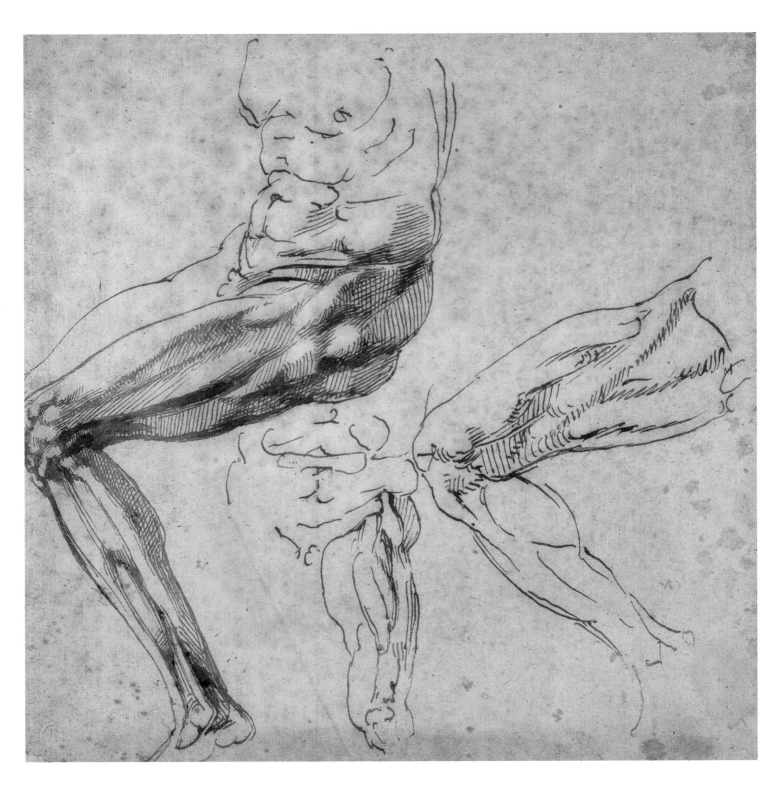

Michelangelo Buonarroti (1475–1564). *Kneeling Male Nude*. Black chalk on paper.

Michelangelo, a religious man, worried that his fascination with the nude body was excessive, even sinful. In the 1550s, Pope Paul IV commissioned Daniele da Volterra to paint over the (many) "shameful parts" in the Sistine Chapel frescoes that Michelangelo had painted for Paul's predecessors. The artist may have obtained the deep black areas of shading by dipping a stick of chalk in oil.

Michelangelo Buonarroti (1475–1564). *Three Studies of a Leg*. Pen and ink on paper.

The middle drawing, a quick frontal sketch, explores roughly how the leg muscle behaves when it is slightly turned out. It seems likely that the second drawing was the leg on the right, and the final draft the figure on the left. Though autopsies were officially forbidden, artists, including Michelangelo, found ways to attend and learn about anatomy.

P. 304

Pietro da Cortona (1596–1669). Drawing for *The Age of Gold*. Ca. 1637. Pen, ink, and red chalk on white paper. 16 ½ x 11 in. (42 x 28 cm).

One of the last stages of the artist's preparation for the large fresco cycle in the Palazzo Pitti's Sala della Stufa was to square off the composition for transfer. This drawing would merely show the proportions and placement of figures and other elements that would be more thoroughly drafted on other sheets. This composition displays the airy weightlessness of the final work.

P. 305

Leonardo da Vinci (1452–1519). *Study of Warriors on Horseback*. Pen and ink on paper.

This sketch may be for the vast mural Leonardo painted in the Florentine Grand Council Chamber, but it also resembles a figure in the background of *The Adoration of the Magi*—it was not unusual for artists to recycle ideas. The pen strokes, weighted more on the right than on the left, are characteristic of this most famous of southpaws.

Francesco Mazzola, called Parmigianino (1503–40). *Circe and the Companions of Ulysses.* Ca. 1527. Black pencil or charcoal, pen and brown ink and wash, and white lead on white paper with watermark. 9 ⅟₁₆ x 11 in. (23 x 27.9 cm).

In this episode from the *Odyssey*, Circe offers Odysseus's men a magic potion that will turn them into beasts, yet leave them helplessly aware of their changed state. Parmigianino's pure joy in line is irresistibly infectious, as seductive as the sorceress's brew. A second hand appears to have gone over Parmigianino's lines with black pencil or charcoal.

Federico Zuccaro (ca. 1541–1609). *Taddeo Zuccaro Copying the Antique Statues of Rome.* Pen and ink and wash and traces of black pencil. 7 ³⁄₁₆ x 16 ¾ in. (18.3 x 42.5 cm).

Taddeo, Federico's elder brother and mentor, is here drawing the *Laocoön,* one of the most influential of the ancient statues discovered in the Renaissance (though its antiquity has since been questioned). Other models, both sculptural and architectural, illustrate the roots of Taddeo's classicism. This sketch was for a panel in a series honoring his brother that Federico designed for his personal *palazzo.*

LEFT
Pieter Bruegel the Elder
(ca. 1525/30–69).
Anger. 1557. 90 ⅟16 x 11 ¹³⁄16 in.
(23 x 30 cm).

Under the reign of wrath, violence and chaos rule. The drawing is signed and dated in the lower left-hand corner—Brueghel would change the spelling of his name two years later to Bruegel, as well as the style, from Gothic to Roman. Made to be engraved for a series, *The Seven Vices*, it is naturally reversed in relation to the final print.

P. 310
Pietro da Cortona (1596–1669).
Drawing for *The Age of Gold.* Ca. 1637.
Pen, ink, and red chalk on white paper.
16 ½ x 11 in. (42 x 28 cm).

One of the last stages of the artist's preparation for the large fresco cycle in the Palazzo Pitti's Sala della Stufa was to square off the composition for transfer. This drawing would merely show the proportions and placement of figures and other elements that would be more thoroughly drafted on other sheets. This composition displays the airy weightlessness of the final work.

P. 311
Pietro da Cortona (1596–1669).
Drawing for The Age of Silver. Ca. 1635.
Black chalk or charcoal and white lead on blue paper. 15 ¾ x 9 ⅞ in.
(40 x 25.1 cm).

Pietro da Cortona—one of the inventors of the Baroque—created a figure that is both monumental and borne aloft upon horizontal draperies. In the final fresco, in Palazzo Pitti's Sala della Stufa, the artist evidently corrected for the height of the fresco, since the foreshortening is more marked in the drawing, which acquired the blue spot during the fresco process.

Workshop of Michelangelo. *Study for a Window in the Porta Pia*. After 1559. Red chalk on paper.

Pius IV, one of the Medici popes, commissioned Michelangelo to build Rome's Porta Pia—the "pious gate," whose style bridged the High Renaissance and Baroque. It was Michelangelo's final architectural project: he was in his mid-eighties when construction began in 1561, and he died in 1564, the year it was completed. The Medici had been his first important patrons, and a Medici was his last.

Pietro da Cortona (1596–1669). *Drawing for The Age of Silver*. Ca. 1635.
Black chalk or charcoal and white lead on blue paper. 15 ¾ x 9 ⅞ in. (40 x 25.1 cm).

Pietro da Cortona—one of the inventors of the Baroque—created a figure that is both monumental and borne aloft upon horizontal draperies. In the final fresco, in Palazzo Pitti's Sala della Stufa, the artist evidently corrected for the height of the fresco, since the foreshortening is more marked in the drawing, which acquired the blue spot during the fresco process.

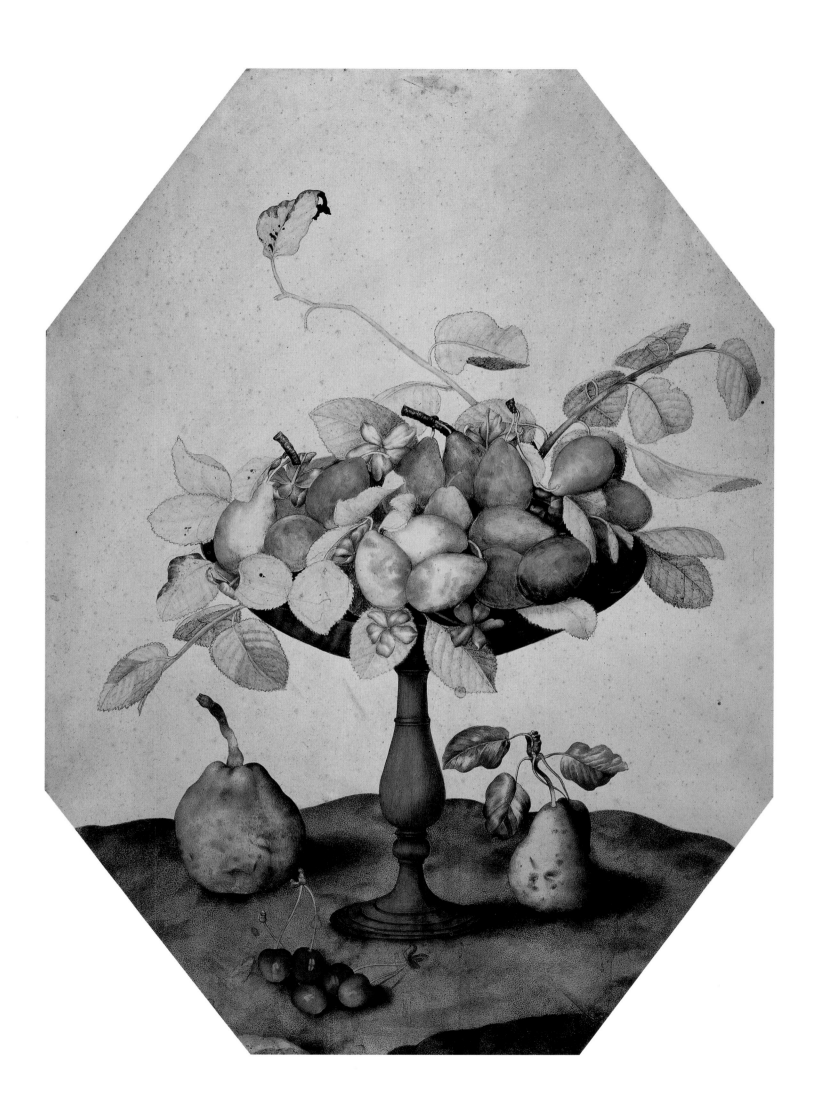

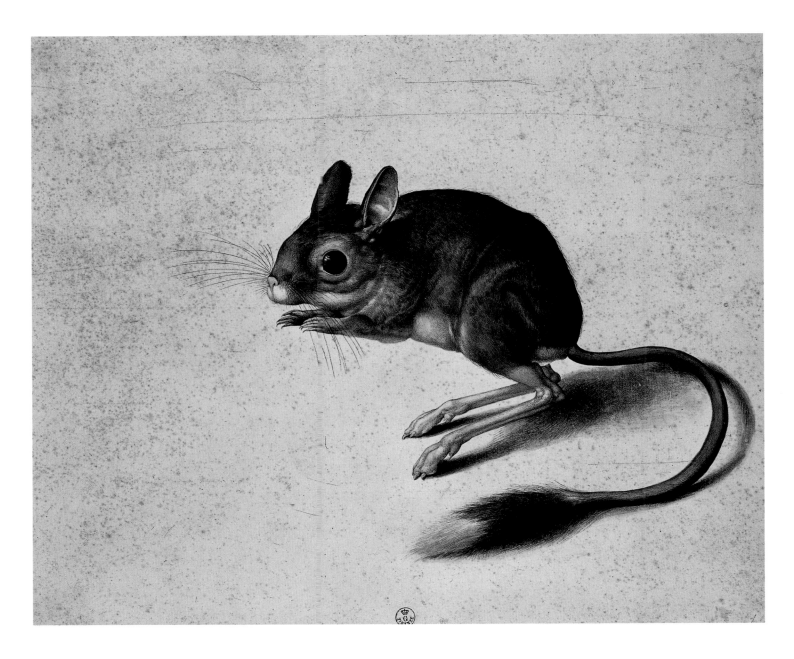

Giovanna Garzoni (1600–70). *Bowl with Plums.* Second quarter of the 17th century.
Tempera on parchment. 26 x 19 ¹⁵⁄₁₆ in. (66 x 49 cm). Galleria degli Uffizi.

Though hinting at the destructive nature of time and the transitory nature of pleasure, these fruits, including a quince on the left, recall classical tales of disappointed birds mistaking the paintings of masters for the real thing. Garzoni worked for the greatest courts of Italy, including, from the early 1640s on, the Medici.

Jacopo Ligozzi (1547–1632). *Gerbil.* 10 ¼ x 13 ⁷⁄₁₆ in. (26 x 34.1 cm).

This meticulously rendered exotic creature recalls that art and science were once on an intellectual continuum. Ligozzi, trained as a miniaturist, began his scientific paintings for Francesco I de' Medici around 1576. He also did decorative work in the Tribuna, loggia, and galleries of the Uffizi; designed for pietra dura work, glass, and ephemeral celebrations; and drew and painted religious subjects.

P. 314
Jacopo Ligozzi (1547–1632). *Psittacus Ararauna.* Last quarter of the 16th century? 26 ⅜ x 18 in. (67 x 45.6 cm).

This spectacular bird is a blue and gold macaw. Today, the species is threatened, but in the later sixteenth century parrots, monkeys, and other foreign-born livestock often accessorized the homes of the European nobility. These birds come from Central and South America, recalling that the Medicis were investors in Columbus's expeditions, and that Mexican antiquities graced the Uffizi galleries.

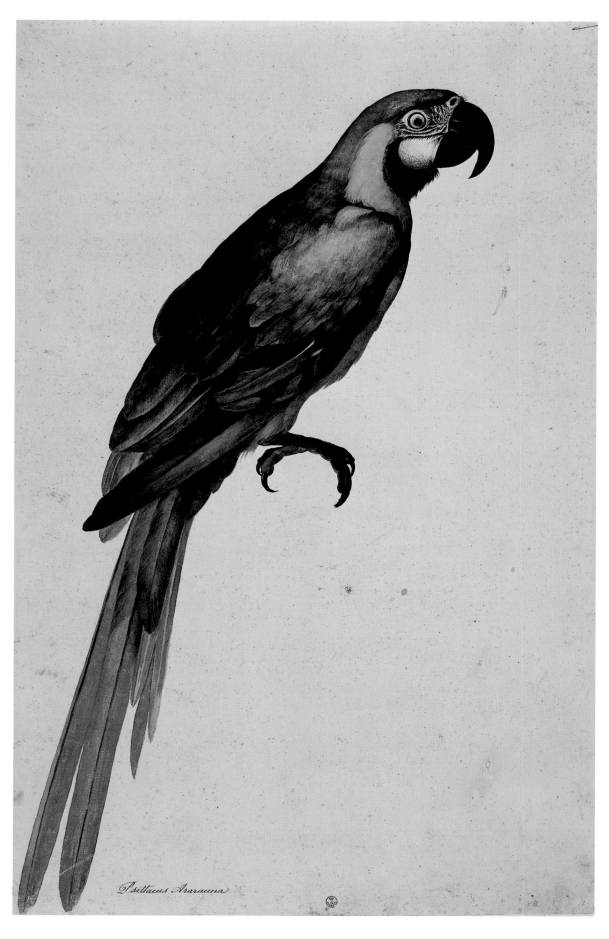

Psittacus Ararauna

OPPOSITE

Jacopo Ligozzi (1547–1632). *Pineapple* (Bromelia ananas). 29 ⁹⁄₁₆ x 18 ⅛ in. (67.5 x 46.1 cm).

Grand Duke Francesco I de' Medici was an enthusiastic student of natural history and the physical sciences. One of his correspondents was the naturalist Ulisse Aldrovandi, to whom Francesco sent drawings by Ligozzi, his court painter, as well as actual plant and animal specimens. In the wake of the age of exploration, drawings such as Ligozzi's were important mediums of study.

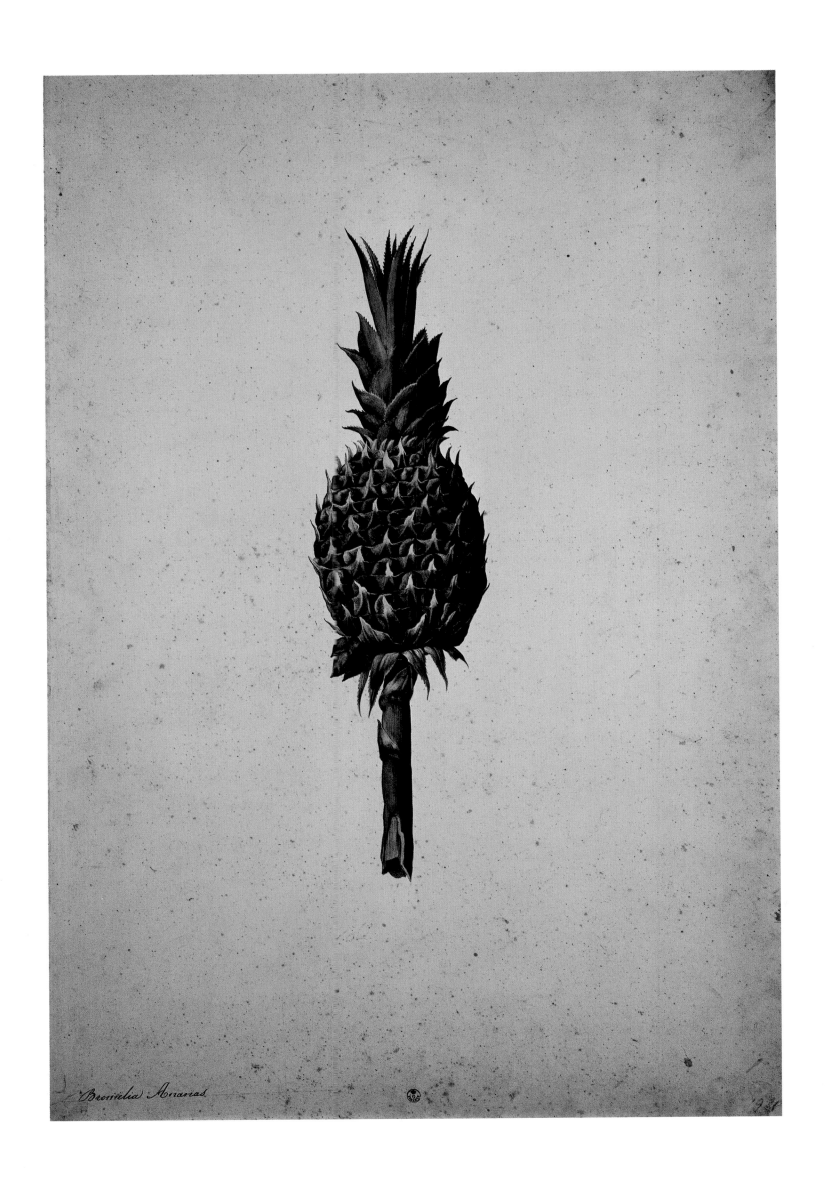

Bromelia Ananas

BIBLIOGRAPHY

Adams, Laurie Schneider. *Art Across Time.* Boston: McGraw-Hill, 1999.

Barocchi, Paola, and Giovanna Gaeta Bertelà. *Collezionismo mediceo: Cosimo I, Francesco I e il Cardinale Ferdinando: Documenti 1540–1587.* Modena: F. C. Parini, 1993.

Belkin, Kristin Lohse. *Rubens.* London: Phaidon, 1998.

Borsook, Eve. *The Companion Guide to Florence.* Woodbridge, Suffolk, UK: Companion Guides, 2000.

Blumenthal, Arthur R. *Theater Art of the Medici.* Hanover, N. H.: Dartmouth College Museum & Galleries; distributed by the University Press of New England, 1980.

Caneva, Caterina, ed. *l corridoio vasariano agli Uffizi.* Florence: Banca Toscana; Milan: Silvana, 2002.

Conti, Cosimo. *Ricerche storiche sull'arte degli arazzi in Firenze.* Florence: Sansoni Editore, 1985.

de Voragine, Jacopo. *The Golden Legend.* Translated by William Granger Ryan. Princeton: Princeton University Press, 1993.

Dizionario biografico degli italiani, vol. 30. Rome: Enciclopedia Treccani, 1984.

Emiliani, Andrea, and August B. Rave, eds. *Giuseppe Maria Crespi: 1665-1747.* Bologna: Nuova Alfa Editoriale, 1990.

Fabbri, Mario, Elvira Garbero Zorzi, and Anna Maria Petrioli Tofani, eds. *Il luogo teatrale a Firenze: Brunelleschi, Vasari, Buontalenti,* Parigi, exh. cat. Milan, 1975.

Freedberg, David. *The Power of Images: Studies in the History and Theory of Response.* Chicago: University of Chicago Press, 1989.

Gli Uffizi: Catalogo generale. Florence: Centro Di, 1979.

Gombrich, E. H. "Norm and Form." In *Gombrich on the Renaissance,* vol. 1. London: Phaidon, 1993.

Gregori, Mina. *Paintings in the Uffizi & Pitti Galleries.* Boston: Little, Brown, 1994.

Grove's Dictionary of Art Online (www.groveart.com).

Guicciardini, Francesco. *Ricordi.* Edited by Vincenzo De Caprio. Rome: Salerno Editrice, 1990.

Hartt, Frederick. *Florentine Art under Fire.* Princeton: Princeton University Press, 1949.

Hibbard, Howard. *Bernini.* London: Penguin Books, 1990.

Hibbert, Christopher. *The Rise and Fall of the House of Medici.* London: Penguin Books, 1979.

Impey, Oliver, and Arthur MacGregor, eds. *The Origins of Museums: The Cabinet of Curiosities in Sixteenth- and Seventeenth-Century Europe.* Oxford, UK: Clarendon Press; New York: Oxford University Press, 1985.

I restauri dell'attentato: Consuntivo 1993–1995. Florence: Centro Di, 1995.

La Galleria degli Uffizi: Guida per il visitatore e catalogo dei dipinti. Florence: Arnaud, 1969.

Lavin, Irving. "Bernini's Image of the Sun King." In *Past-Present: Essays on Historicism in Art from Donatello to Picasso.* Berkeley: University of California Press, 1993.

Macadam, Alta. *Blue Guide: Tuscany.* London: A. & C. Black; New York: W. W. Norton, 2002.

McCorquodale, Charles. *Bronzino.* London: Harper & Row, 1981.

Meoni, Lucia. *Gli arazzi nei musei fiorentini: La collezione medicea.* Catalogo completo: 1. La manifattura da Cosimo I a Cosimo II (1545–1621). Leghorn: Sillabe, 1998.

Micheletti, Emma. *Family Portrait: The Medici of Florence*. Florence: Scala Books, 1980.

Neff, Amy. "The Pain of *Compassio*: Mary's Labor at the Foot of the Cross." *The Art Bulletin* 80, no. 2 (June 1998): 254–273.

Origo, Iris. "The Domestic Enemy: The Eastern Slaves in Tuscany in the Fourteenth and Fifteenth Centuries." *Speculum* 30, no. 3 (July 1955): 321–366.

Payne, Blanche. *History of Costume: From the Ancient Egyptians to the Twentieth Century*. New York: Harper & Row, 1965.

Steinberg, Leo. *The Sexuality of Christ in Renaissance Art and in Modern Oblivion*. Chicago: University of Chicago Press, 1996.

Tazartes, Maurizia. *Bronzino*. Geneva and Milan: Rizzoli/Skira, 2003.

Tofani, Anna Maria Petrioli, ed. *Andrea del Sarto: Drawings*. Florence: La Nuova Italia, 1985.

———. *Italian Painting: The Uffizi, Florence*. Cologne: Taschen, 2000.

Treasures of the Uffizi, Florence. New York: Abbeville Press, 1996.

Vasari, Giorgio. *Le vite dei più eccellenti pittori scultori e architetti*. Edited by Jacopo Recupero. 1568. Reprint: Milan: Rusconi Libri, 1966.

Vatti, Aristodemo. *Le Meraviglie dell'Arte nella R. Galleria Uffizi di Firenze*. Florence, Libreria Salesiana Editrice, n.d.

Winspeare, Massimo. *I Medici: L'epoca aurea del collezionismo*. Florence: Sillabe/Firenze Musei, 2000.

Yates, Frances A. *The Valois Tapestries*. London: Warburg Institute, University of London, 1959.

Zuffi, Stefano. *Gospel Figures in Art*. Translated by Thomas Michael Hartmann. Los Angeles: The J. Paul Getty Museum, 2003.

PHOTOGRAPHY CREDITS

INDEX

THE MEDICI

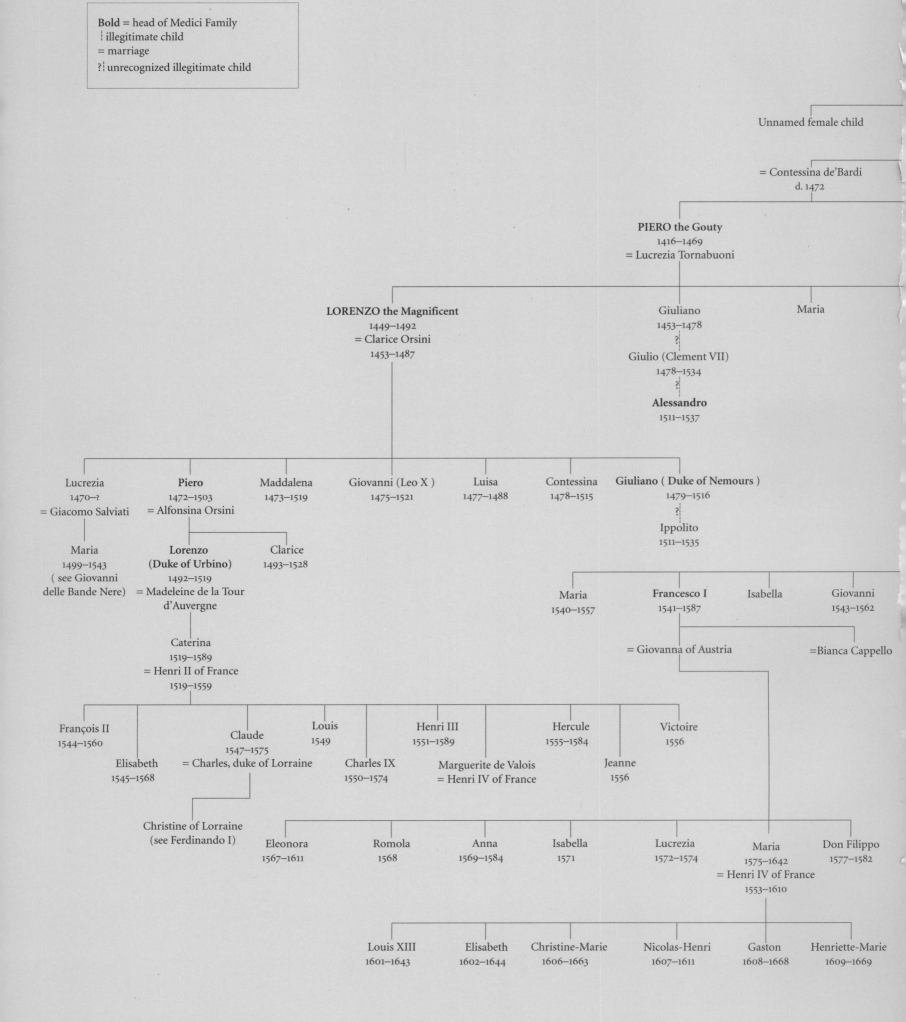

Bold = head of Medici Family
⋮ illegitimate child
= marriage
?⋮ unrecognized illegitimate child

Unnamed female child

= Contessina de'Bardi
d. 1472

PIERO the Gouty
1416–1469
= Lucrezia Tornabuoni

LORENZO the Magnificent
1449–1492
= Clarice Orsini
1453–1487

Giuliano
1453–1478
?⋮
Giulio (Clement VII)
1478–1534
?⋮
Alessandro
1511–1537

Maria

Lucrezia
1470–?
= Giacomo Salviati

Piero
1472–1503
= Alfonsina Orsini

Maddalena
1473–1519

Giovanni (Leo X)
1475–1521

Luisa
1477–1488

Contessina
1478–1515

Giuliano (Duke of Nemours)
1479–1516
?⋮
Ippolito
1511–1535

Maria
1499–1543
(see Giovanni
delle Bande Nere)

**Lorenzo
(Duke of Urbino)**
1492–1519
= Madeleine de la Tour
d'Auvergne

Clarice
1493–1528

Maria
1540–1557

Francesco I
1541–1587

Isabella

Giovanni
1543–1562

Caterina
1519–1589
= Henri II of France
1519–1559

= Giovanna of Austria

=Bianca Cappello

François II
1544–1560

Elisabeth
1545–1568

Claude
1547–1575
= Charles, duke of Lorraine

Louis
1549

Charles IX
1550–1574

Henri III
1551–1589

Marguerite de Valois
= Henri IV of France

Hercule
1555–1584

Jeanne
1556

Victoire
1556

Christine of Lorraine
(see Ferdinando I)

Eleonora
1567–1611

Romola
1568

Anna
1569–1584

Isabella
1571

Lucrezia
1572–1574

Maria
1575–1642
= Henri IV of France
1553–1610

Don Filippo
1577–1582

Louis XIII
1601–1643

Elisabeth
1602–1644

Christine-Marie
1606–1663

Nicolas-Henri
1607–1611

Gaston
1608–1668

Henriette-Marie
1609–1669